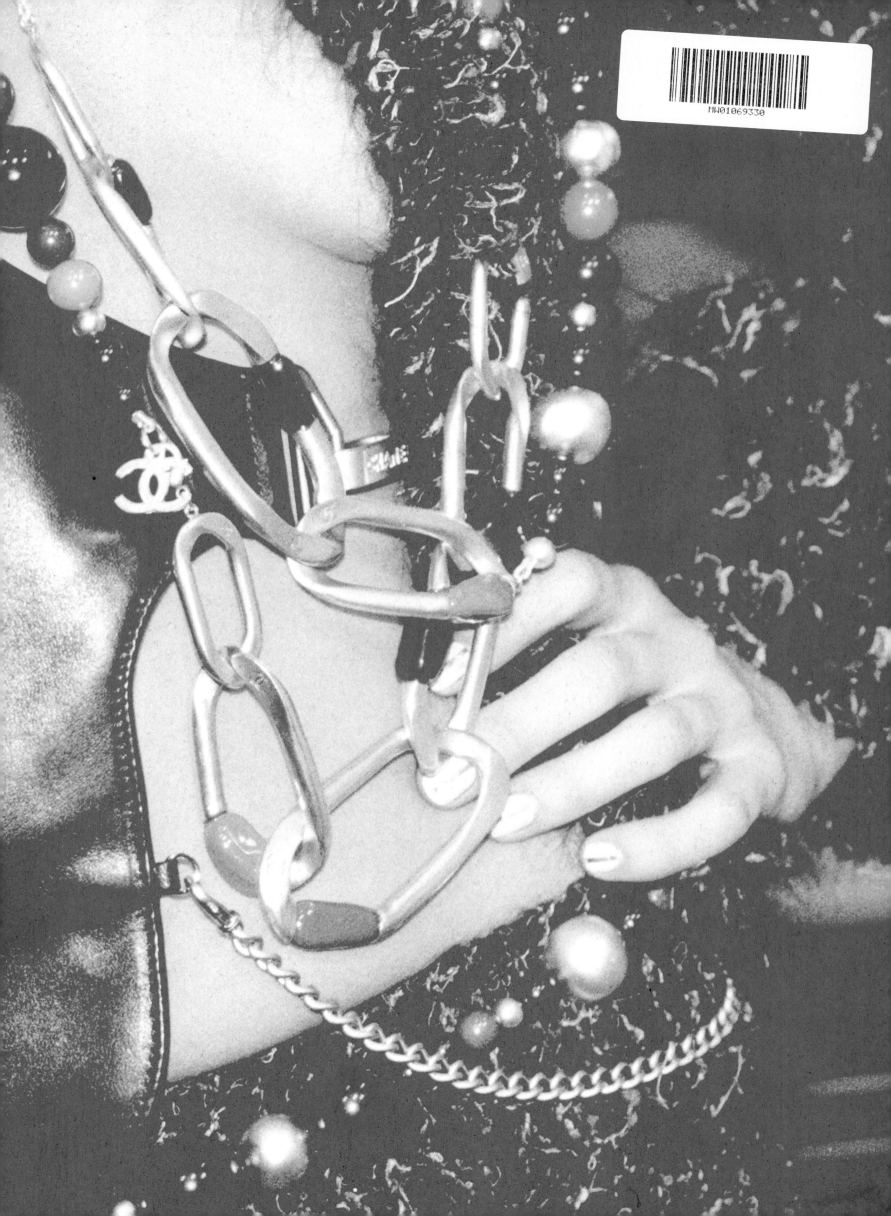

Karl
Lagerfeld
Unseen

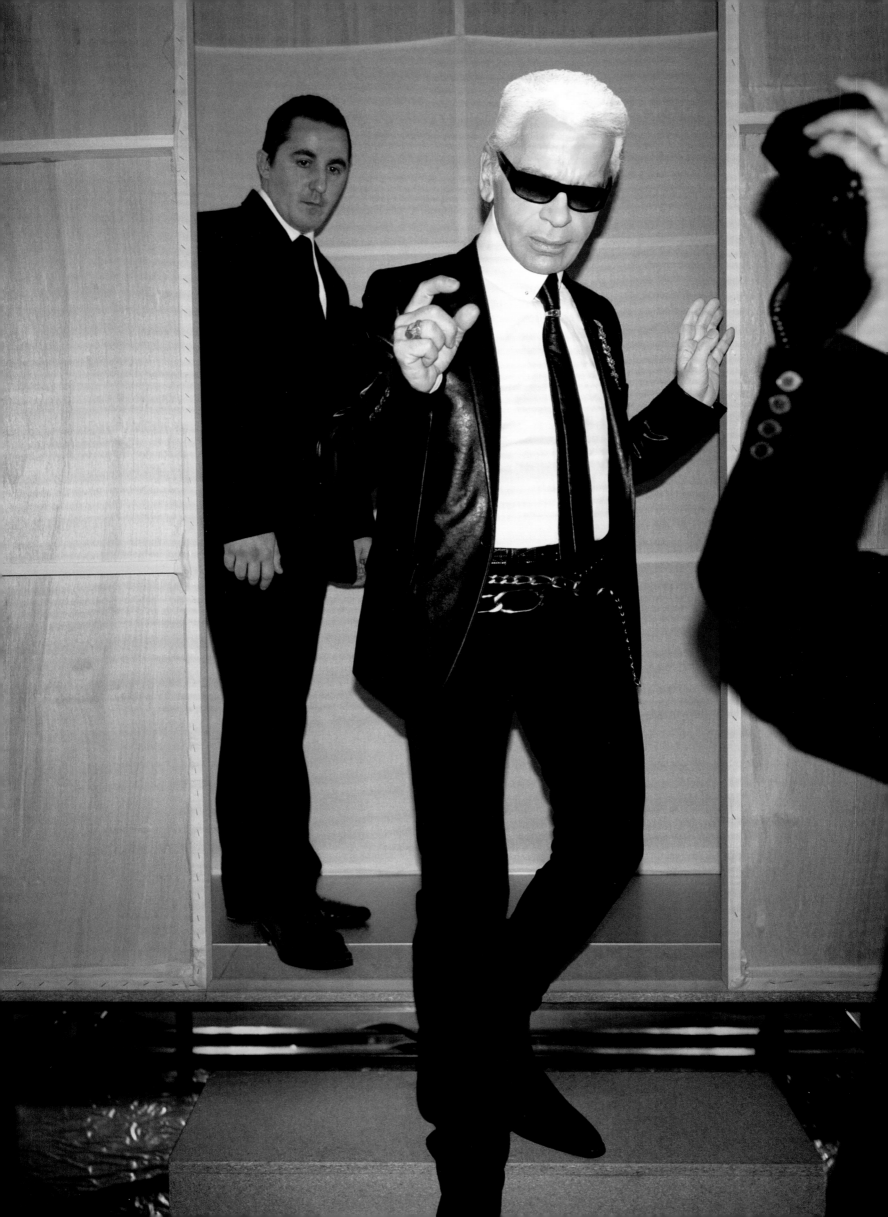

Robert Fairer

Karl Lagerfeld *Unseen*

THE CHANEL YEARS

With texts by Sally Singer,
Natasha A. Fraser, Robert Fairer,
Elisabeth von Thurn und Taxis and others

Abrams, New York

'In Karl's mind, the backstage was often more important than the runway. He loved the moment when his sketches, his vision, swirled into life, crackling with the nervous energy and beauty of the models. He would walk down the line of girls in their first outfits, adjusting a ribbon or asking for more pearls, telling a girl to put her hand in her pocket or throw her shoulders back to enforce the line of a jacket. Memories of crazy heady shows must have hovered like sunspots — when girls styled themselves seconds before dancing down the catwalk.

The backstage is a launch pad of possibility. Karl would often turn to me as the show was about to begin, his dark glasses flicking from the monitor to the line-up of the first girls: "This doesn't make the next one but I already have an idea for the set." He always wanted to "do better", and at the point when his collection was about to take flight — Michel Gaubert's show soundscape filling the *coulisses* over the shouts of the teams backstage and the first girl given the "GO! GO! GO!" to walk out into the blinding wall of lights — he knew he couldn't refine, mix, clash, tease any further … but it always gave him an idea for his next step.

The minutes between "First outfits, everyone" and "The show is about to start" are sluiced with adrenaline: every gesture remains imprinted on the retina, framed in a blur of hair and make-up teams working their way down the line, shouting to their lead assistants to adjust hats that have dislodged a curl or powder where dressers have not put a dress on carefully. Robert Fairer catches the joy, edge and beauty of a world Karl adored — the unseen world of Karl — the backstage.'

Amanda Harlech

PREFACE

Sally Singer

On the surface, this is a work of documentary photography by the tirelessly clever and observant Robert Fairer. It chronicles the runway collections, front and backstage, for the house of Chanel by Karl Lagerfeld in the years 1994–2007, a period in which he established the codes and qualities that would ultimately transform a Parisian heritage marque into the very definition of a global luxury empire. This is the period in which Lagerfeld, also tirelessly clever and observant, set the table for the banquet that would follow.

And yet, *Karl Lagerfeld Unseen: The Chanel Years* is so much more than a record of a house and time. For me, and for many of my contemporaries I would assume, it is a work of haunting intensity and brilliance. Ghosts leap from its pages, causing the most exquisite racket in my brain; and each time I pore through the pages I am rattled to the core. There is, of course, Mr Lagerfeld himself: a figure who was so omnipresent, youthful and prolific that it seemed impossible that he could pass from this world. There is André Leon Talley, whose insights and wild intelligence are sprinkled throughout these pages like caviar beading on a floor-length cape (which was a very André look). There is Stella Tennant, a woman of such grace, gravitas and ineffable cool that it seems completely unfair that the world goes on without her. And there is the partnership of Lagerfeld and Amanda Harlech (herself a writer of ghost stories), which was one of those very rare couplings in the history of fashion in which the outcomes are even greater than the sum of the parts.

So much has been lost of late … and how wonderful to discover it here again in Fairer's bewitching photographs. The world of Chanel revealed in these pages is itself a ghost, a pre-social-media time in which fashion shows were staged for editors, buyers and clients, and documented by a select few (lucky) photographers. The shows were often spectacular, but they were not the spectacles that would come to transform the Grand Palais into an airport, a supermarket, a rocket ship. Sure the prêt-à-porter collections could be theme-y and cheeky, with logos and product galore; true the couture could be shown in a walled garden or how-did-we-get-here hippodrome. But so much was kept behind the curtain and revealed cunningly and gently to a small, discerning audience. I can't judge if it was better or worse; it was simply different. And it is a pleasure to see it all again, and through Fairer's intimate lens.

I have a ghost story of my own to tell. Two decades ago I wrote something which infuriated Lagerfeld. It was completely unintentional on my part; I had been praising the work of another designer and had only mentioned Karl in passing. He wrote me a many-paged letter detailing all that I did not understand about his legacy and fashion generally. I couldn't bring myself to apologize — I didn't think that what I had written was incorrect — but I was mortified that I had hurt his feelings; he was a legend, after all. And so I did what any immature idiot does when they are embarrassed and dumbstruck: I hid. I haunted the rue Cambon, slunk through previews, slid into shows, shrunk behind columns at Met Balls, possibly crouched under a bleacher at a Fendi show or two. It took me years to straighten up and walk tall in his presence. Now, of course, I am haunted by the fact that this great man had once bothered to read something I had written and to take me seriously enough to care and to respond in a handwritten letter. What an honour and a privilege. And what a time.

INTRODUCTION
'IN THE COURT OF THE KING OF FASHION'

Natasha A Fraser

Within a year of arriving at Chanel in 1983, Karl Lagerfeld had revolutionized the French luxury house and made it into a must-have brand. As Robert Fairer's poignant backstage photographs illustrate, Lagerfeld's Chanel shows continued to be heightened and euphoric throughout the 1990s and 2000s. 'Fashion has to be fun, otherwise what's the point?' the German designer used to tell me. His reign as Chanel's creative director — and Lagerfeld really forged an enviable kingdom on every front — lasted a staggering 36 years. With Teutonic discipline and precision, he breathed back a lively relevance into Chanel, yet weaved in Parisian excellence and reintroduced the house's heritage and codes. The brilliantly innovative founder Gabrielle Chanel — termed 'a mystery and paradox' by Lagerfeld — had dreamed up a fashion vocabulary of tweed suits, little black dresses, quilted handbags, costume pearls and camellias. Nevertheless, the stylish list was in desperate need of a revamp.

After Mademoiselle died in 1971, the atmosphere at Chanel was described as resembling the Kremlin post Stalin's death. Philippe Guibourgé may have been hired to design a brand-new ready-to-wear line, but the place required a serious/charismatic shake-up. Enter Karl — a brave and black knight of sorts — who had caused wonders at Chloé and Fendi. True, both houses were *prêt-à-porter*, but the then 50-year-old's roots had begun in haute couture: Balmain, followed by Patou. A powerhouse waiting to be discovered, Karl possessed an impressive memory bank with regard to fashion styles, he could sketch at a prodigious rate, and he dared to ignite Chanel's fashion shows — formerly uptight, staid affairs on little gold chairs — into exciting events. This was then unheard of. Indeed, ignoring initial cries of horror from Chanel couture clients and traditionalists, Karl swept in and, each

season, tirelessly injected every element with his humour, imagination and savoir-faire. Uninterested in achieving perfection — sensational hits tended to eclipse the duds — Karl never stopped or wavered. He was charged by the immediate, refusing to rest on his former laurels or failures. At Chanel's helm, he set new terms for the haute couture. It needed to evolve with the seasons. And Karl aimed to do the same with luxury ready-to-wear. His attitude dynamited Paris in the 1980s. Of course, there was the exalted band of *enfants terribles* — designers Azzedine Alaïa, Jean Paul Gaultier, Kenzo Takada, Claude Montana, Thierry Mugler — but although they owned their eponymous houses, none of them designed couture. Karl was the first to take over a major fashion house and fire on every front.

And it has to be stressed that Karl, who became my boss in November 1989, was this spectacular personage. Due to his unusual appearance — the dark sunglasses, powdered pony-tailed hair, and theatrical waving of a fan — he was instantly recognizable. A journalist's dream, Karl also managed to be witty and/or outspoken in four languages. At that time, couturiers were discreet. Their lack of English didn't help either. Not so with the Kaiser — Karl's brief nickname — whose English, French and Italian were as excellent as his native tongue. Being wildly quotable, he intrigued and piqued interest from a non-fashion public. Karl broke all barriers.

I realized this at my 21st birthday party, held at my mother's Notting Hill Gate home in 1984. Someone gave me a gift from Chanel. And the sight of the little white box with double-C insignia and black satin ribbon caused a stir. My then boyfriend had a jealous fit — dismissing the Chanel drop pearl earrings as fake — while my trendsetting girlfriends urged me to put them on. Having been a fusty label for my generation — one associated

with perfume, wealthy grannies, and conventional tweed suits with over-the-knee skirts — suddenly Chanel rocked. This situation was confirmed when my friend Lucy Ferry — the fashion-forward wife of the rock star Bryan Ferry — wore a Chanel couture gown to the Marquess of Bristol's society wedding at Ickworth, his stately home. The exquisite evening dress, embroidered with piano-like detailing, was a memorable showstopper. By the following year, when I moved to Los Angeles, Chanel fever had exploded. The ivory, navy and black colour palette was echoed in all of the Beverly Hills boutiques, and then there were Karl's television appearances and interviews. He was a glamorous news item, and so was his leggy muse — Ines de la Fressange. For sophisticated American women, she epitomized Parisian chic by wearing knobby tweed suits, gold-chained accessories and immaculately applied red lipstick.

I thought nothing more about Karl and Ines until I decided to leave Andy Warhol's *Interview* magazine and move from New York to Paris in 1989. It was an ill-planned idea — my French was non-existent — until Anna Wintour offered to help. She had tried to hire me at American *Vogue* (my working papers situation proved it impossible). However, her faxes sent to Gilles Dufour at Chanel, Loulou de la Falaise at Yves Saint Laurent, Jean-Jacques Picart at Christian Lacroix and Isabel Canovas paved my way in Paris. Apart from Canovas (a costume jewelry designer), Chanel, Saint Laurent and Lacroix were among the top couture houses within American *Vogue*'s pages. The house of Christian Dior — having been newly taken over by Gianfranco Ferré — was finding its bearings, whereas both Emanuel Ungaro and Givenchy were functioning but aimed at a mature clientele.

In many ways, Anna Wintour returned Paris couture back to her readers. Indeed, her first *Vogue* cover in November 1988 — teaming a Lacroix couture jacket with jeans — was a surprise and sent the New York fashion world/Seventh Avenue into a spin. I still remember the designer Oscar de la Renta spitting tacks about the choice. Prior to Anna's arrival, American designers like Geoffrey Beene, Bill Blass, Perry Ellis, Donna Karan and Calvin Klein ruled the roost. It was a golden period for American ready-to-wear. Yet Anna sensed, added, and drove something else. And it was interesting that her charismatic *Vogue* team were mostly French-speakers. I refer to the likes of André Leon Talley and iconic stylists such as Grace Coddington, Carlyne Cerf de Dudzeele and Brana Wolf. Of course, there was also the extraordinary stable of photographers like Peter Lindbergh, Helmut Newton and Patrick Demarchelier. And then there were the Super Models.

Whatever has been written about Linda Evangelista, Claudia Schiffer, Christy Turlington, Karen Mulder, Naomi Campbell and Helena Christensen has not been exaggerated. Otherworldly, it was as if they had been beamed in from planet Venus, except they blasted the catwalk with sassiness and attitude. Miraculously photogenic with smooth skin and endless limbs, they understood clothes and captured the public's imagination. During this period, Hollywood actresses were playing it down and were occasionally frumpy. The red carpet did not exist. As a result, the Super Models were the new pin-ups. Wisely, they milked it.

Just as the Italian designer Gianni Versace grasped the Super Model phenomenon, so too did Karl Lagerfeld at Chanel. To give an idea of haute couture fittings in January 1990, Linda et al would rush from the Chanel studio on rue Cambon and cross the road to the Ritz hotel's secret rue Cambon entrance for their appointments with Gianni, or vice versa. From the Chanel studio's window, I remember watching them run to and fro — not realizing that I was witnessing a chapter of fashion history. On one occasion, I had to accompany Naomi because of a Hollywood actor's behaviour. His suggestive remarks made her feel uncomfortable. And while waiting outside Versace's suite, I met the famous Ines de la Fressange, who was being squired by Luigi d'Urso, a family friend. However, the brief encounter remained secret because Karl had just had a much-publicized almighty bust-up with Ines, his former muse.

Finally, I was assisting at the Chanel studio. It had taken two months of badgering Gilles Dufour, Karl's *bras droit*, and required Anna Wintour's eventual intervention. I had never been so desperate for a post and was terrified about being turned down. Even though every single Parisian I met said, 'Karl will love you', I feared the worst. What if the discerning pony-tailed Kaiser loathed me?

Our first meeting took place in November 1989 at the Chanel studio. To announce his arrival, the receptionist called. 'Monsieur Lagerfeld est arrivé,'

she whispered. As soon as the news hit, there was a wave of reaction from my Chanel studio colleagues — namely Virginie Viard, Victoire de Castellane, Armelle Saint-Mleux and Franciane Moreau. Chunky jewelry was added, lipstick was applied, and high heels were slipped on. Suddenly, a fleet of white canvas tote bags appeared, delivered by Brahim, Lagerfeld's chauffeur. The ceremony was regal and followed by Karl who was sporting a forest-green loden coat. Quite plump and small, he refused to look me in the eye when Gilles introduced us. Instead, he pushed his sunglasses up, peered down, and chose to comb through a tote packed with papers, crayons and pencils. While placing his coloured sketches on his desk, he revealed that he had met my mother (Antonia Fraser) and my grandmother (Elizabeth Longford) at the house of George Weidenfeld, their Austrian-born book publisher.

Karl's conduct was strange but I instinctively liked him, deciding that he was irked by the disruption, being keener to work. In spite of the mild gruffness, he was touching. When leaving, Gilles helped him put on his coat, due to Karl's exceedingly short arms, hastily described as 'an unfortunate family characteristic'. There was also the light trace of make-up: foundation — noticeable above his broad and mobile mouth — and the specks of white powder on his collar, due to the dry shampoo sprayed on his head for the 18th-century effect. Nevertheless, I kept such thoughts to myself. Karl was a king, surrounded by courtiers eager to repeat stories and win favour.

A few days later, at Gilles's insistence, Karl was introduced to my découpage jewelry and scarf designs, initially commissioned by Jean-Jacques Picart at Lacroix. After choosing two pairs of earrings — one was an enamel seahorse, and the other was a mussel holding a baroque pearl — he focused on my fabric that depicted a teapot pouring out jewels. Taking an A3 piece of paper and thick pen, Karl sketched and marked out how the teapots should be placed, then swiftly handed it over to Gilles. 'We'll add some double Cs and use it for *prêt-à-porter*,' he said. The following season, my teapots were splashed across a black satin silk fabric, manufactured by Cugnasca in Italy, and used for Chanel blouses, jackets and skirt linings. Two more prints eventually followed, one showing hand-drawn double-C cards amid strings of pearls and diamond

tears, and the final one using double-C clocks flying on jewelled wings.

However, apart from these three curiously successful yet unpaid endeavours, I was a complete Chanel studio dilettante. As Karl later said, 'Natasha, you spent your life on the telephone.' Blasé as it will sound, I did. Such behaviour stemmed from speaking little French and making everyone laugh. Karl described me as 'a good-natured belle époque actress'. (Having begun photography, he took my portrait several times.) There were also his magnificent candlelit dinners — either held at his rue de l'Université apartment or at Lamée, a charming country house, outside Paris. An enthusiastic collector of the 18th century, Karl was a walking encyclopaedia about the period. A skilled host, he made me feel included even though the other guests were infinitely more soigné and international.

Looking back, those soirées captured how high fashion was still wrapped up in Parisian society — and Karl straddled both worlds, seamlessly. As did his ex-friend Yves Saint Laurent. The designers had fallen out over Jacques de Bascher, Karl's boyfriend, and the rift further widened. There was even a sense that Paris was divided between Yves's camp and Karl's.

Fuelling the animosity was Suzy Menkes's unforgettable review in the *International Herald Tribune*, which opined, 'in the judgment of fashion history, and in spite of his ebullient talents, Lagerfeld risks playing Salieri to Saint Laurent's Mozart'. I can still hear Gilles reading it out to Karl on the telephone. Many wondered if the influential English journalist was stating her allegiance to Pierre Bergé, Saint Laurent's business partner. Quite understandably — though, publicly, he respected Menkes — Karl never forgave her.

Meanwhile, the only time that I was cattle-pronged into action — usually by Gilles — was when Karl accessorized Chanel's collections and produced shows. During those periods, the studio was set alight by Karl's creativity. Gilles distributed his original sketches to the various ateliers. Two personal favourites were Monsieur Paquito — responsible for haute couture *tailleur*/suits — and Madame Edith, who had worked with Mademoiselle Chanel and did ready-to-wear *flou*/dresses. In the meantime, the Chanel studio's long, portable screen was pinned with photocopies of Karl's sketches.

If only I owned photographs of them... Each one was delicately coloured with Chanel make-up, while the buttons and trim were accented with a gold pen. Karl used to say that the fashion illustrator Antonio Lopez had no equal. However, Karl was capable of sketching and imitating every single designer's style. Achieved in seconds, it was fascinating to watch.

Whereas Karl's senior assistants like Virginie Viard and Victoire de Castellane were in charge of hats, shoes and jewelry, camellias became my domain. It meant working with Madame Jeanne at Lemarié. On one occasion, I ordered eighty taffeta camellias to match Linda Evangelista's green eyes. Unfortunately, the celadon dress was never used.

Accessory time meant Karl's desk being covered in trays and trays of Chanel's earrings, brooches, cuffs, quilted bags and chain belts — the fashion world's equivalent of Aladdin's cave — as well as the appearance in the studio of fashion notables like Anna Wintour, Liz Tilberis, Carlyne Cerf de Dudzeele, André Leon Talley, and also the boyfriends of the models. An unforgettable and priceless image remains Karl being seated at his desk between the rock star Michael Hutchence — Helena Christensen's partner — and screen legend Sylvester Stallone. Typically, Karl managed with aplomb, just as he did with the Super Models. Linda Evangelista seemed like the gang's head girl. She had authority. On one occasion, she asked if she should cut her hair. 'Yes,' cried Anna Wintour, echoed by others seated beside her.

Naturally, there were dramas. During the 1990 Autumn/Winter couture show, in which Linda and Christy Turlington brandished Lesage-embellished redingotes and matching thigh-high boots, certain flaps had not been closed. Ravishing as they looked, their underwear was revealed. The show was unveiled at the Ritz. And I remember overhearing Princess Caroline of Monaco joke, 'Well, come next season, we need to show our panties.' Poor Colette — in charge of the offending atelier — was fired. It seemed odd for such a professional seamstress — I was often sent to collect outfits from her — and I wondered if the looks had been sabotaged. Karl had never liked Colette.

No question, there was a darkness to Karl. Yet, in general, those days were light-hearted and fun. As a joke, Gilles called up Karen Mulder and pretended that all the blondes were going raven-haired black for the season. Fortunately, she was

her good-natured self. A twilight period in Parisian fashion, it was when individual creativity reigned. The design of clothes outshone handbags. Parties were spontaneous, raucous and inclusive. Eccentric and/or bratty behaviour towards the press was tolerated.

Four years later, it would totally change. The designer Hubert de Givenchy was the first to retire in 1995. He had sold his house to Bernard Arnault — the luxury titan — who had already acquired Christian Dior, Christian Lacroix, Louis Vuitton and Céline. It was the beginning of major money in fashion and major corporations offering their Faustian pacts to creators. Soon, it became apparent that the fashion landscape was divided between the old guard (Yves Saint Laurent, Emanuel Ungaro, Claude Montana) versus the new guard (Tom Ford at Gucci, John Galliano at Givenchy then Dior, Marc Jacobs at Vuitton, and Karl).

Instead of nose-diving like his nemesis Saint Laurent, who disappeared into a sea of drugs and alcohol, the ever-sober Karl foresaw the change and was jet-propelled during the 1990s. Having been at Chanel for a successful decade, he turned his back on Paris and *le bon goût français*, and went global. Mastering the Internet, armed with his infinitely quotable one-liners, helped his cause. Perhaps Karl was thirty years older than Tom, Marc and John, but — as long as he avoided minimalism — he was firing on every cylinder. Competition stimulated Karl and pushed him further. His Chanel shows bristled with excitement and remained a main event.

As Robert Fairer's photographs attest, Karl seemed unleashed. A new companion was in his life — Amanda, Lady Harlech — who had previously been John Galliano's muse. The British-born and Oxford University-educated Amanda, renowned for her taste and charm, lightened the load around the well-read Karl. Finally, there was someone who suited his clothes and got his jokes. Amanda could laugh at the phonic similarity between the philosopher Schopenhauer and the term 'shopping hour'.

By strange coincidence, this also became the moment of British model Stella Tennant. Having height and nonchalance, the androgynous aristocrat inspired Karl. A throwback to Ines de la Fressange, Stella evoked elegance in every Chanel outfit and became the ideal contrast to blonde models like Claudia Schiffer, Karen Mulder and Eva Herzigova.

NATASHA A FRASER

As caught by Fairer's lens, Stella's considerable range included a taffeta jumpsuit (see p. 21), the briefest double-C bikini (pp. 48–49), an embroidered dress (p. 62), a black couture evening showstopper in chiffon and satin, emanating Gabrielle Chanel (p. 154), and an embroidered tweed outfit, accompanied by bleached hair (p. 296).

Stella also remained when the ever-mercurial Karl reinvented Chanel for the 21st century. To personally prepare for the noughties, he sold off his esteemed 18th-century collection and, having always battled his weight, lost 92lbs in 13 months and kept it off. Browsing through Fairer's images, one can see that there was a new freshness and versatility to his designs: Chanel jackets were loosened up, skirts tended to be shorter, flowers and feathers were favoured, and the models became younger.

To be backstage at Chanel, whether it was couture or ready-to-wear, was to be blasted with an incomparable joie de vivre. Although everyone was working, there was a sense of 'bienvenue to the Chanel party'. Groups of models resembled modern-day flapper girls. Blissed out, they were giddy and animated, comparing their outfits — which might be a mix of funky tweed, chain necklaces dripping with coins, or hems frayed with marabou feathers.

There was also a sense of camaraderie between Karl's intimates: Amanda Harlech might be ribbing André Leon Talley, whom I nicknamed Stage Momma because he could be so bossy. And Karl would be there with Virginie Viard at the exit, verifying all the models. It was warmly done, but he might make the teeniest adjustments. Though casually presented, nothing was left to chance in his Chanel shows.

When Karl began in 1983, he was designing six Chanel collections but only doing four fashion shows. However, by the end of his life in February 2019, he was designing eight Chanel collections and putting on six blazing fashion spectacles — either filling the likes of the Grand Palais or achieving the equivalent in places as far-flung as Dubai, Havana, Miami, Seoul, Tokyo and Shanghai. Karl was so full on yet determined to make it look easy — 'apart from sketching, talking and reading, there's not much I can do,' he told me in 2009 — that he almost had to die to be completely appreciated.

The workload of the enigmatic and industrious Karl Lagerfeld was equivalent to that of five designers. His achievement was remaining grounded, yet masterfully adapting to every period in order to keep the house of Chanel relevant. Like Gabrielle Chanel, he knew how to express the times, and proved genius-like when faced with her timeless fashion vocabulary — her tweed suits, little black dresses, quilted handbags. That said, he was incapable of reaching the same heights for his eponymous label.

In many ways, Karl was a company man. He found his perfect employers in the form of Alain and Gérard Wertheimer, Chanel's owners. The relationship was mutual. Karl was a dream for Chanel because he was intent that the house 'endure generation upon generation', and he remained evergreen creative. 'You cannot understand why suddenly one thing becomes mythical and other things disappear,' he said. 'This is a question with no answer, and there shouldn't be an answer because then all mystery would die, and [fashion] would only be a business matter.'

THE
COLLECTIONS

AUTUMN/WINTER 1994–1995
READY-TO-WEAR

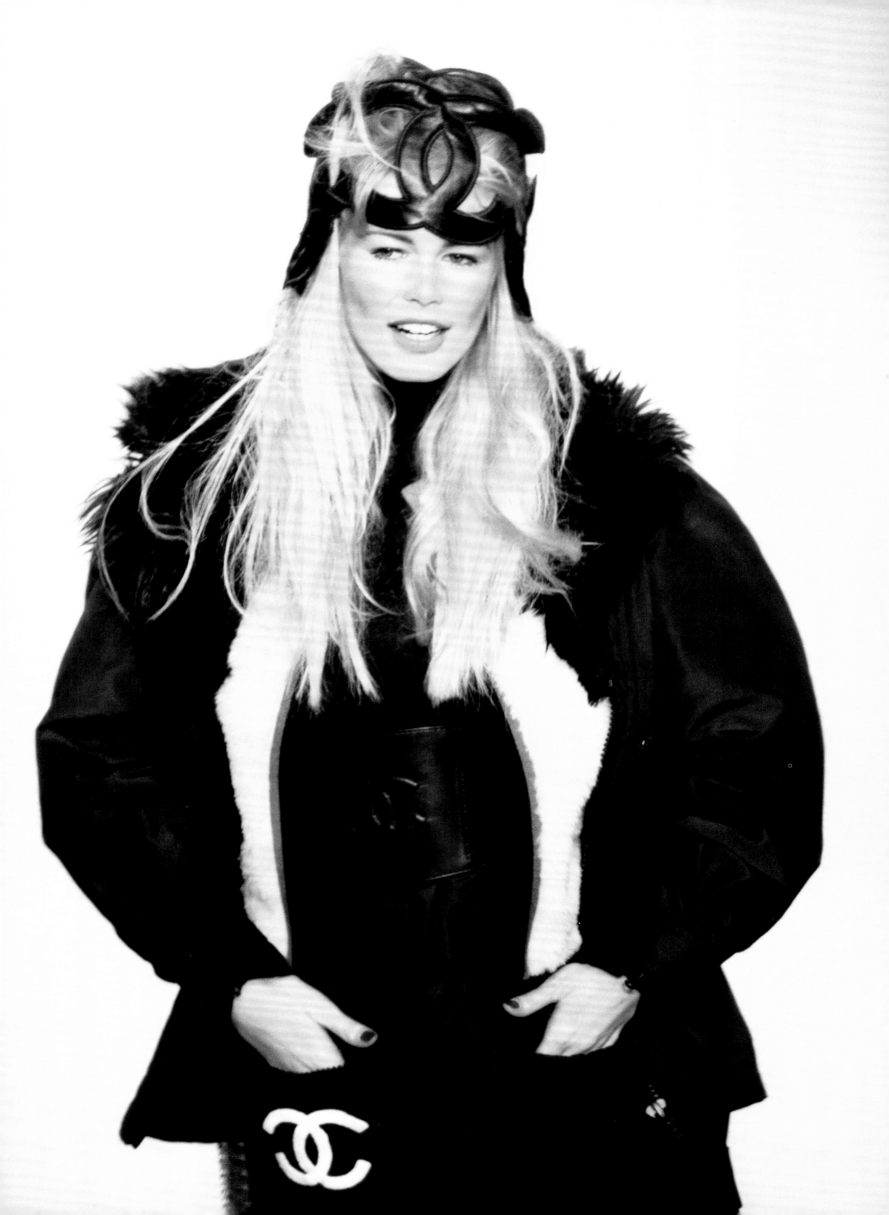

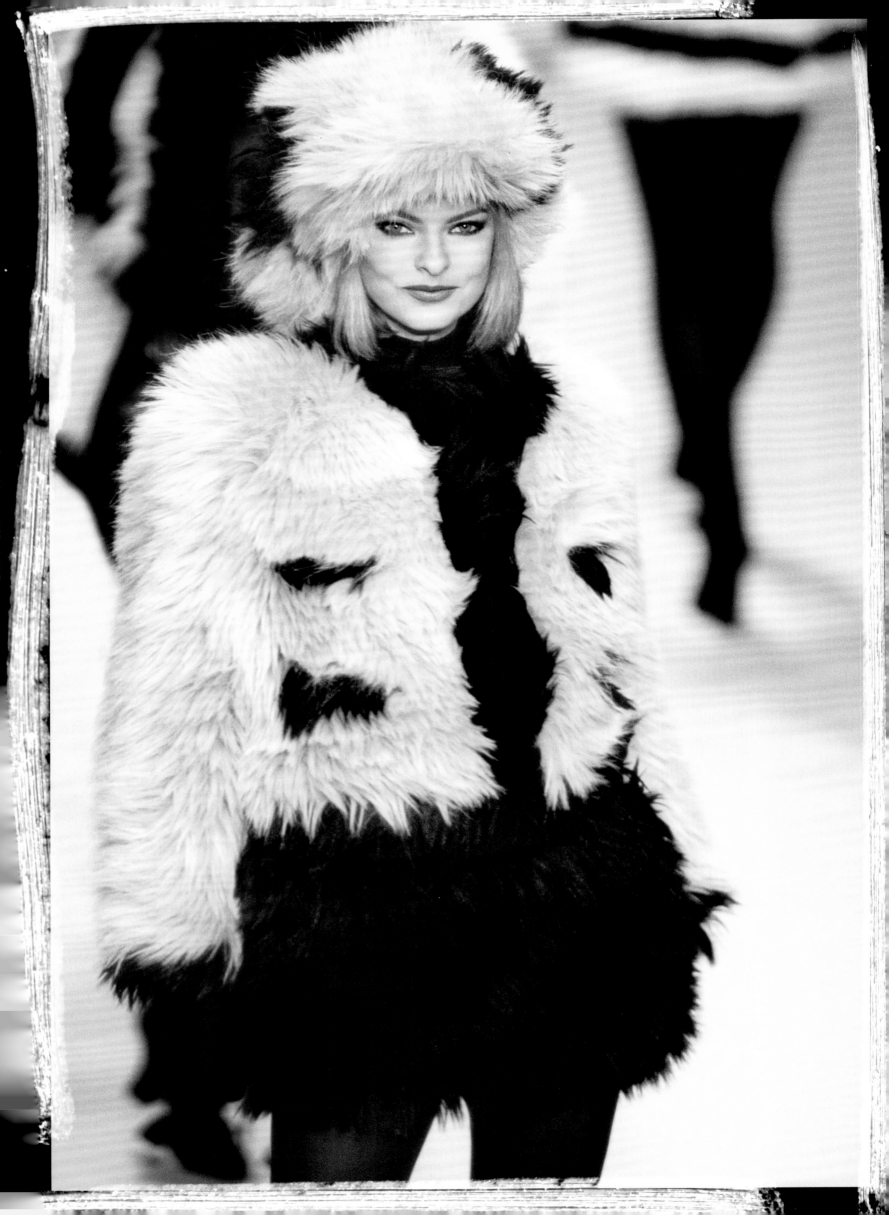

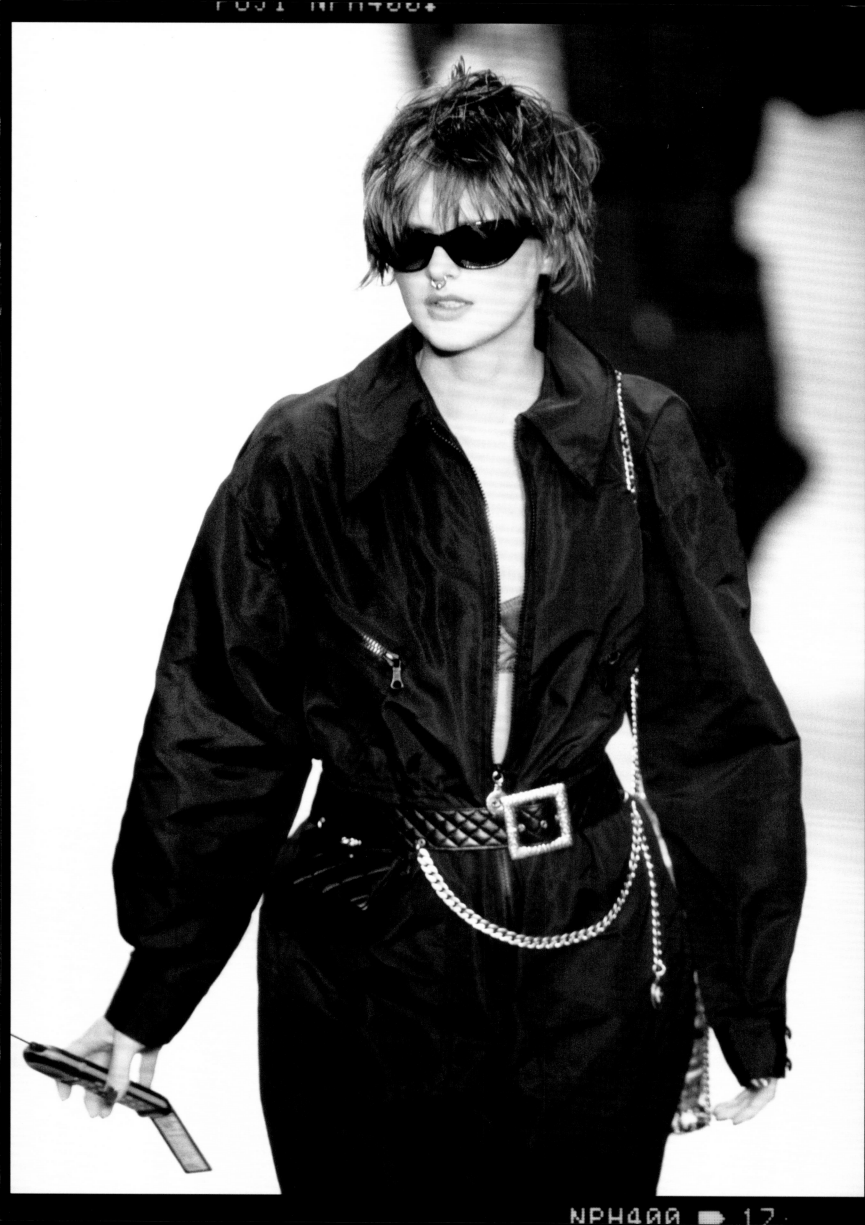

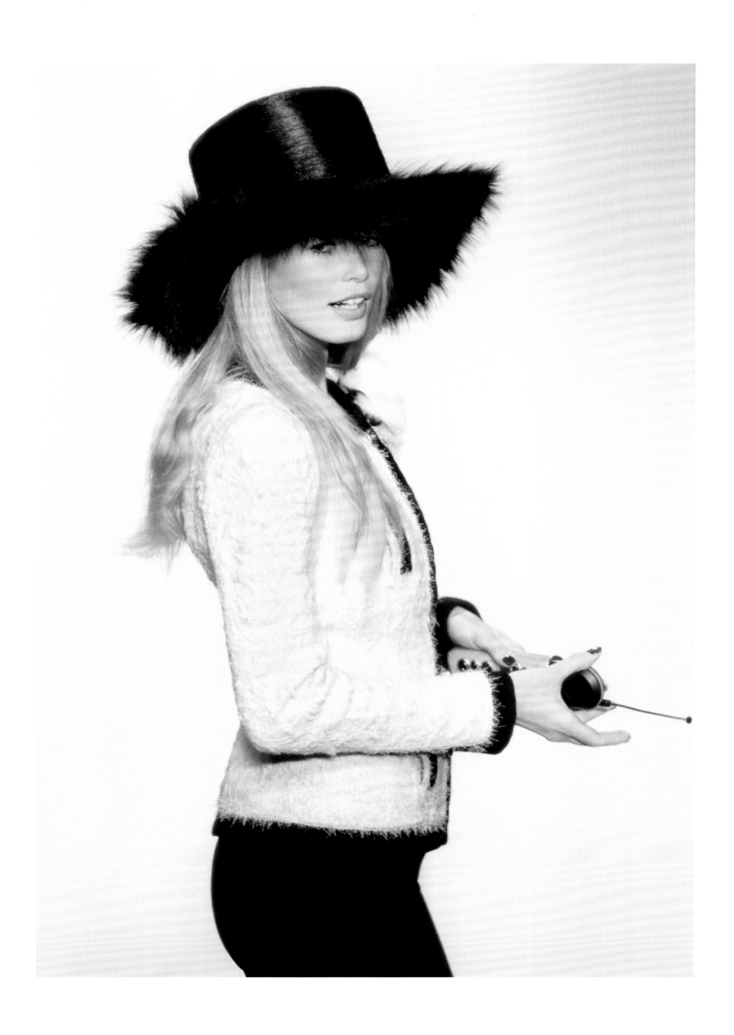

AUTUMN/WINTER 1994–1995 READY-TO-WEAR

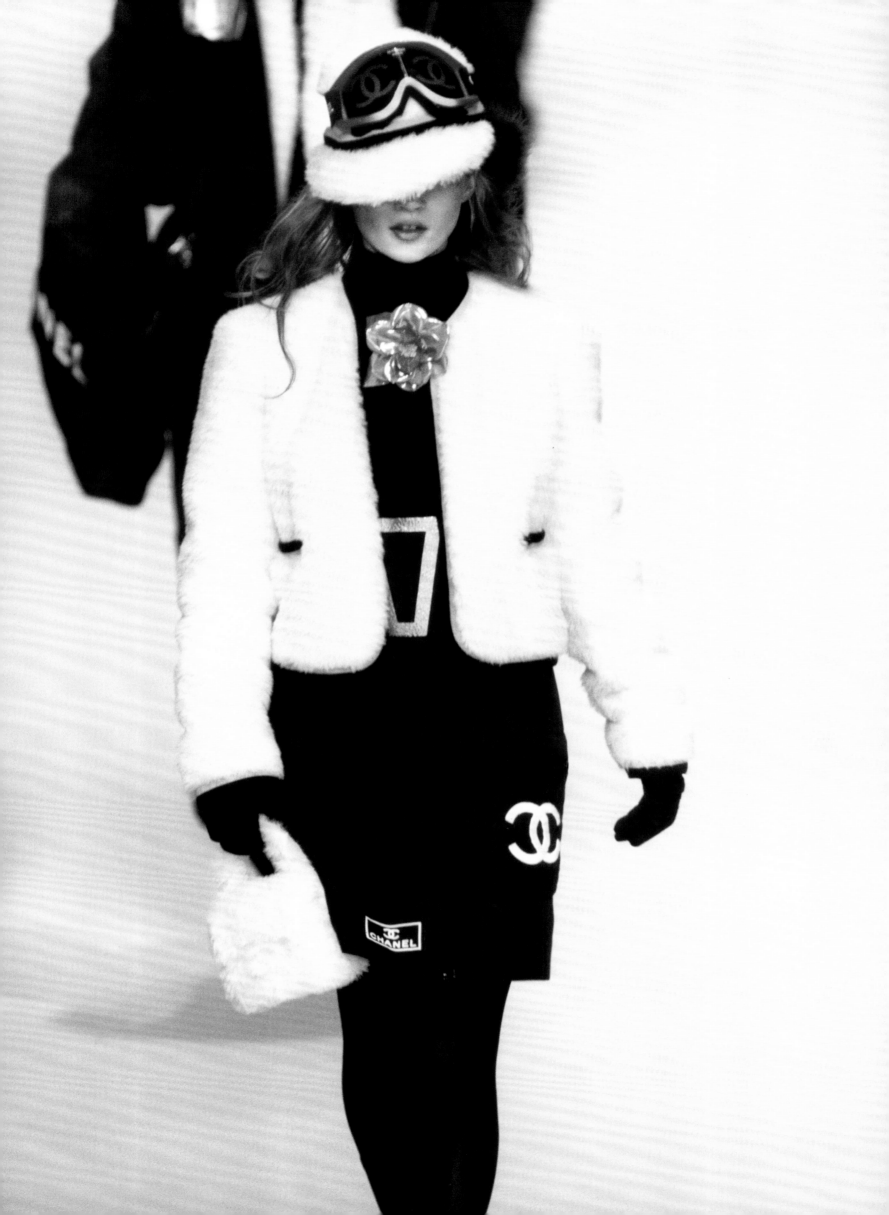

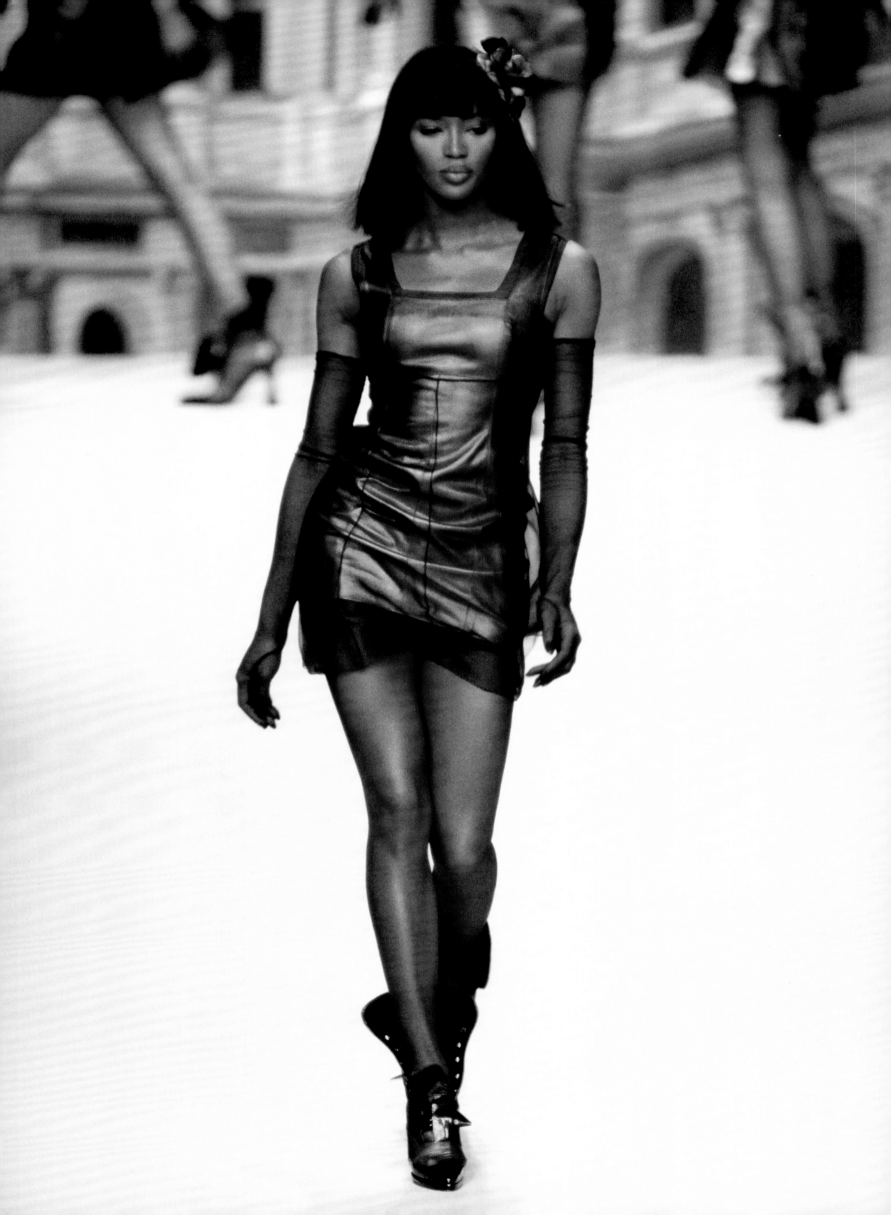

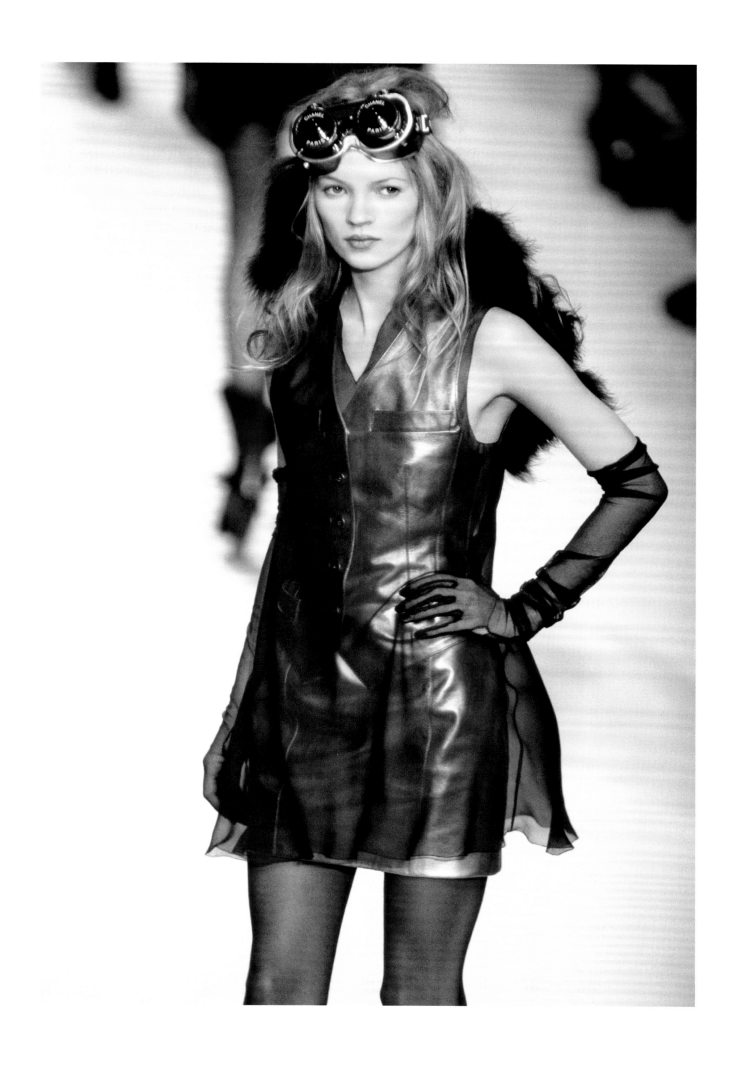

SPRING/SUMMER 1995
READY-TO-WEAR

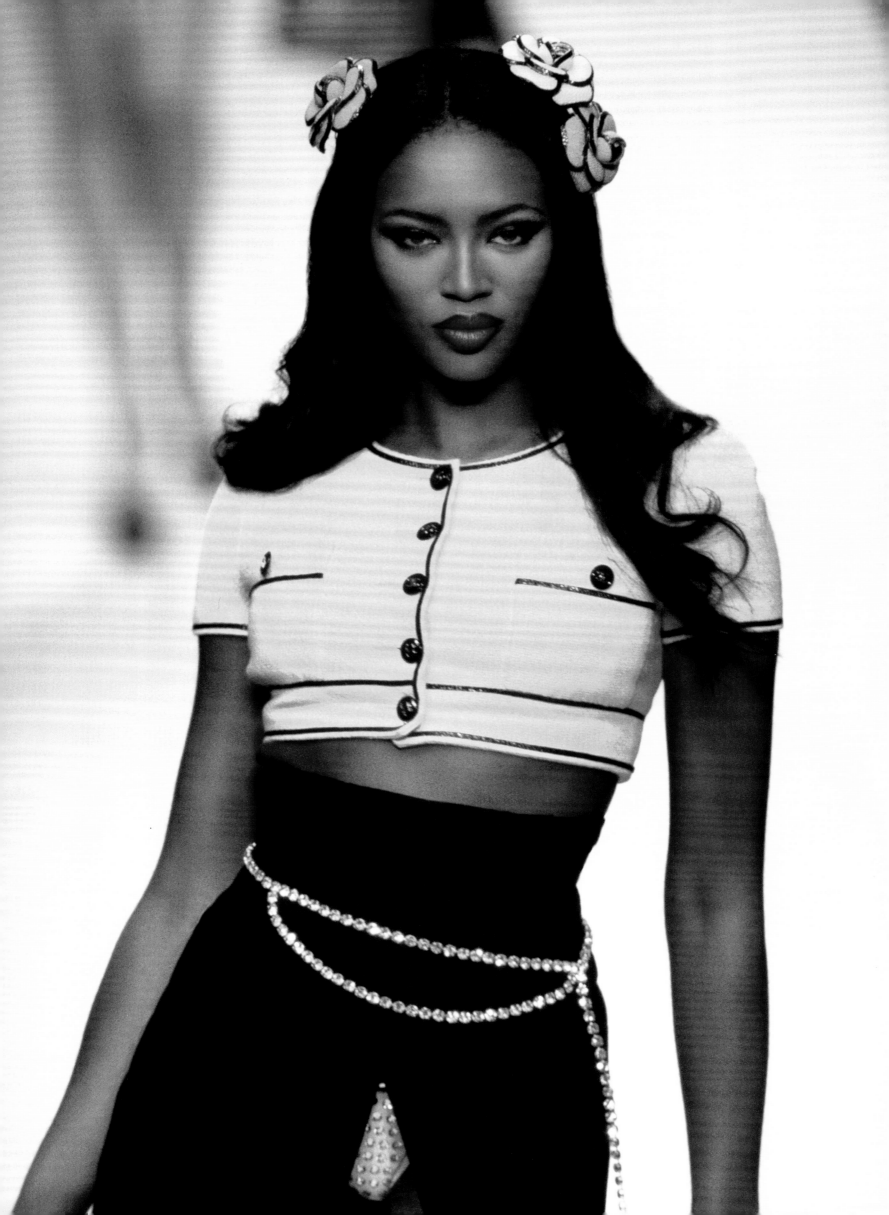

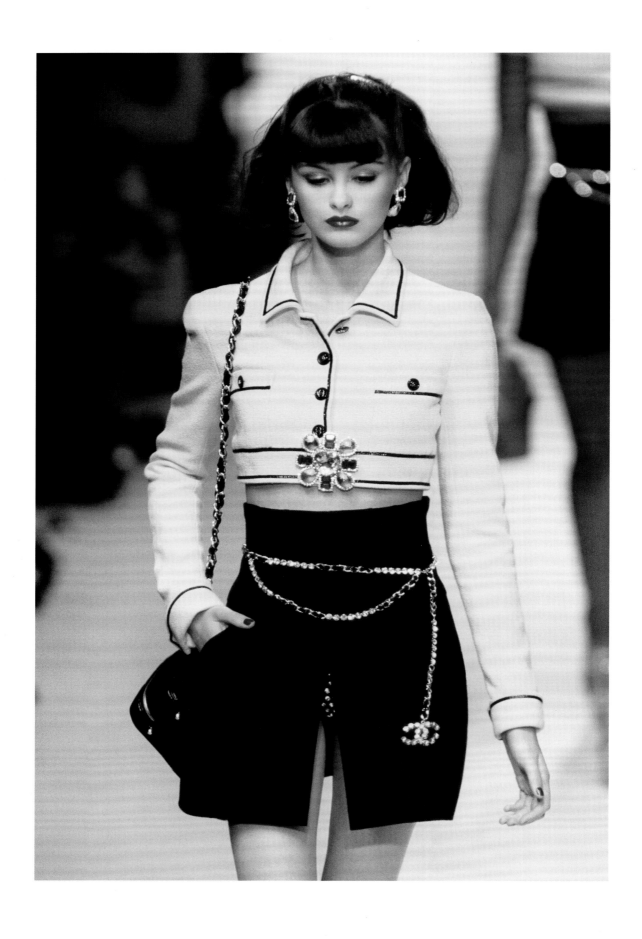

SPRING/SUMMER 1995 READY-TO-WEAR

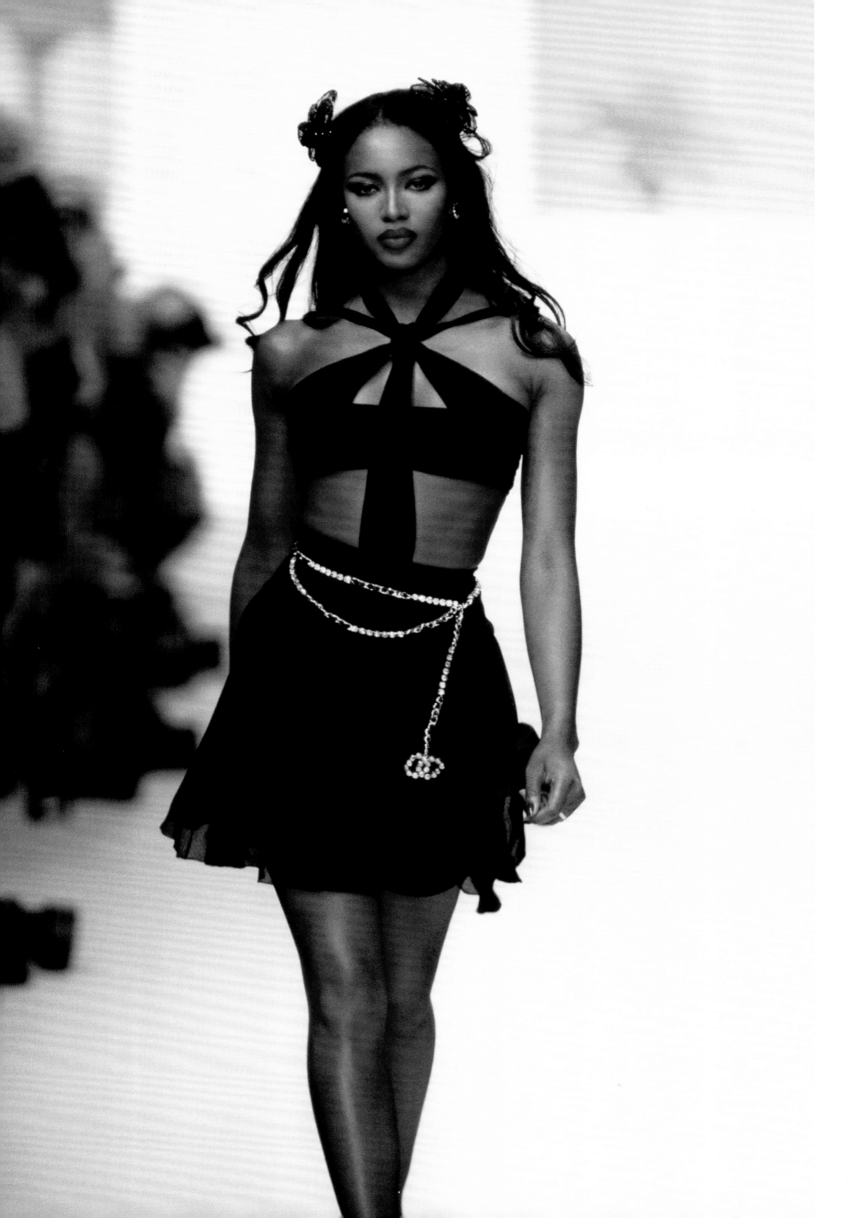

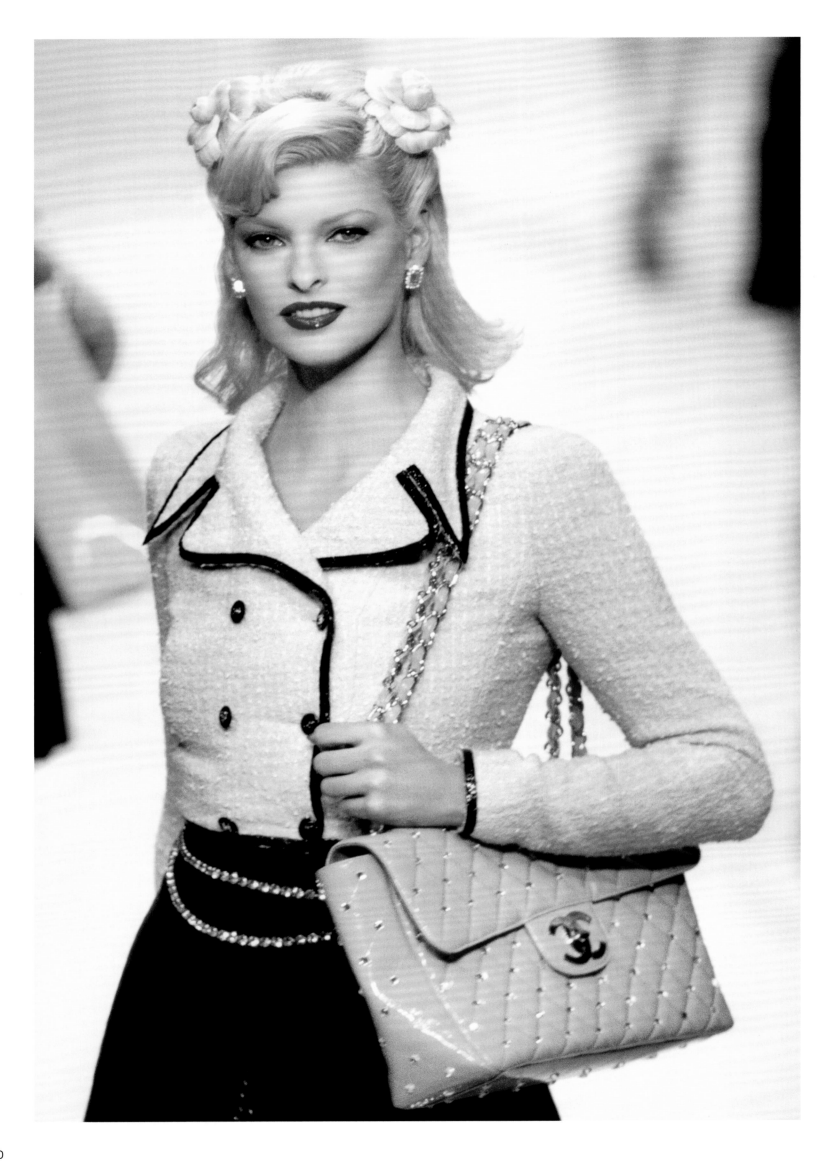

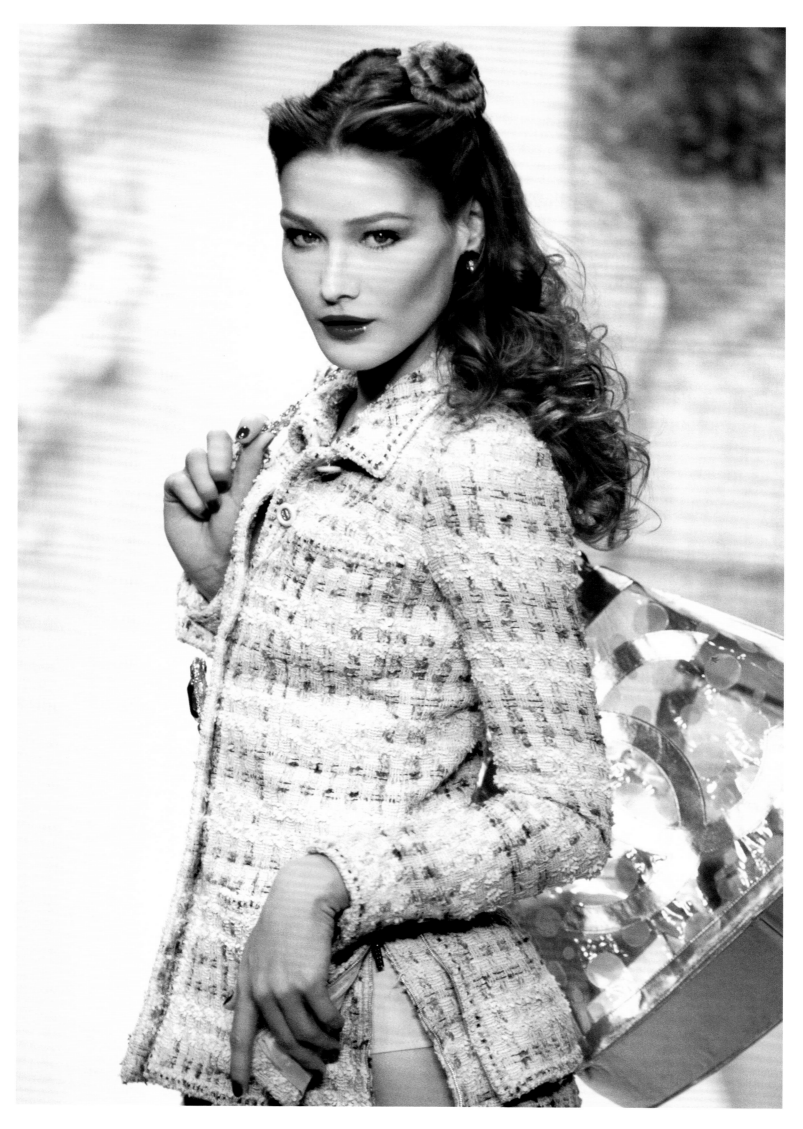

SPRING/SUMMER 1995 READY-TO-WEAR

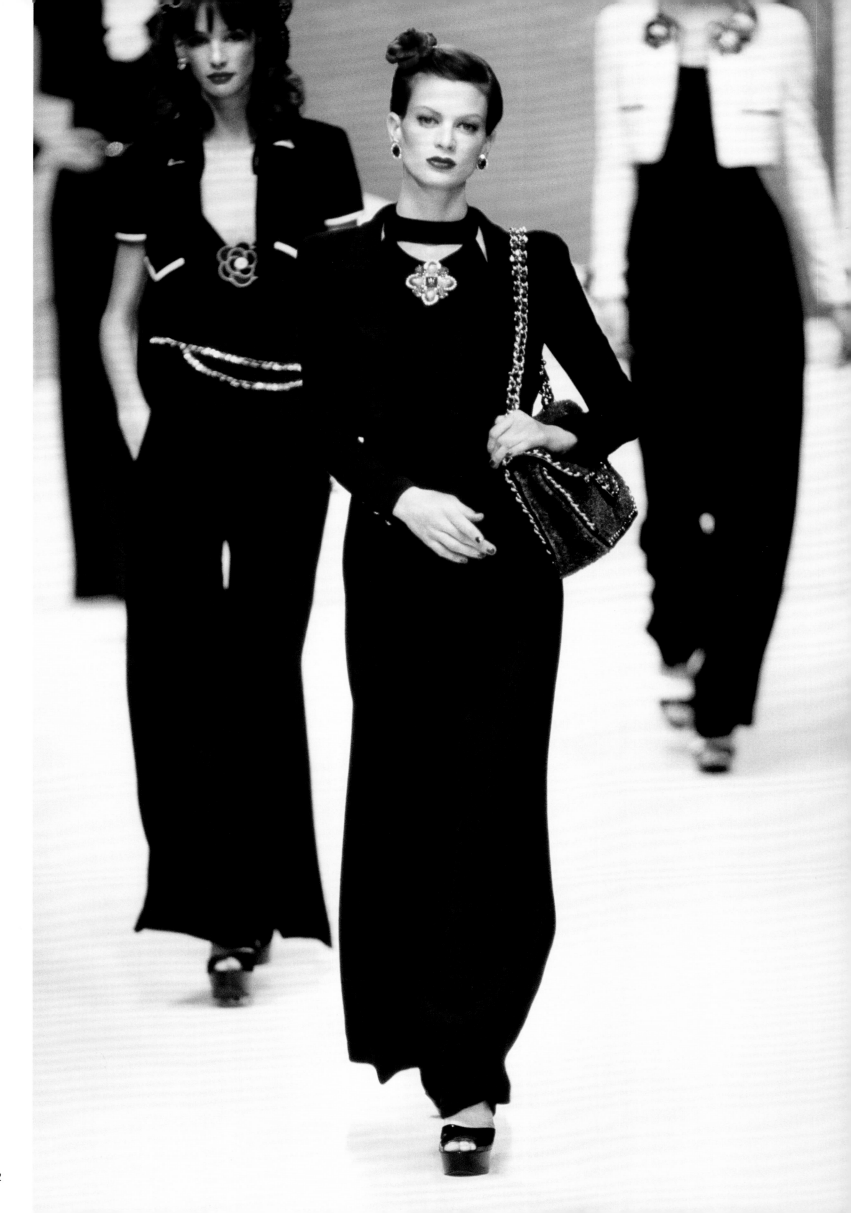

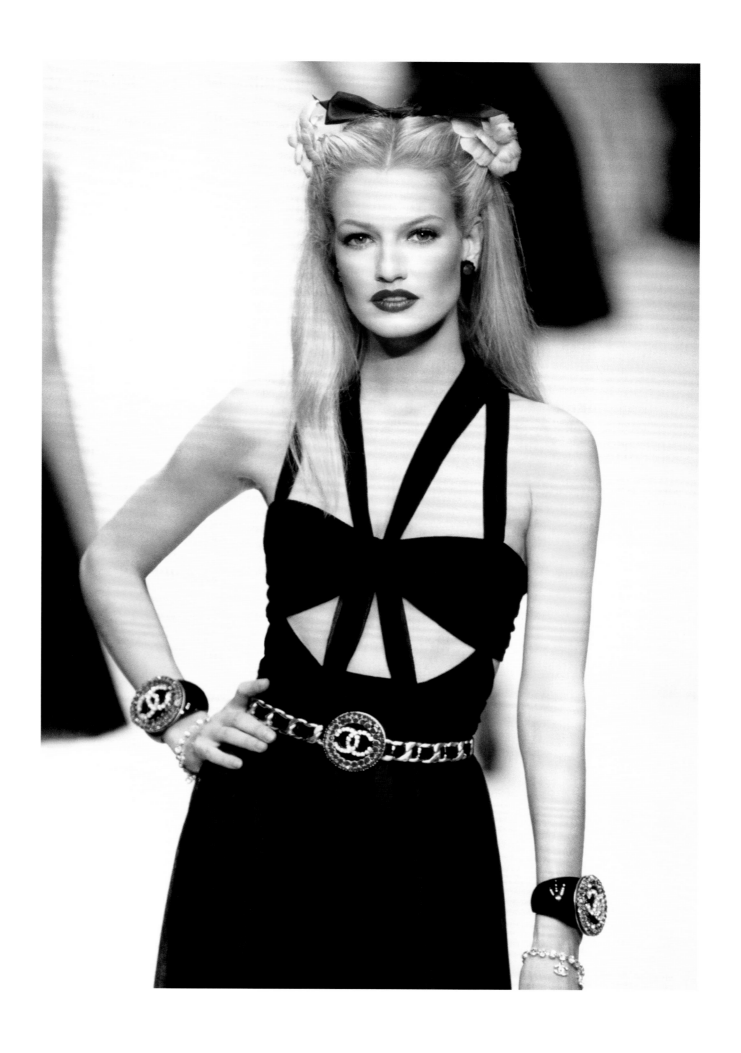

AUTUMN/WINTER 1995–1996
READY-TO-WEAR

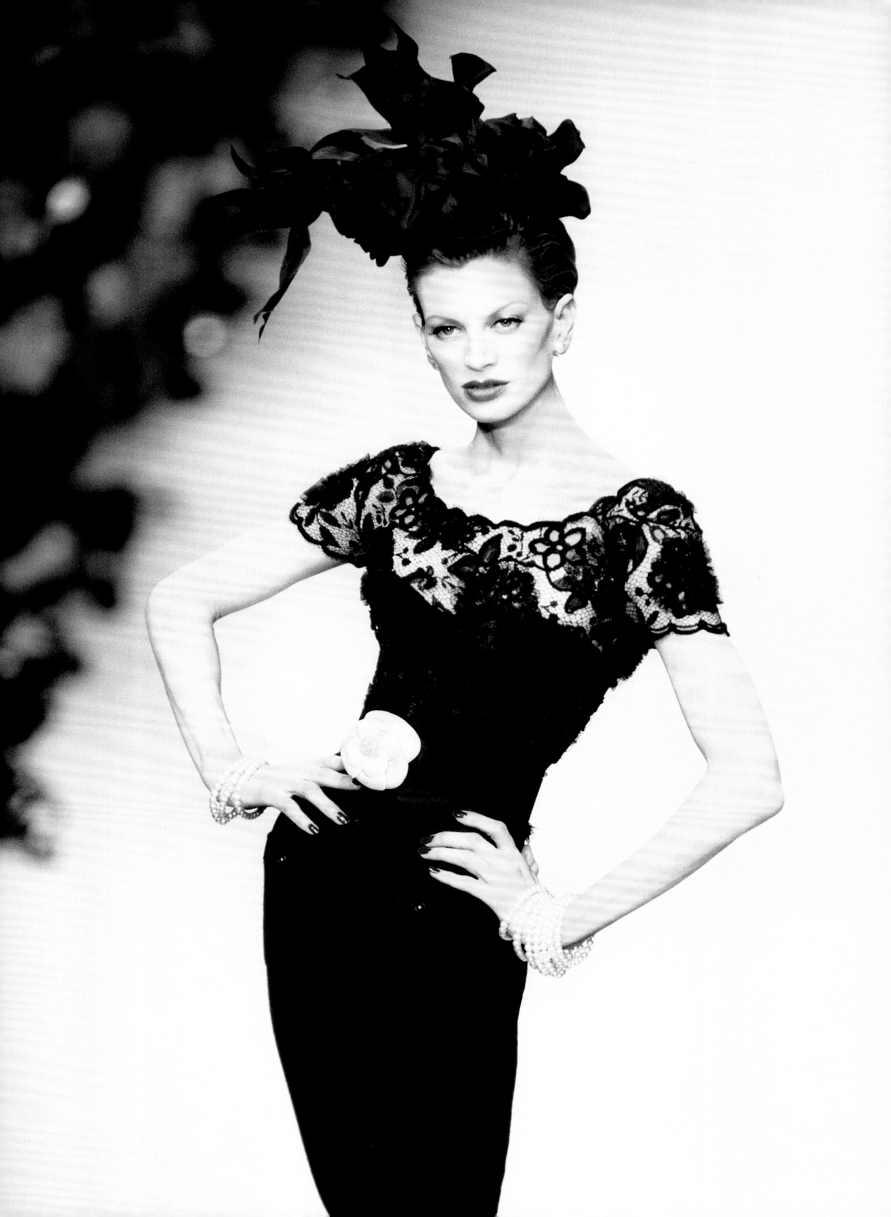

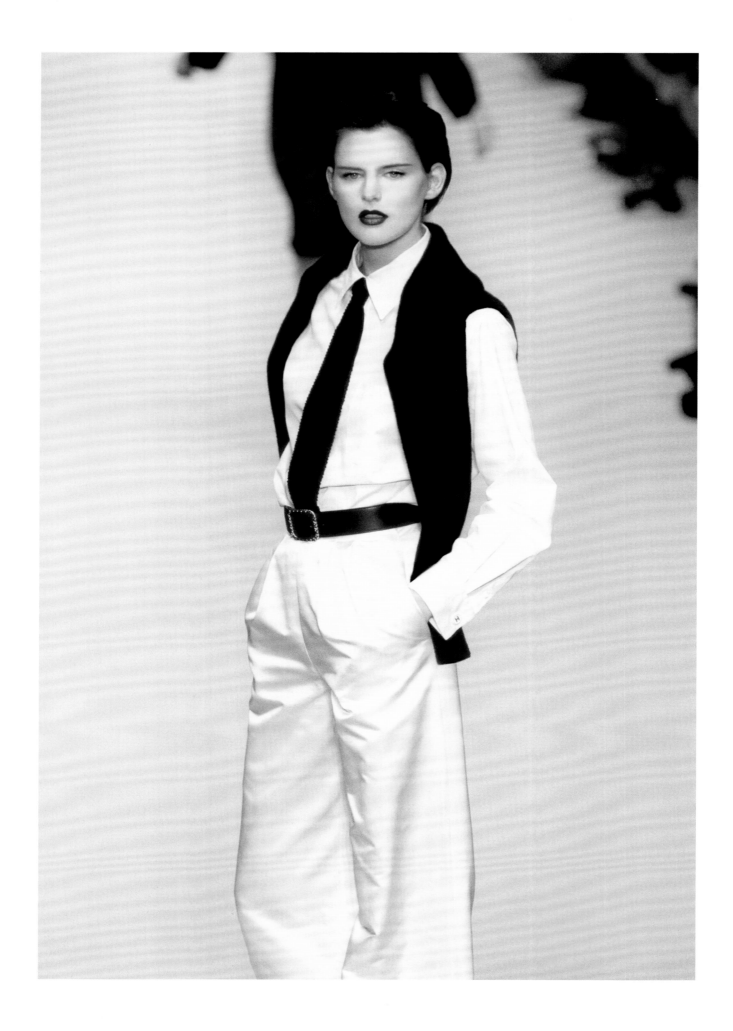

AUTUMN/WINTER 1995–1996 READY-TO-WEAR

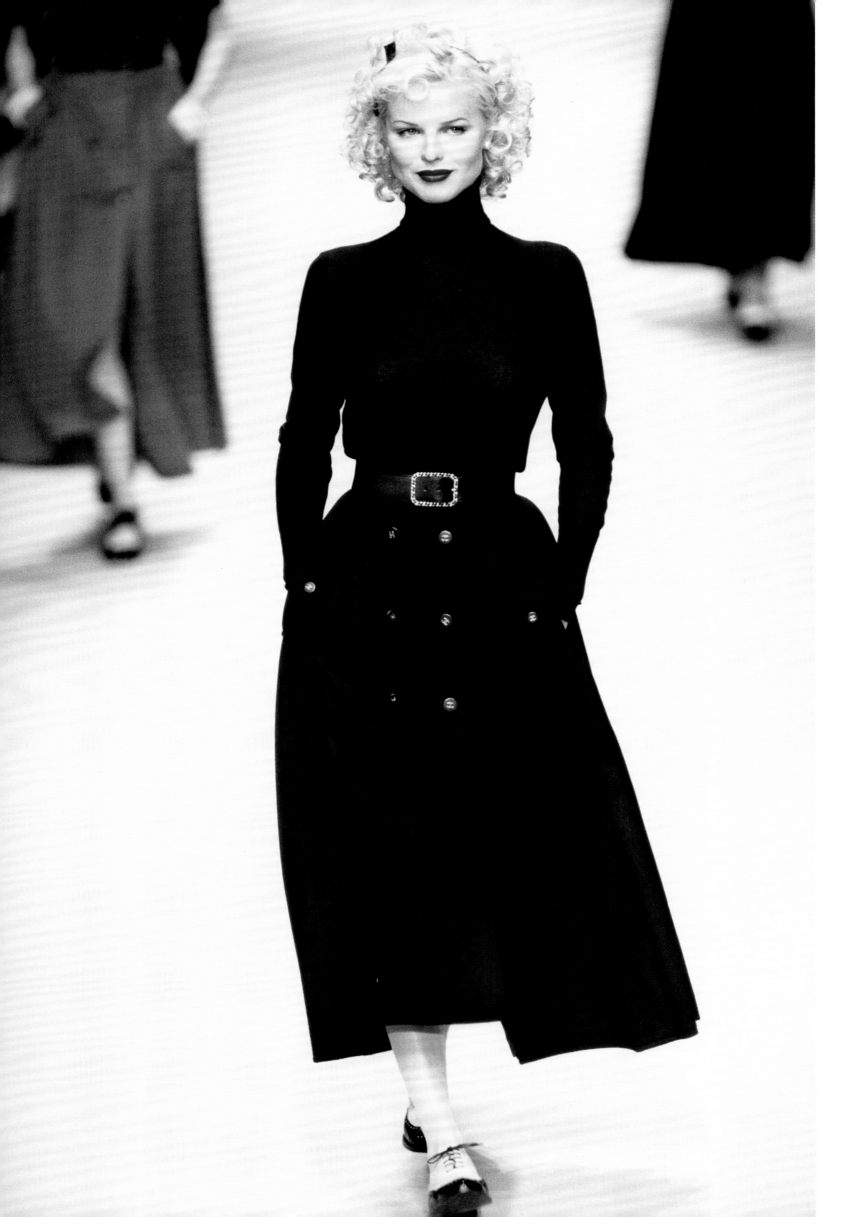

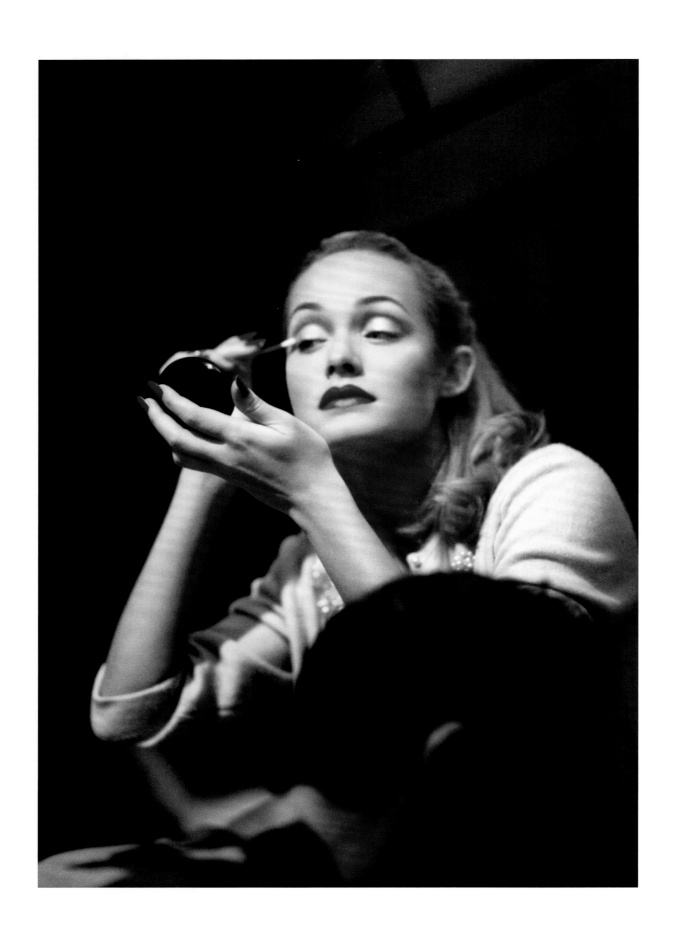

AUTUMN/WINTER 1995–1996 READY-TO-WEAR

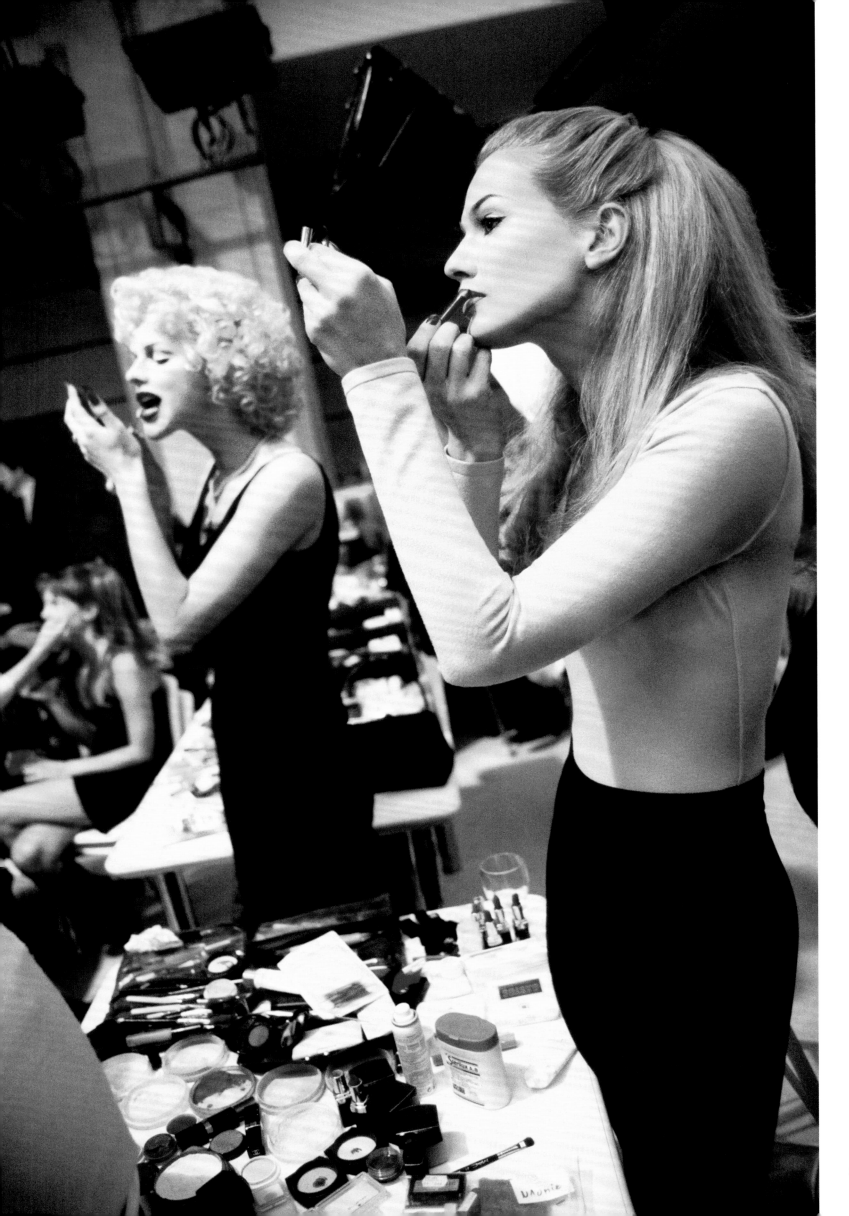

'My job is not to do what [Coco] did,
but what she would have done.
The good thing about Chanel
is it is an idea you can adapt
to many things.'

Karl Lagerfeld

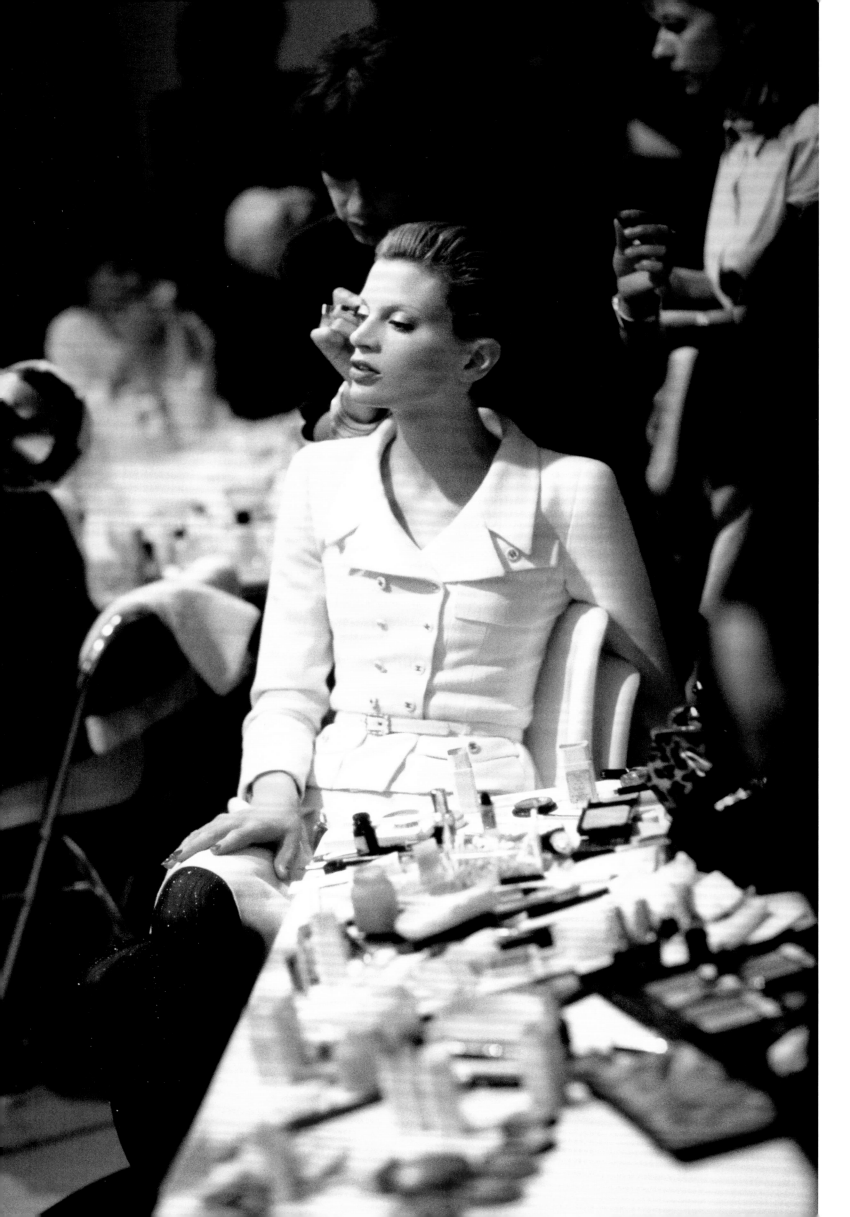

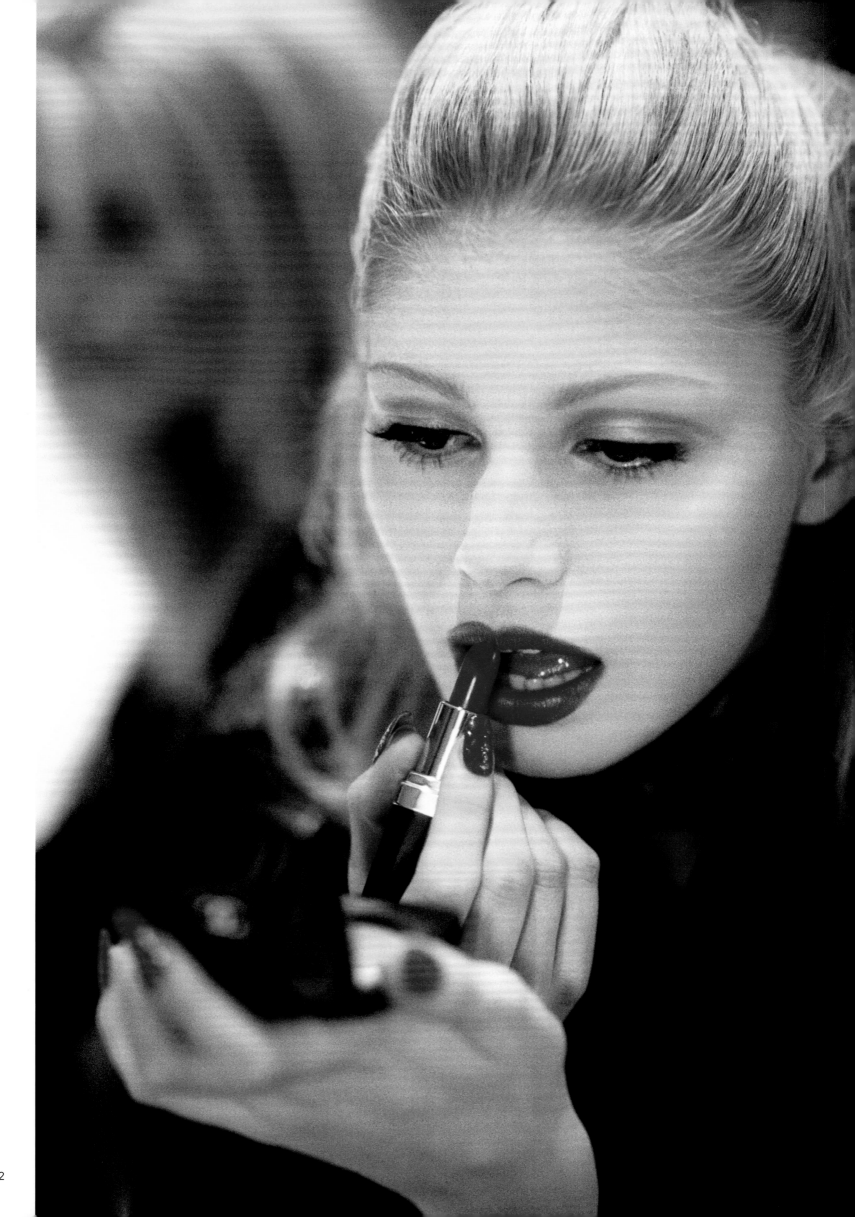

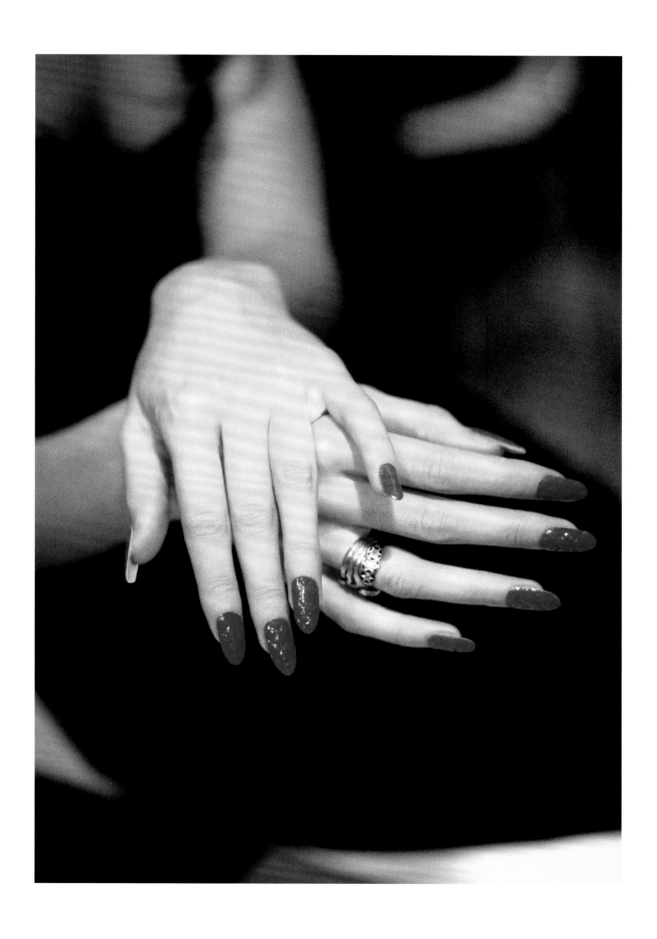

SPRING/SUMMER 1996
READY-TO-WEAR

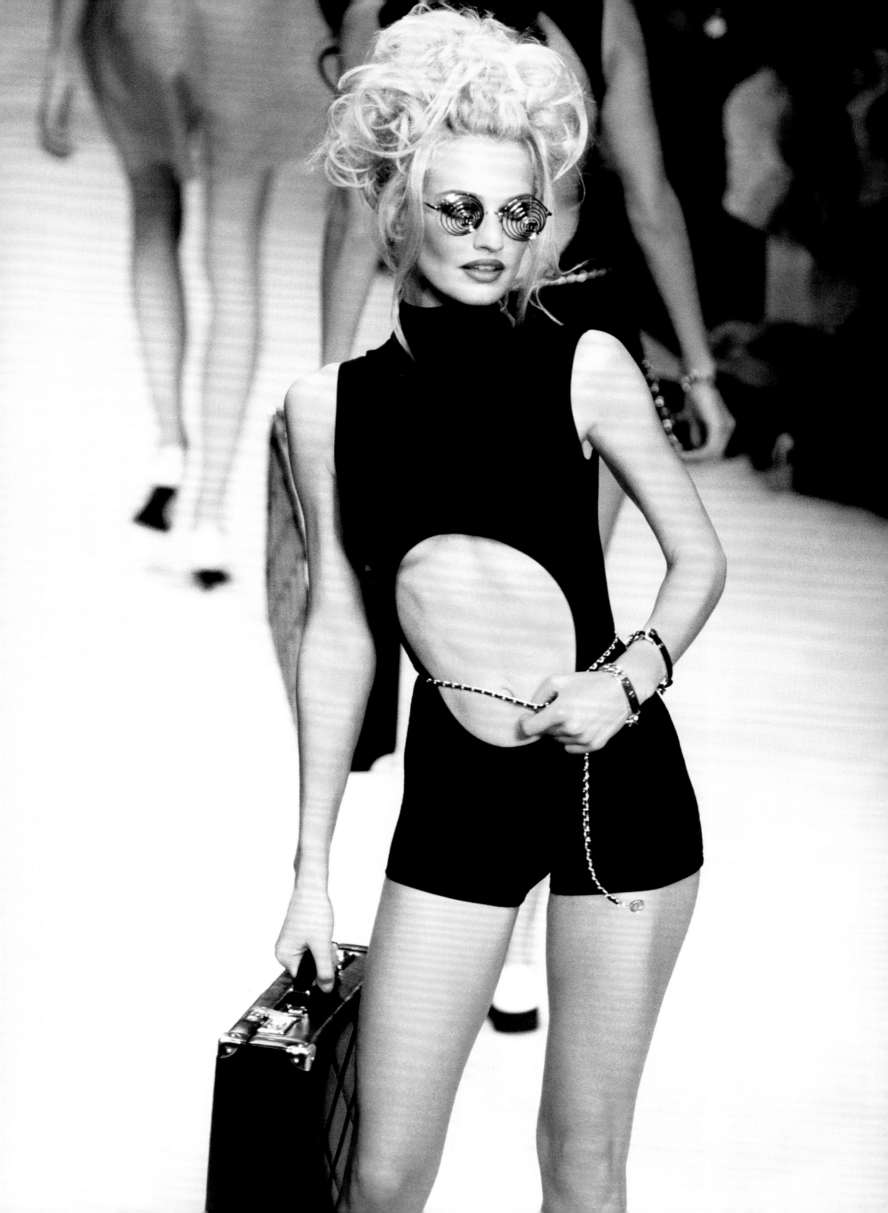

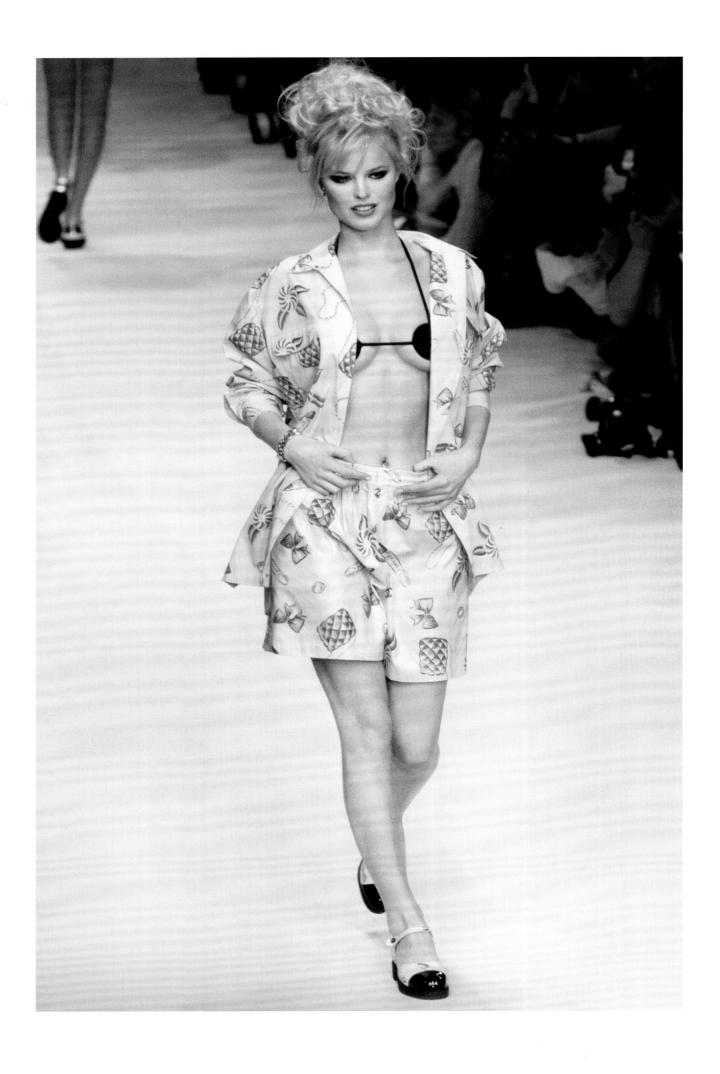

SPRING/SUMMER 1996 READY-TO-WEAR

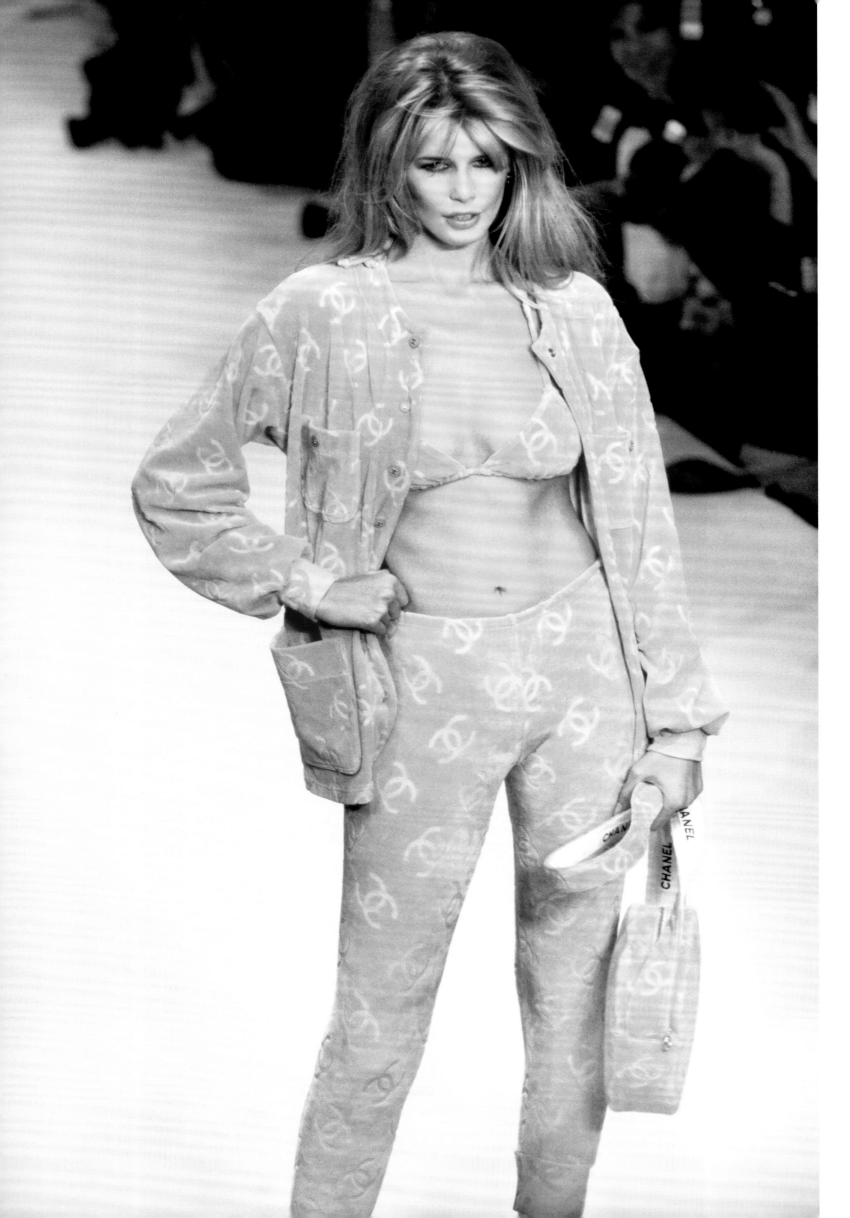

47

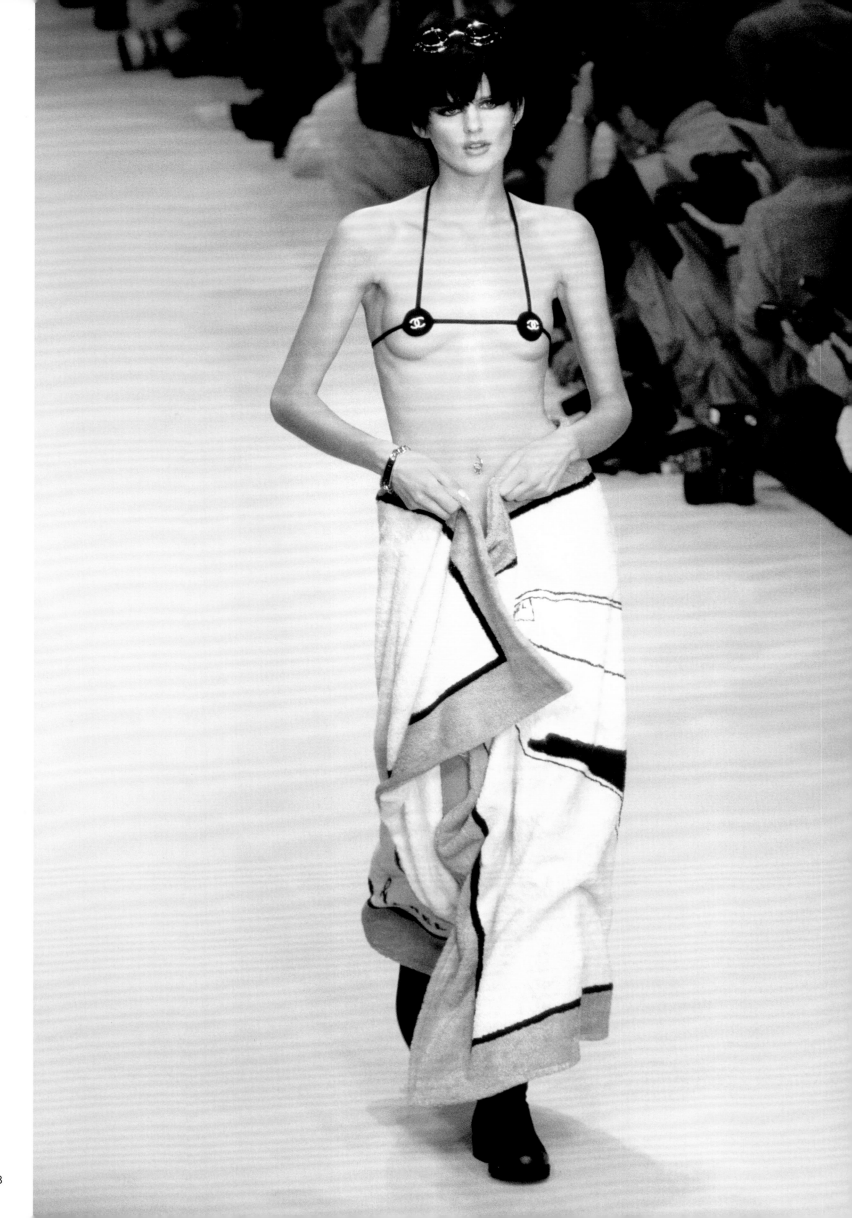

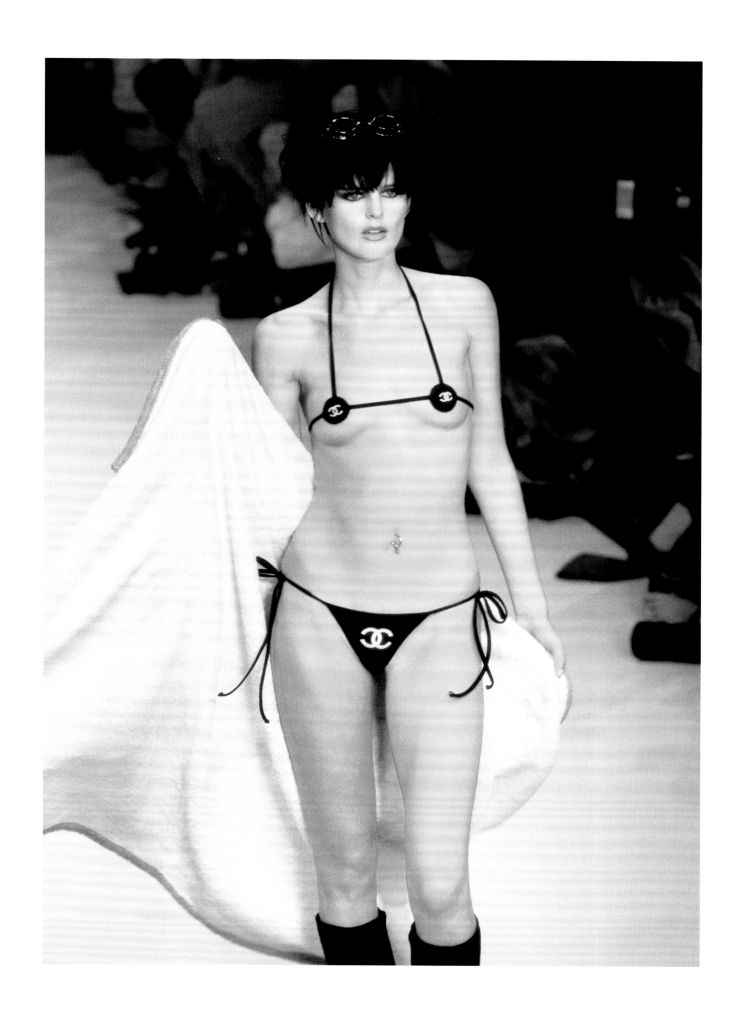

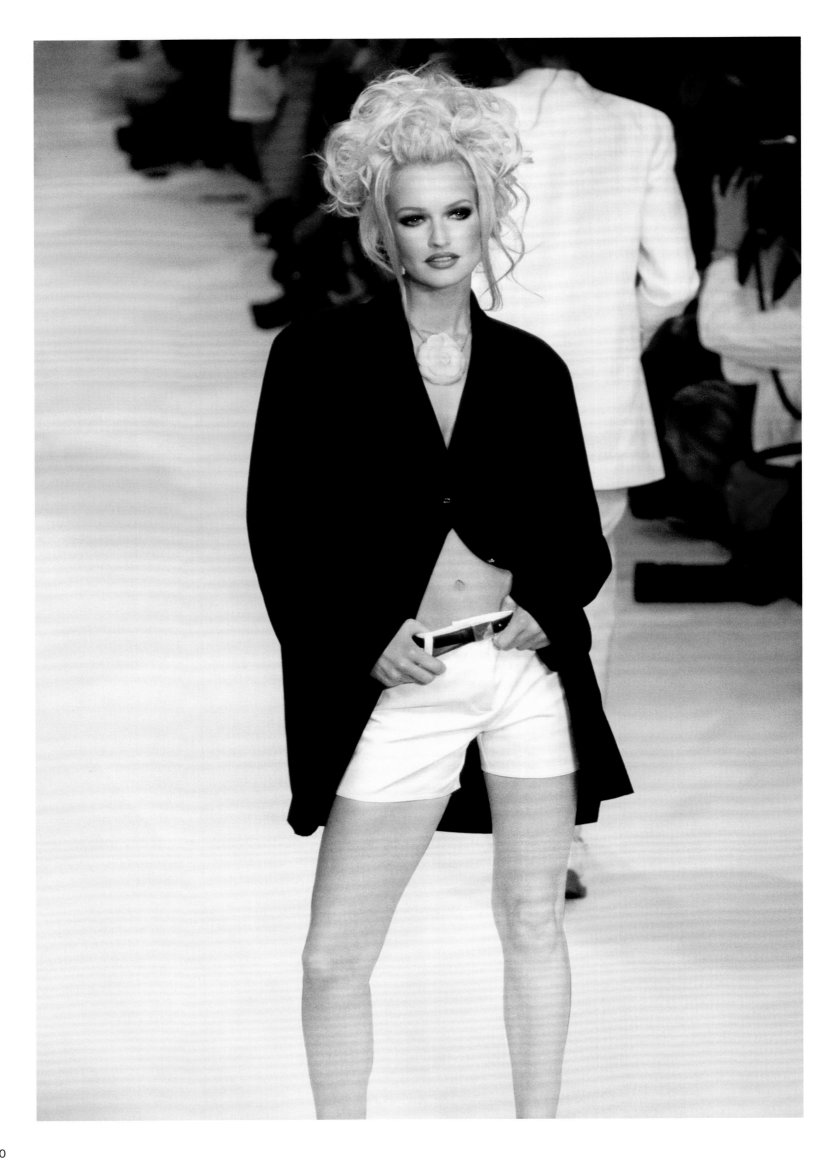

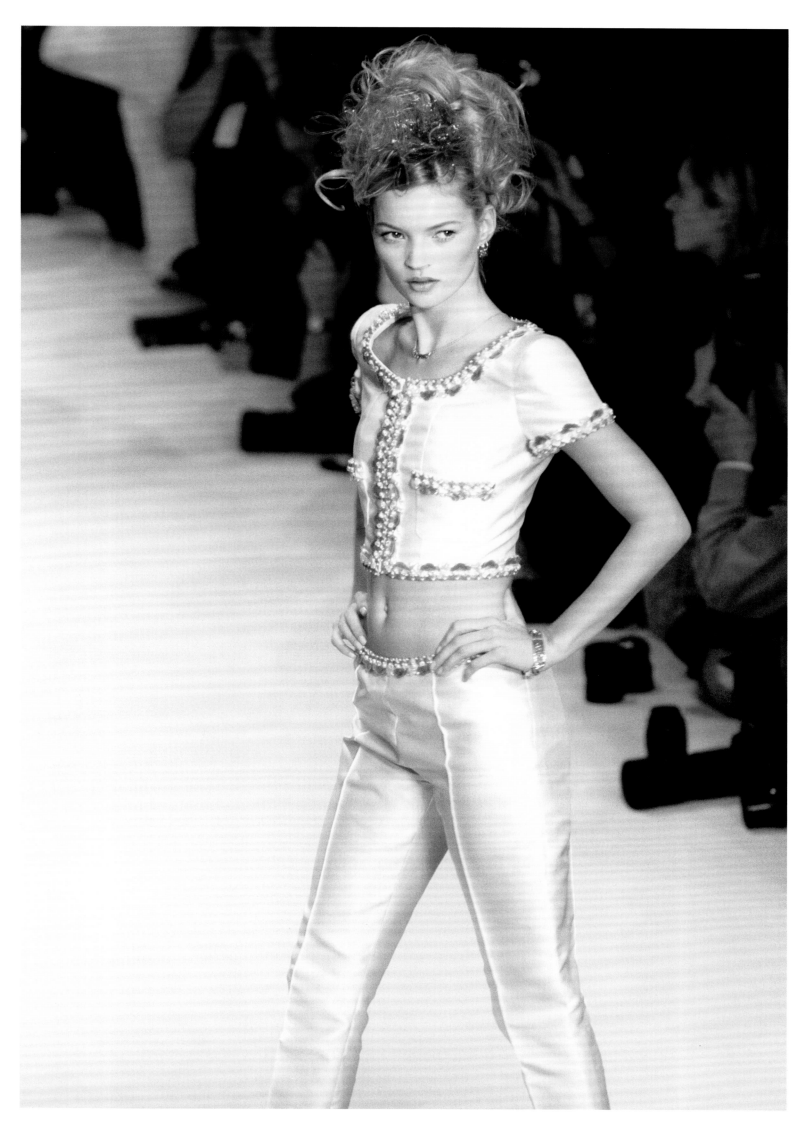

SPRING/SUMMER 1996 READY-TO-WEAR

AUTUMN/WINTER 1996–1997
READY-TO-WEAR

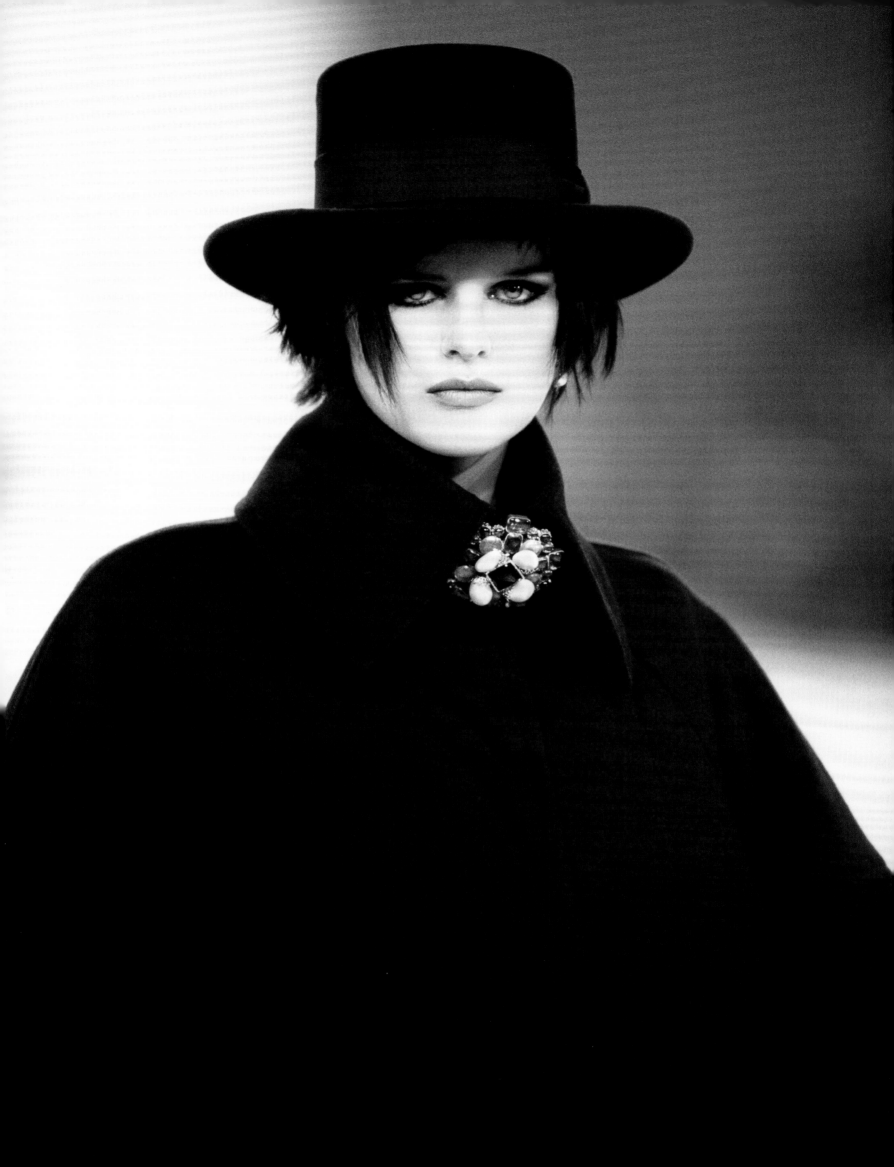

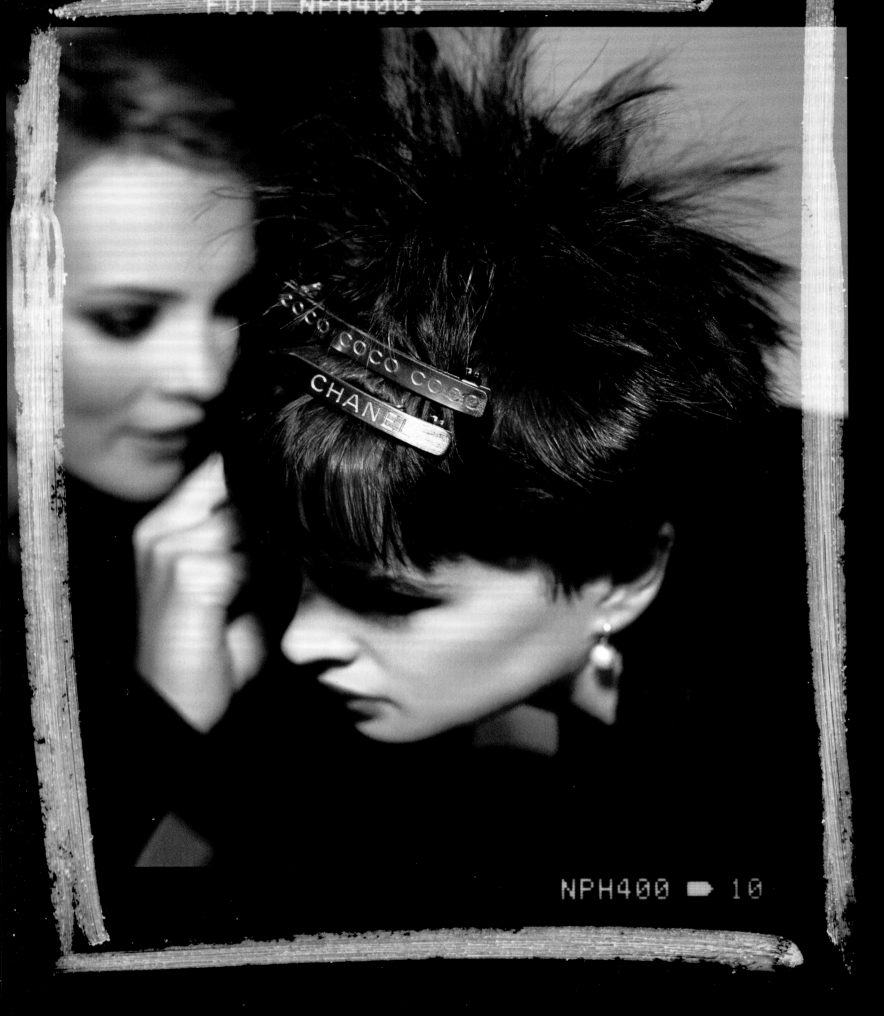

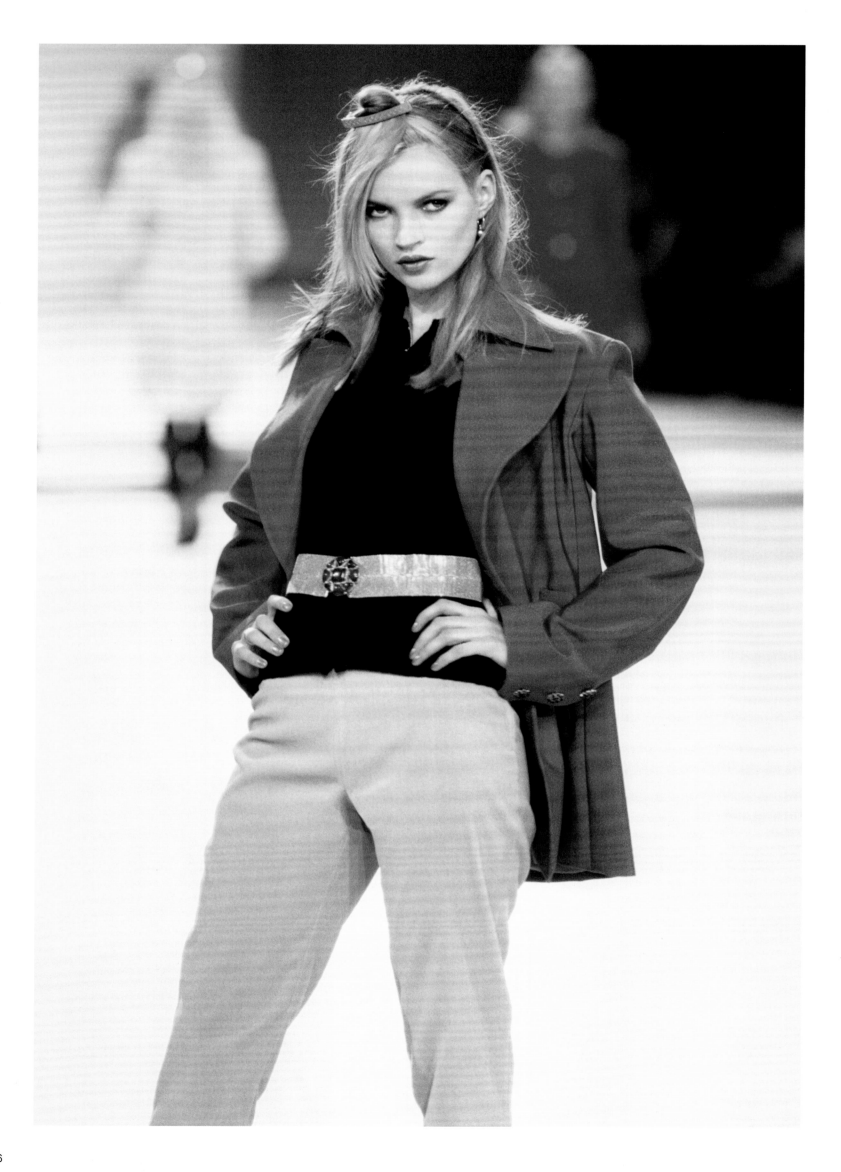

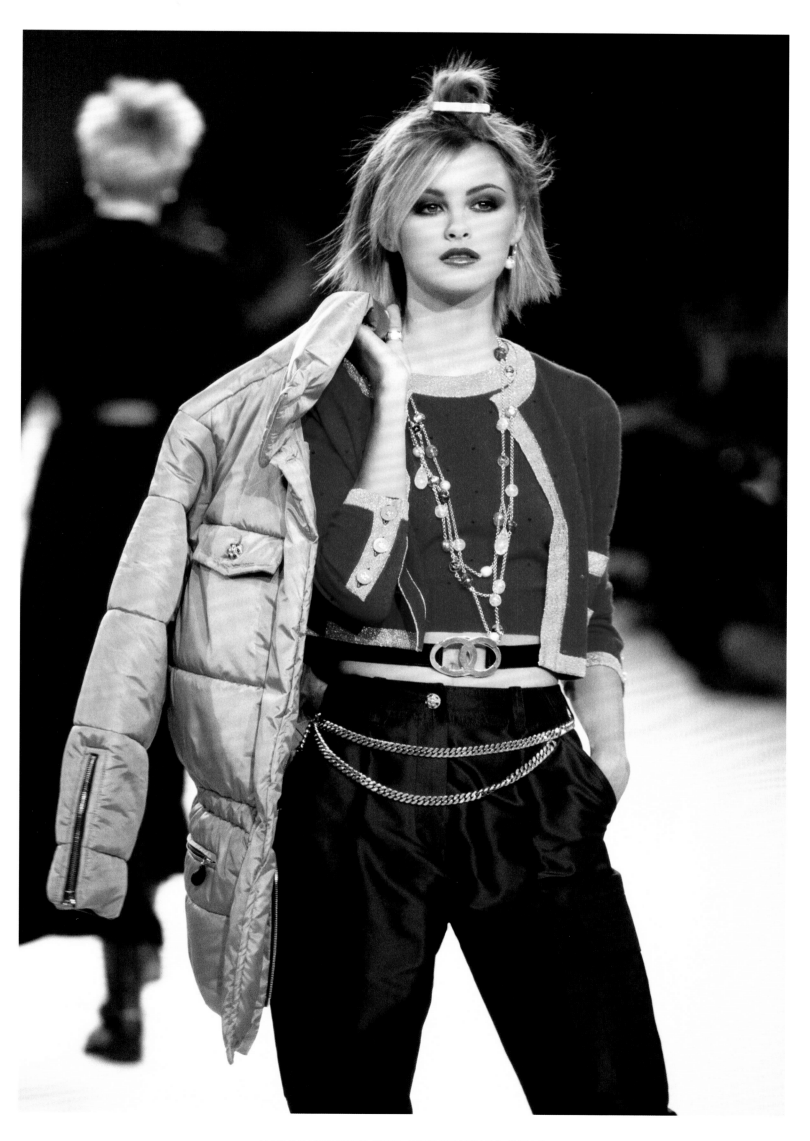

AUTUMN/WINTER 1996–1997 READY-TO-WEAR

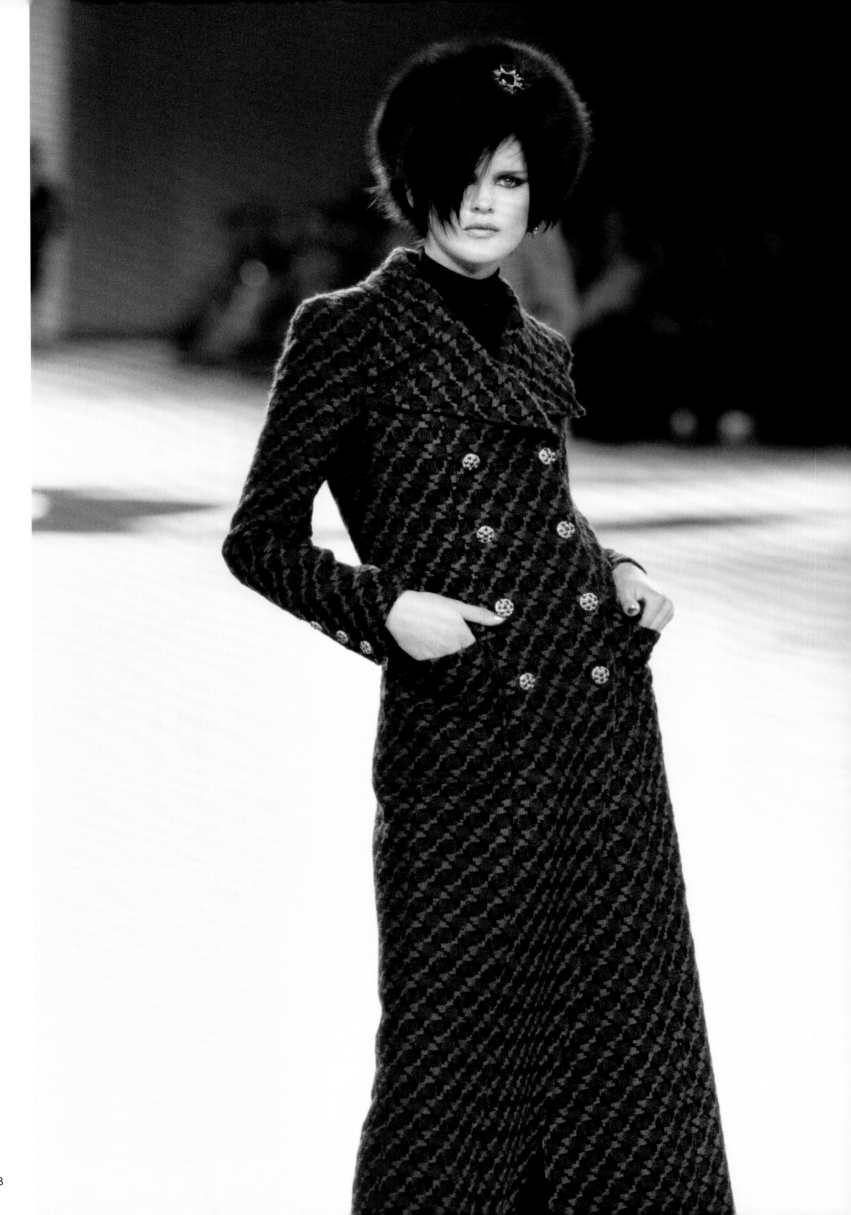

'True luxury is being free to mix things up. It's the movement that counts, a silhouette for the city and for modern life — a strong attitude, a kind of visual aggressivity.'

Karl Lagerfeld

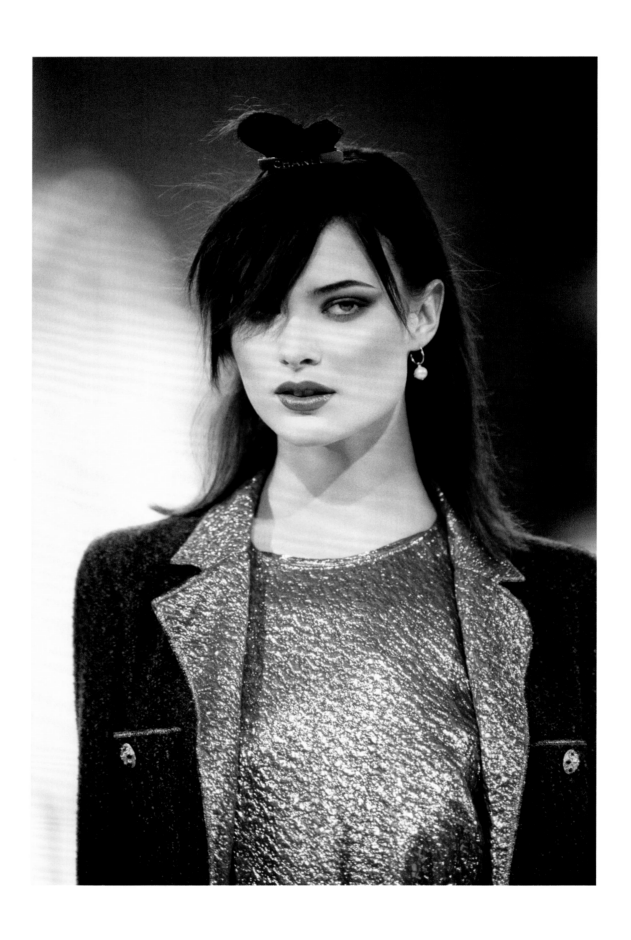

AUTUMN/WINTER 1996–1997 READY-TO-WEAR

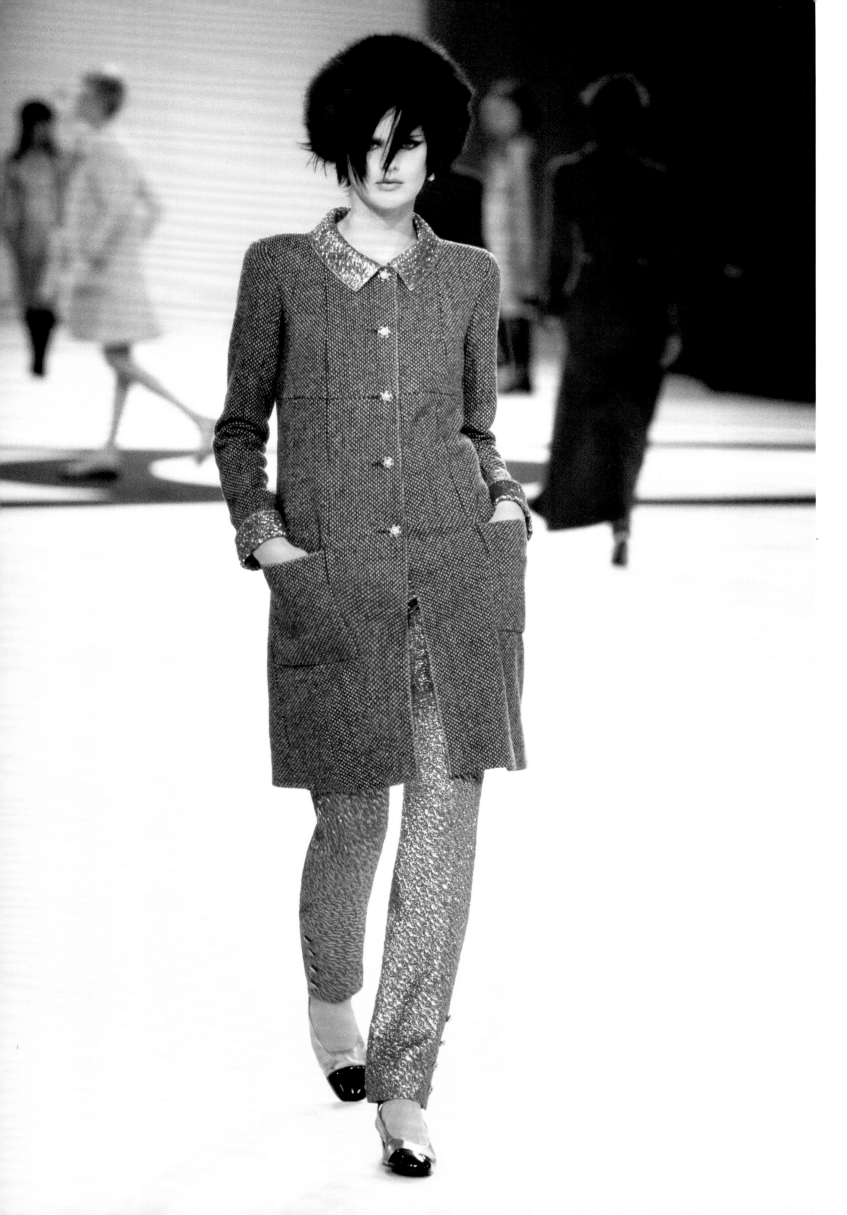

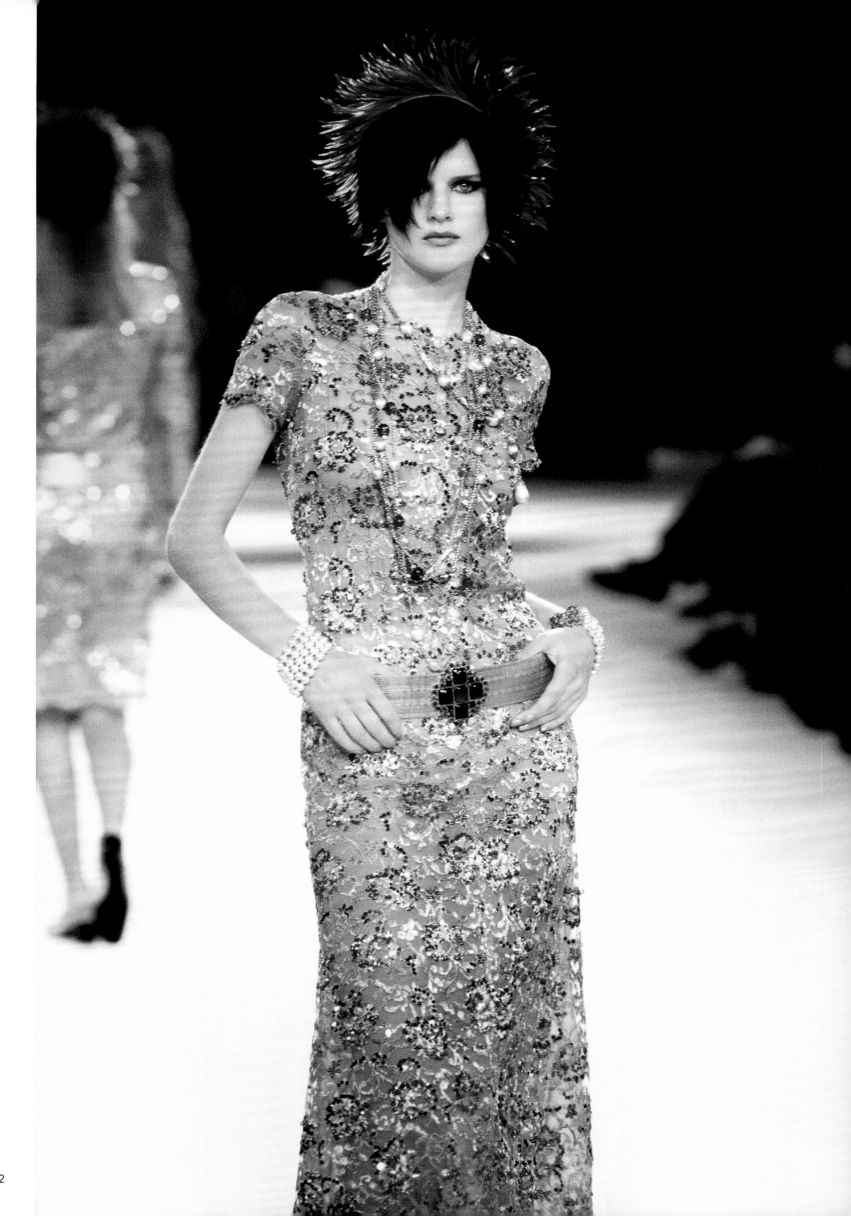

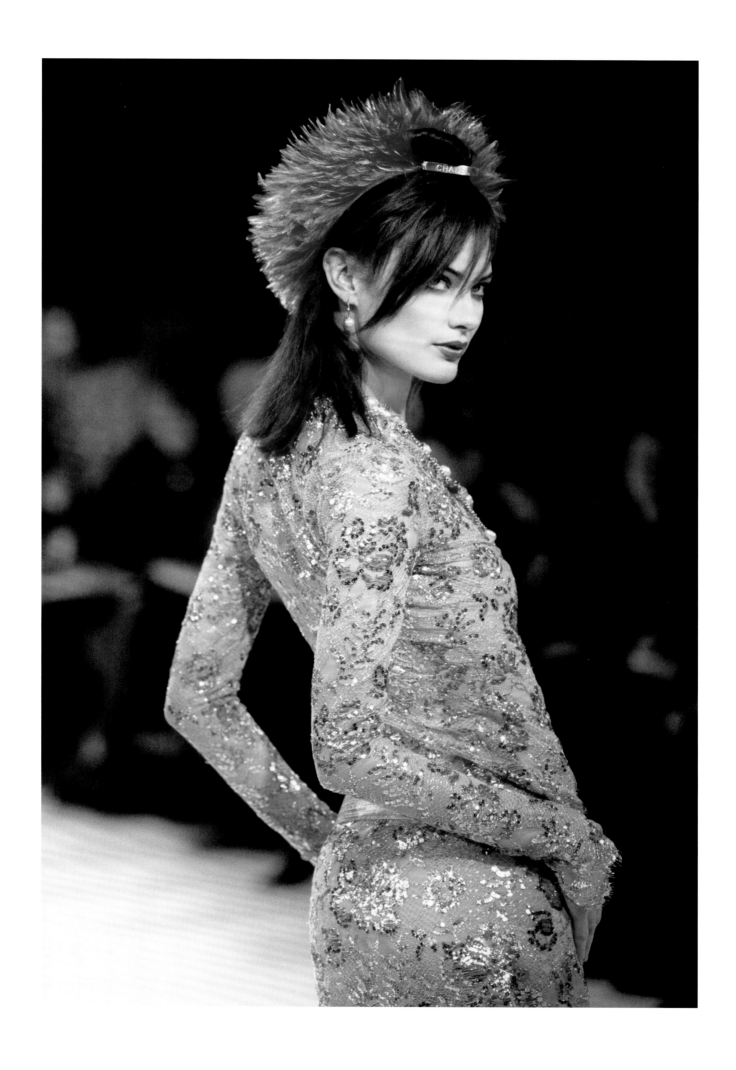

AUTUMN/WINTER 1997–1998
READY-TO-WEAR

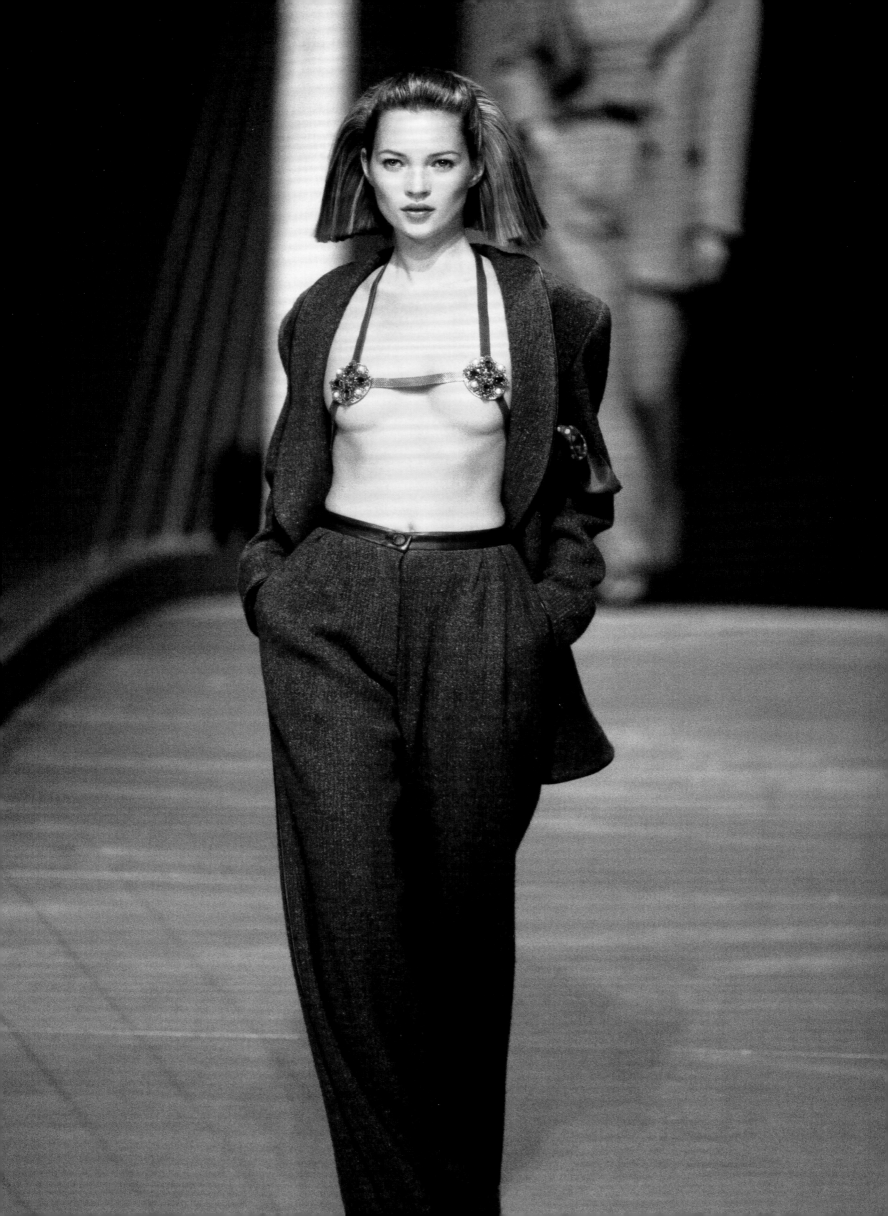

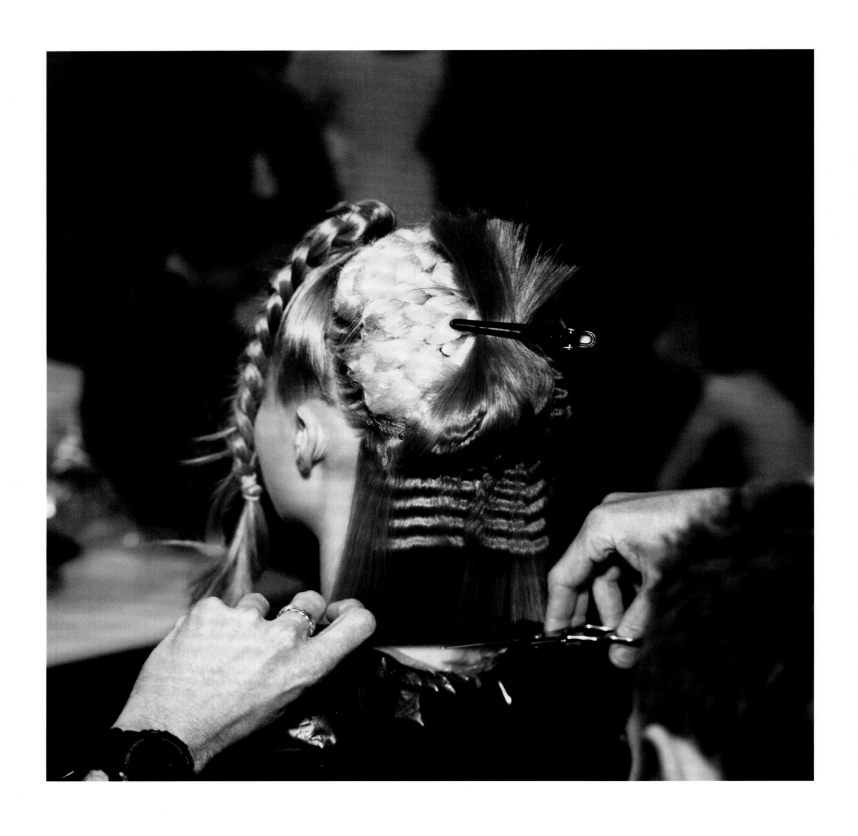

AUTUMN/WINTER 1997–1998 READY-TO-WEAR

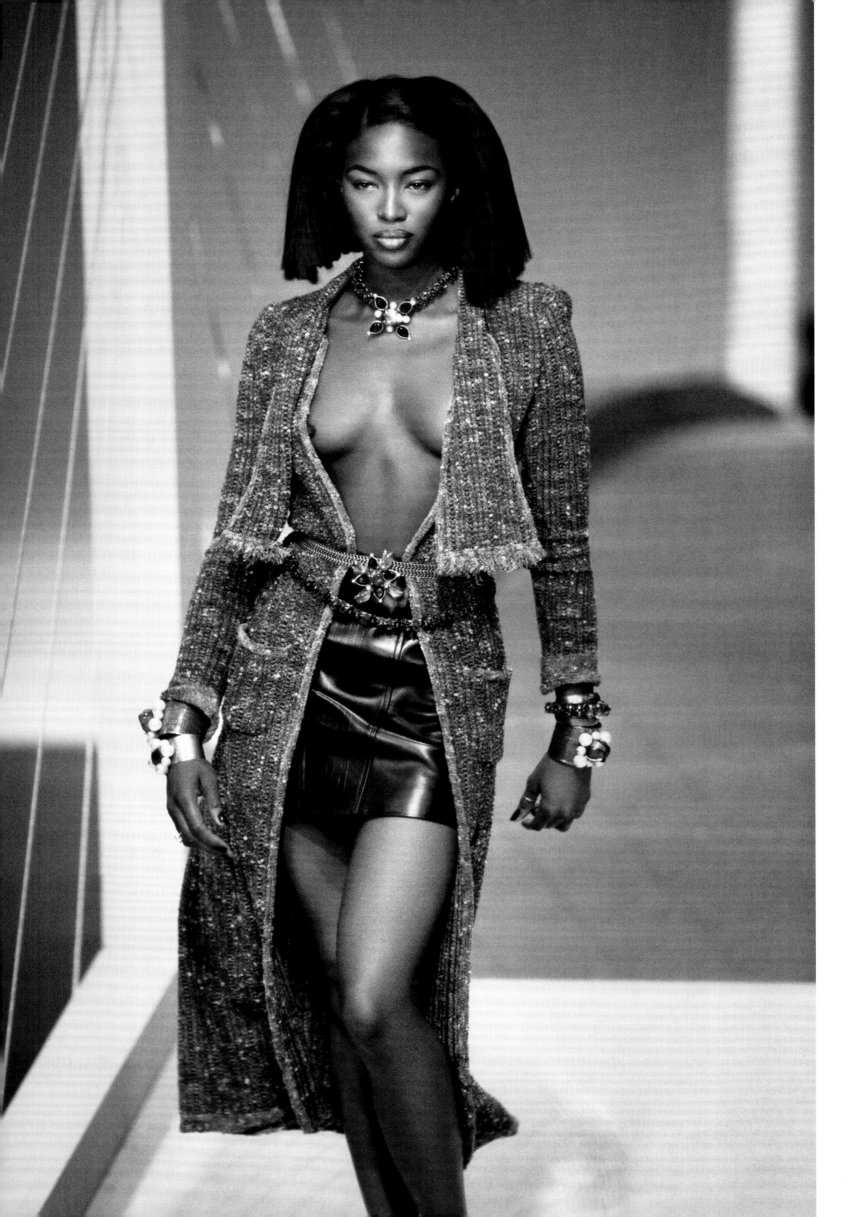

SPRING/SUMMER 1998
READY-TO-WEAR

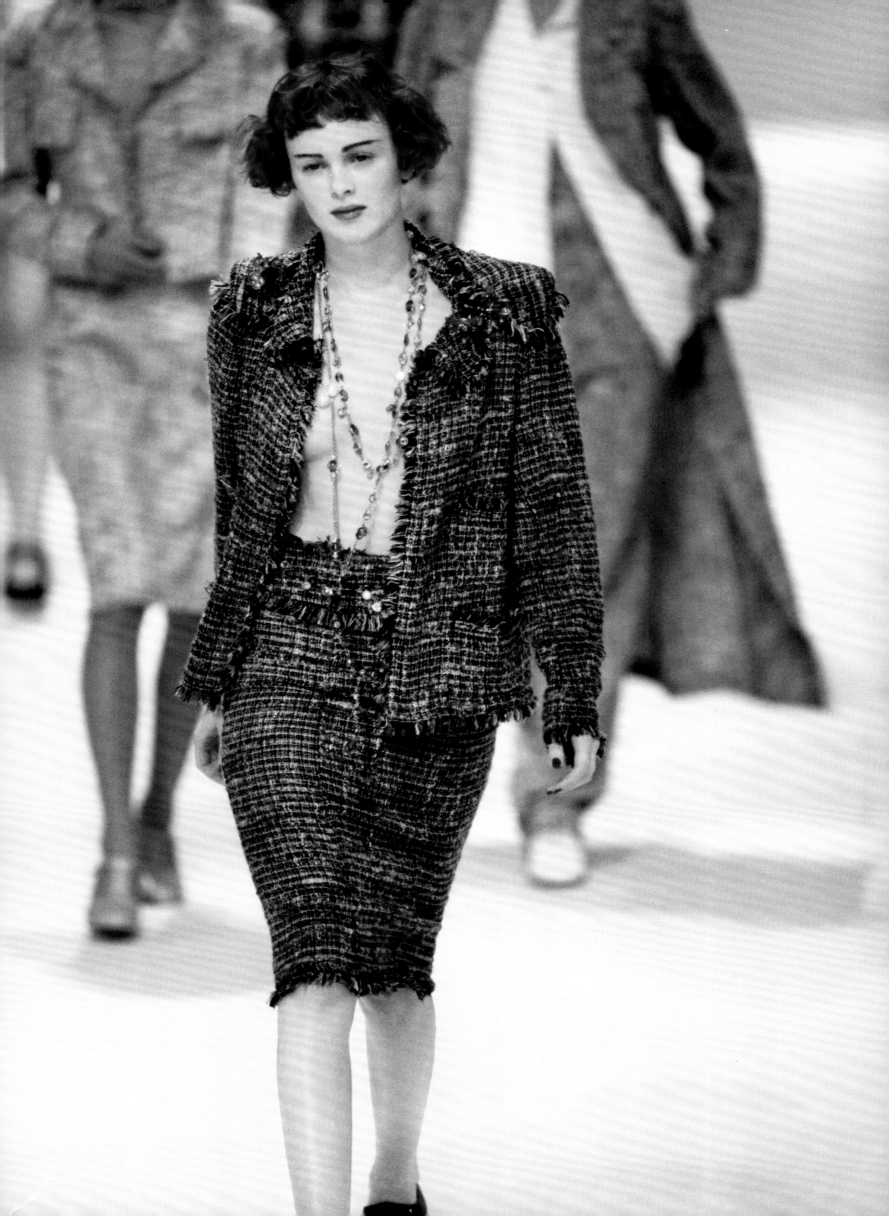

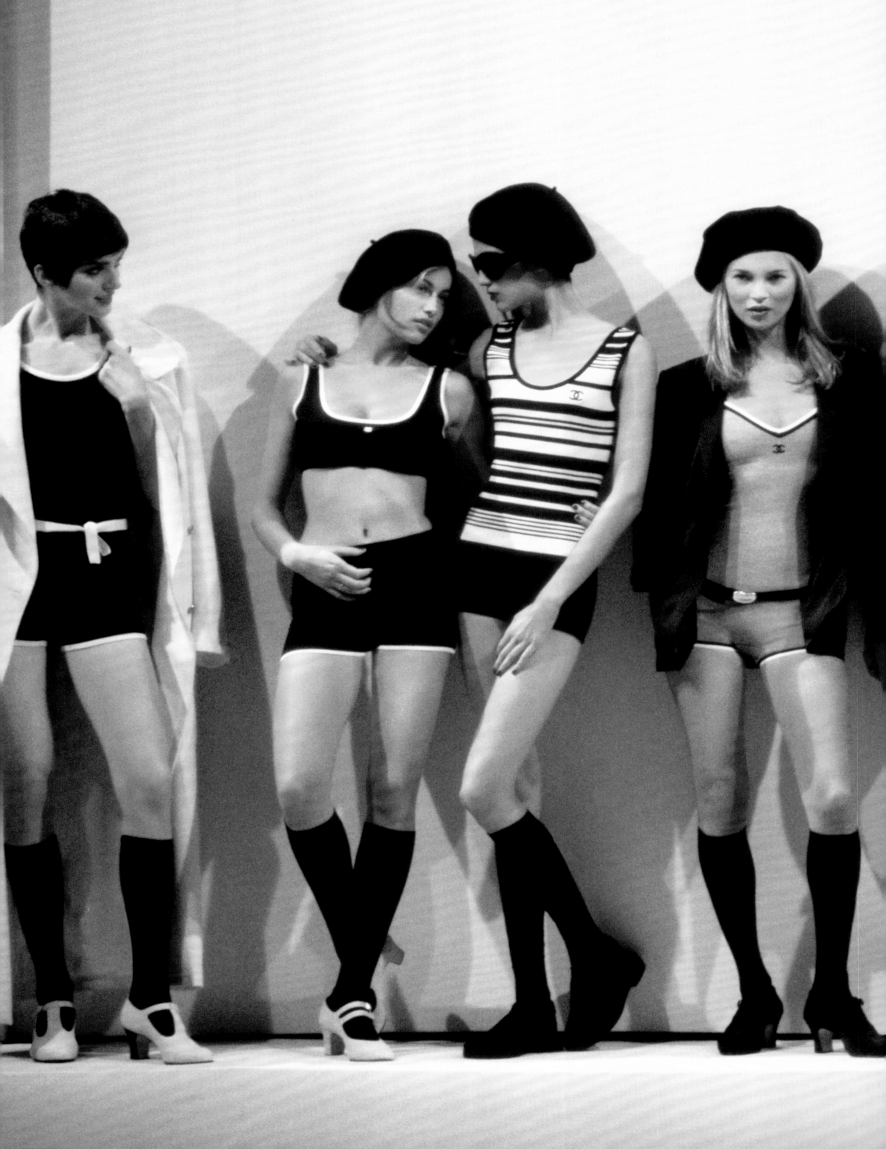

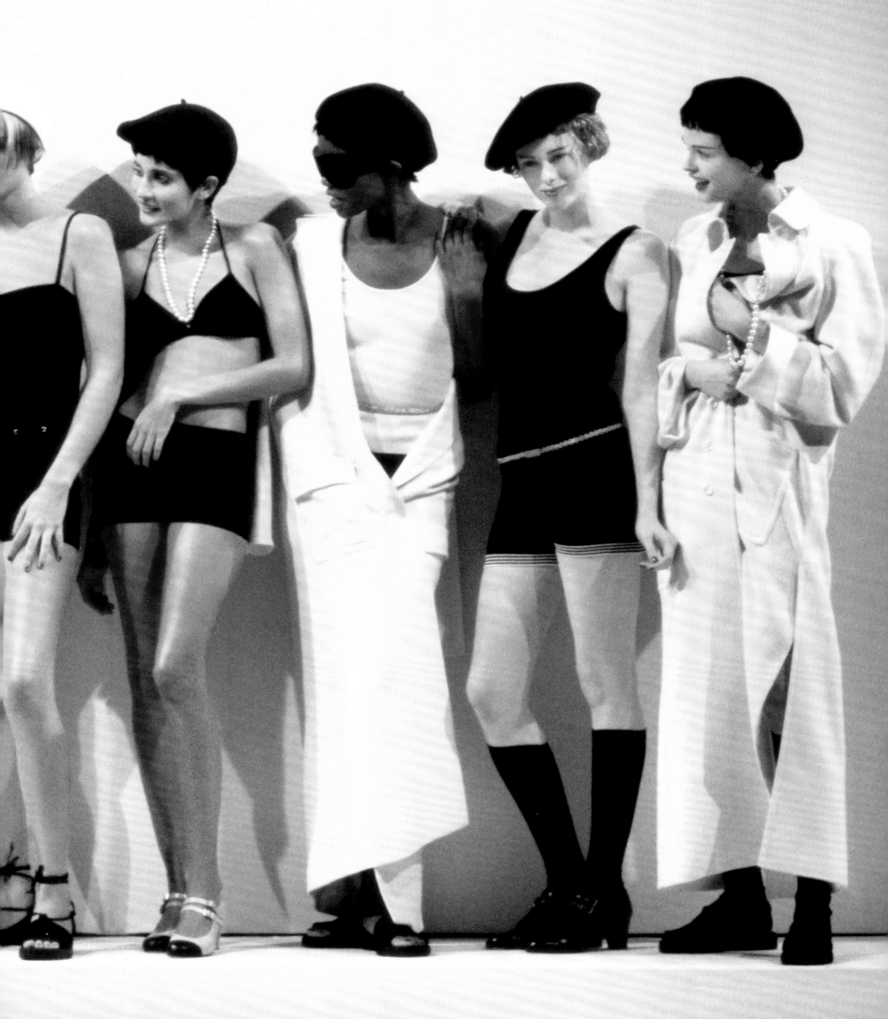

'The wonder of backstage photography
is that it captures the unguarded or
spontaneous; a documentary of
a fleeting moment in time off stage,
in the wings — it has its own drama'

Amanda Harlech

SPRING/SUMMER 2000
READY-TO-WEAR

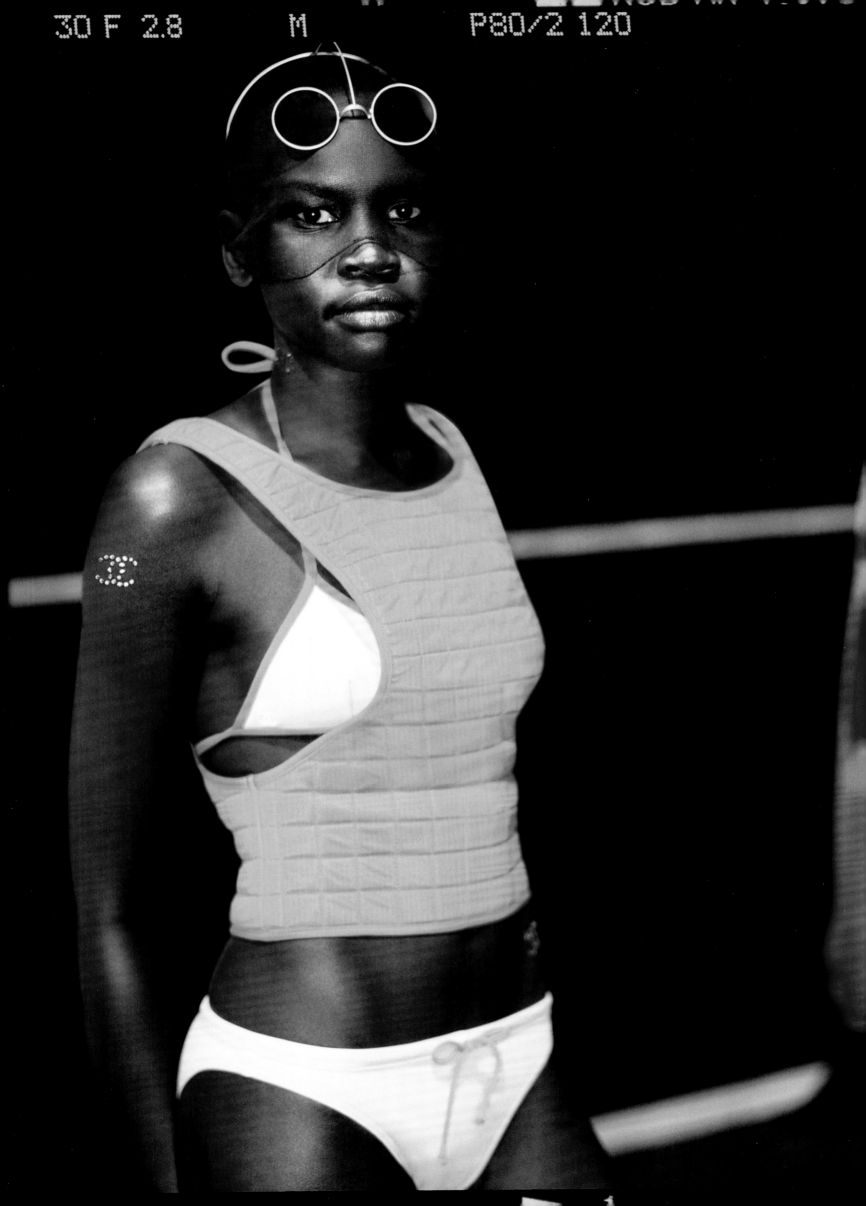

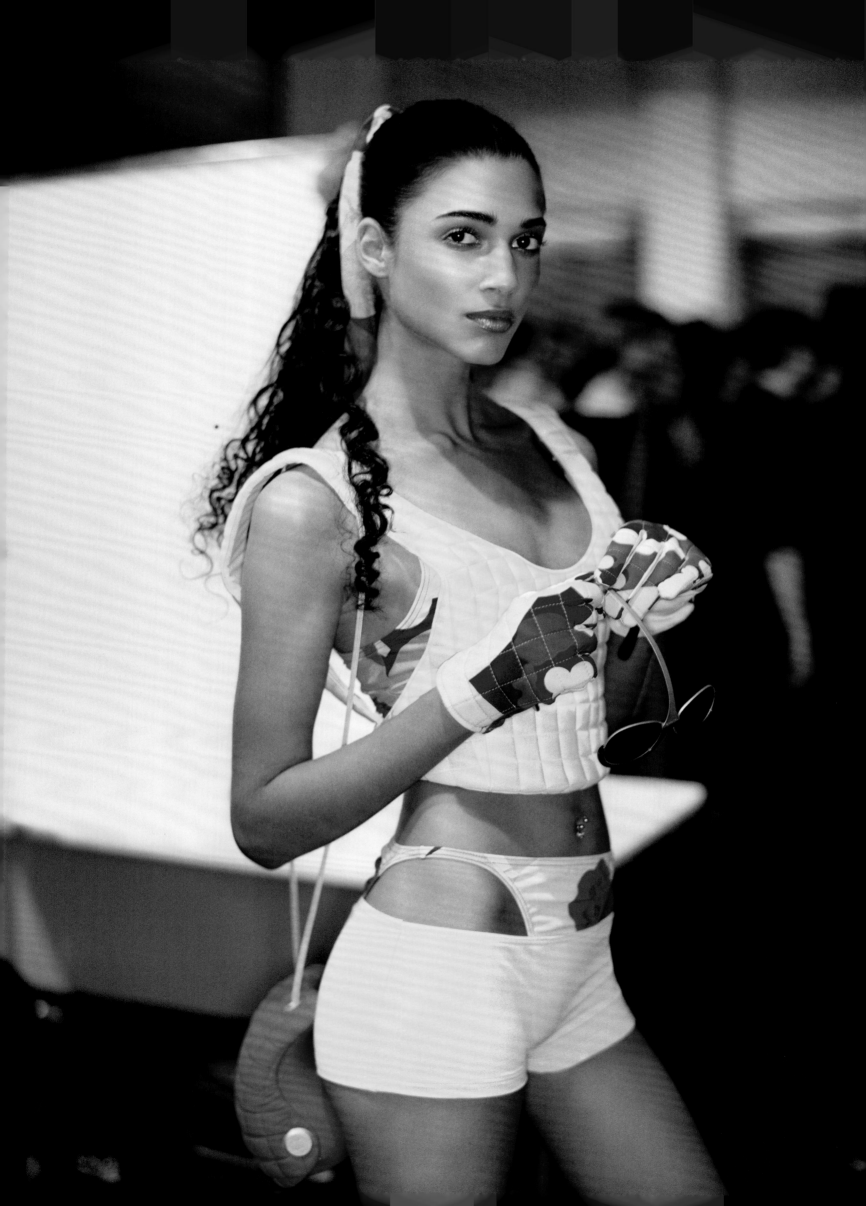

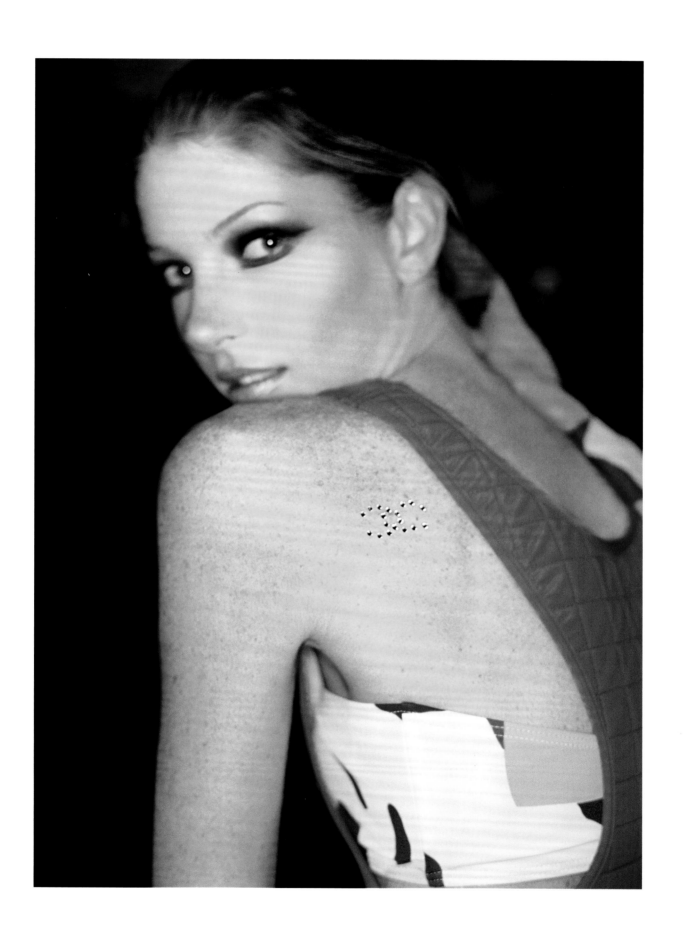

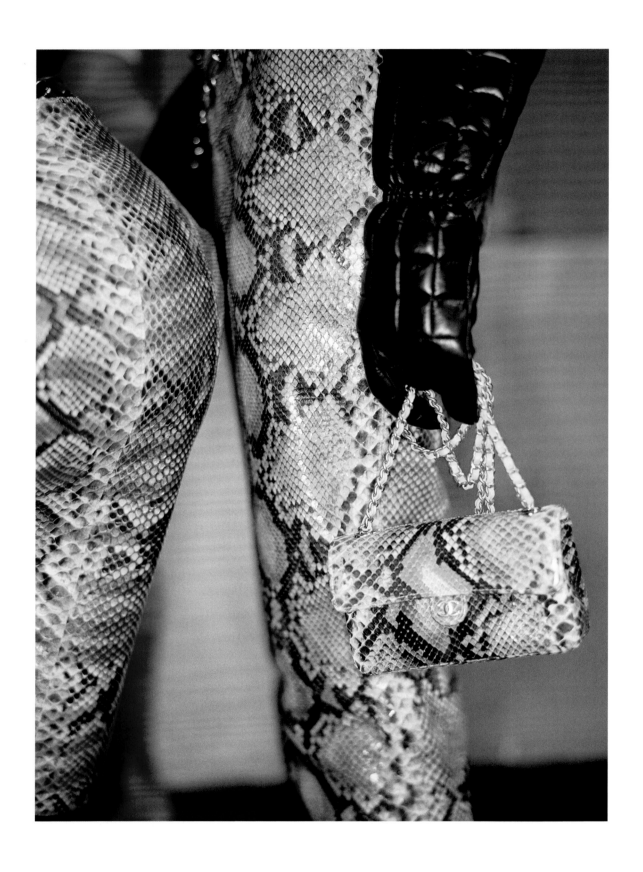

SPRING/SUMMER 2000 READY-TO-WEAR

'Fashion is the spirit you give things
to make them evolve'

Karl Lagerfeld

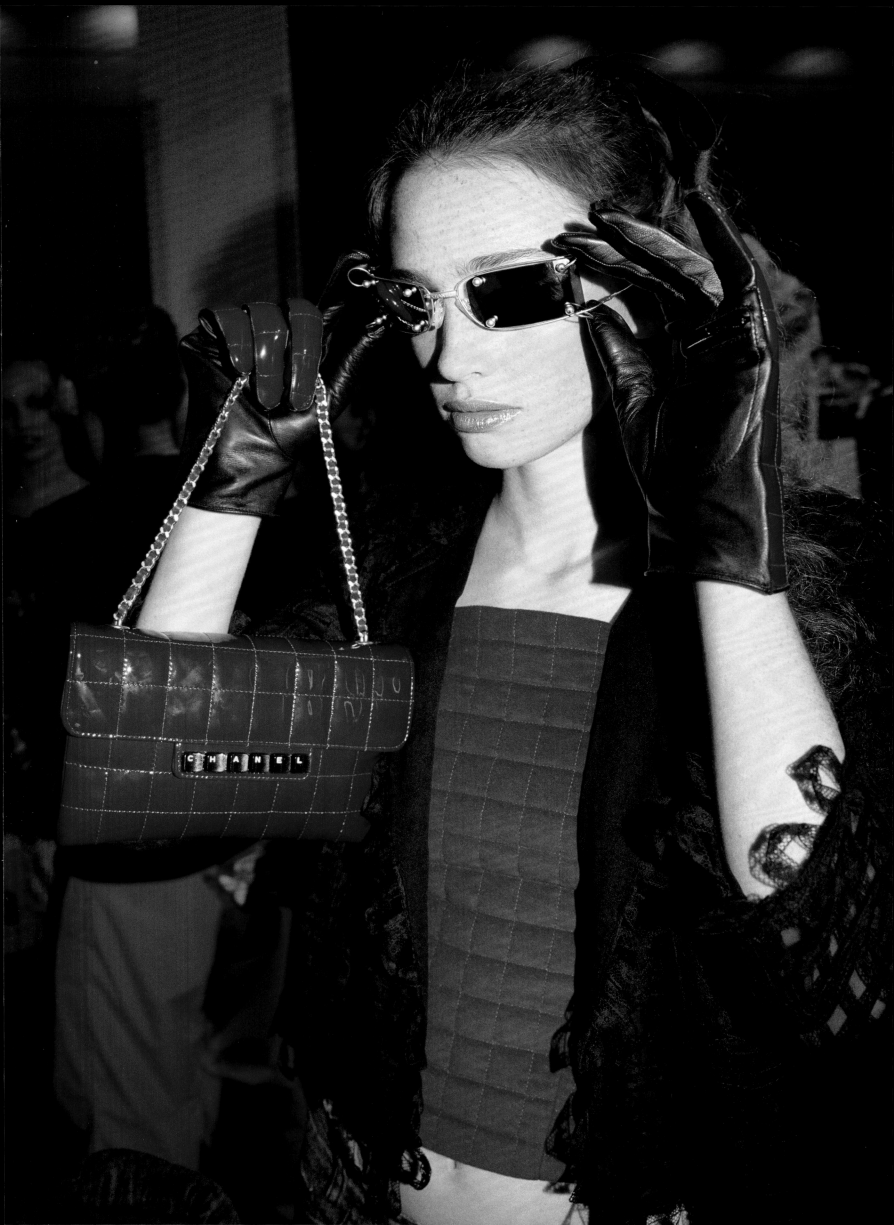

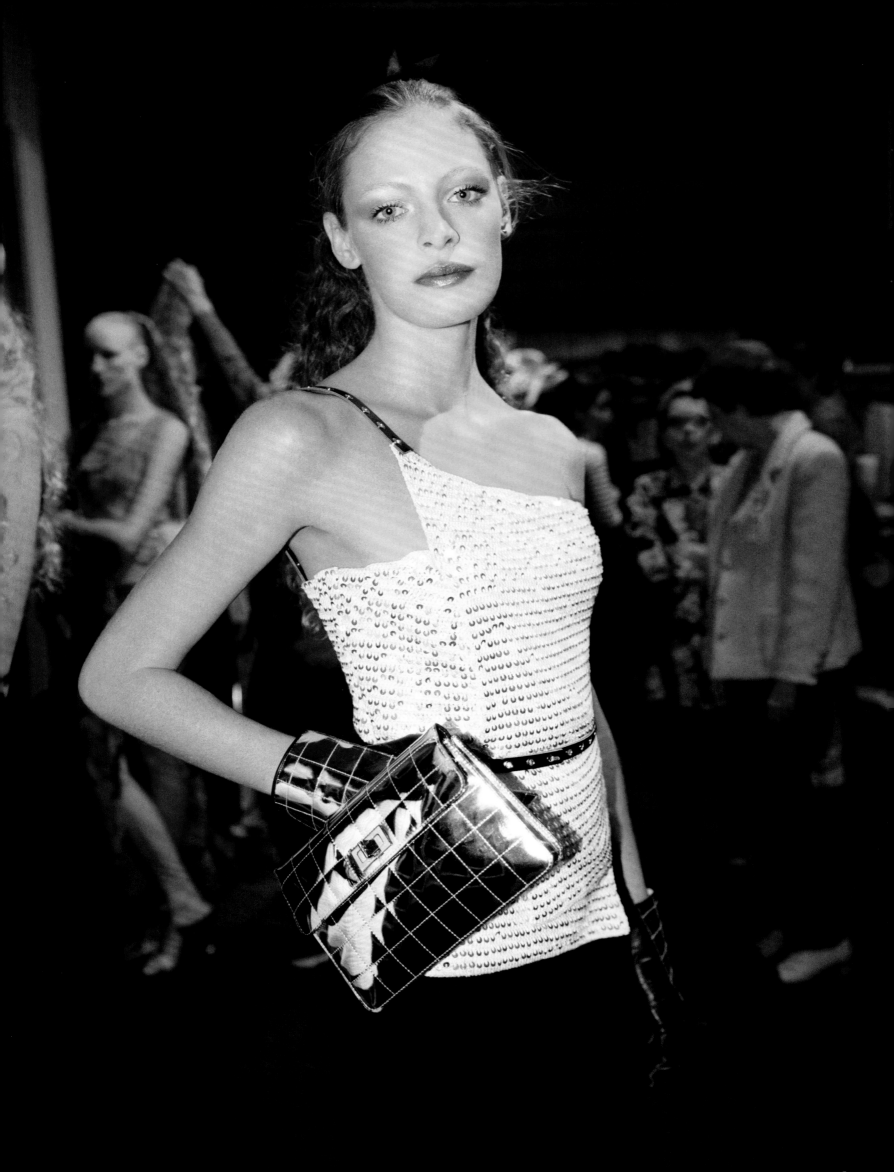

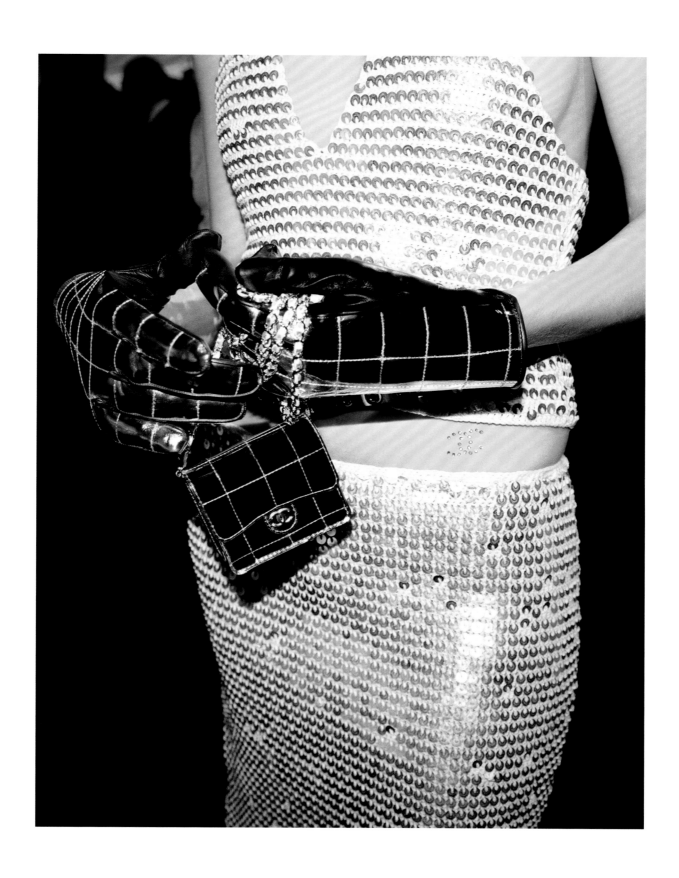

SPRING/SUMMER 2000 READY-TO-WEAR

AUTUMN/WINTER 2000-2001
READY-TO-WEAR

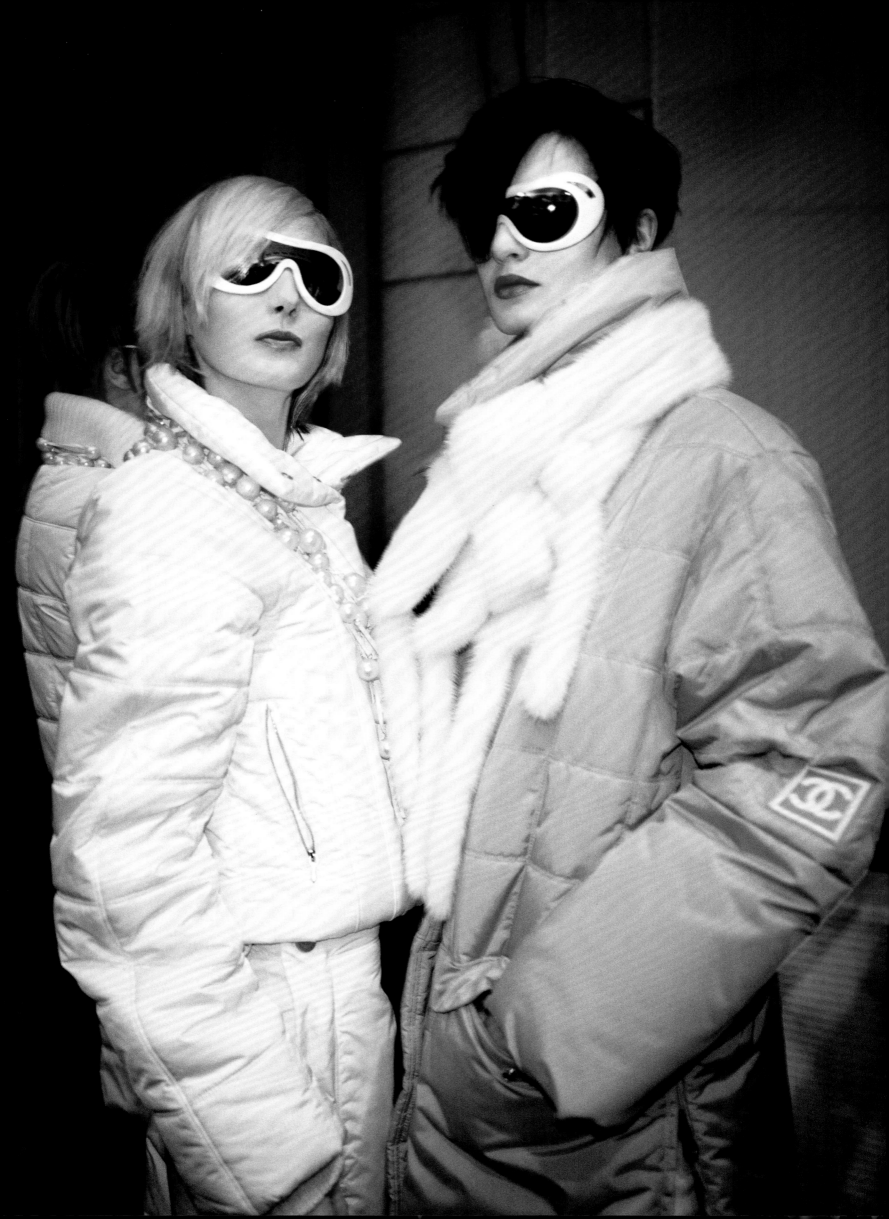

AUTUMN/WINTER 2000–2001 READY-TO-WEAR

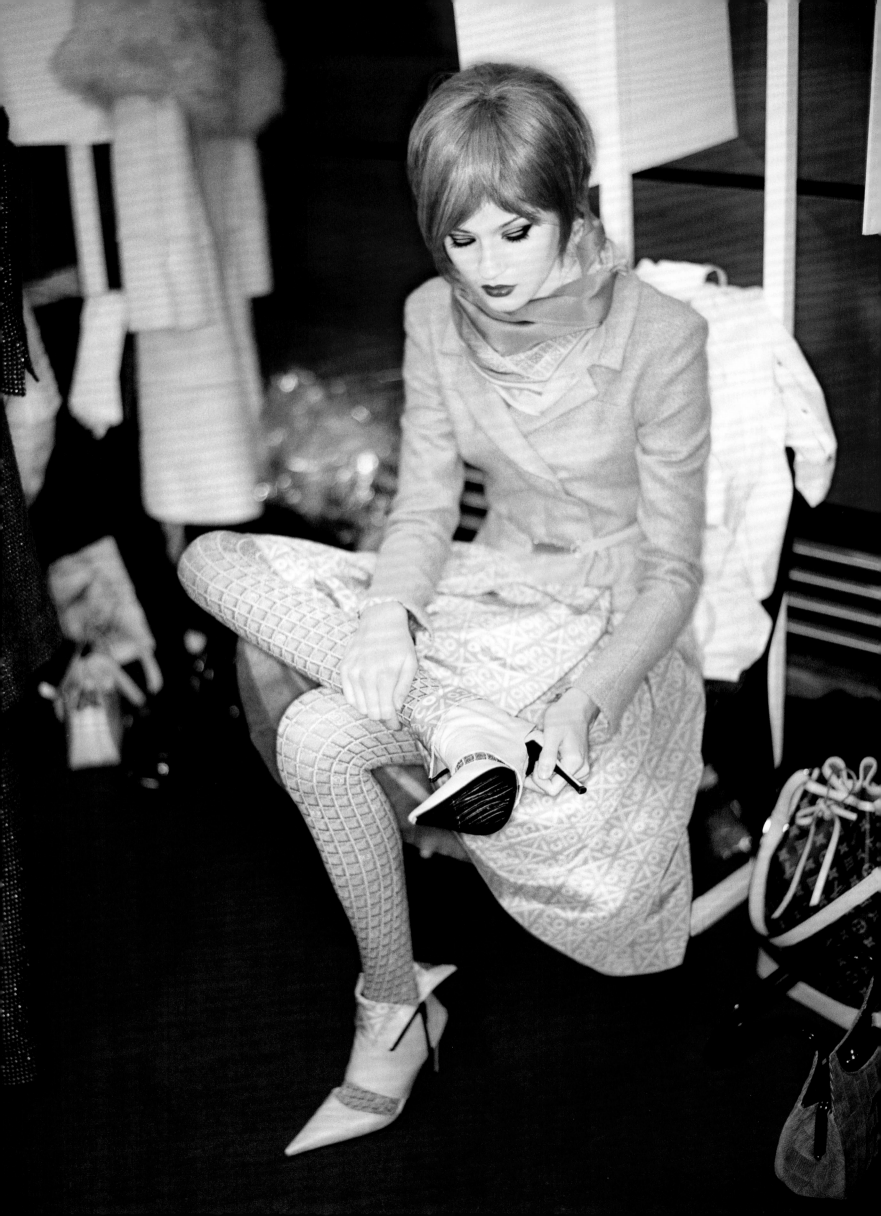

AUTUMN/WINTER 2000–2001
HAUTE COUTURE

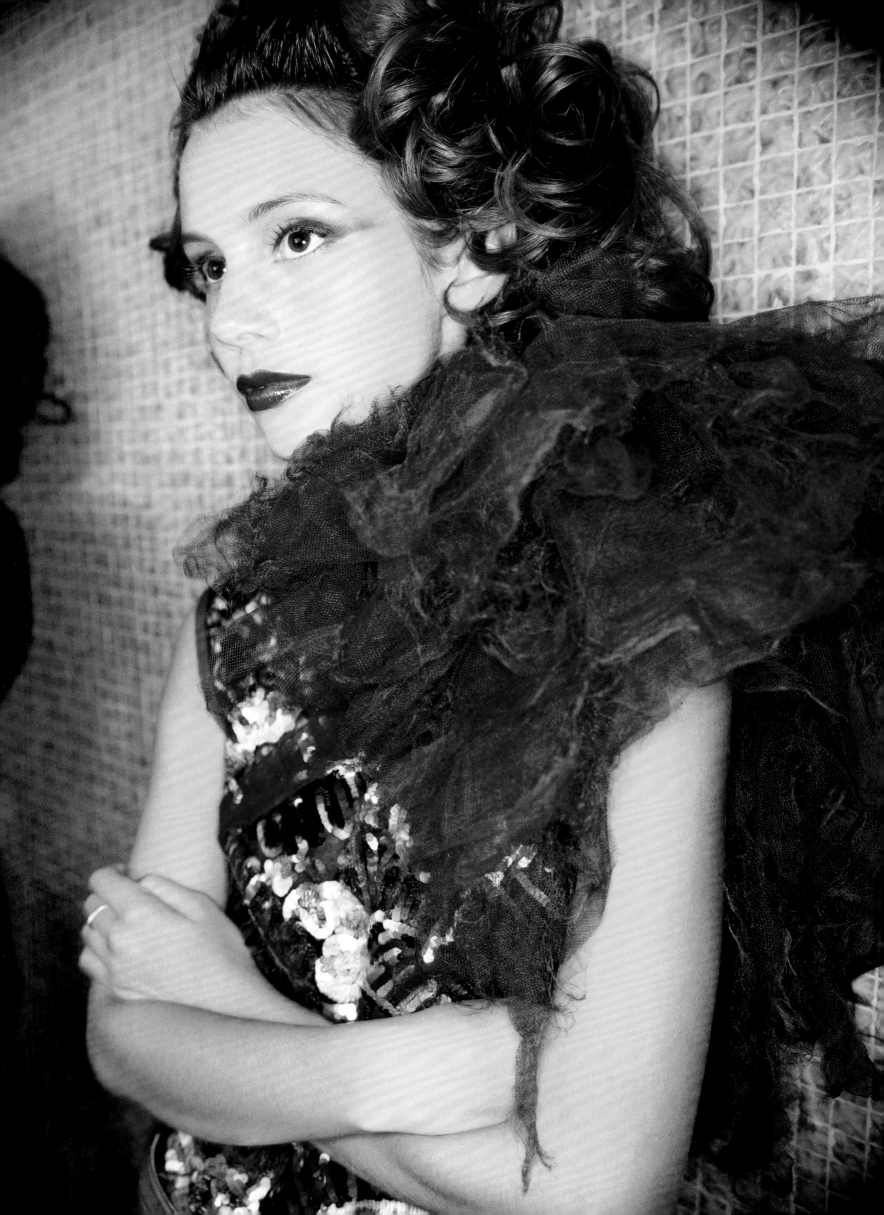

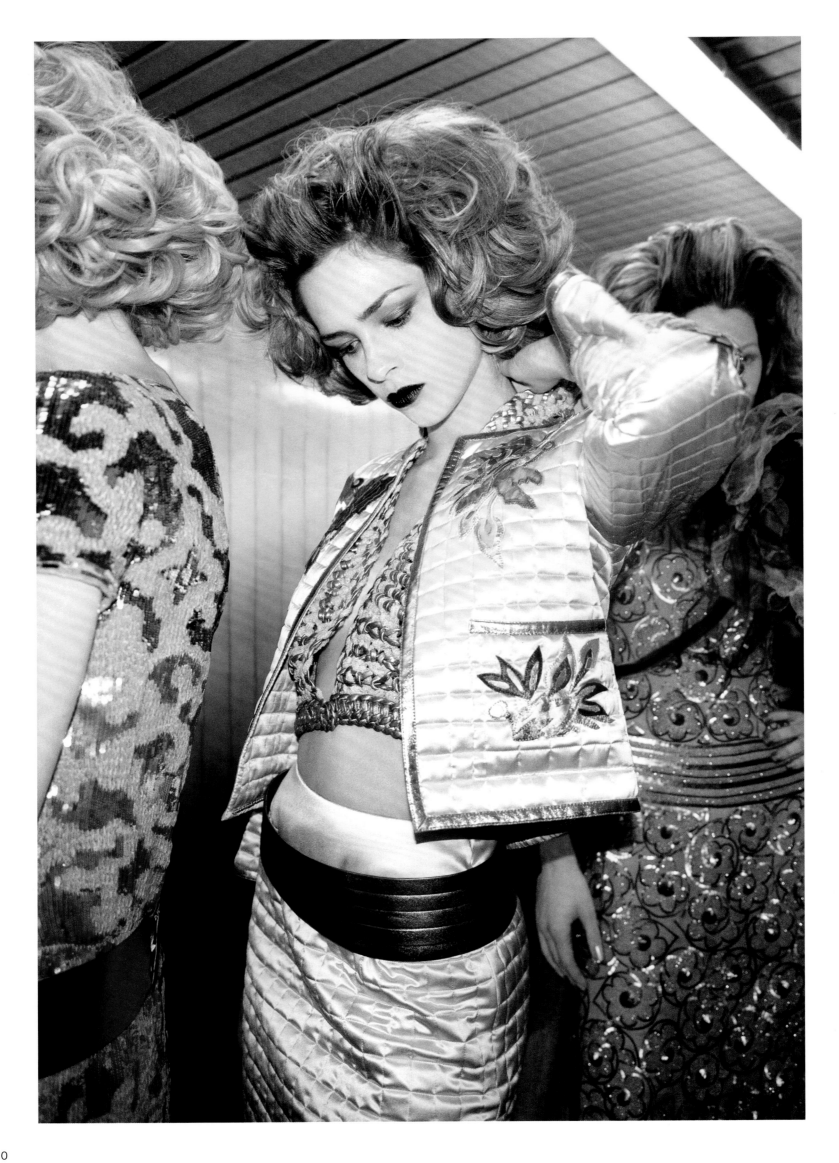

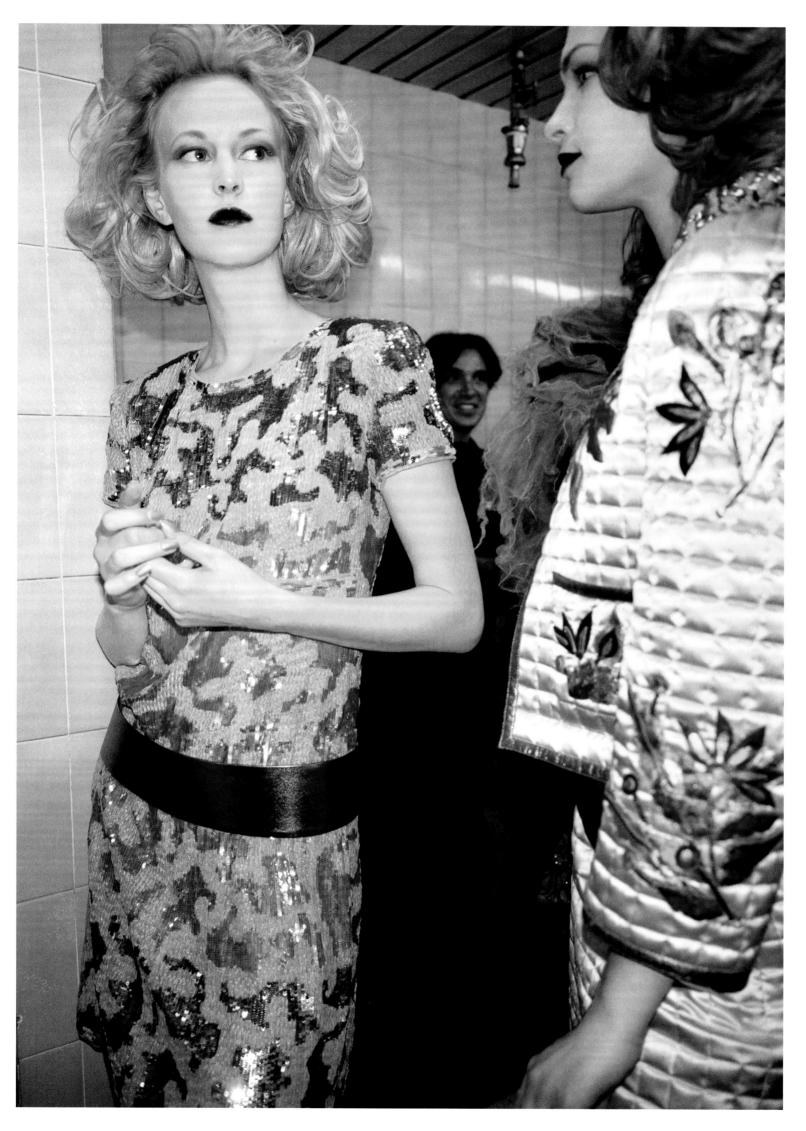

AUTUMN/WINTER 2000–2001 HAUTE COUTURE

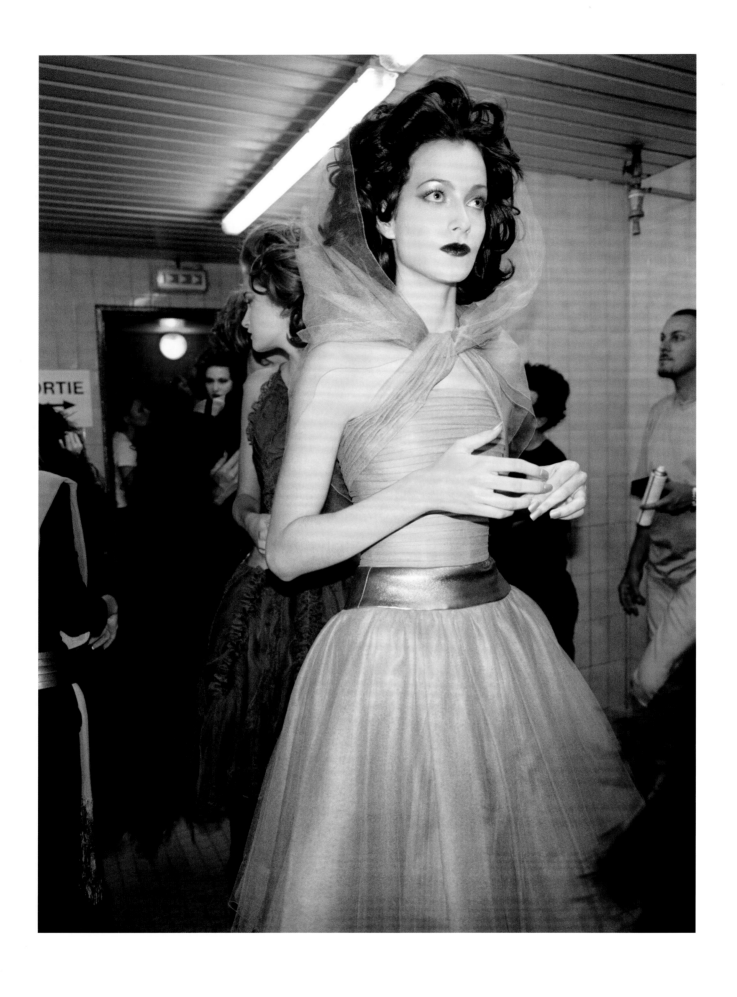

AUTUMN/WINTER 2000–2001 HAUTE COUTURE

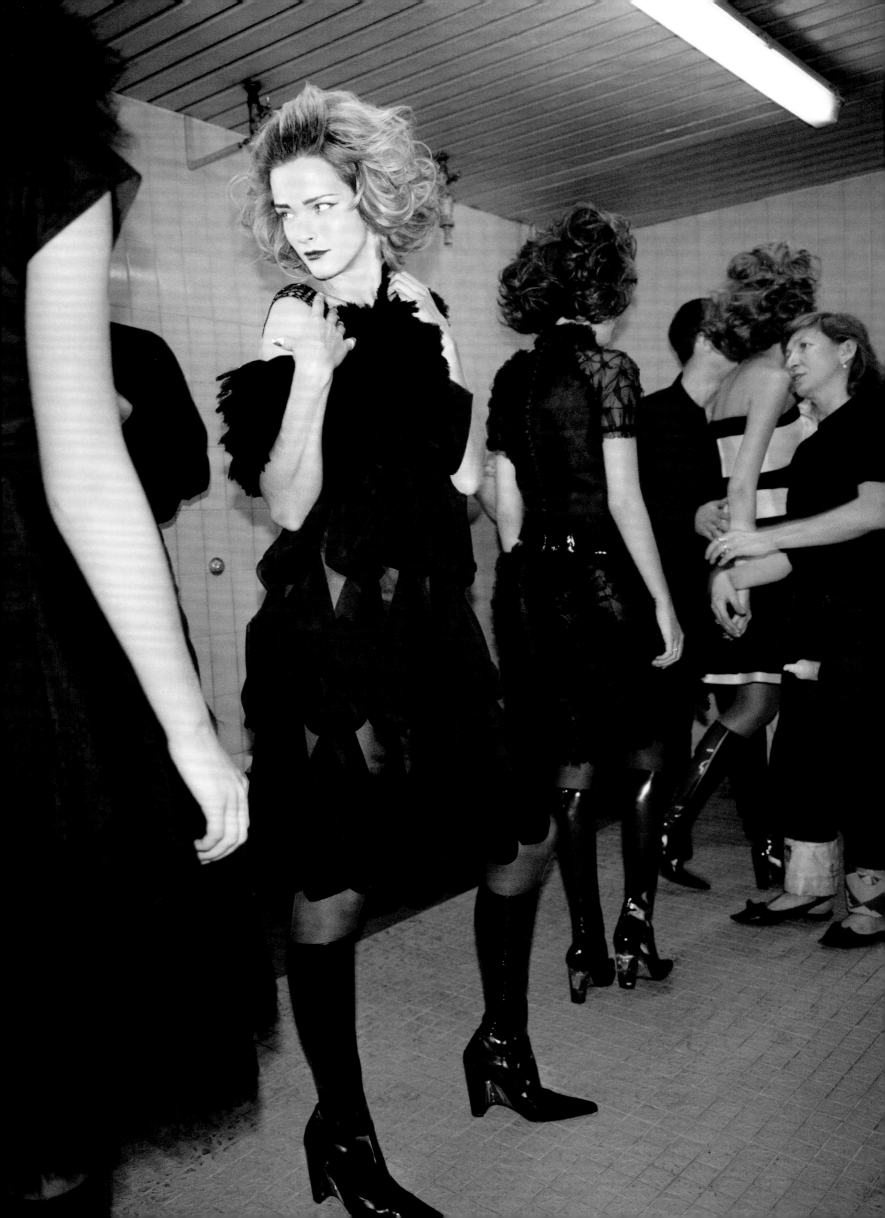

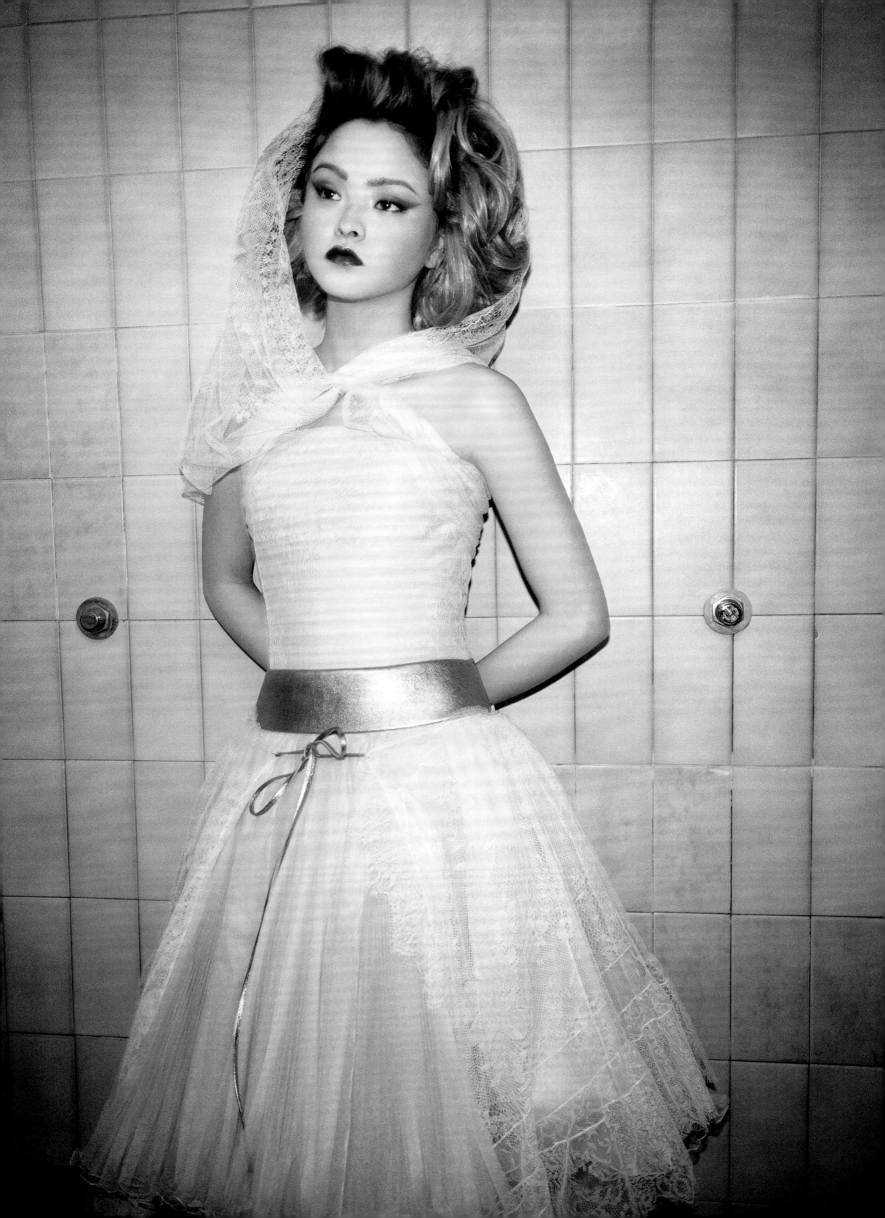

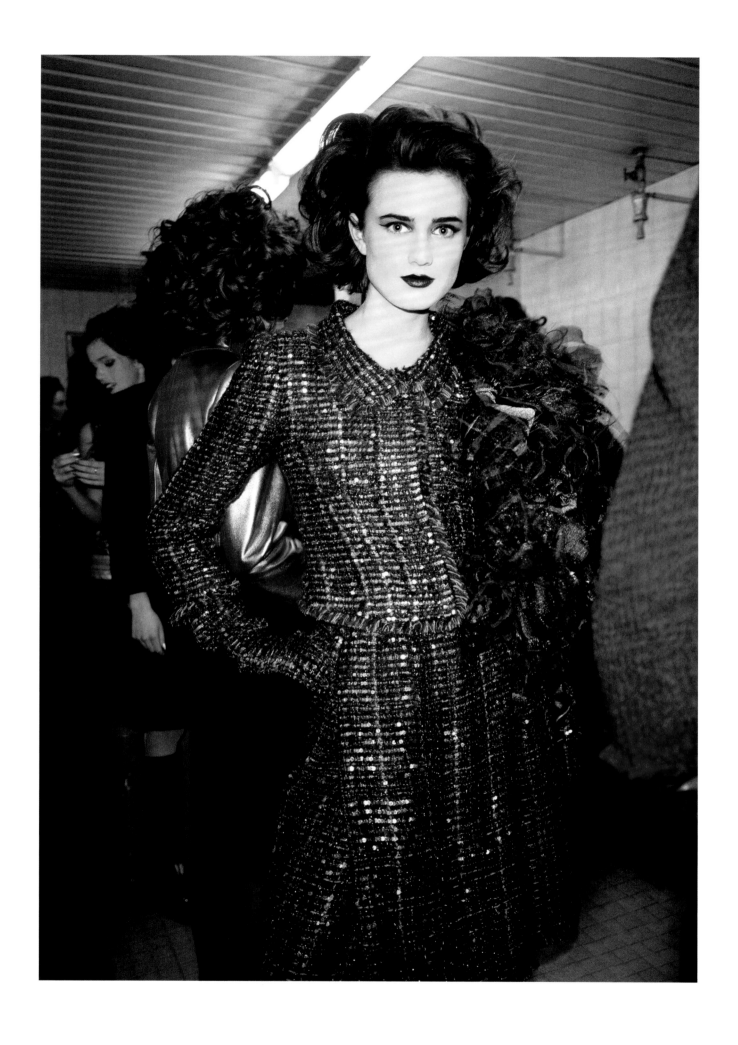

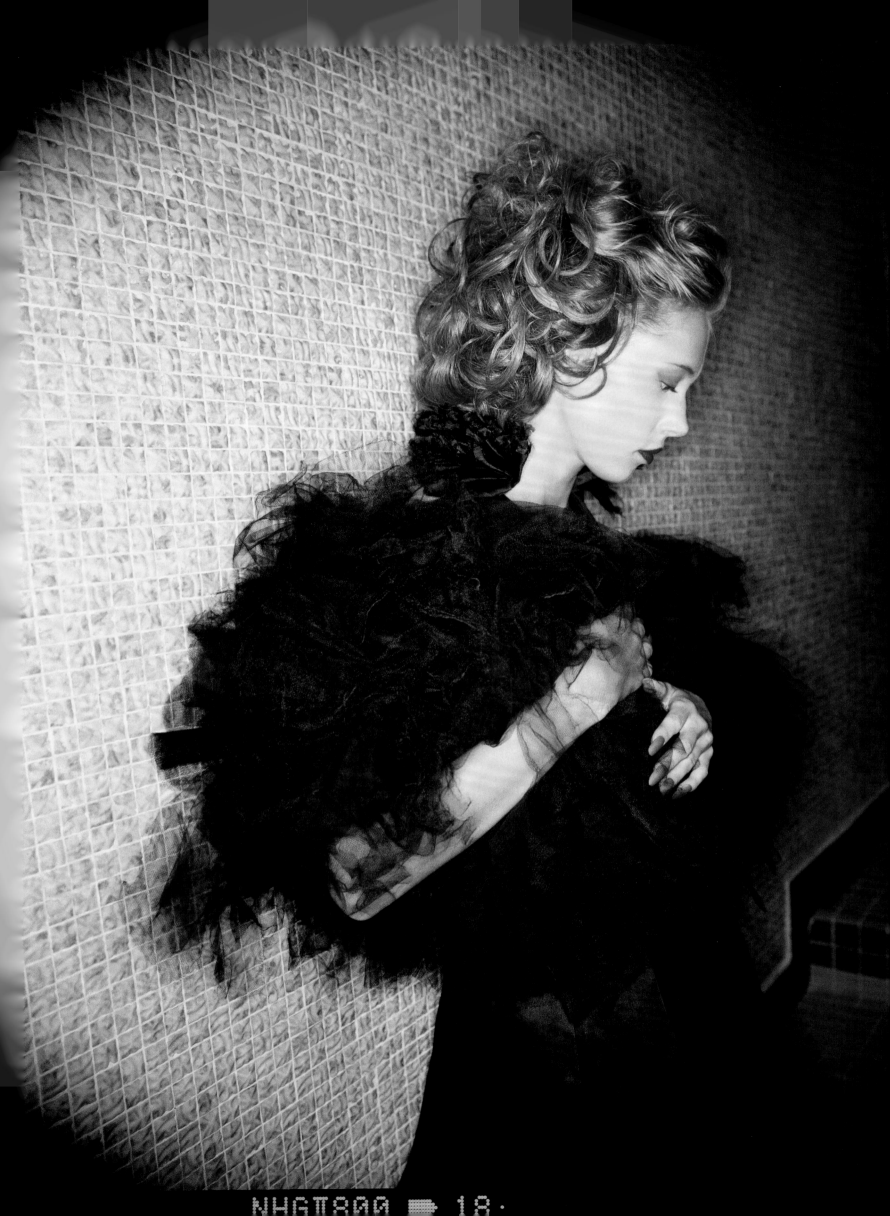
NHGT800 18.

'One is never underdressed or overdressed with a little black dress or a little black jacket'

Karl Lagerfeld

SPRING/SUMMER 2001
READY-TO-WEAR

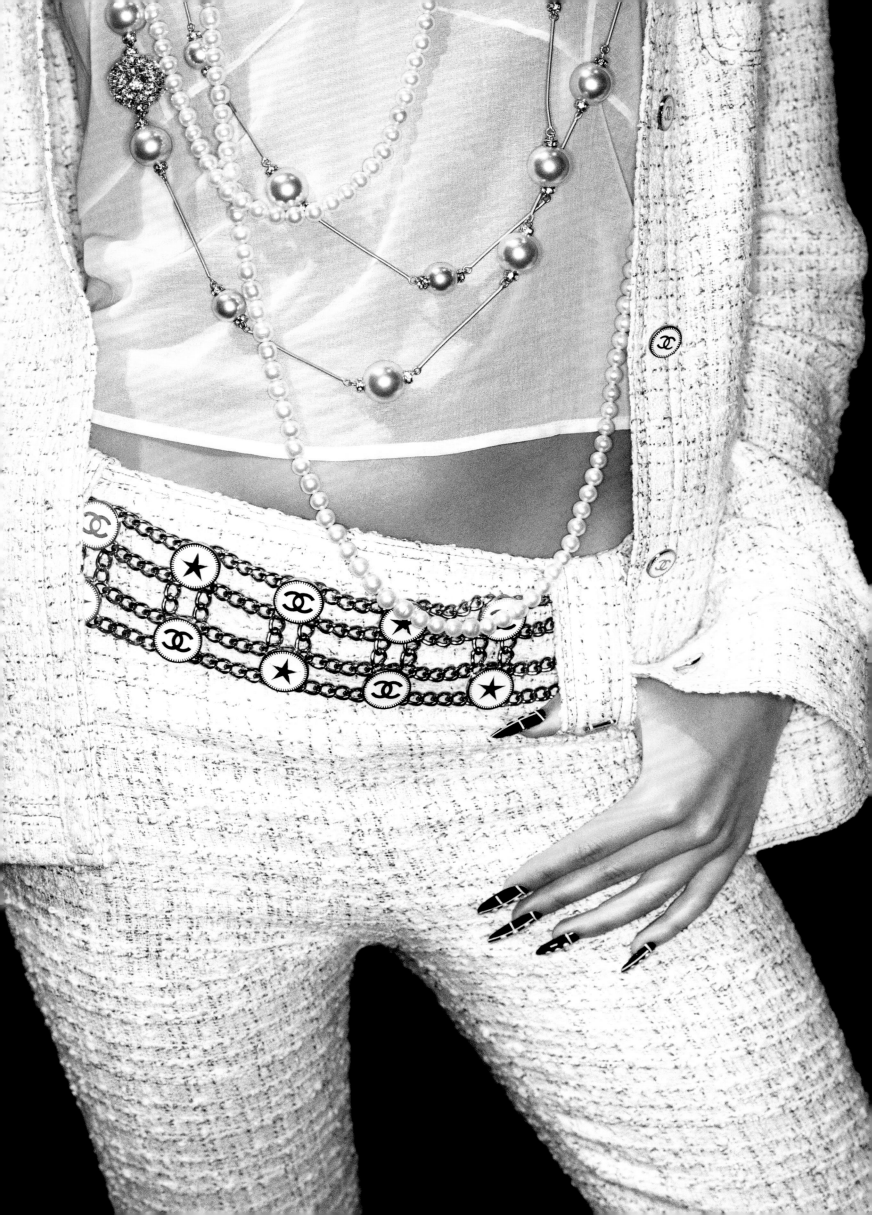

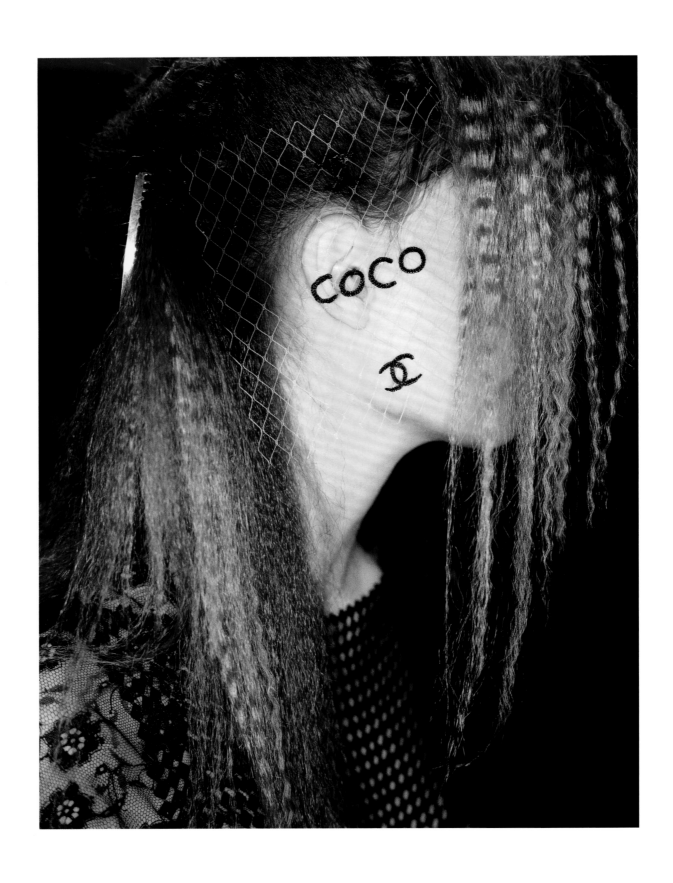

SPRING/SUMMER 2001 READY-TO-WEAR

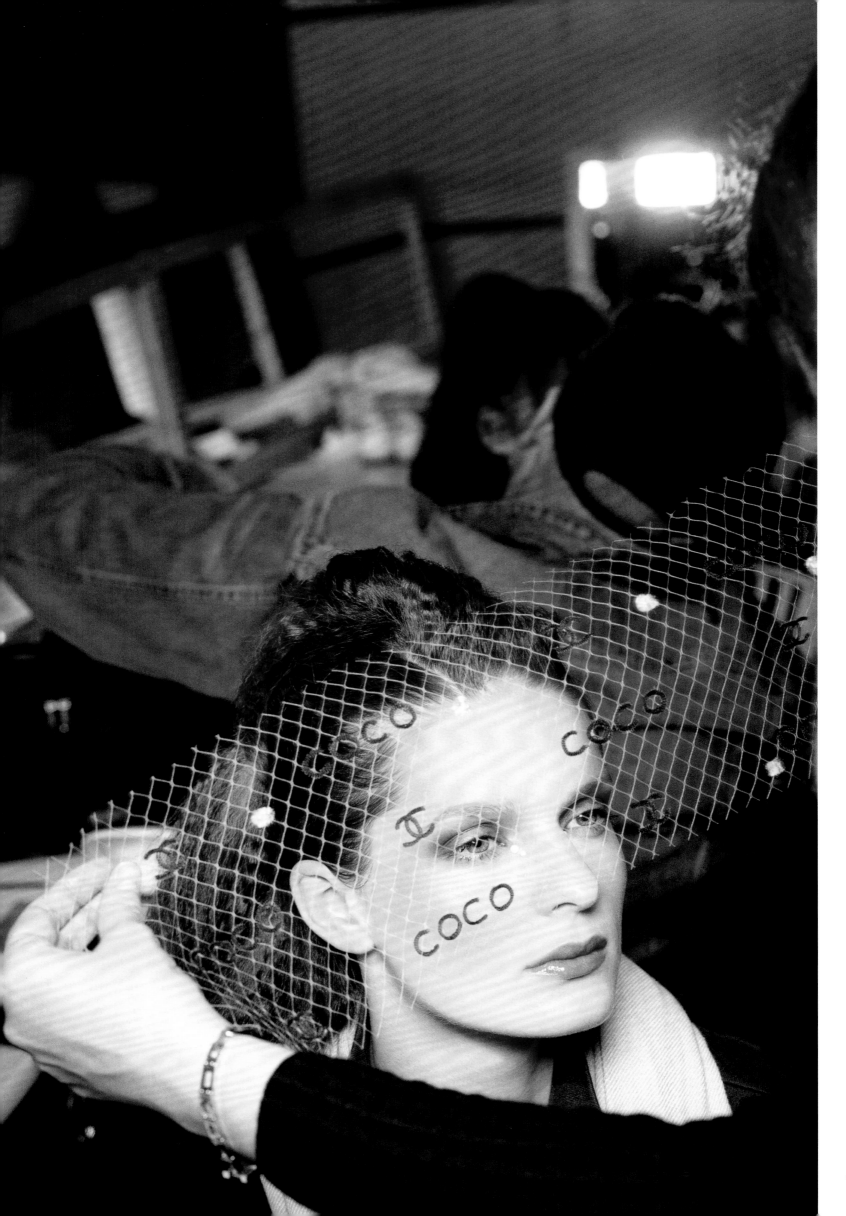

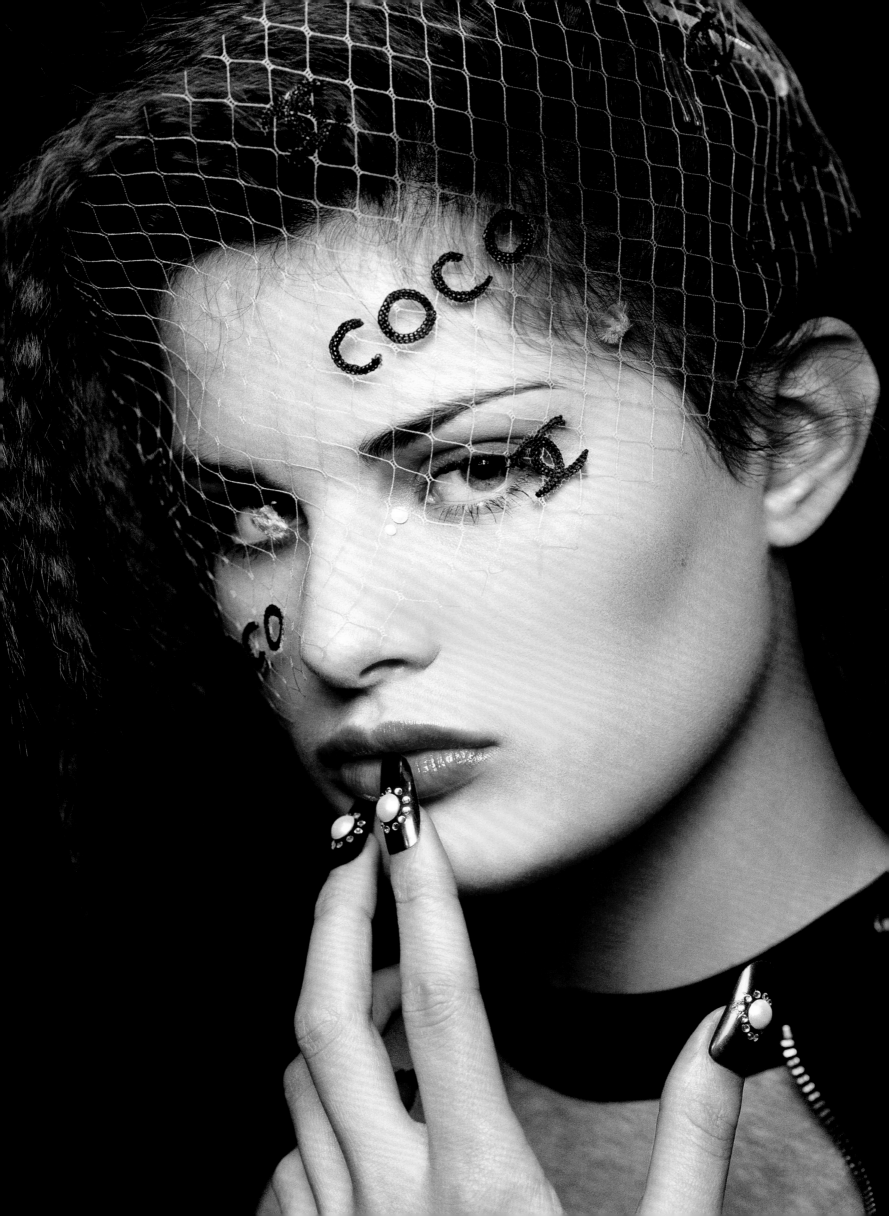

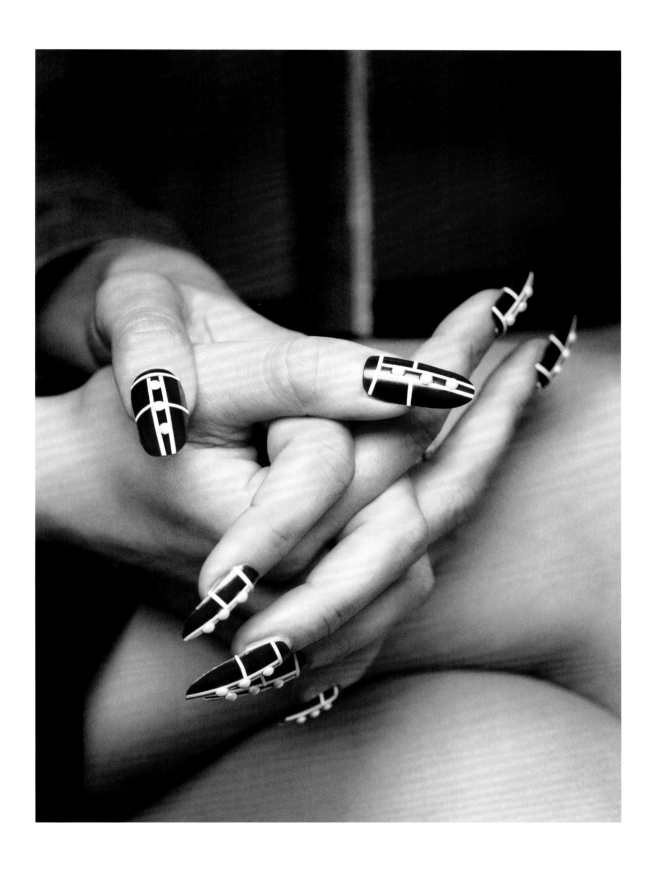

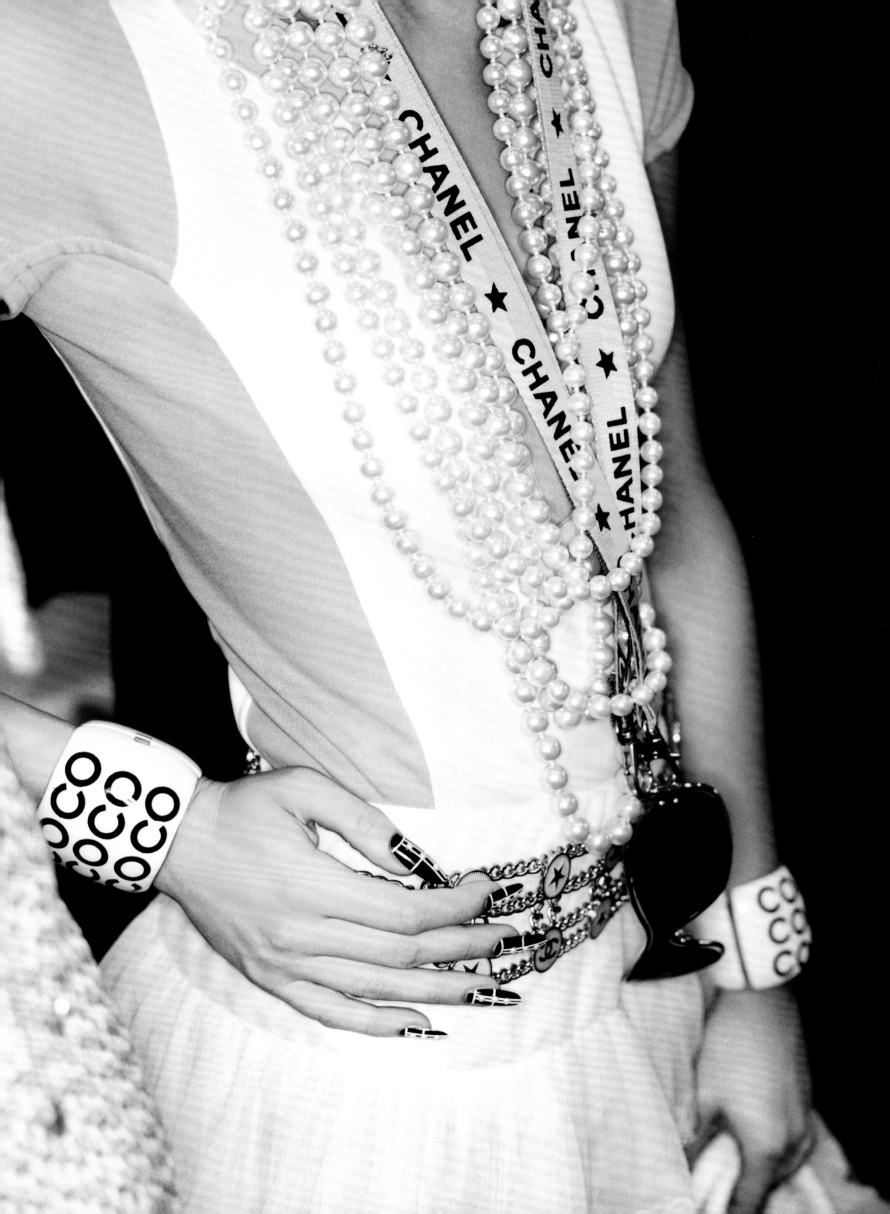

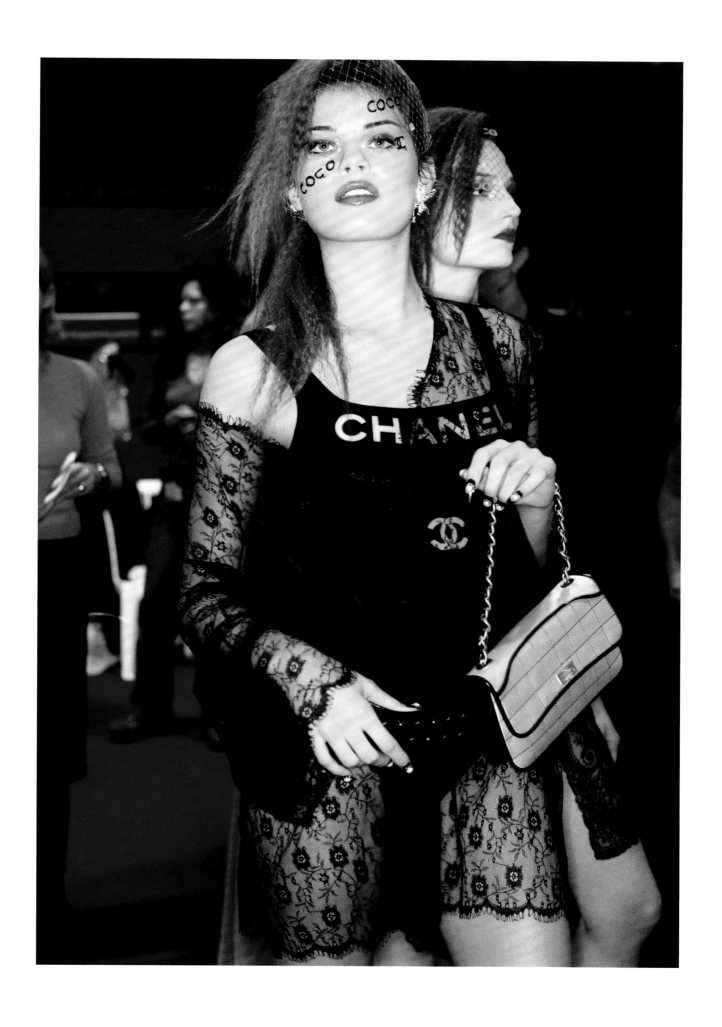

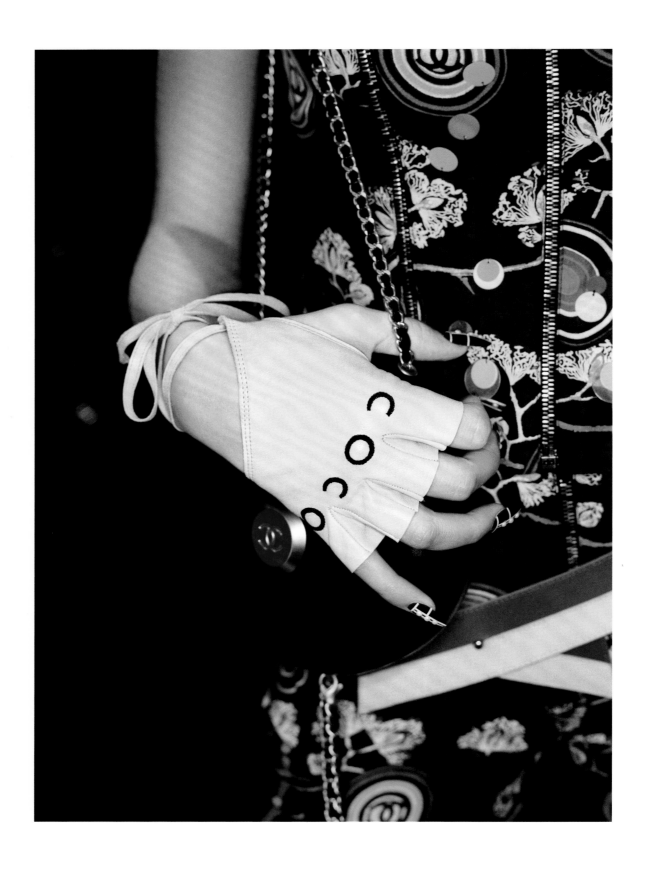

SPRING/SUMMER 2001 READY-TO-WEAR

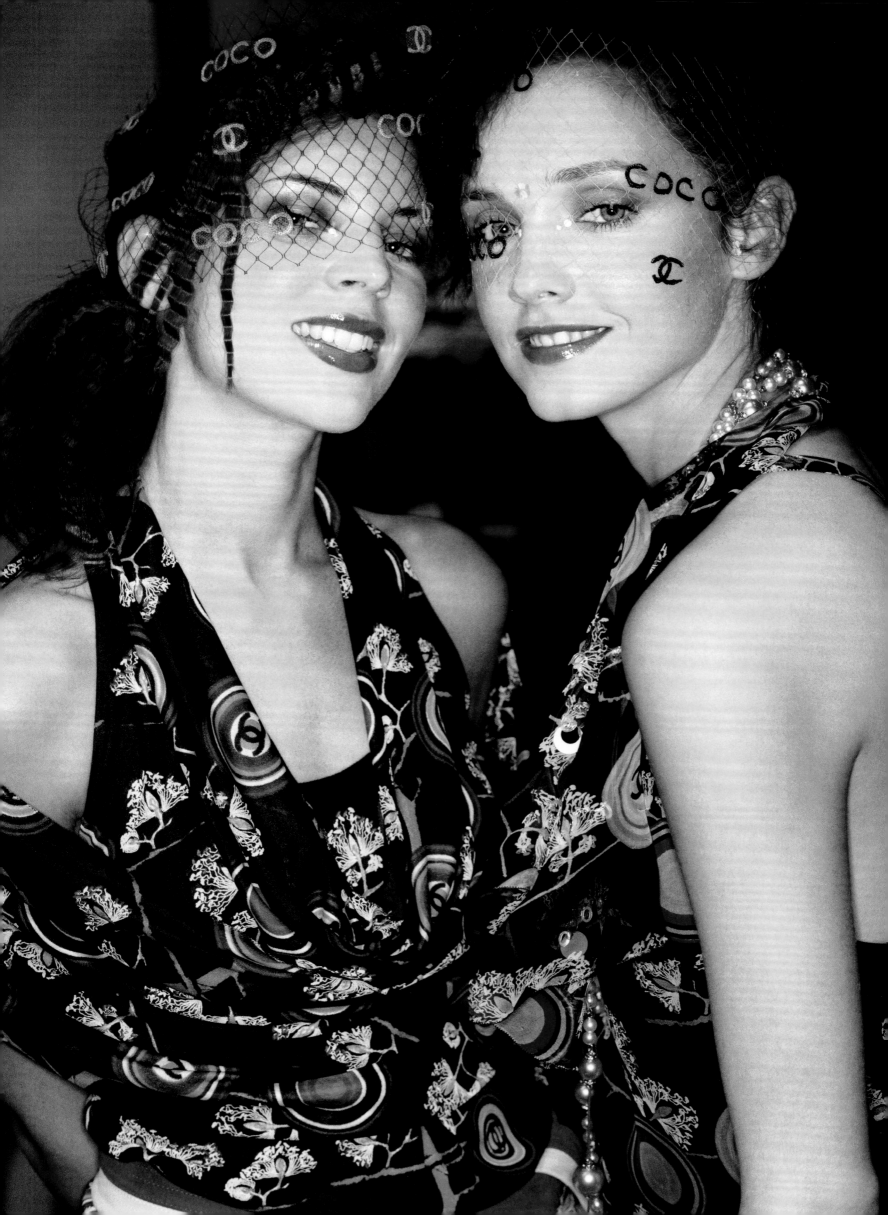

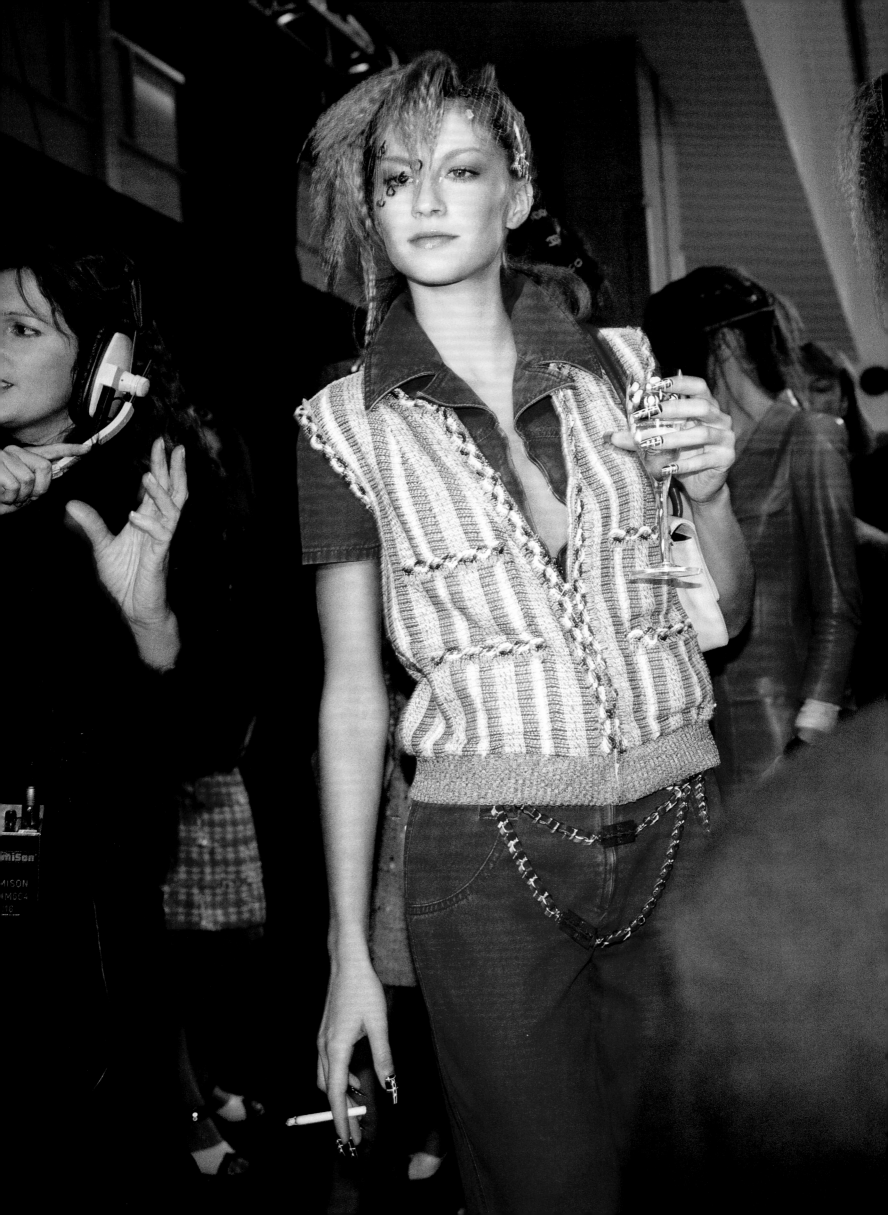

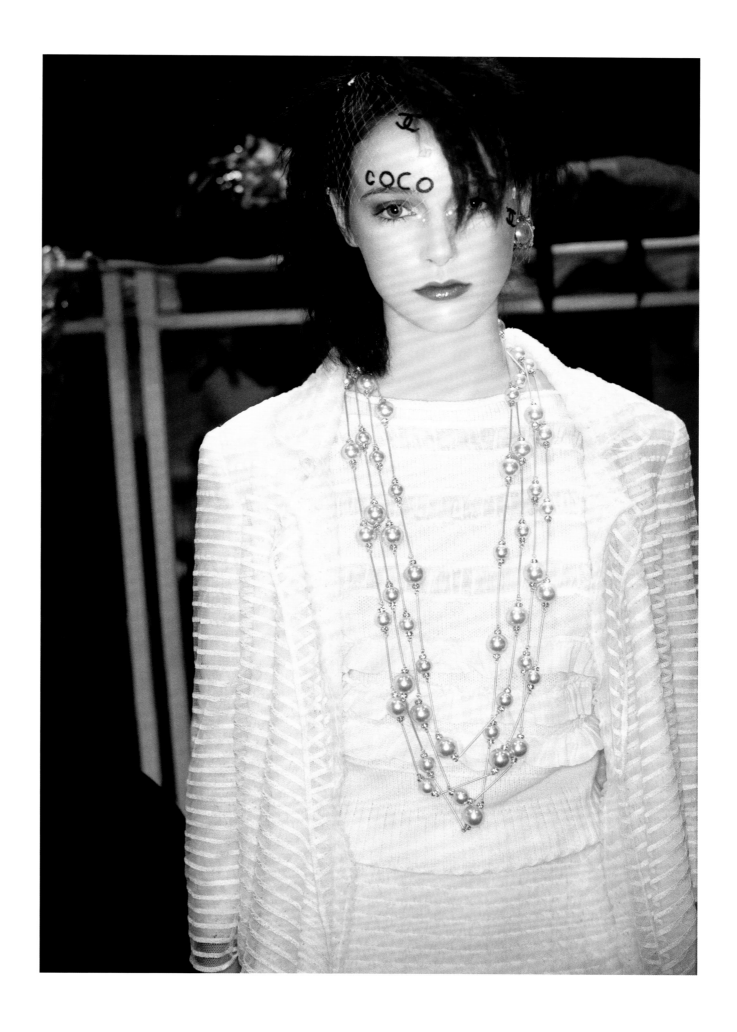

'Chanel left us with something better than fashion: style. And style, as she preached it, doesn't grow old.'

Karl Lagerfeld

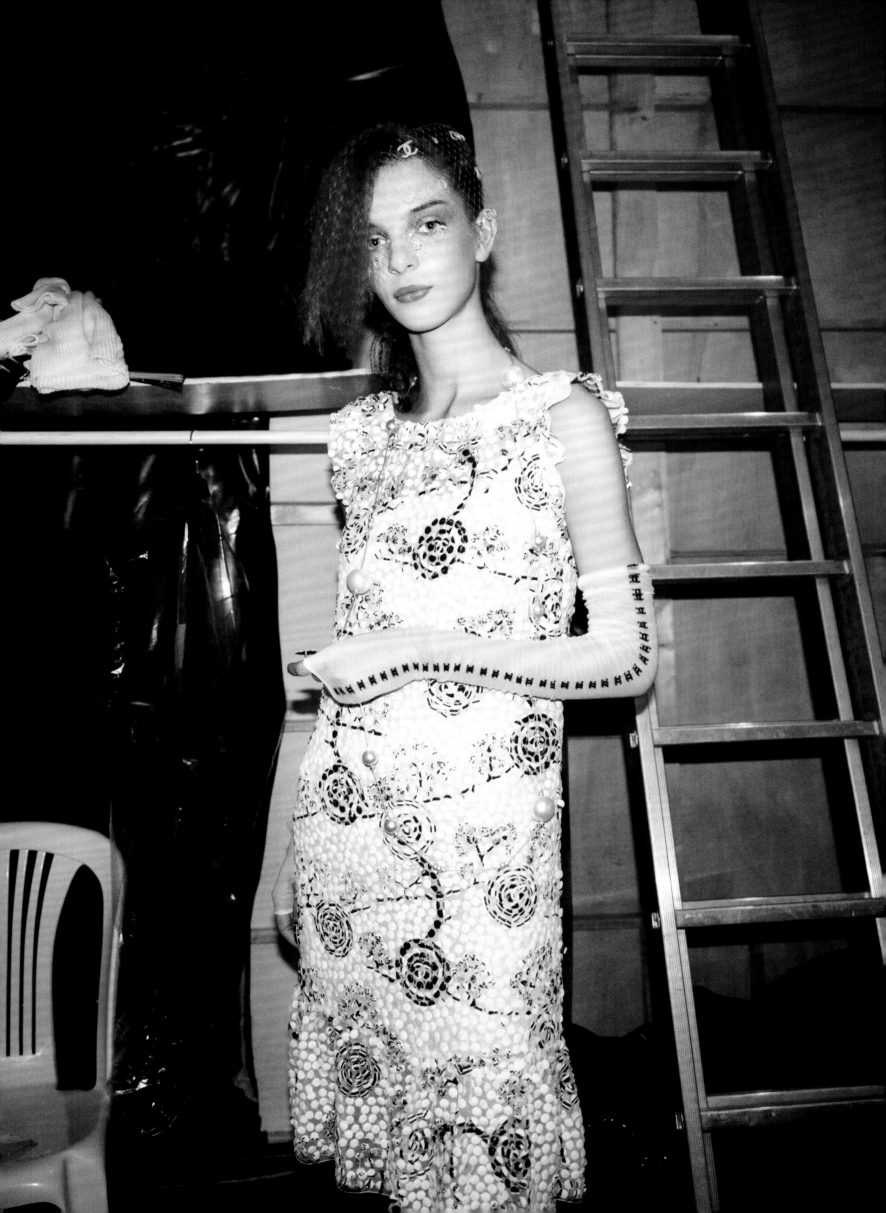

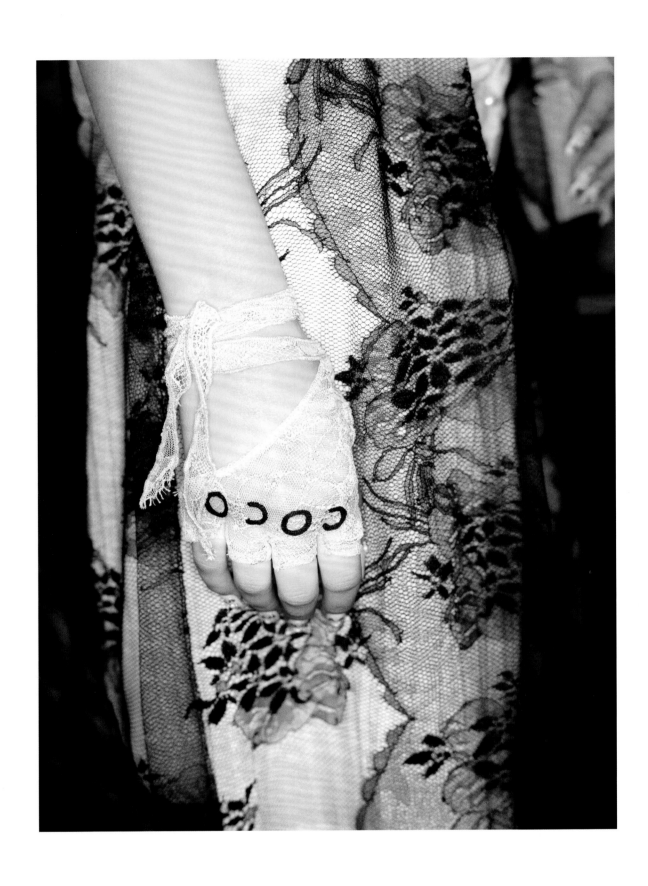

SPRING/SUMMER 2001 READY-TO-WEAR

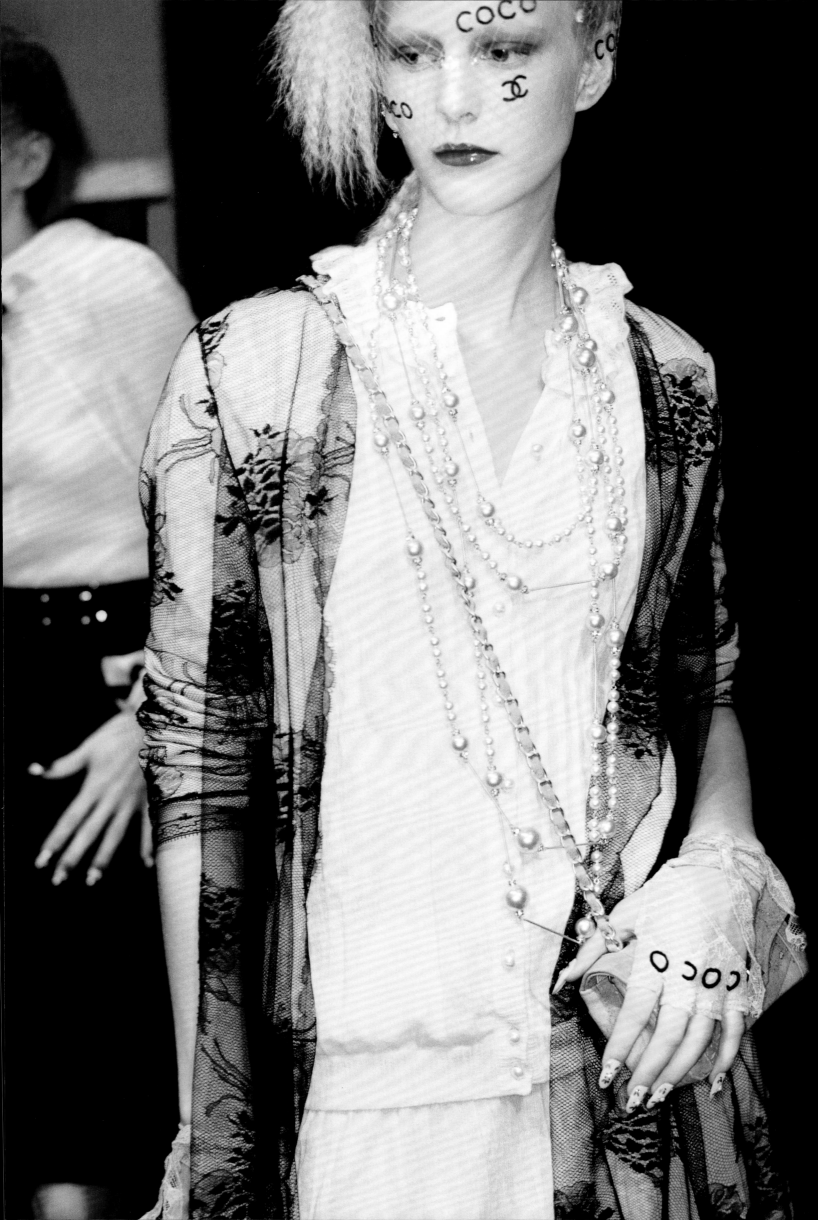

SPRING/SUMMER 2001
HAUTE COUTURE

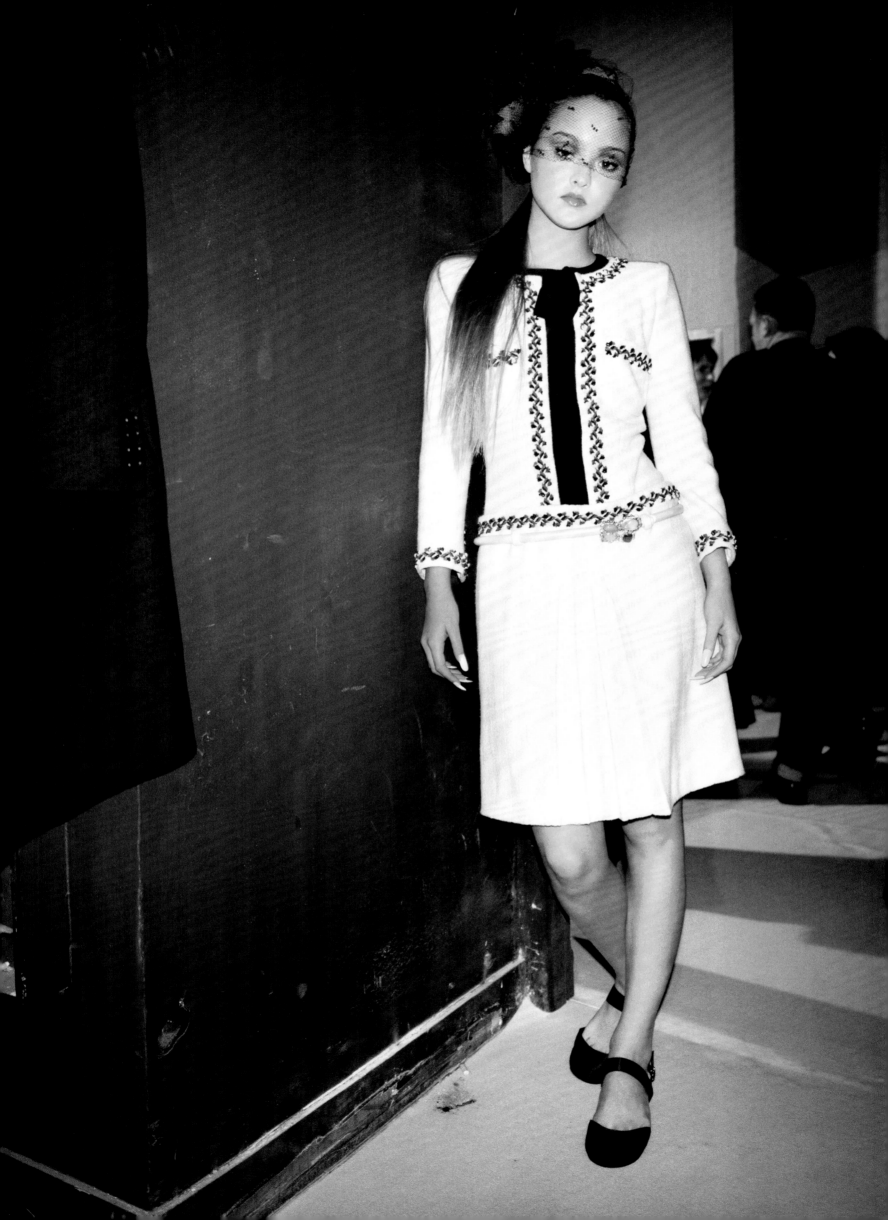

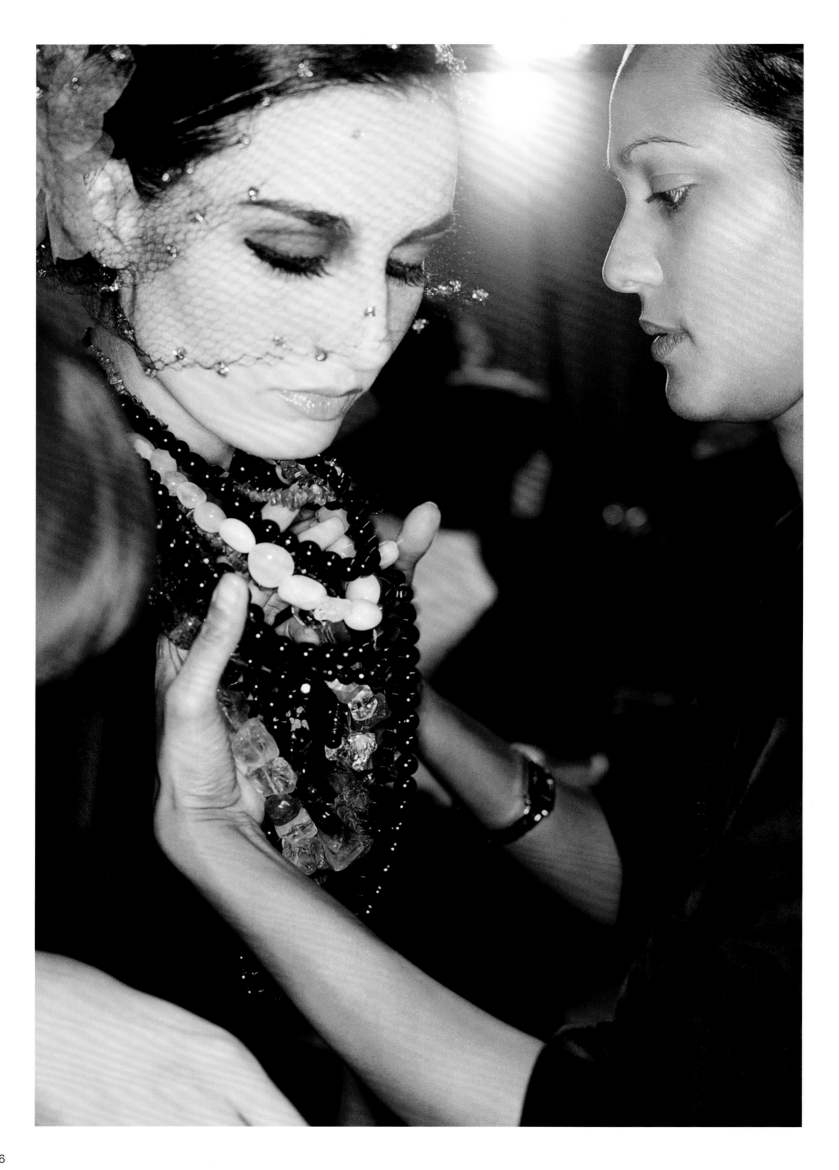

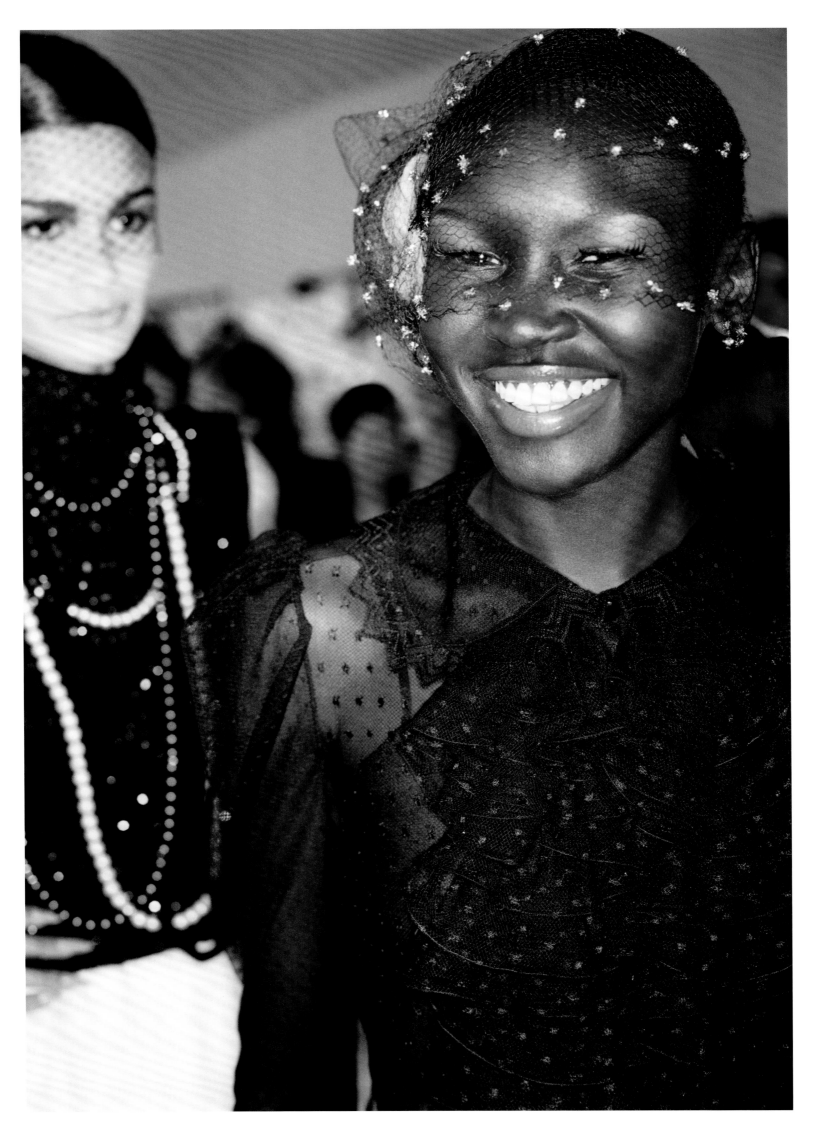

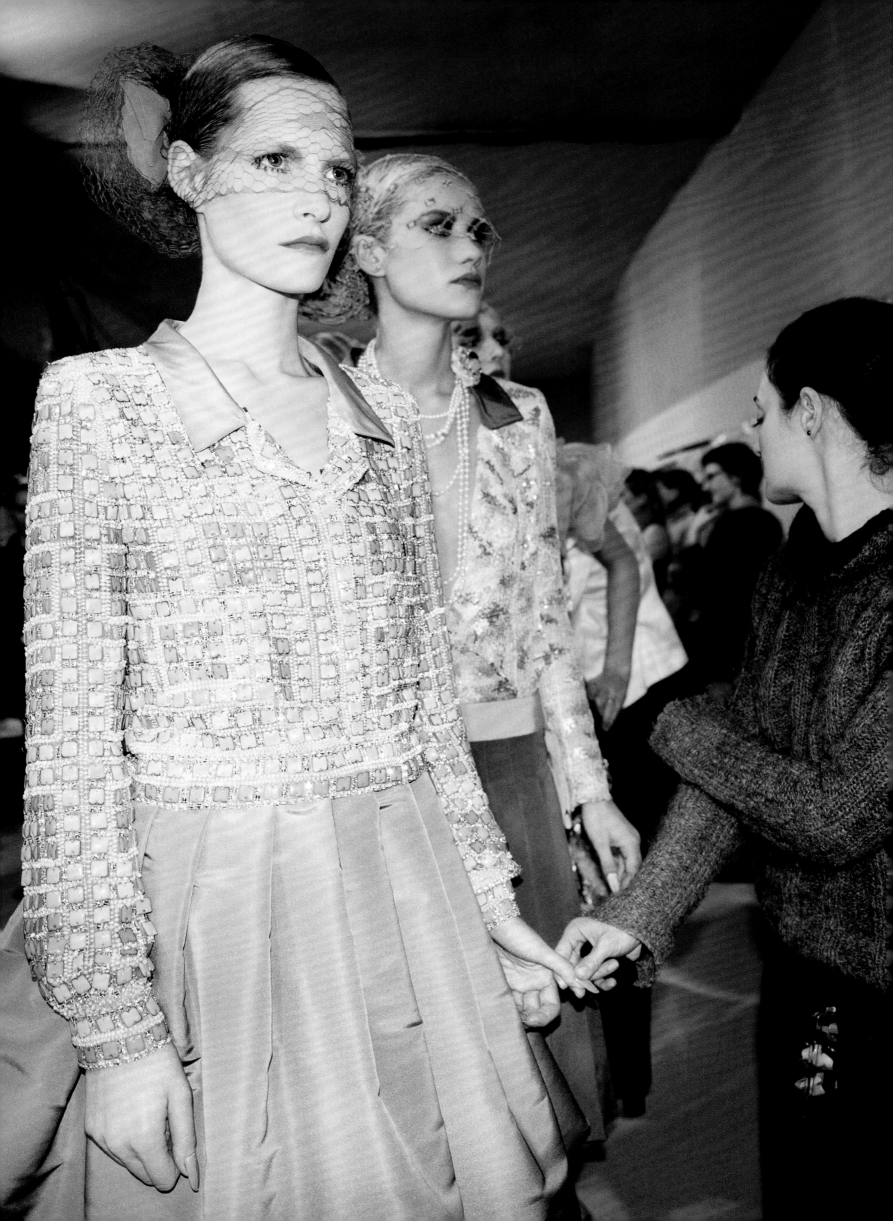

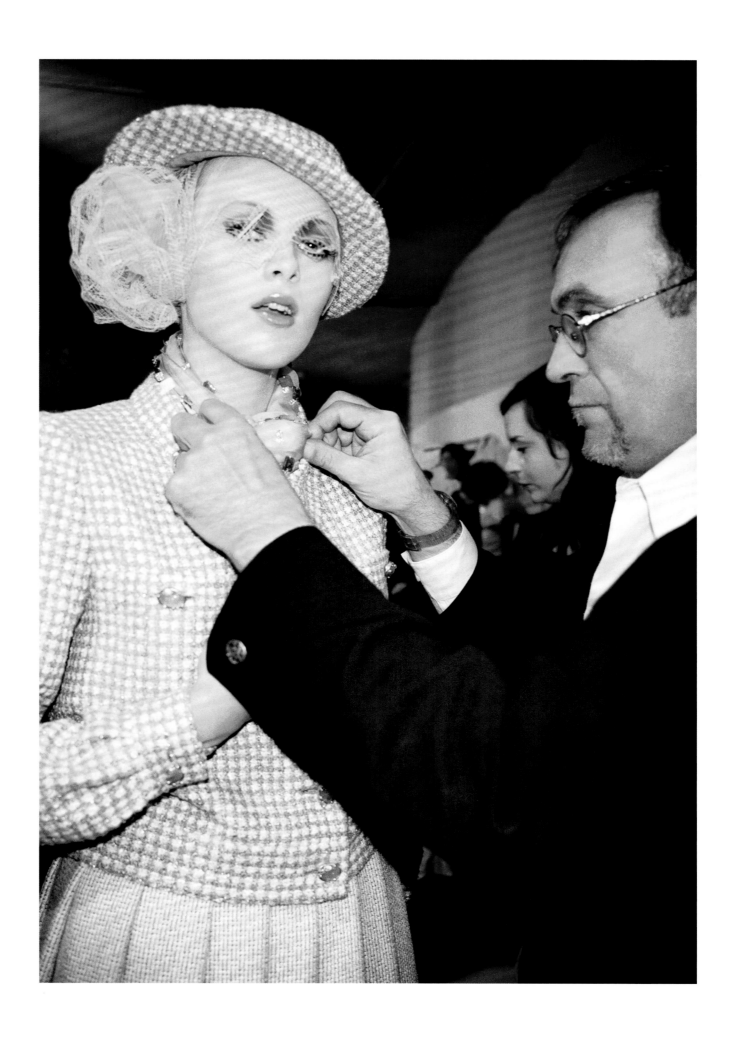

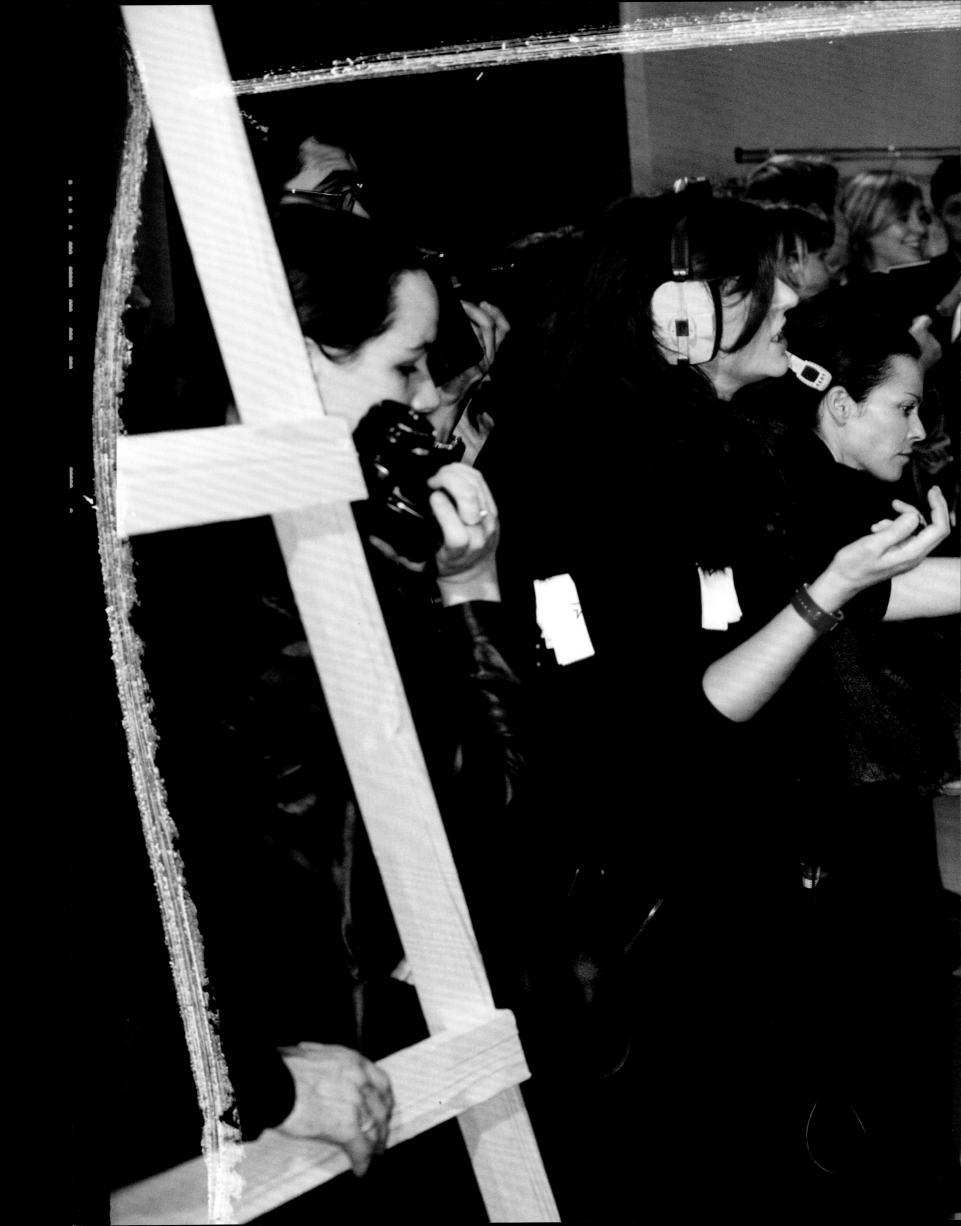

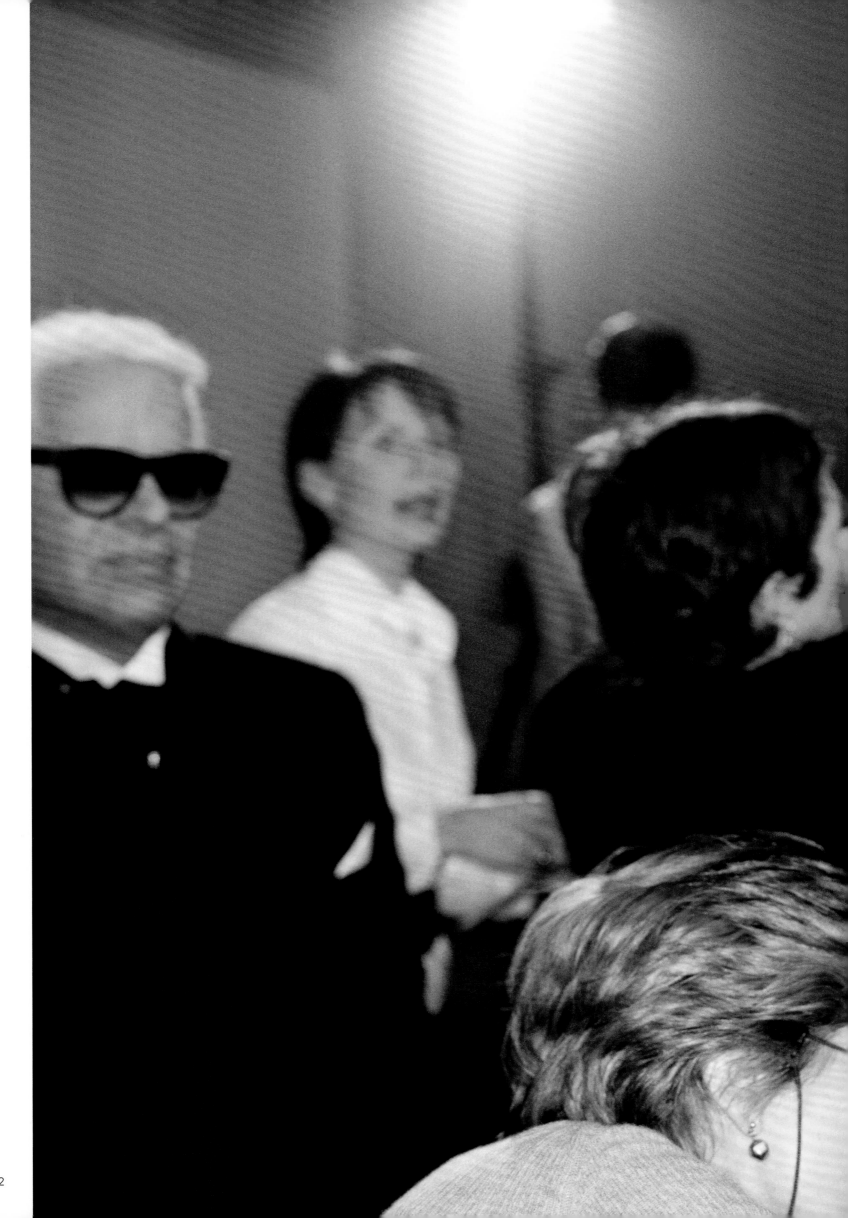

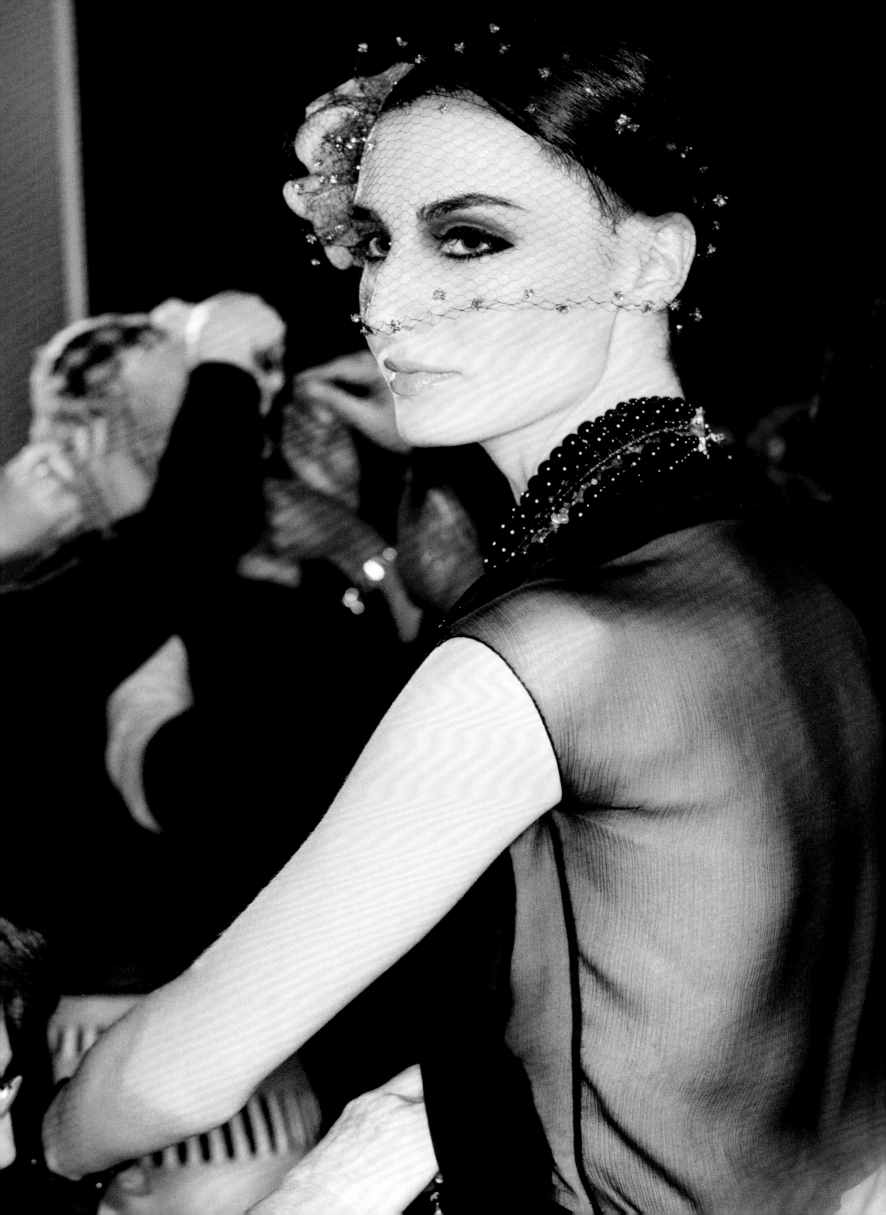

AUTUMN/WINTER 2001–2002
READY-TO-WEAR

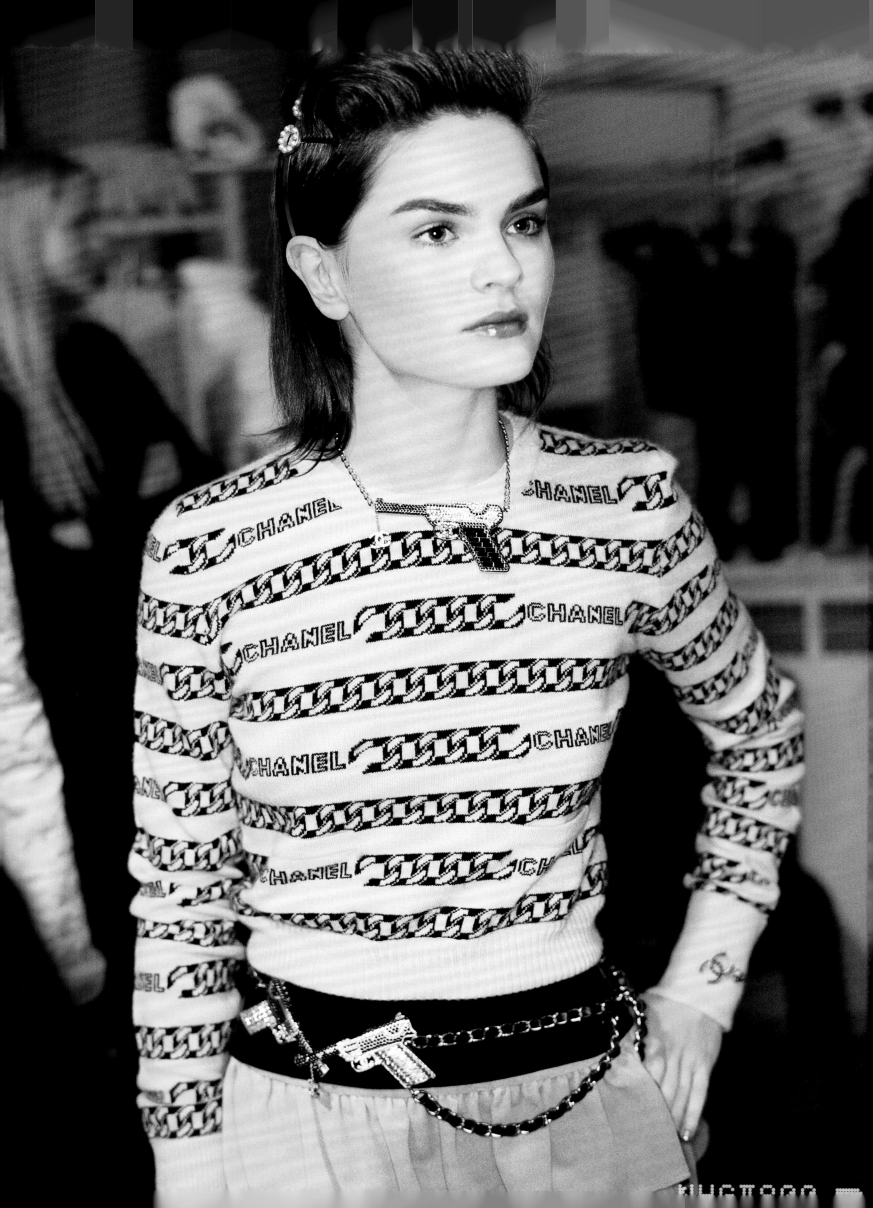

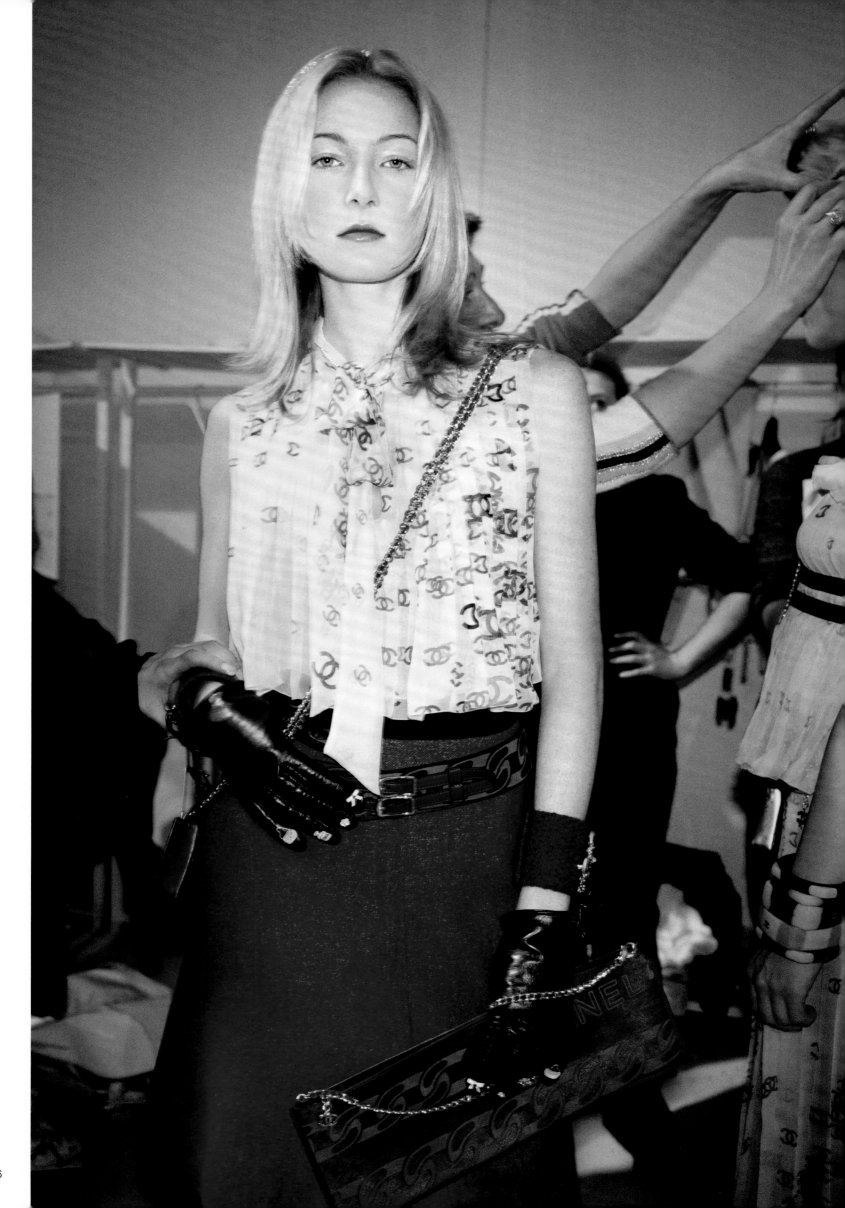

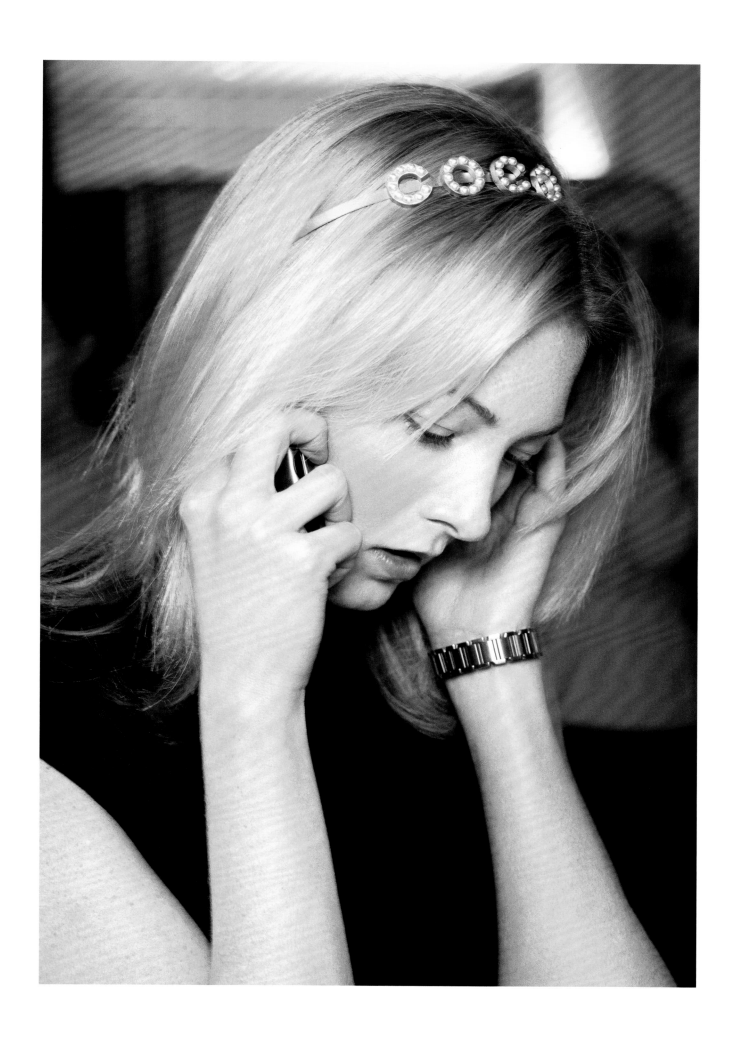

'I first met Karl through Peter Lindbergh.
I was very *impressionnée*, as we say
in French, very much in awe of him,
but Peter told me "Just work with him.
He is somebody '*très touchant*'."
So, I did. Karl and I worked together for
eighteen years, and it was incredible.'

Odile Gilbert

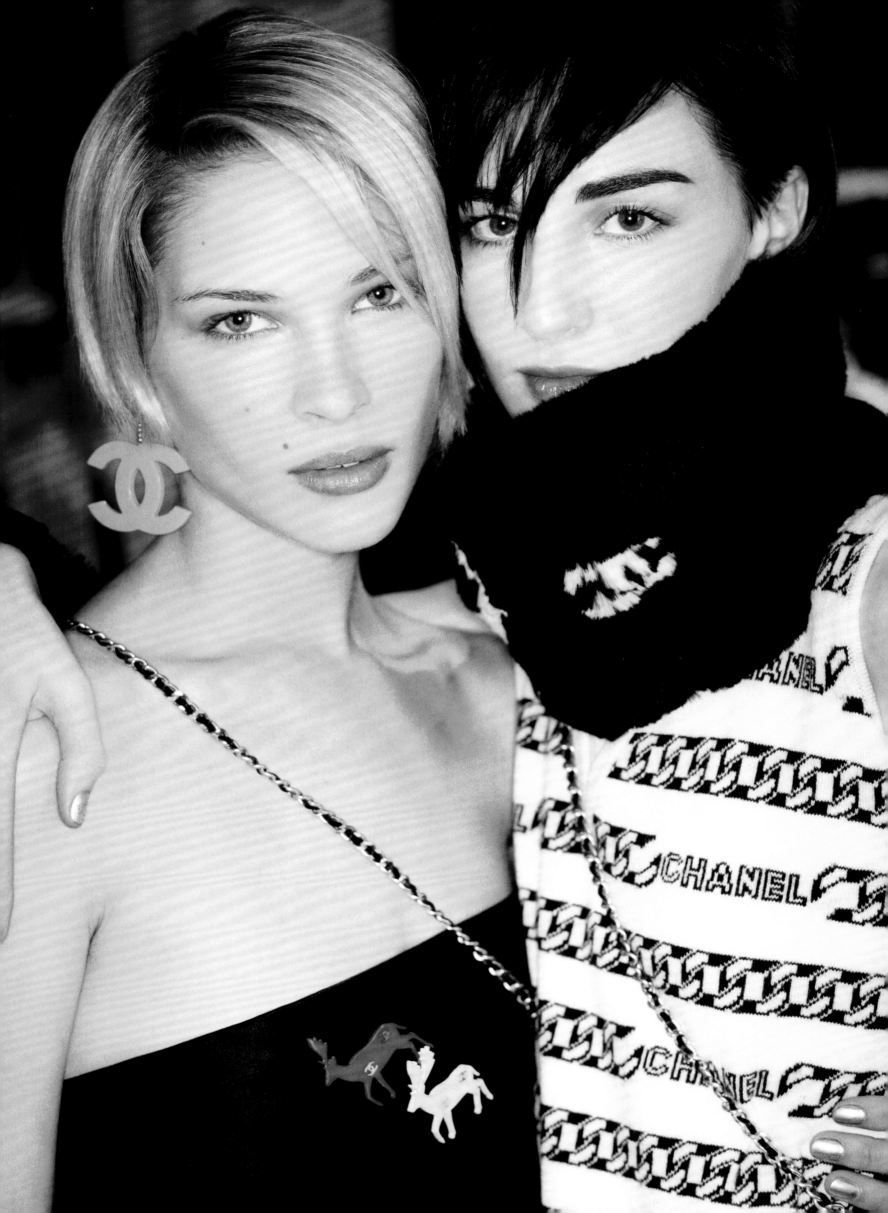

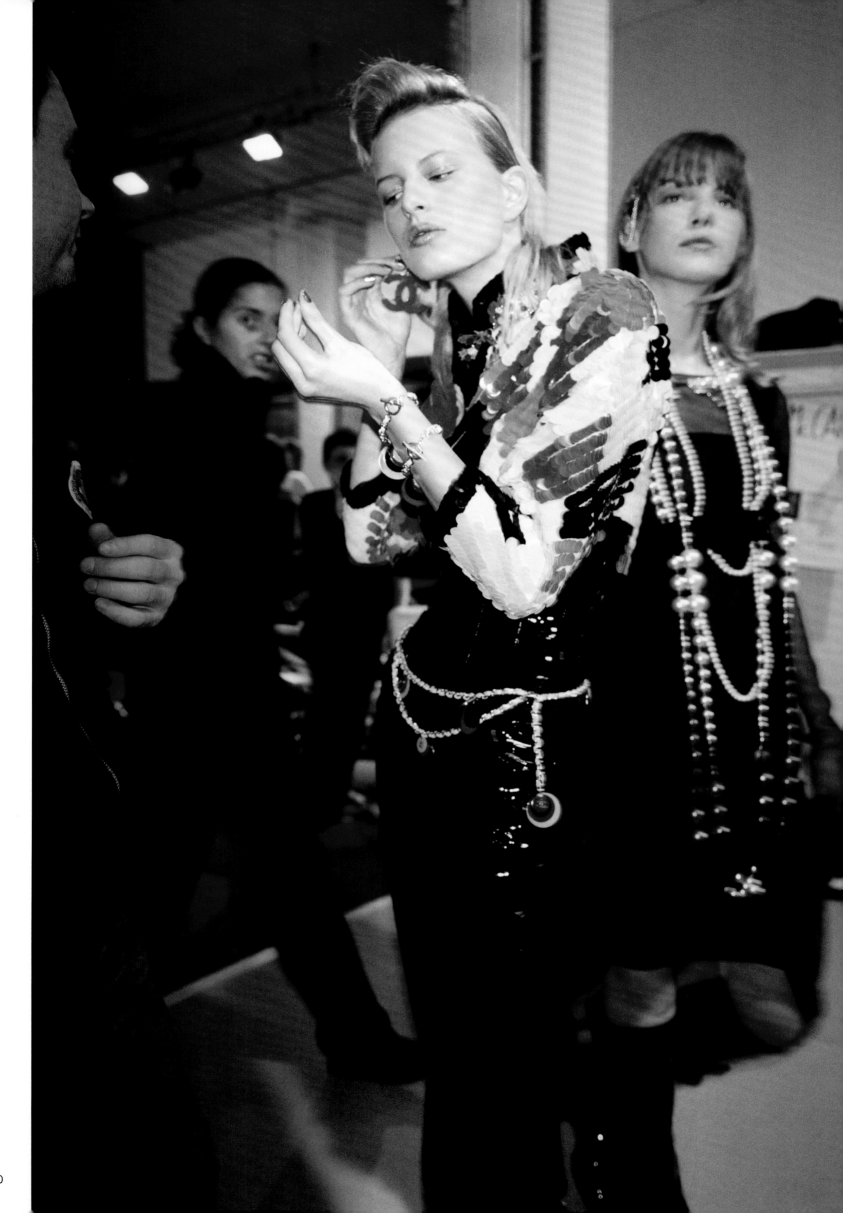

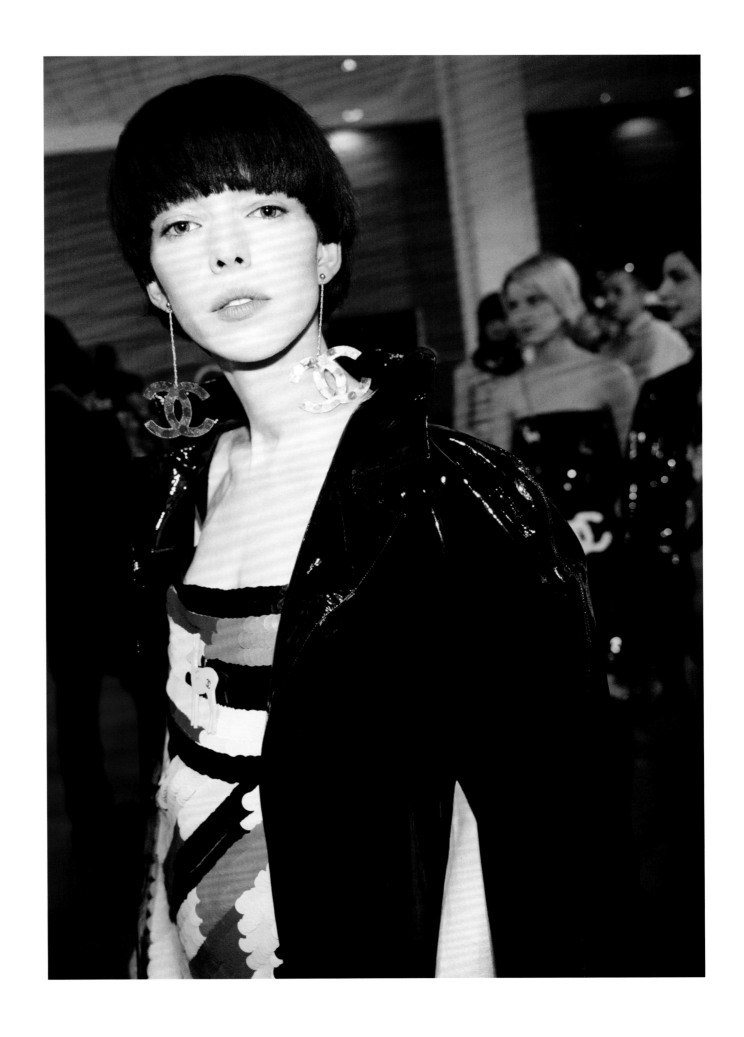

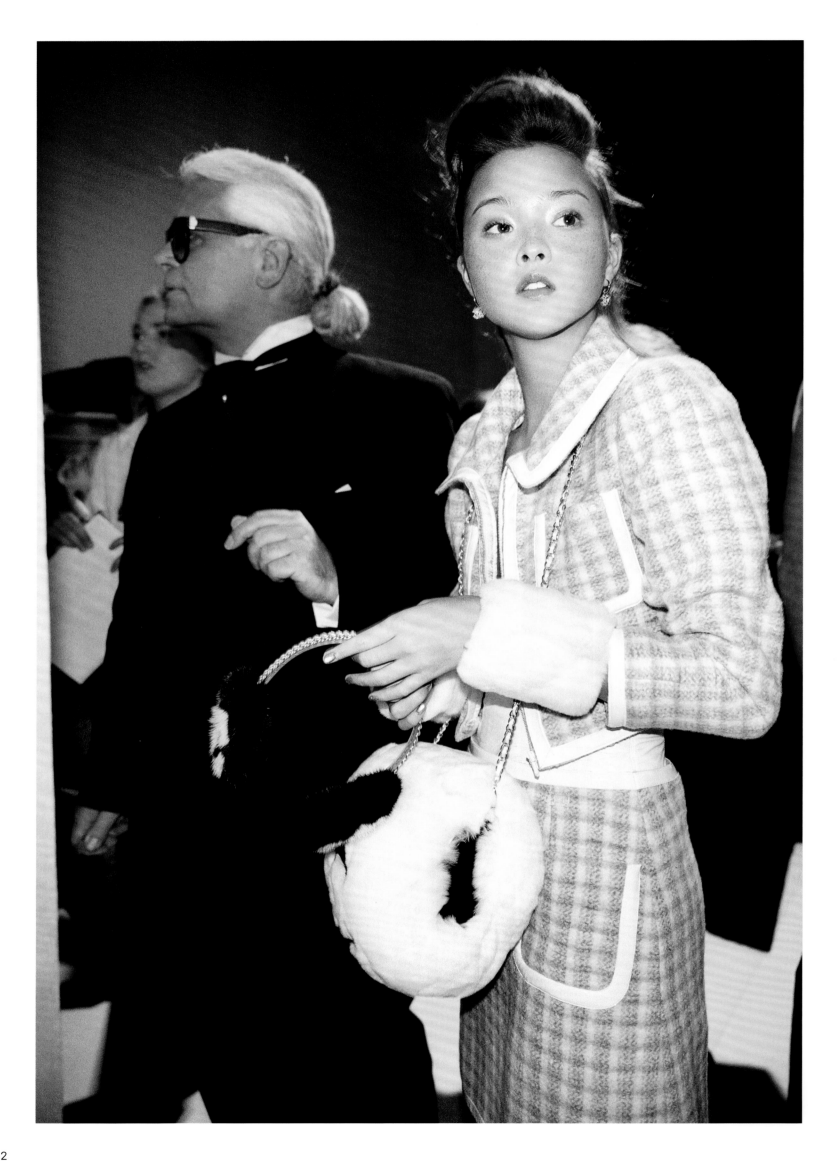

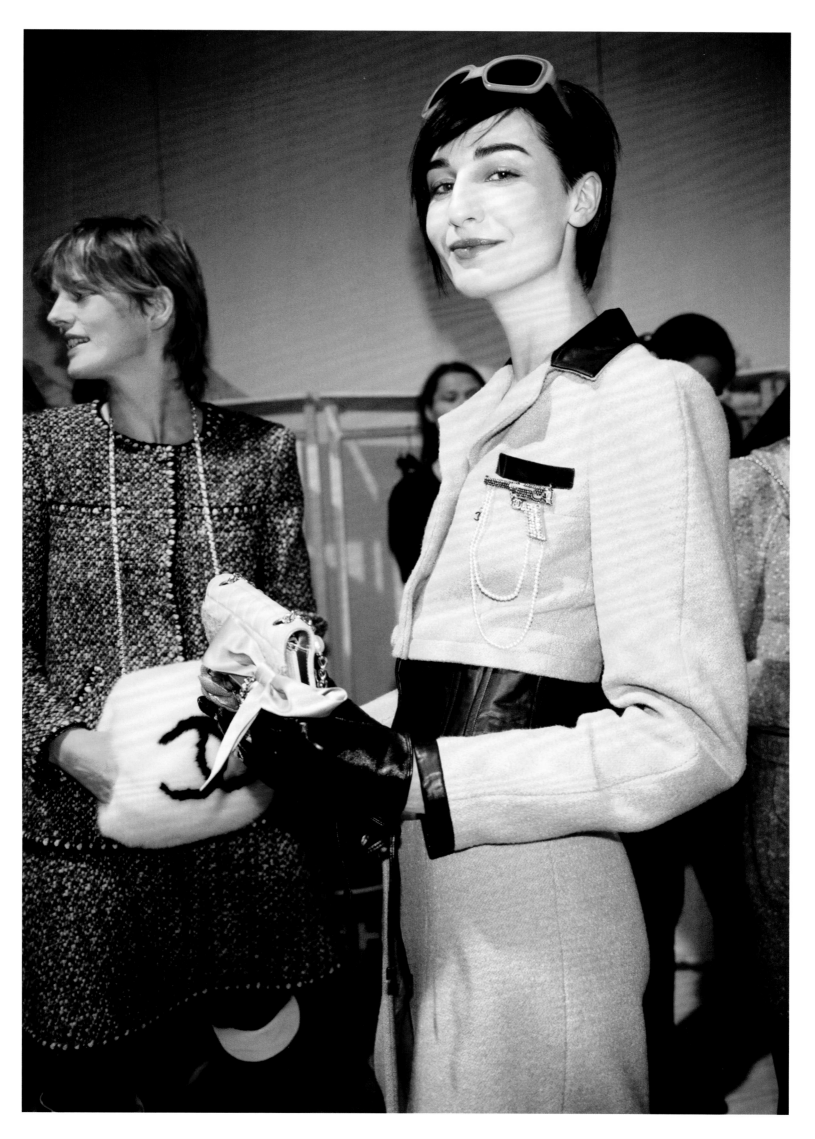

AUTUMN/WINTER 2001–2002 READY-TO-WEAR

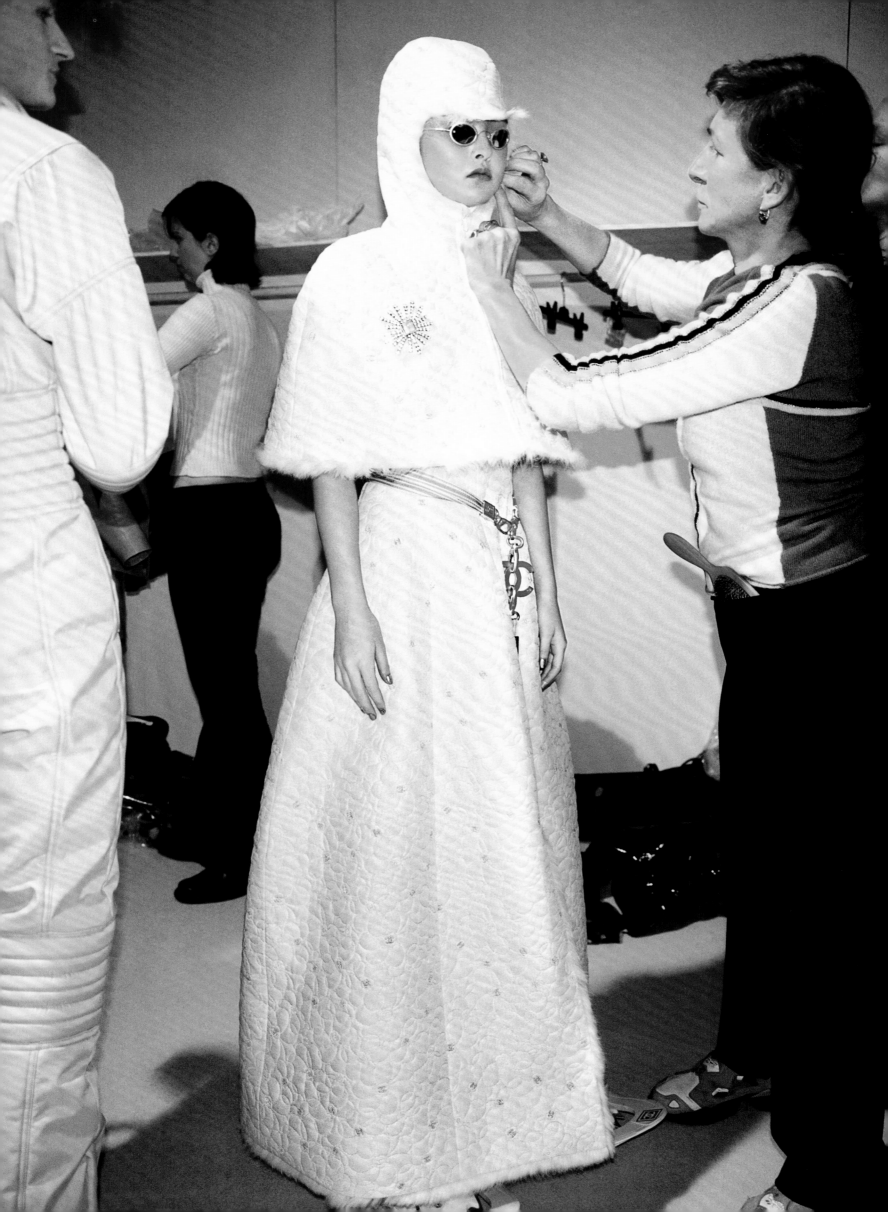

SPRING/SUMMER 2002
READY-TO-WEAR

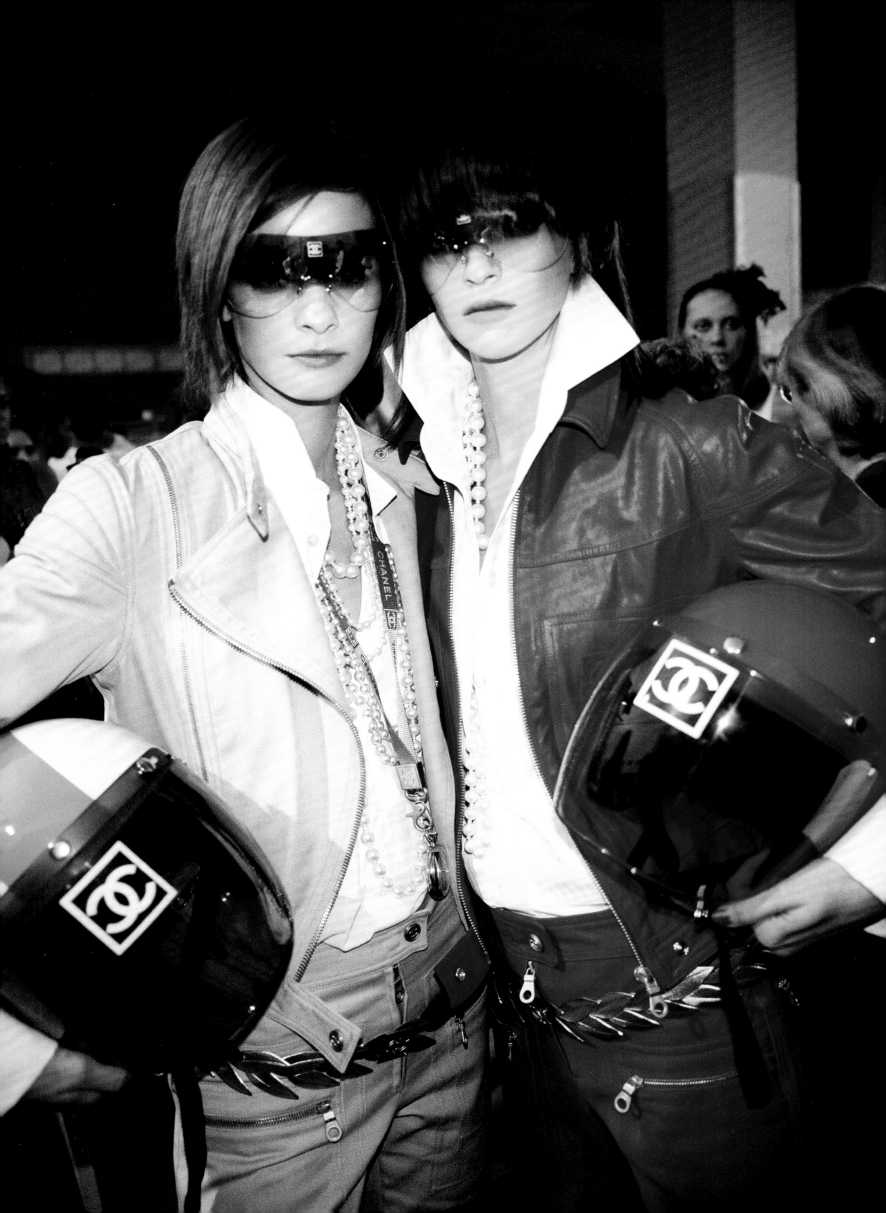

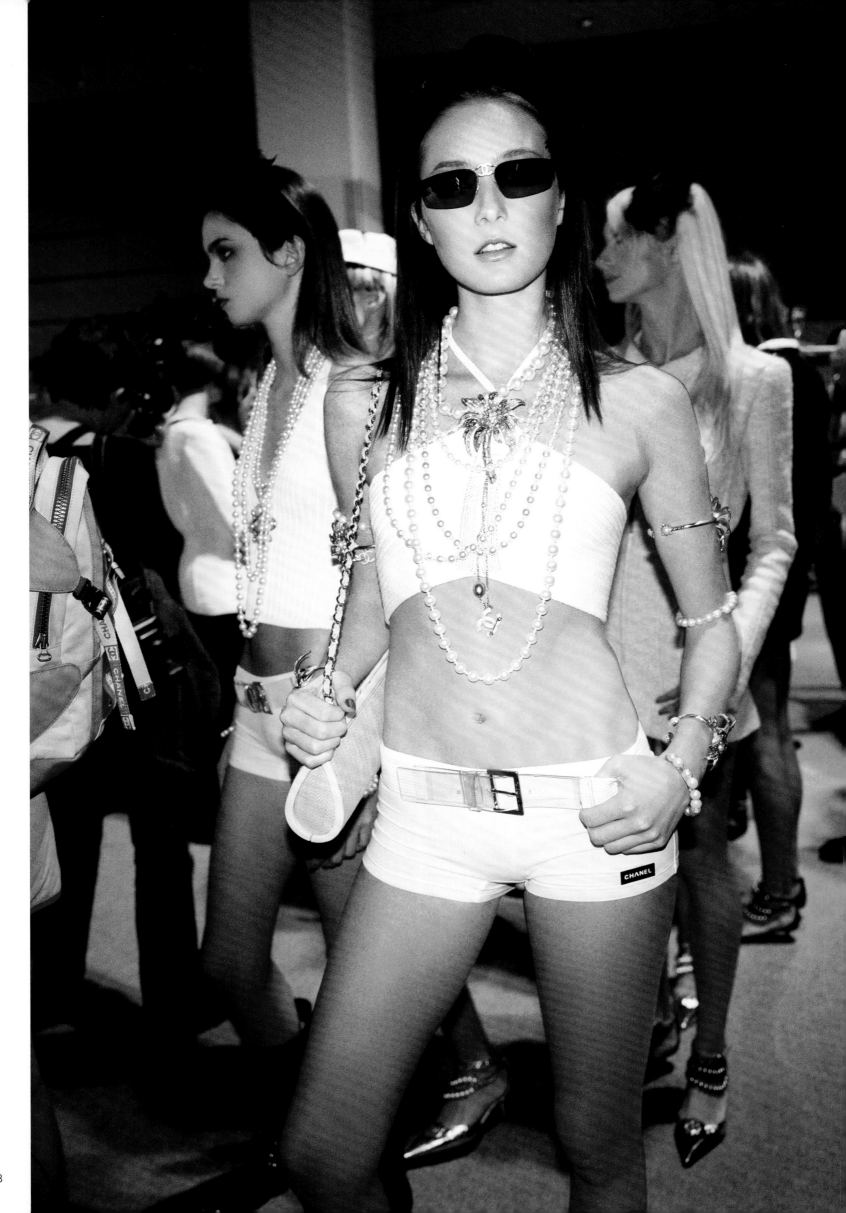

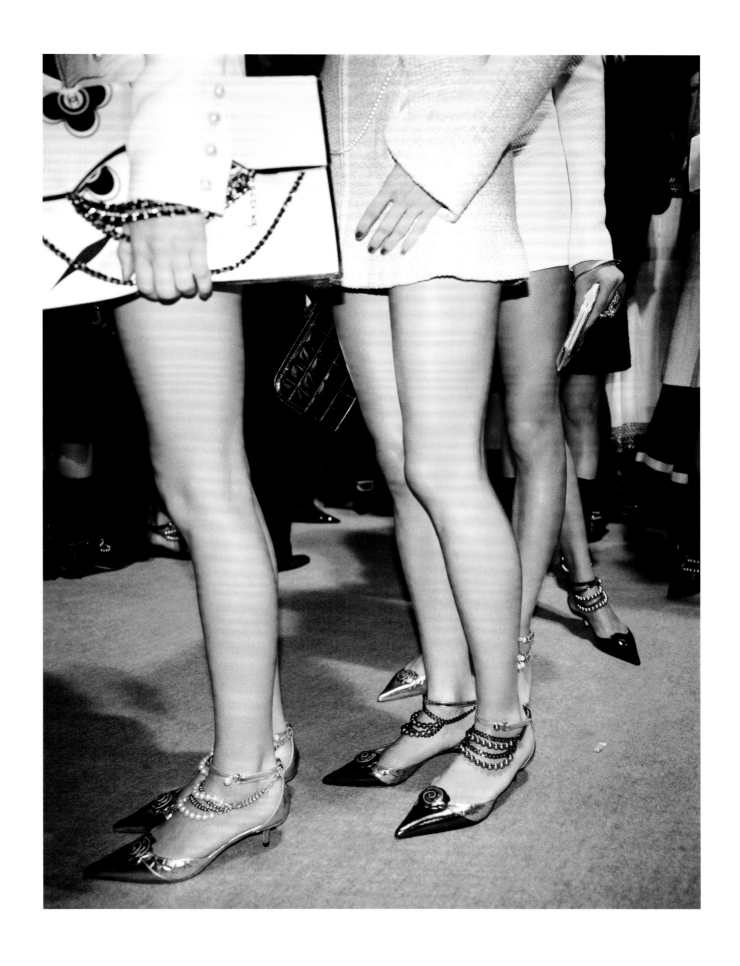

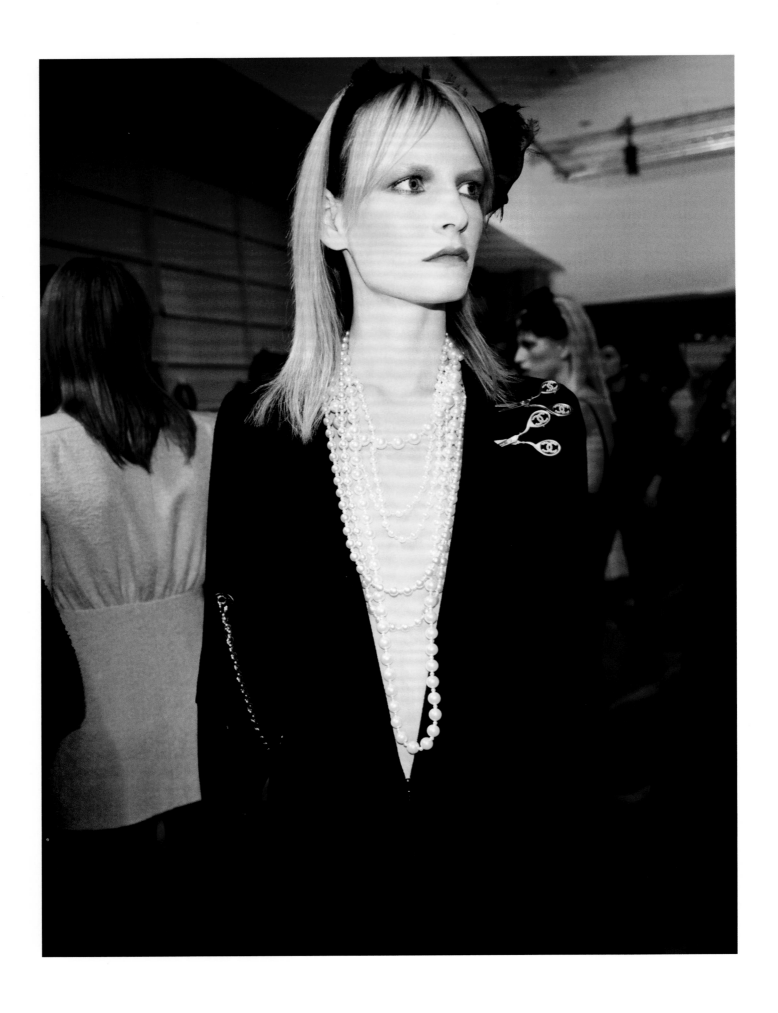

SPRING/SUMMER 2002 READY-TO-WEAR

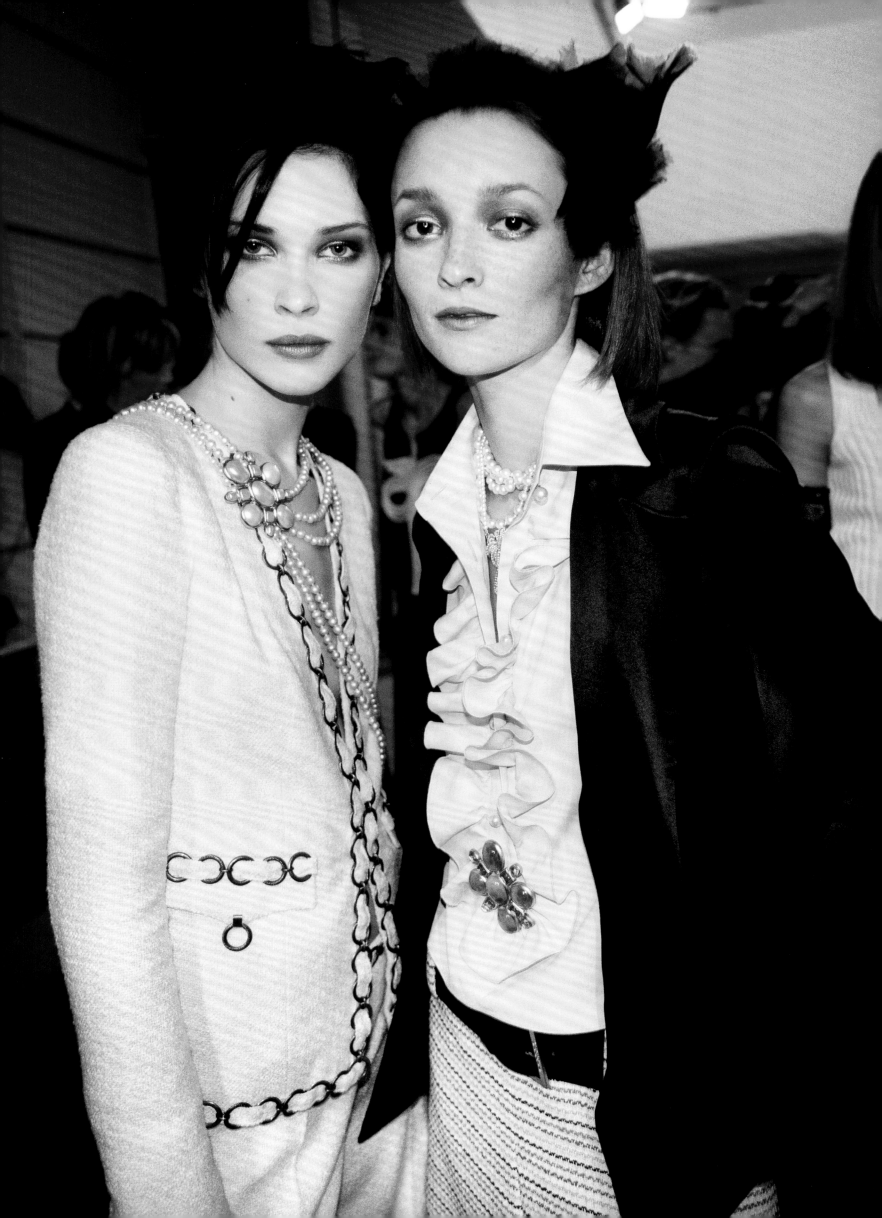

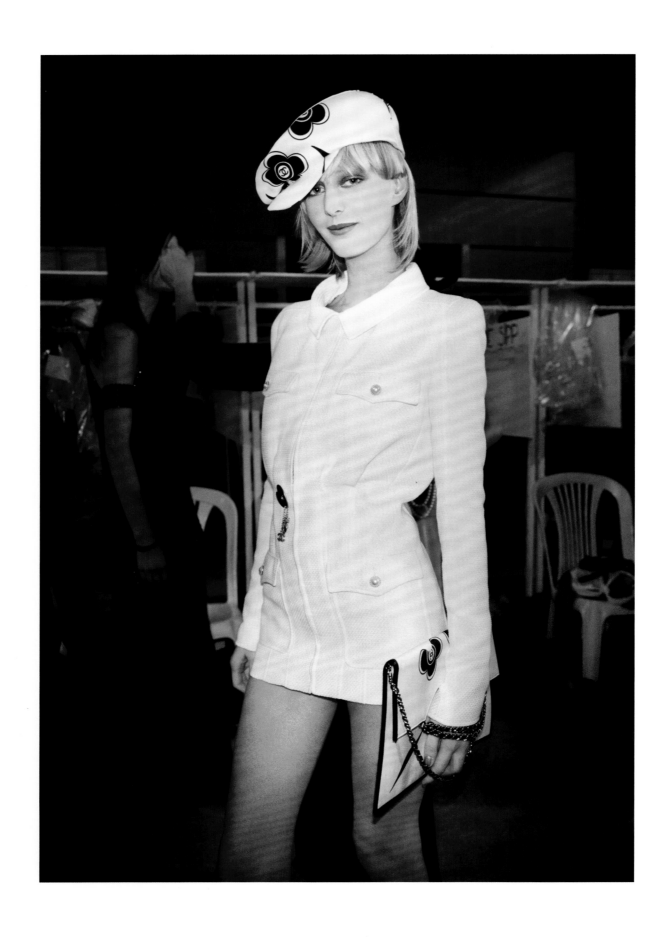

SPRING/SUMMER 2002 READY-TO-WEAR

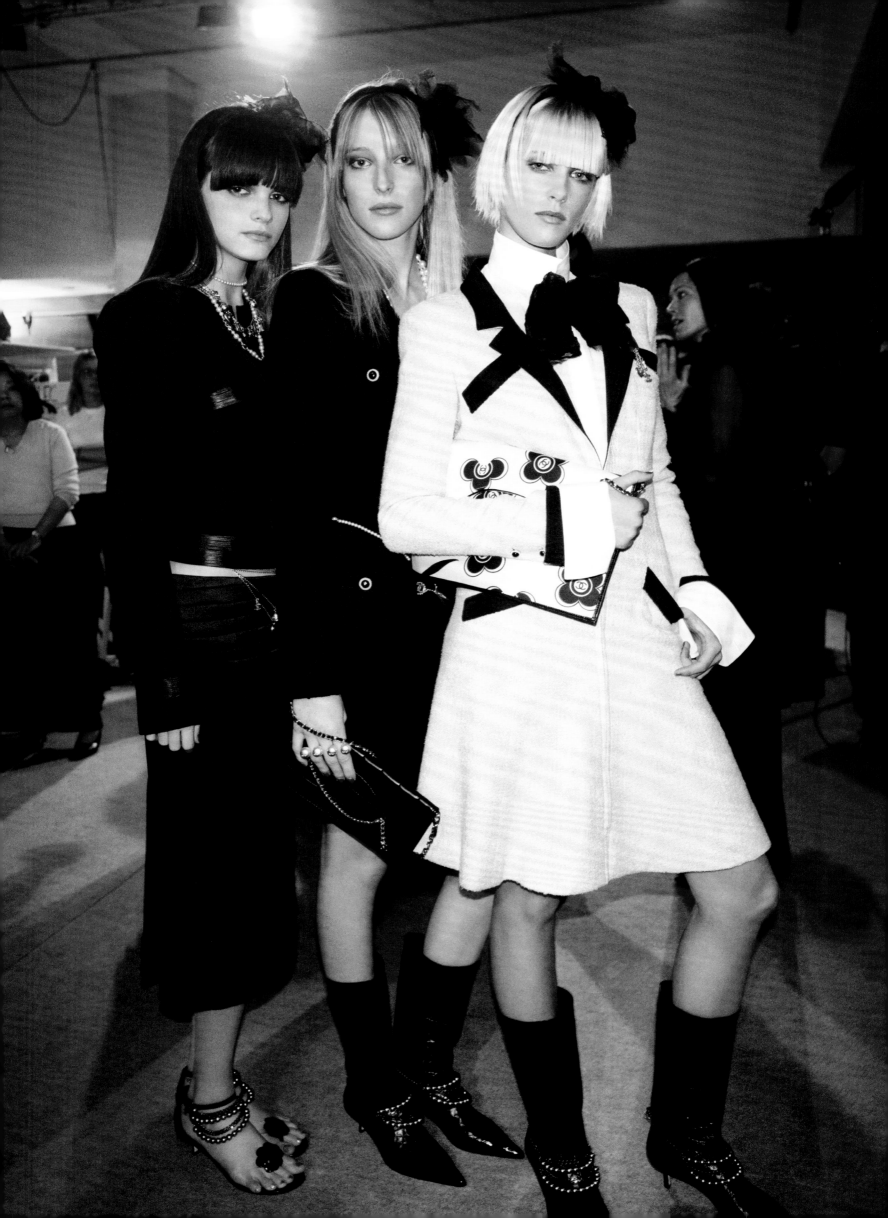

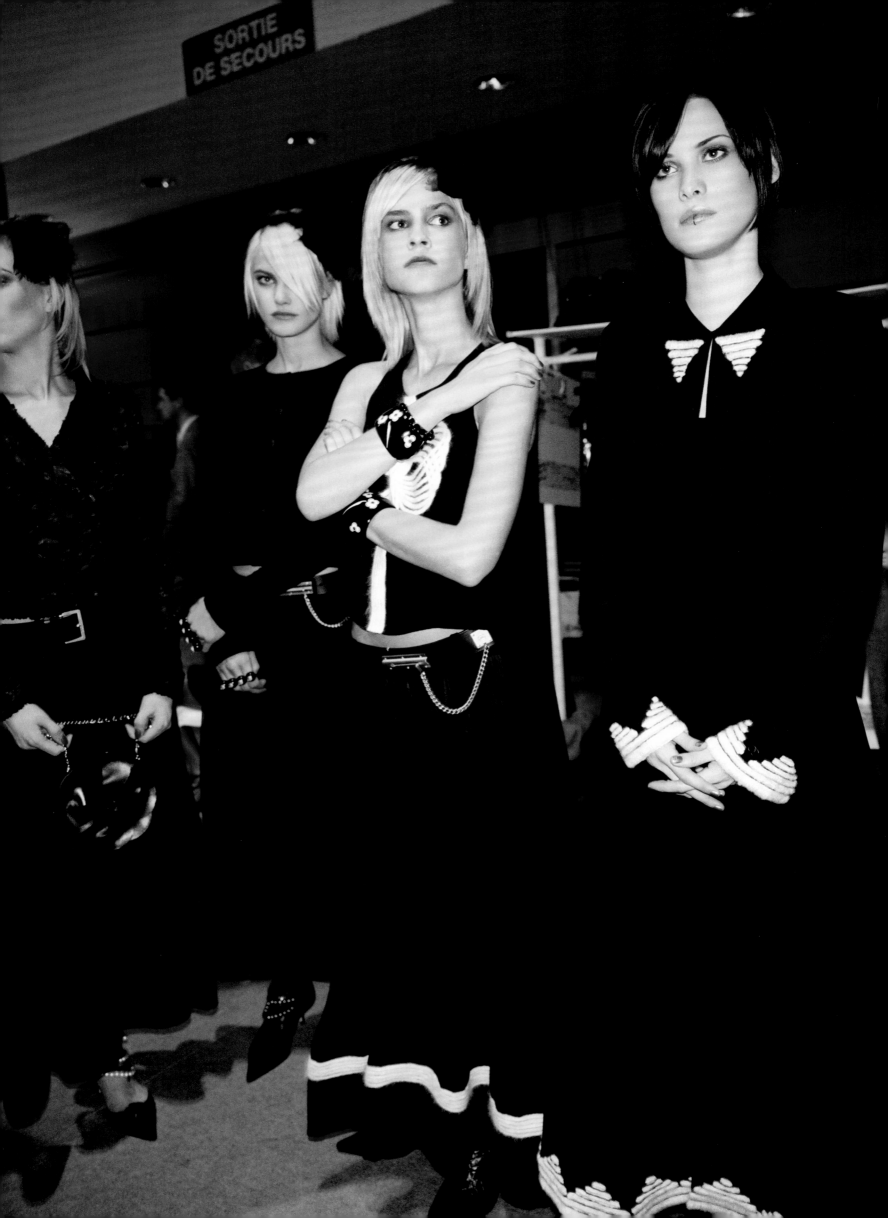

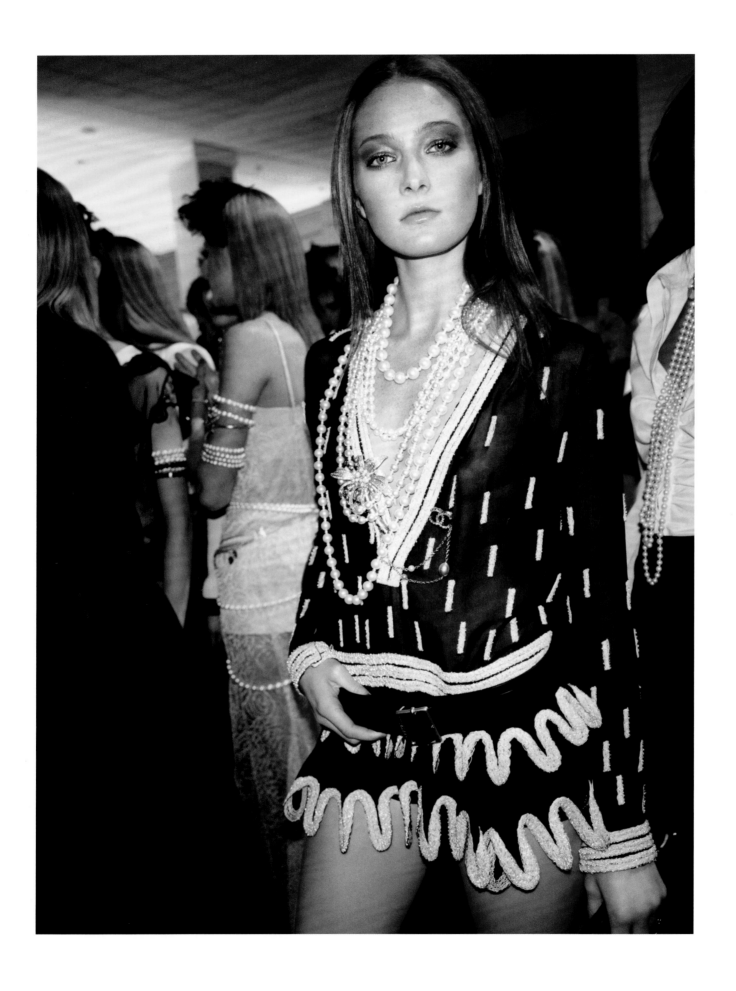

SPRING/SUMMER 2002 READY-TO-WEAR

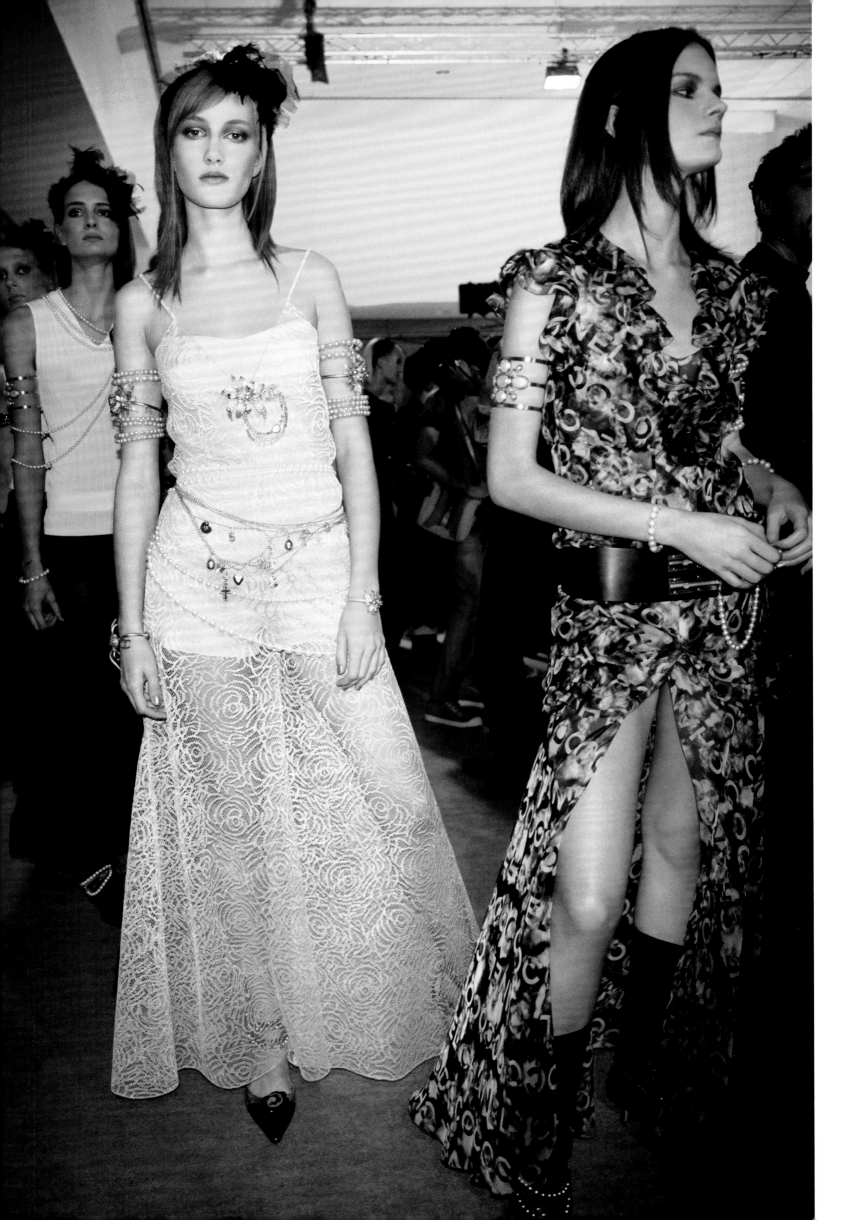

SPRING/SUMMER 2002
HAUTE COUTURE

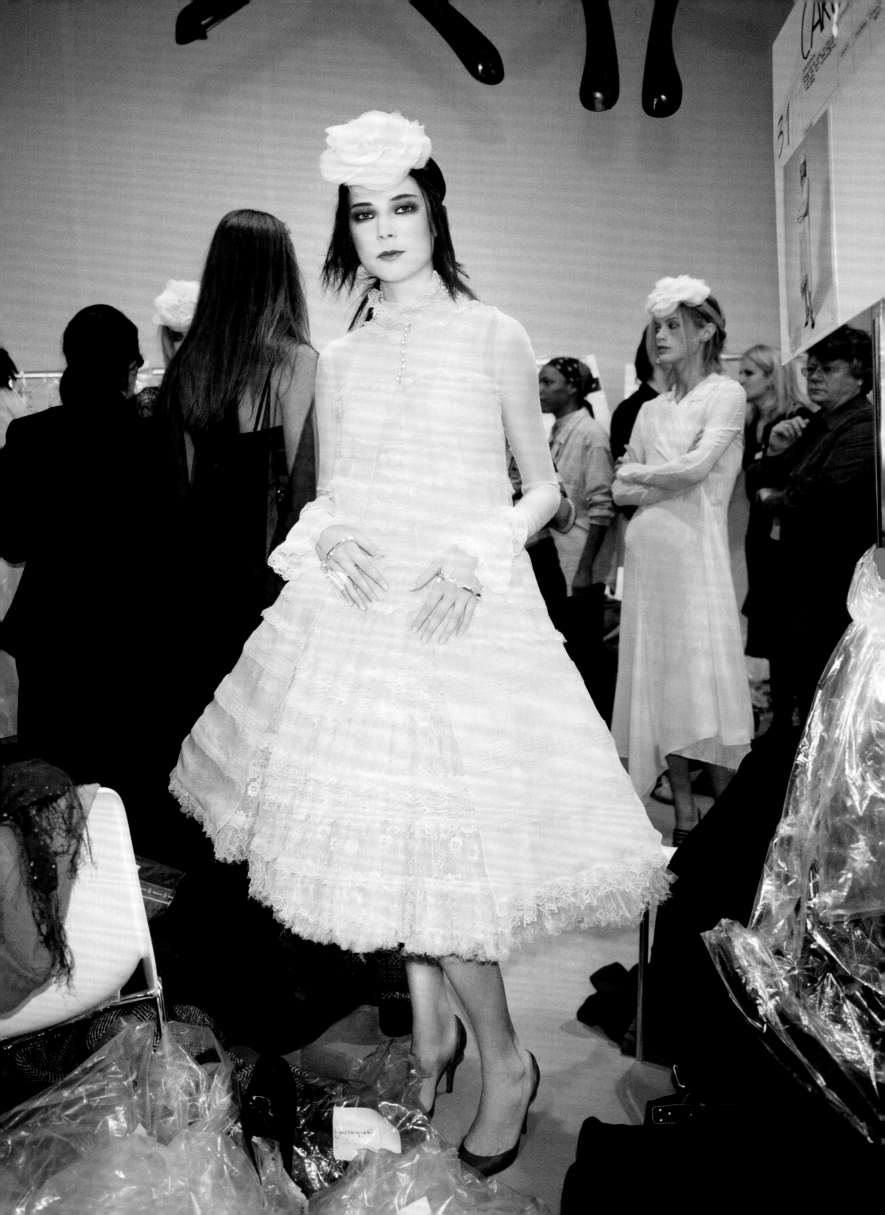

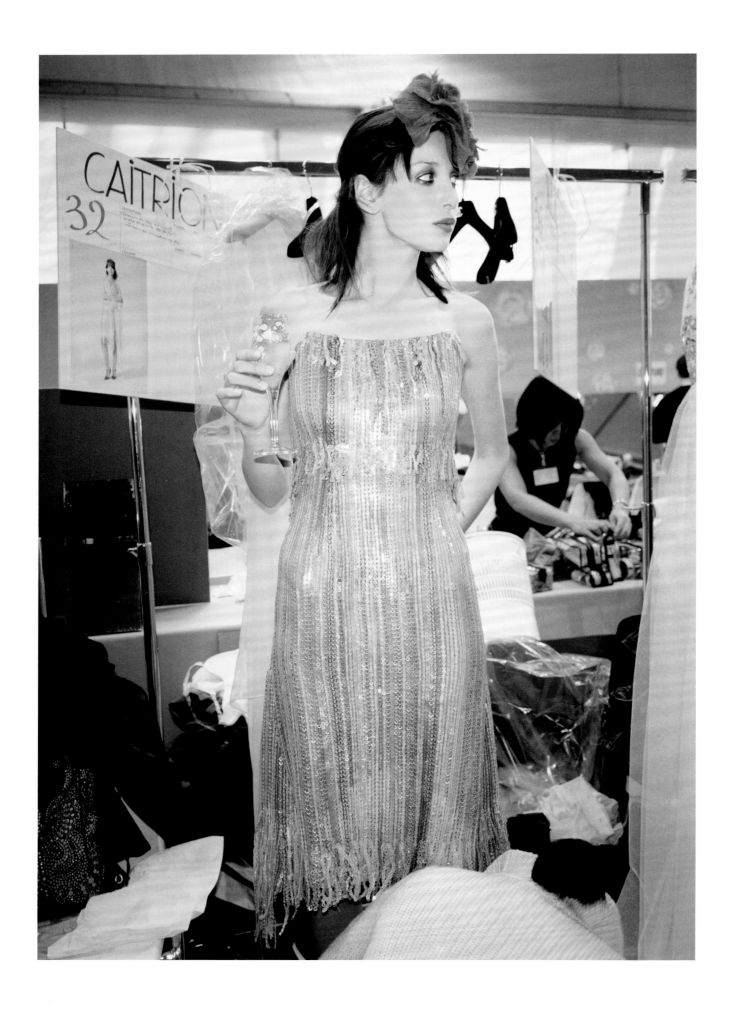

SPRING/SUMMER 2002 HAUTE COUTURE

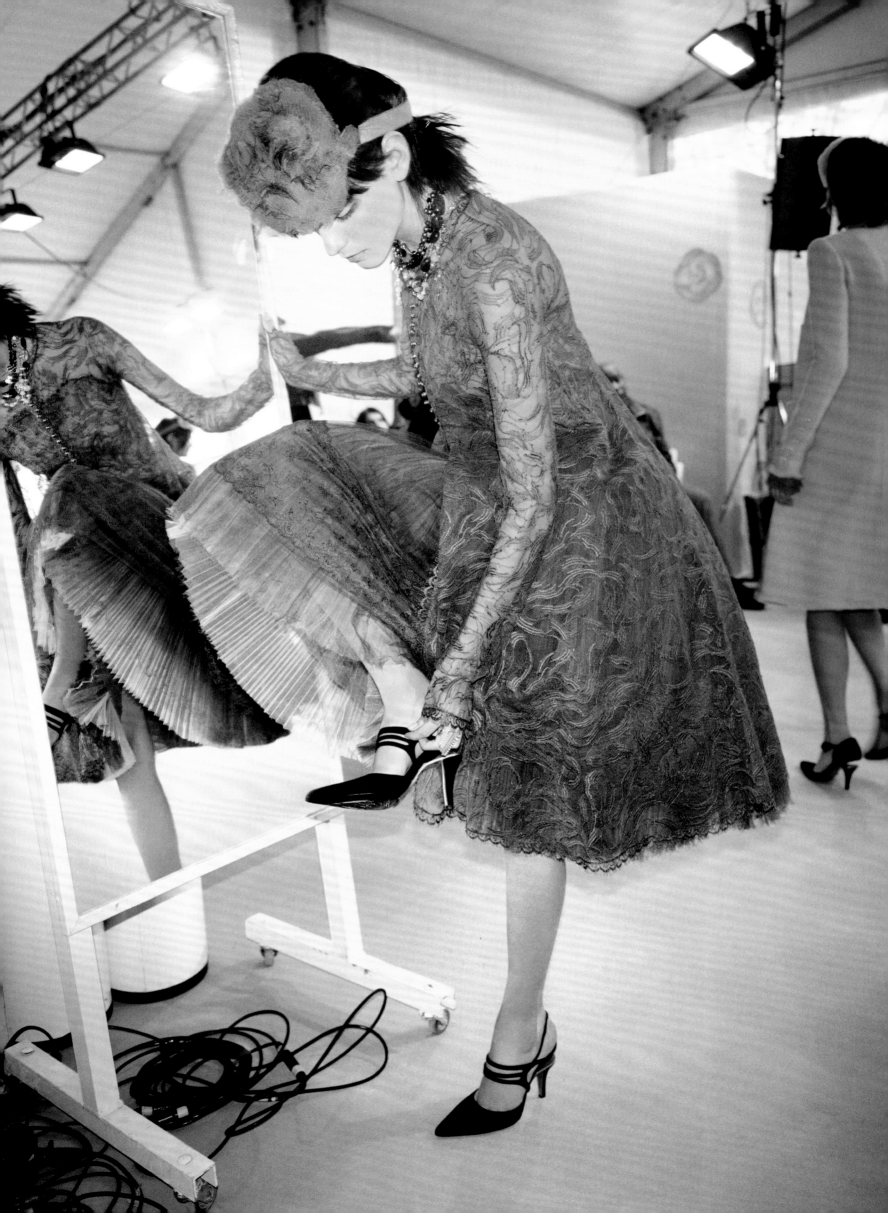

'I know Chanel's DNA thoroughly,
and it's strong enough not
to have to talk about it'

Karl Lagerfeld

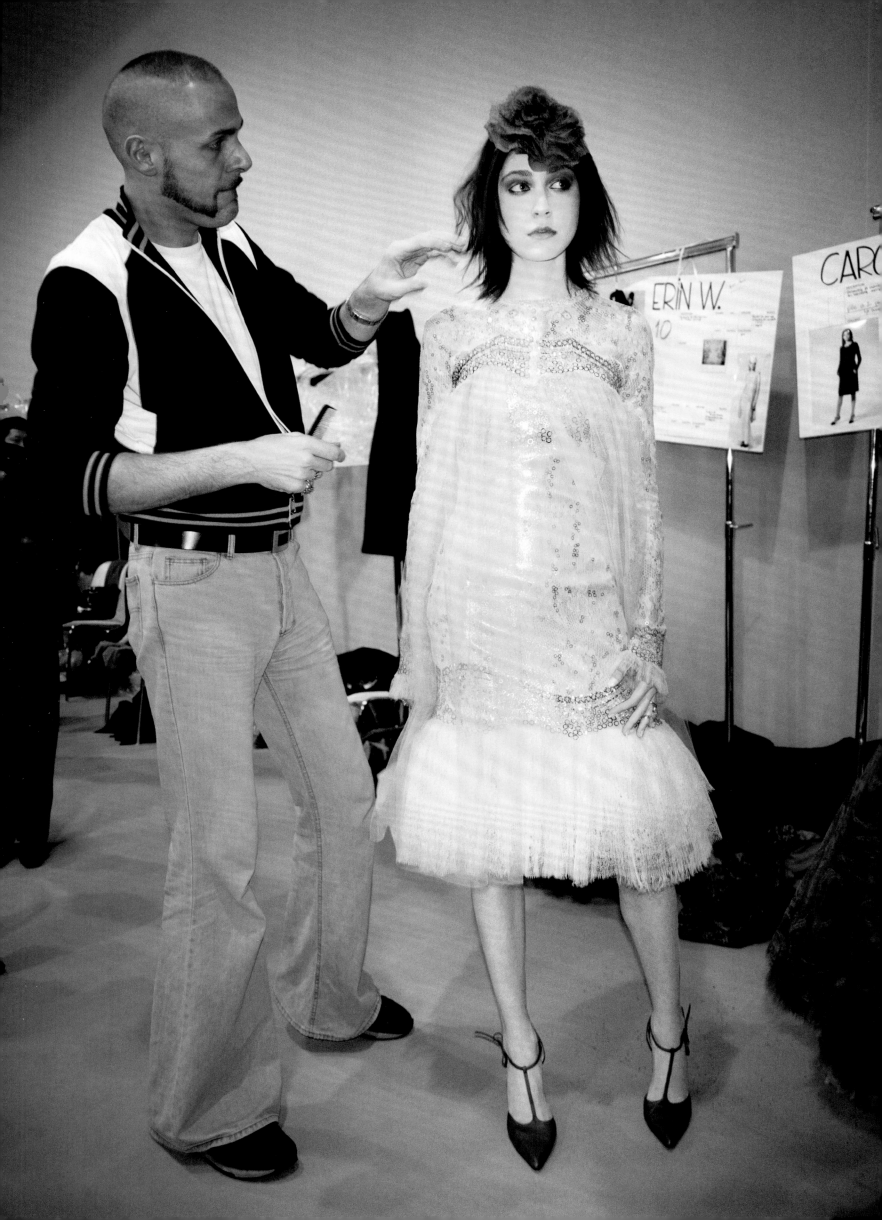

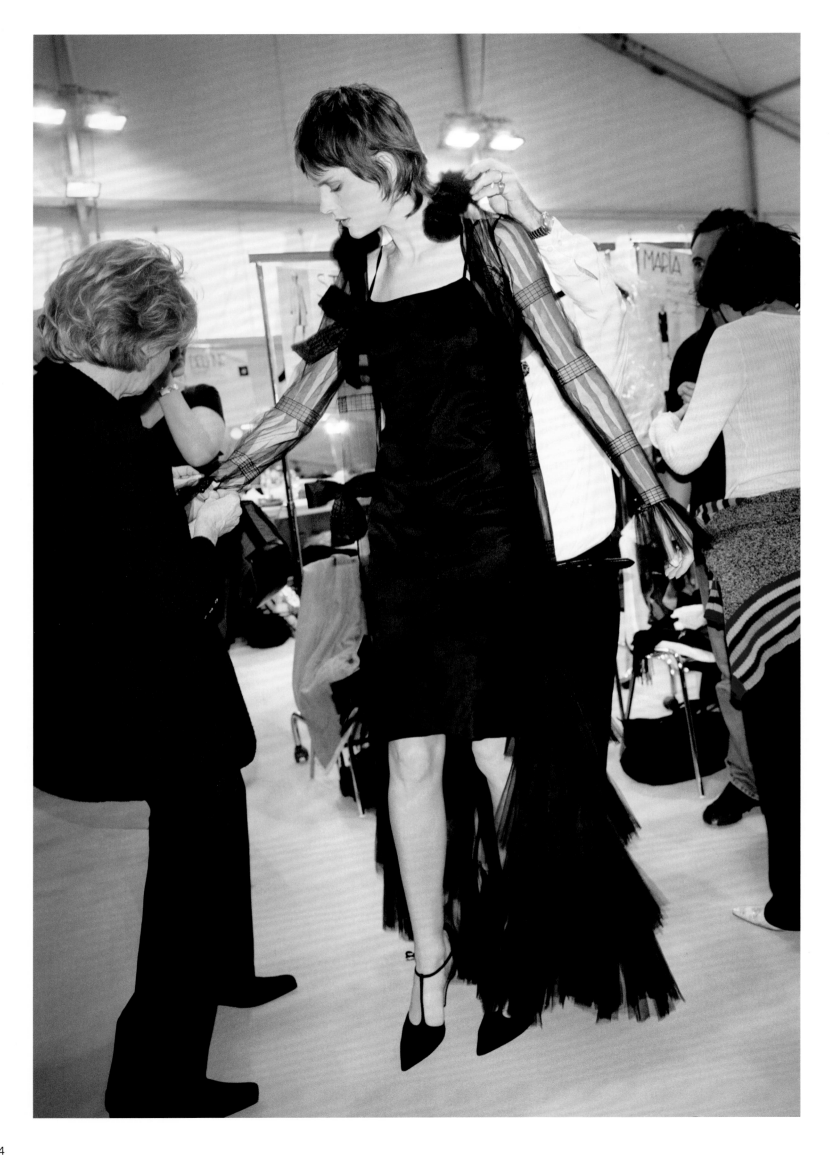

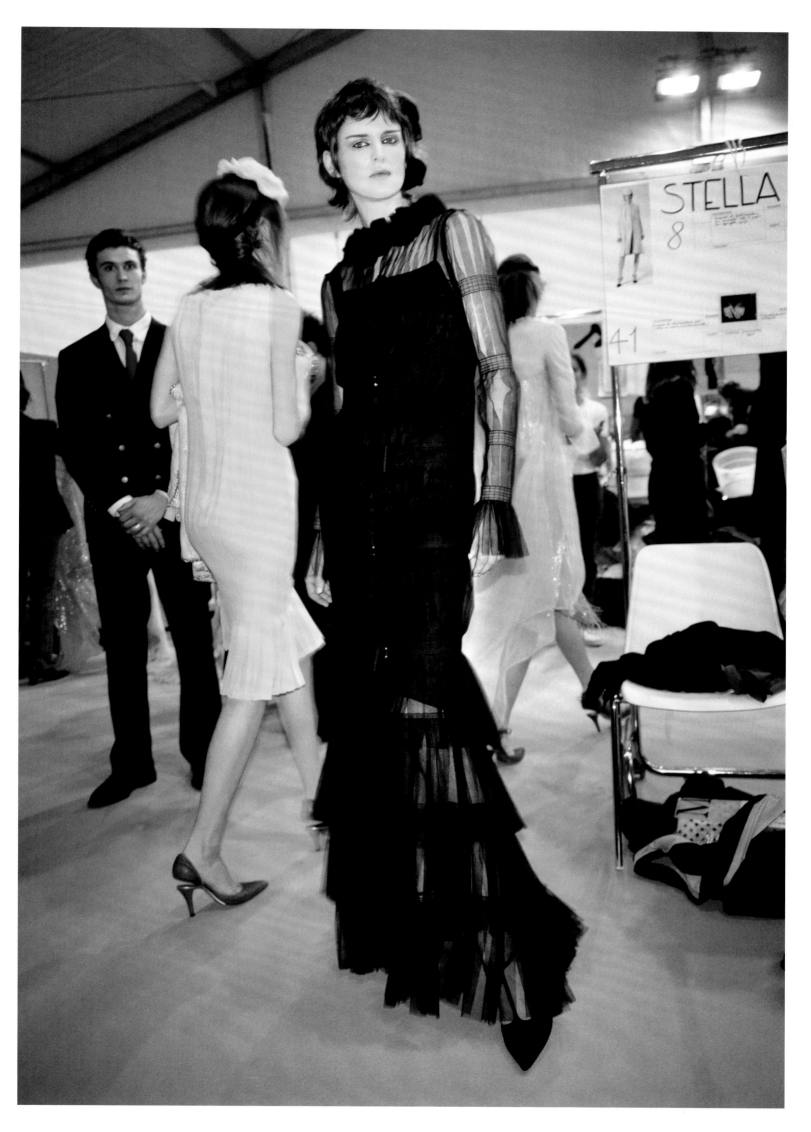

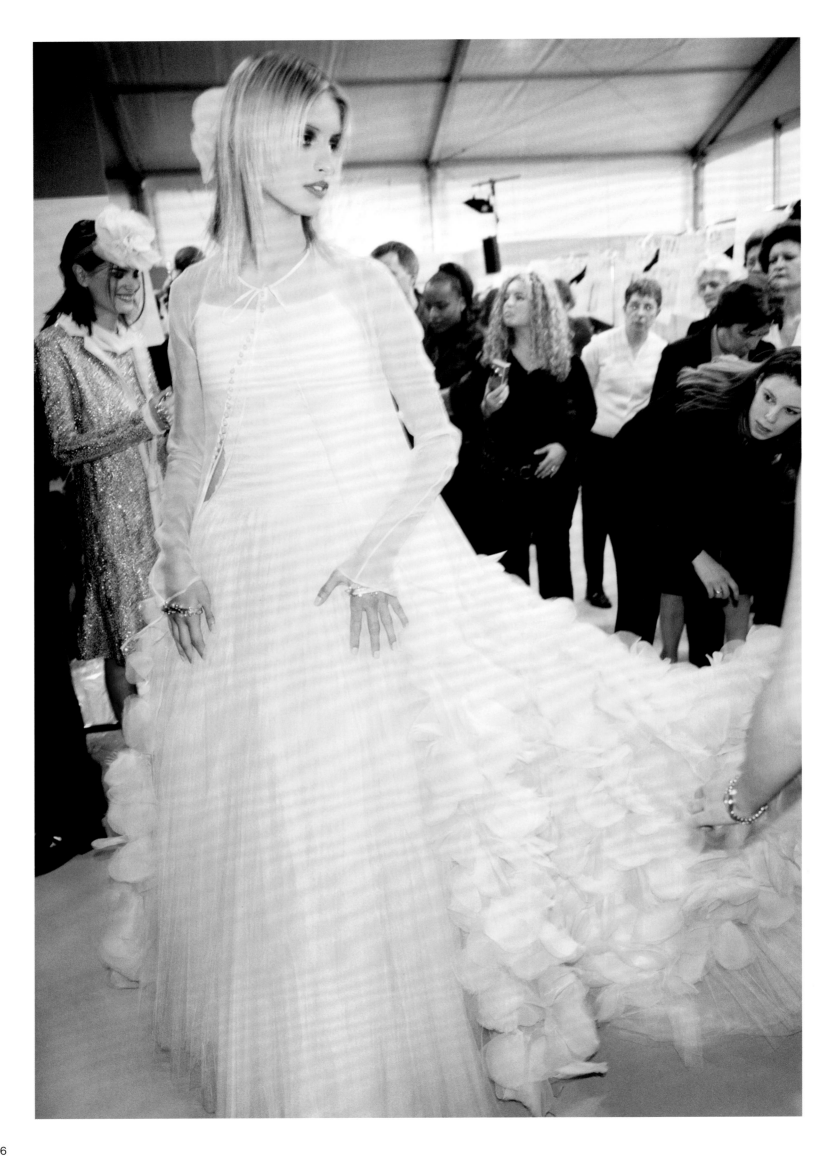

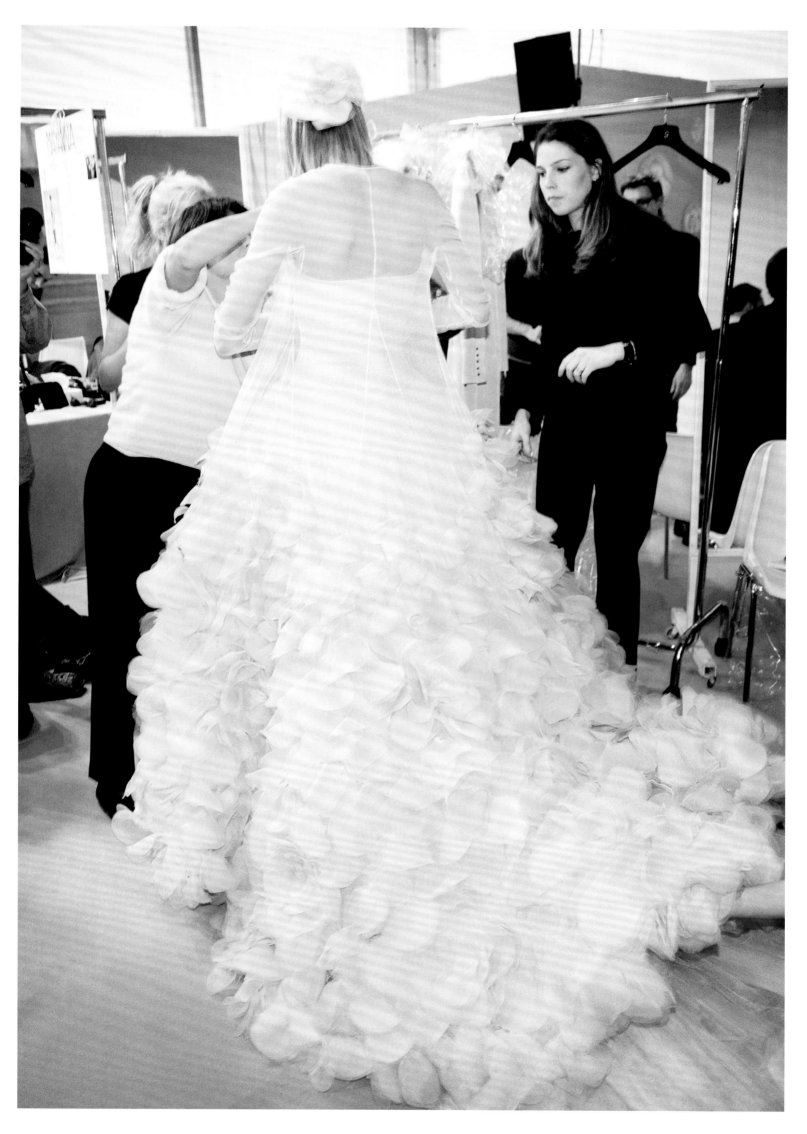

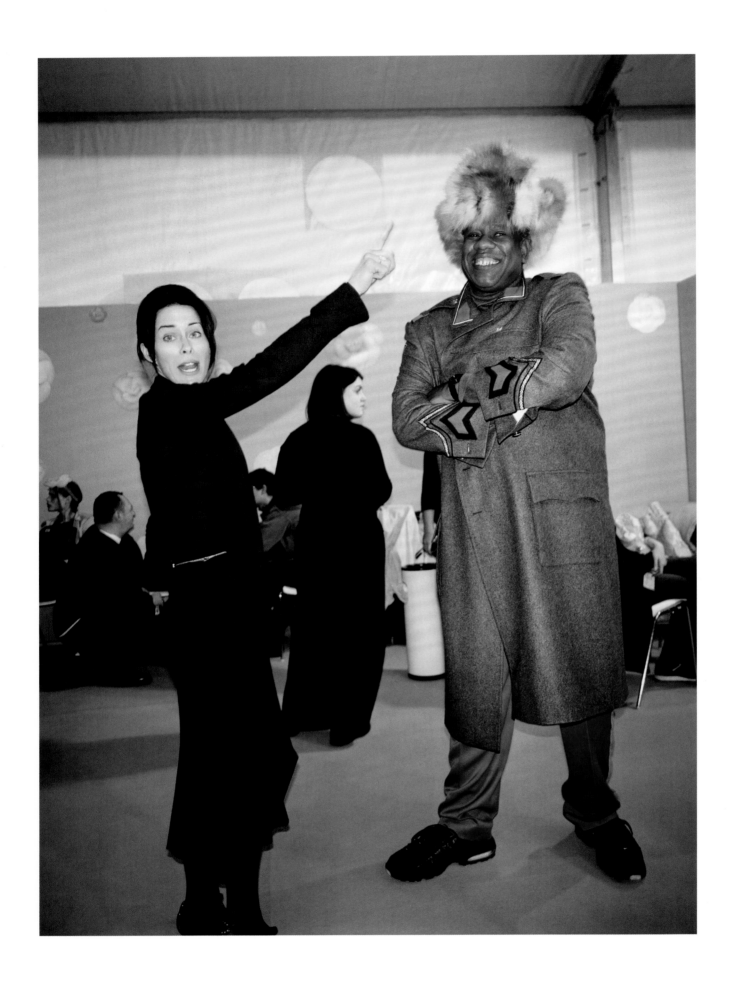

SPRING/SUMMER 2002 HAUTE COUTURE

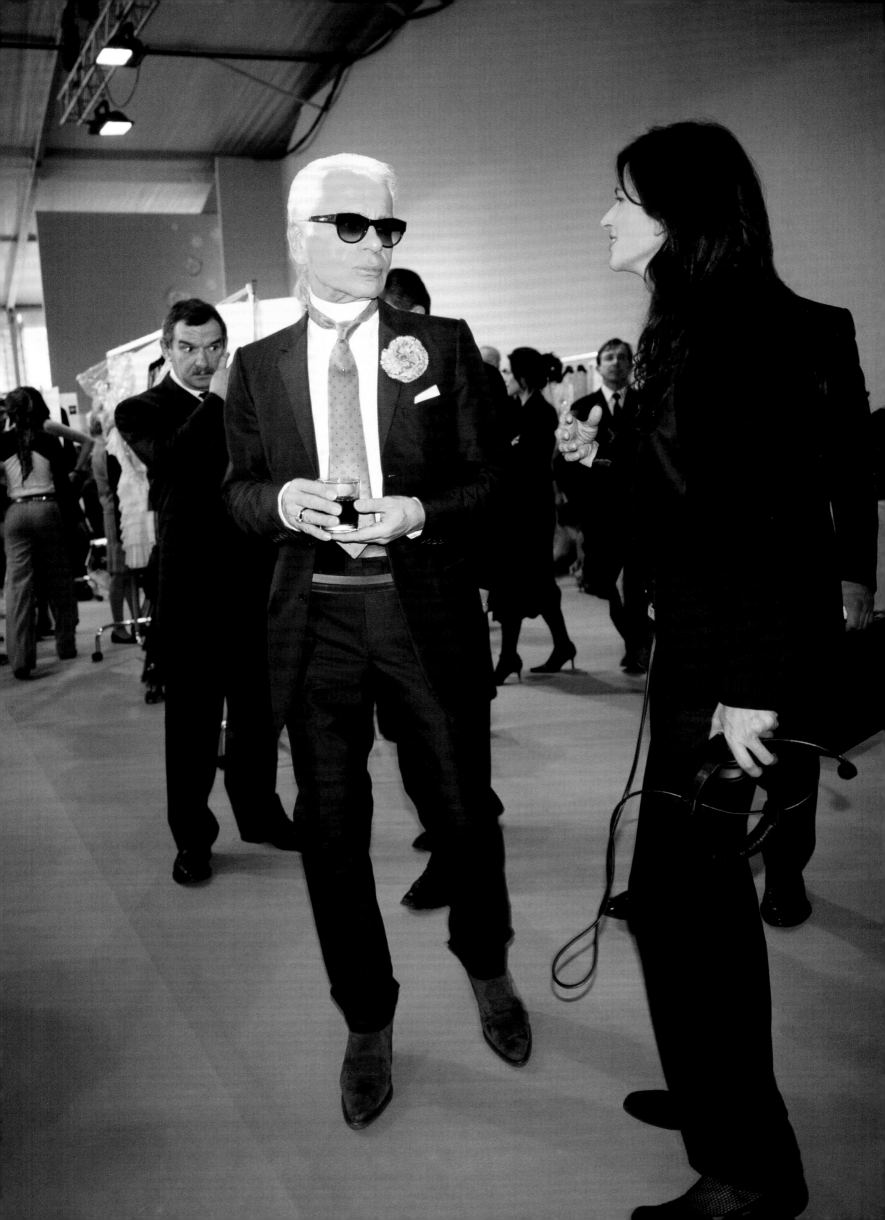

AUTUMN/WINTER 2002–2003
HAUTE COUTURE

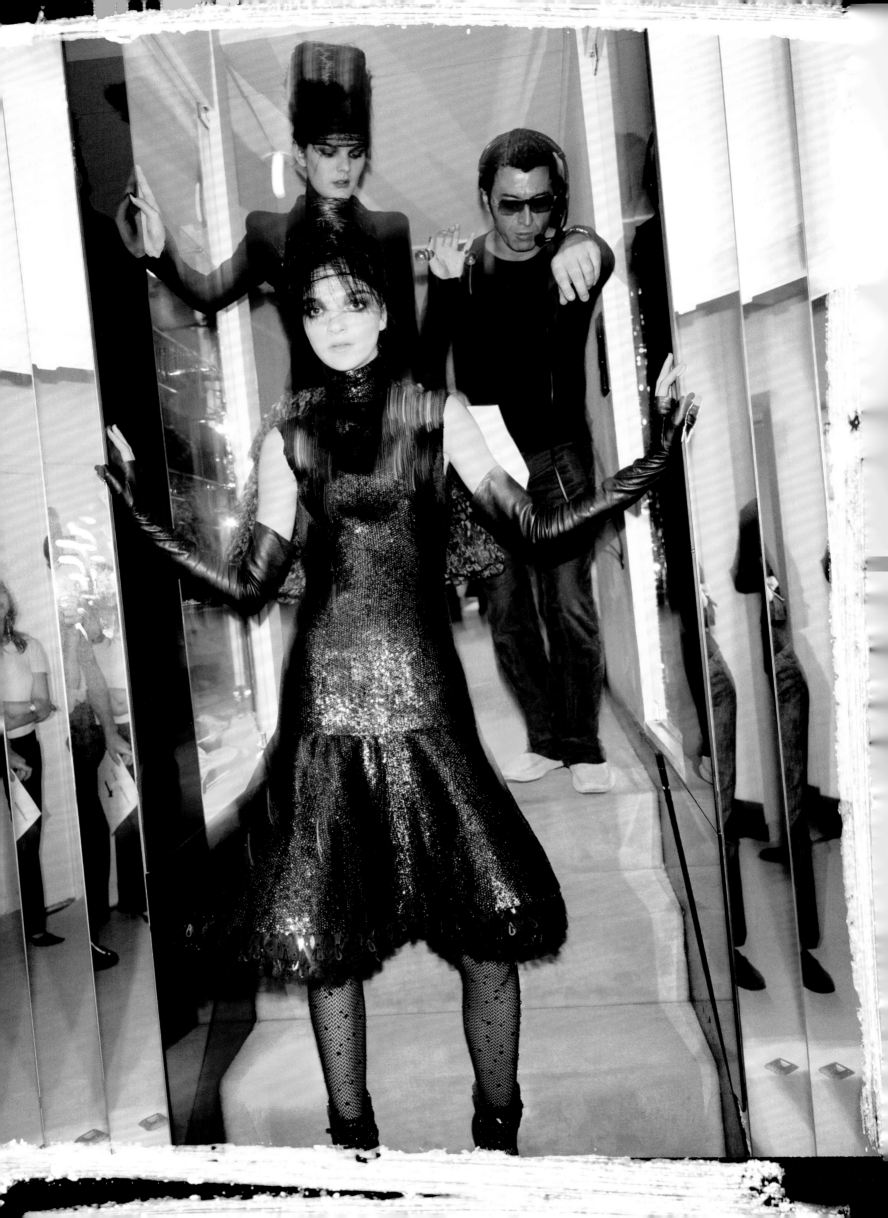

AUTUMN/WINTER 2002–2003 HAUTE COUTURE

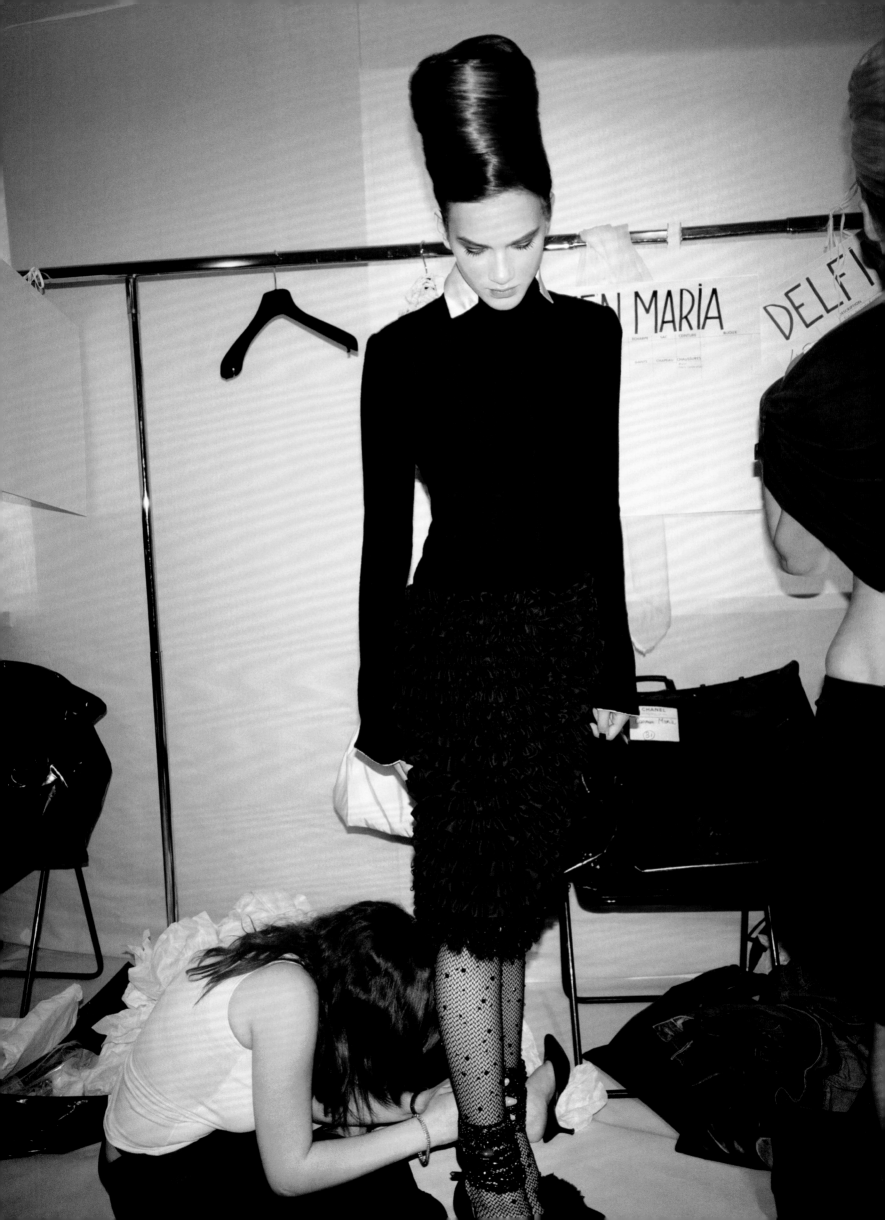

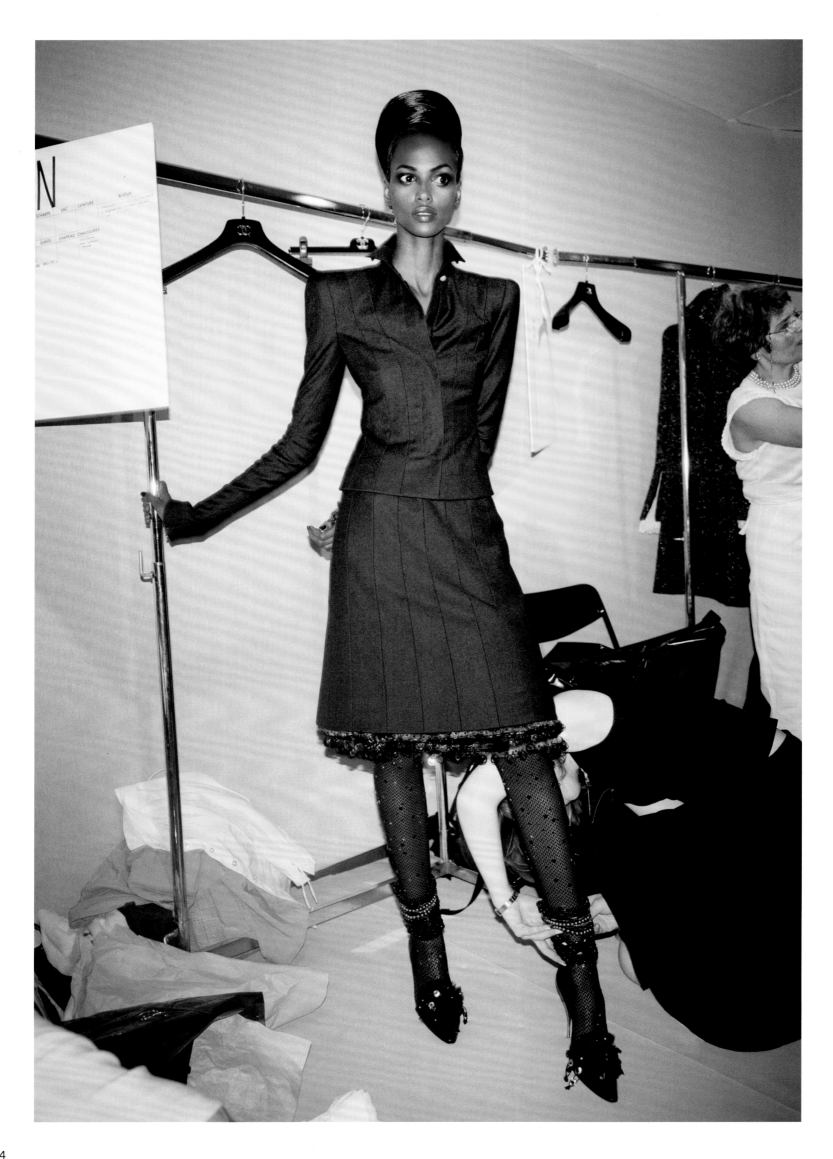

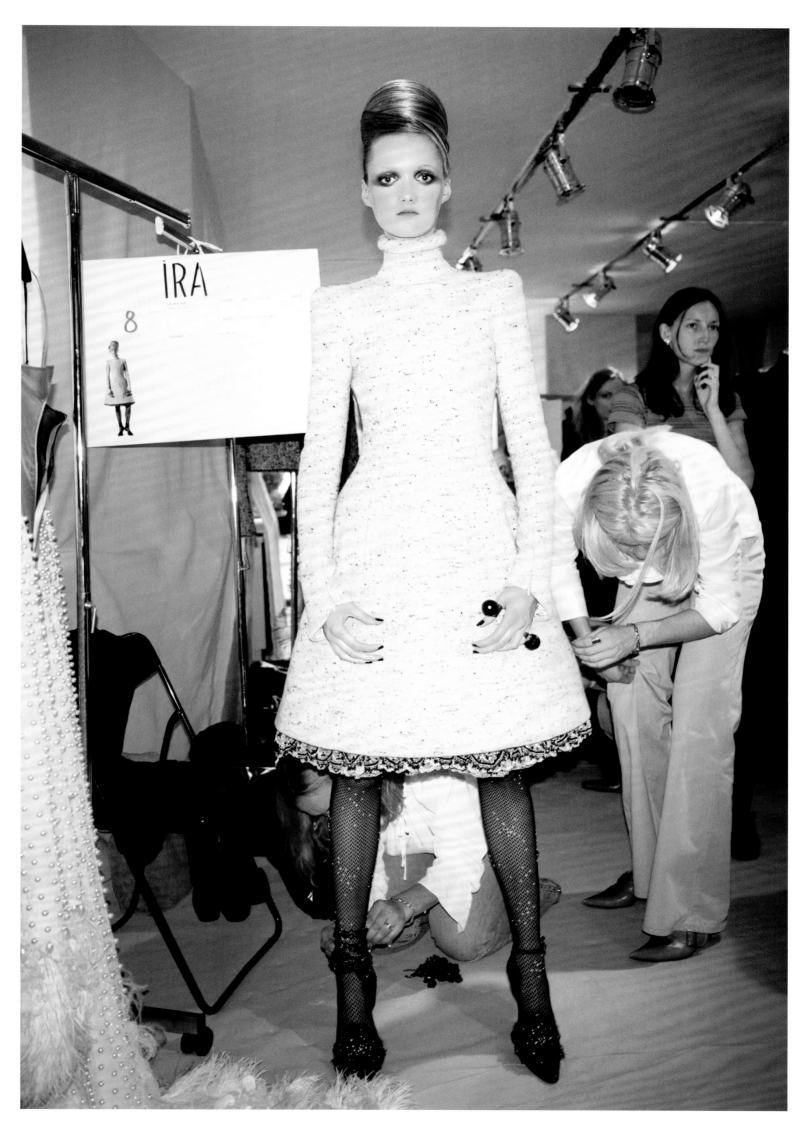

AUTUMN/WINTER 2002–2003 HAUTE COUTURE

SPRING/SUMMER 2003
READY-TO-WEAR

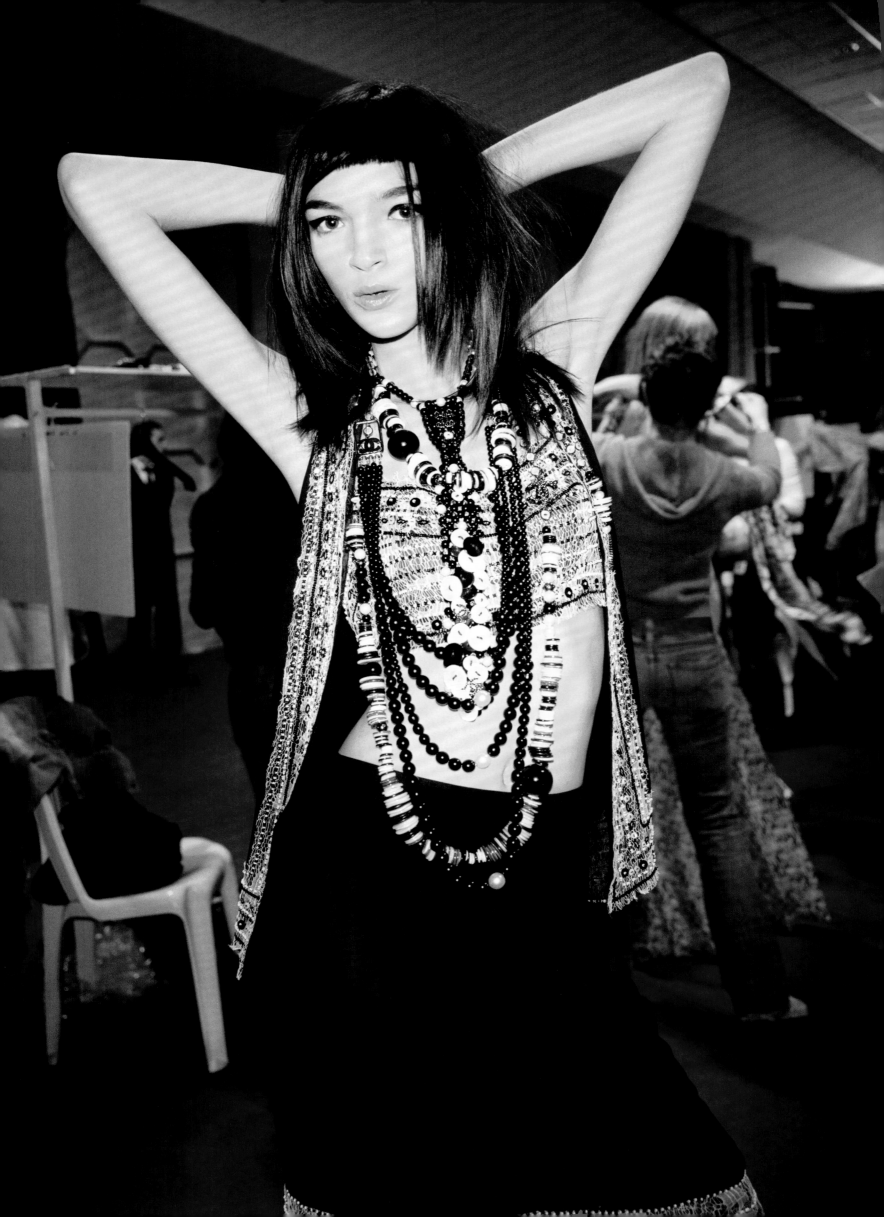

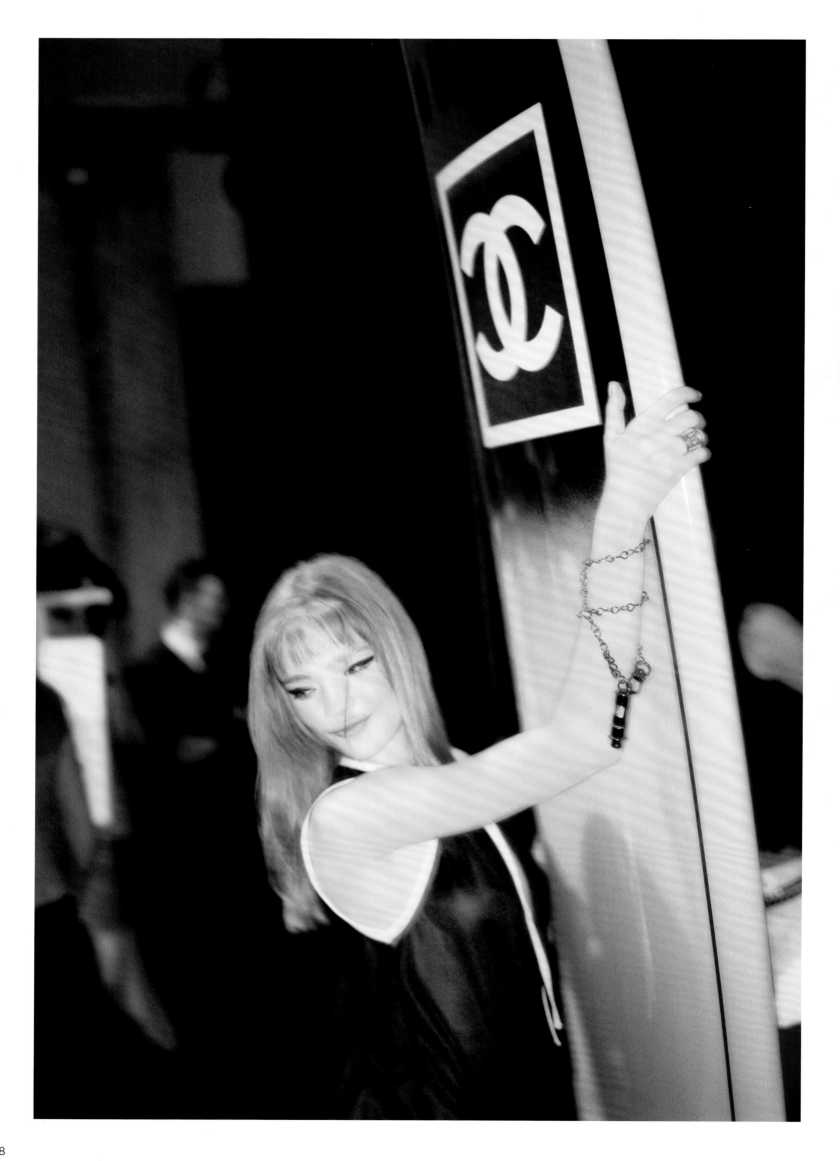

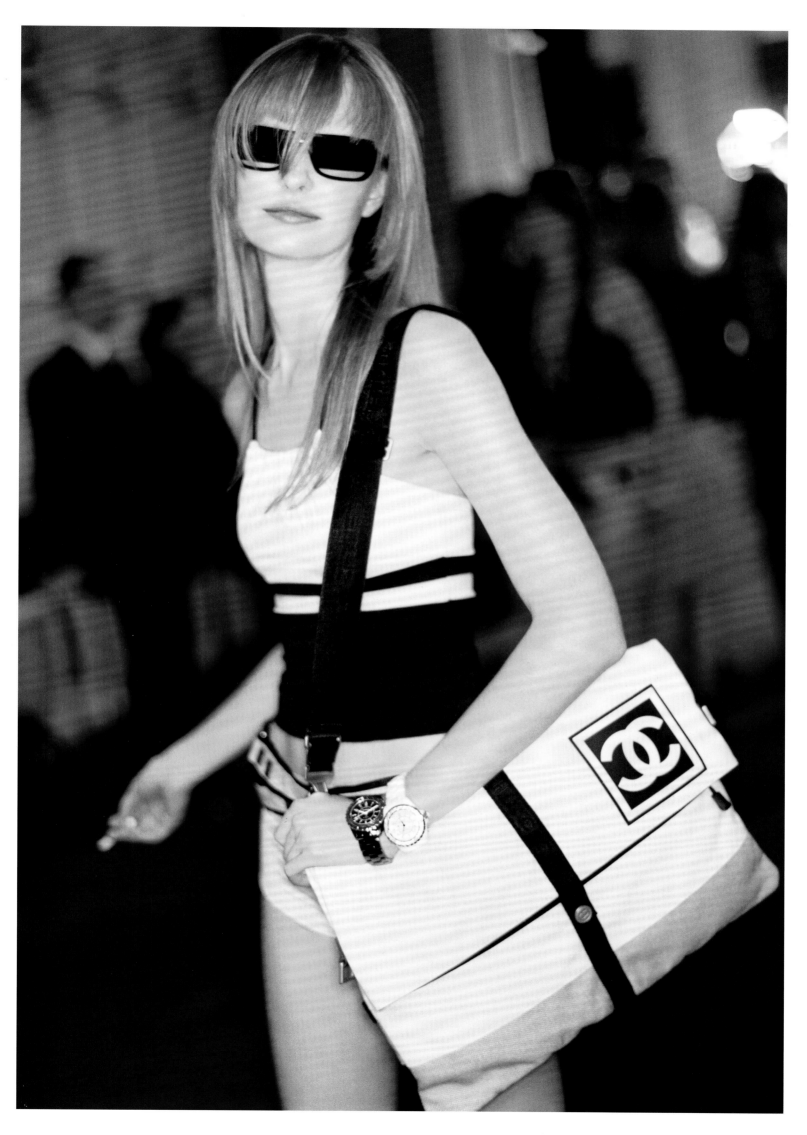

SPRING/SUMMER 2003 READY-TO-WEAR

'Chanel is a look that can be adapted
to every era, to every age range.
It's the elements of a wardrobe,
like jeans, the T-shirt, the white shirt.
The Chanel jacket is like the
two-button suit for a man.'

Karl Lagerfeld

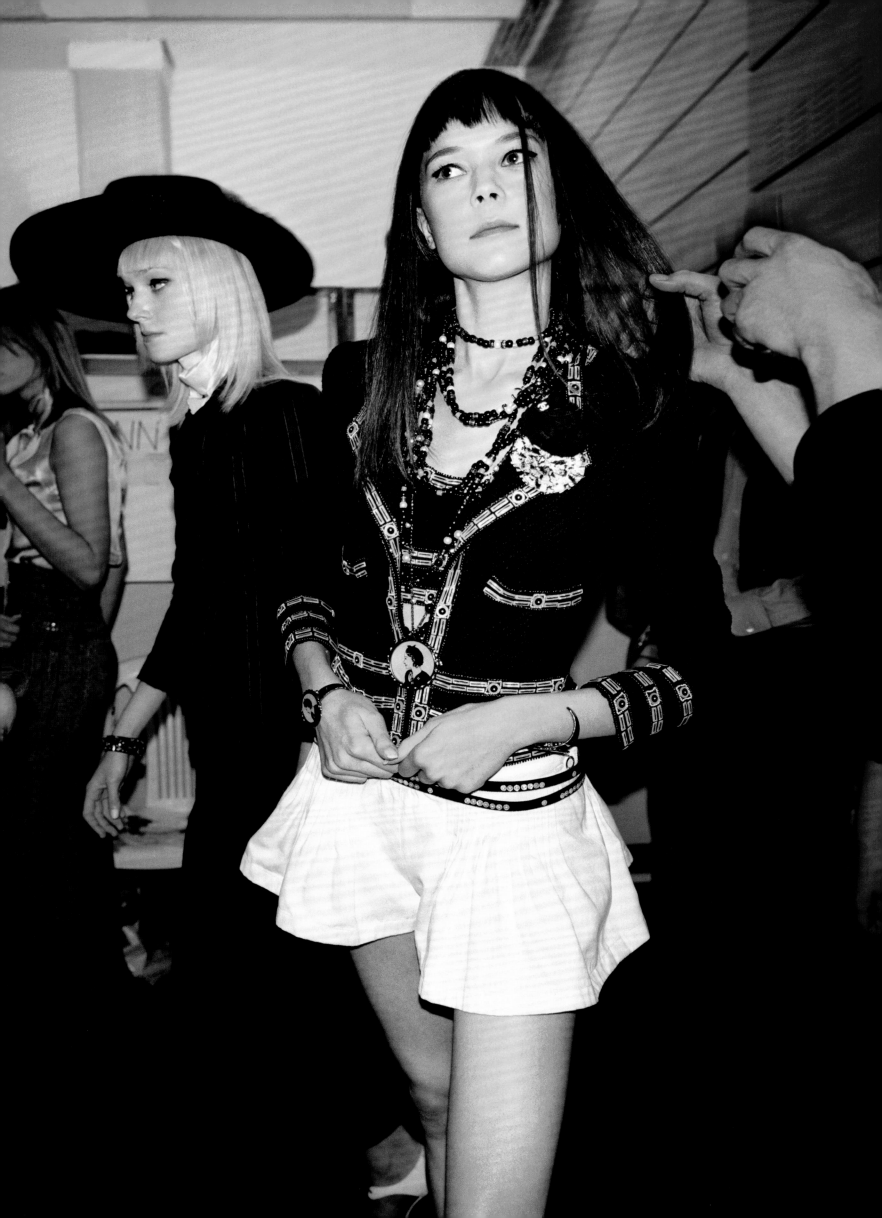

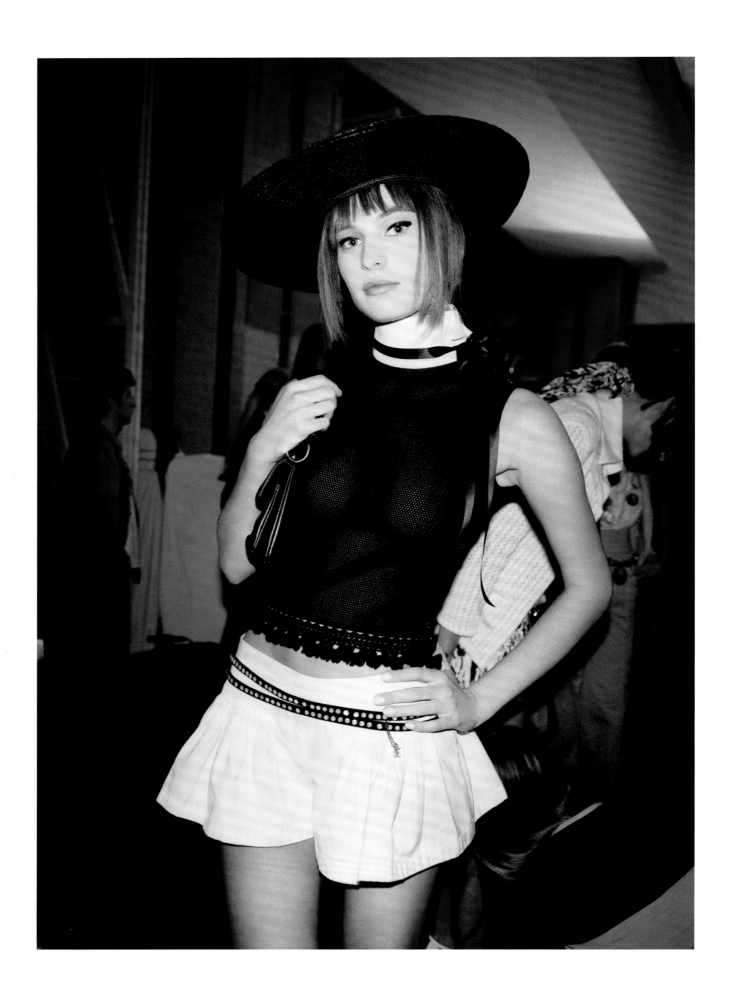

SPRING/SUMMER 2003 READY-TO-WEAR

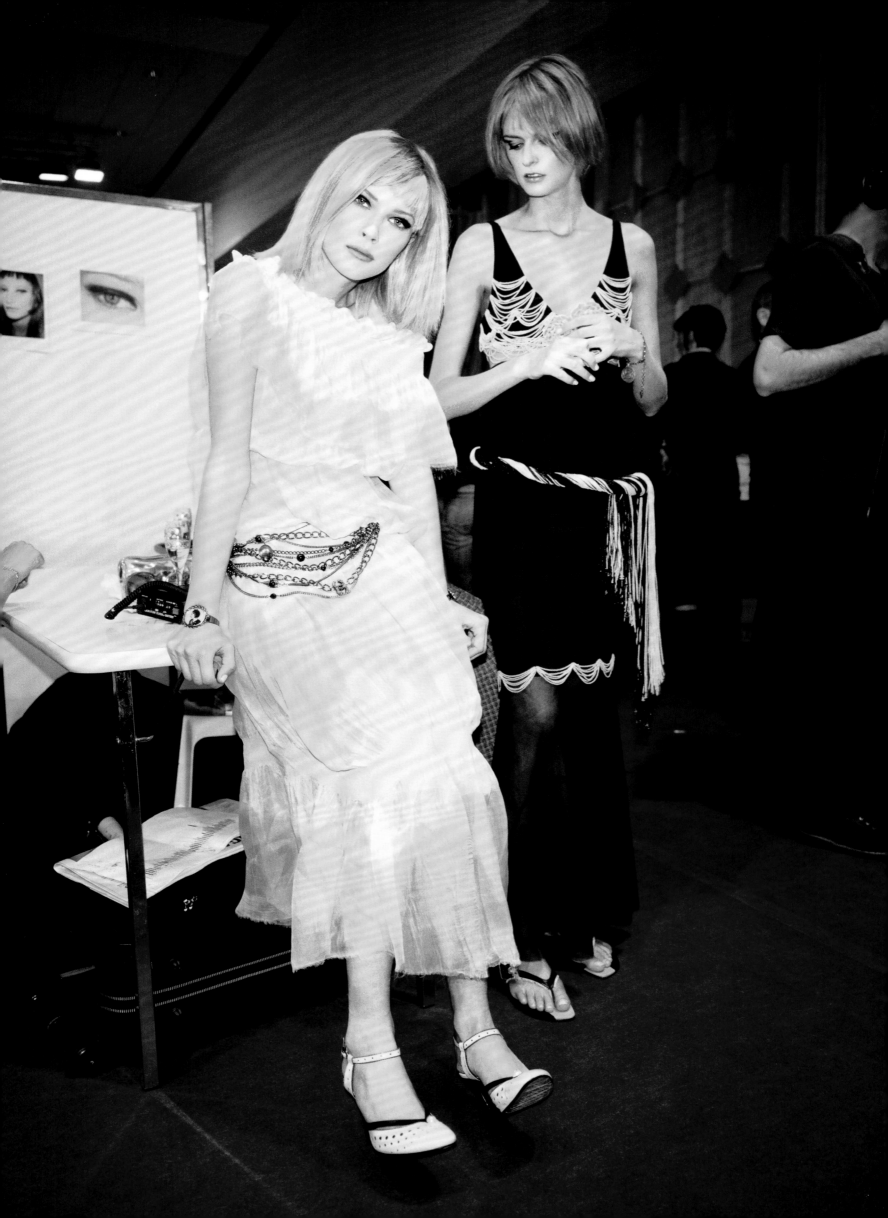

SPRING/SUMMER 2003
HAUTE COUTURE

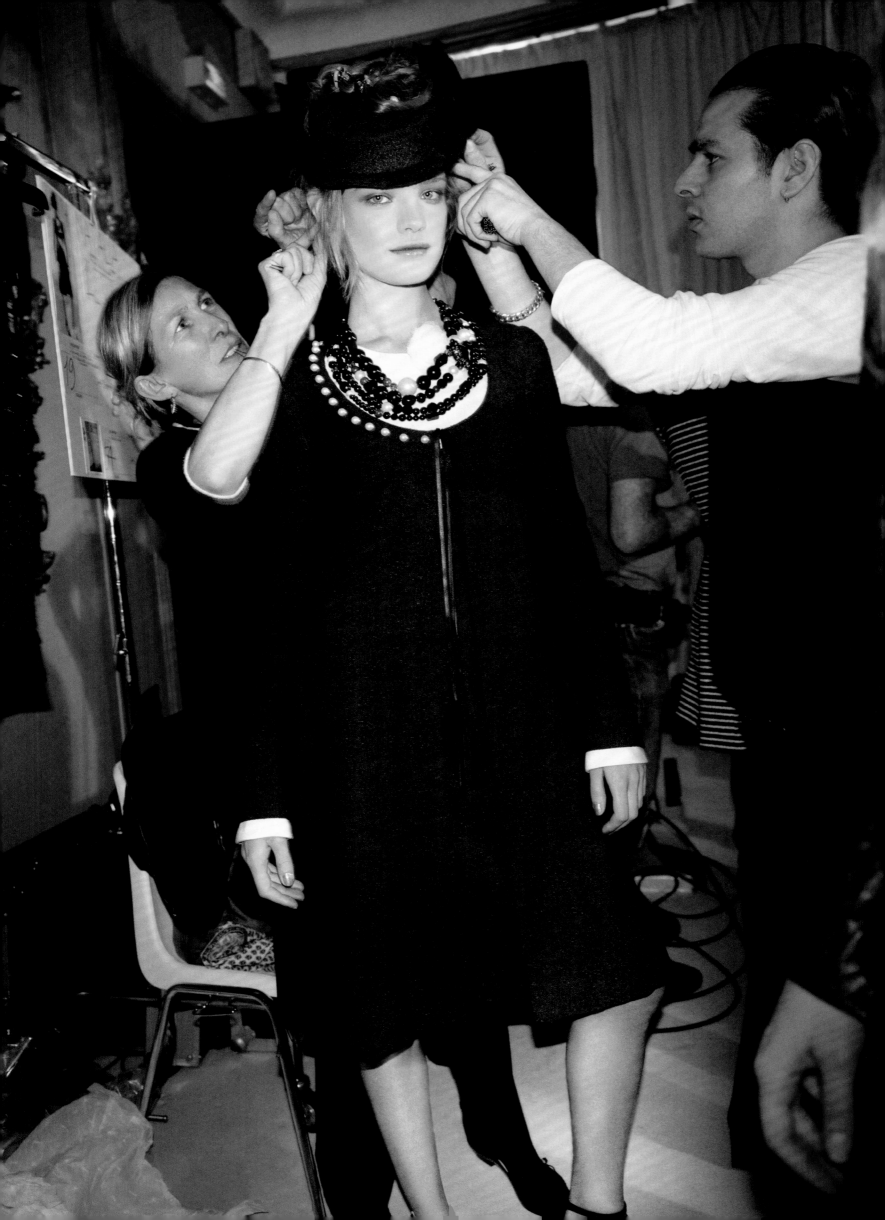

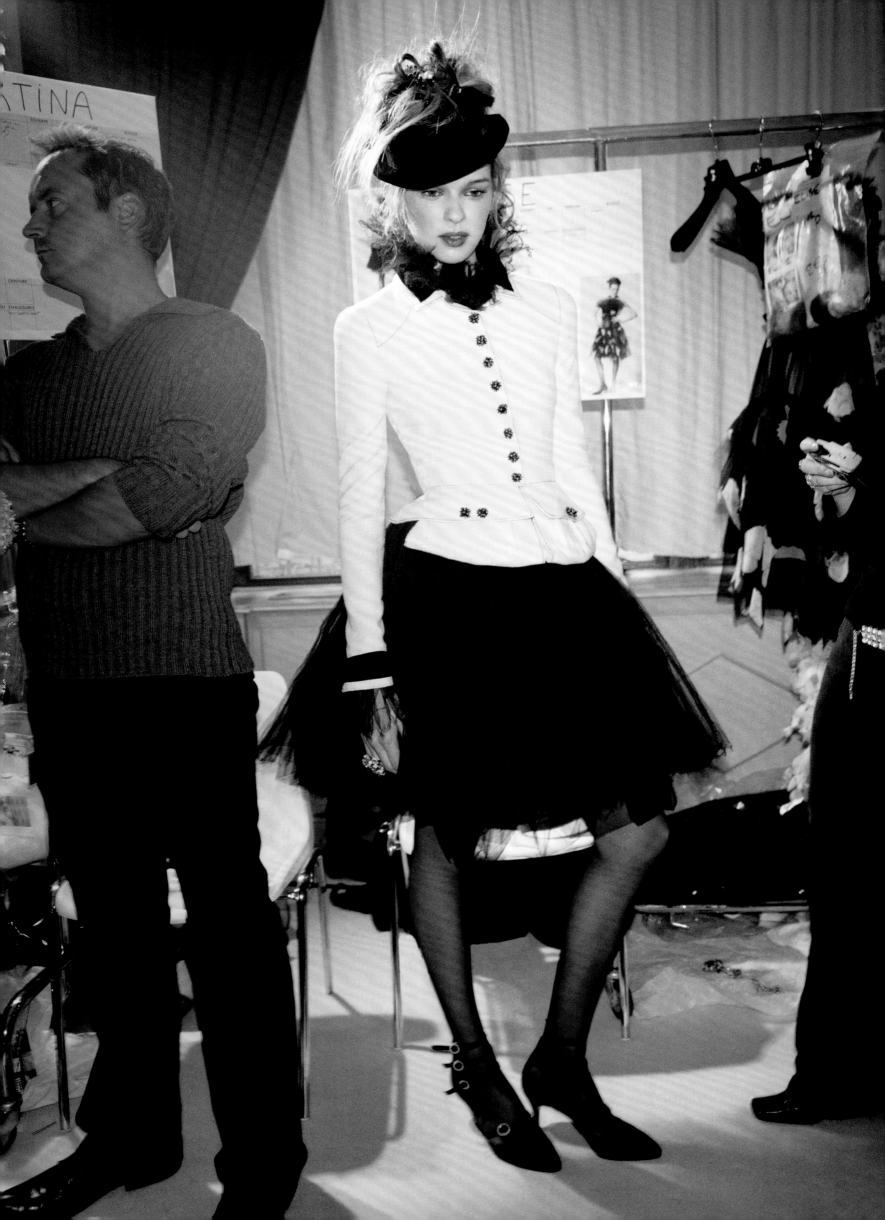

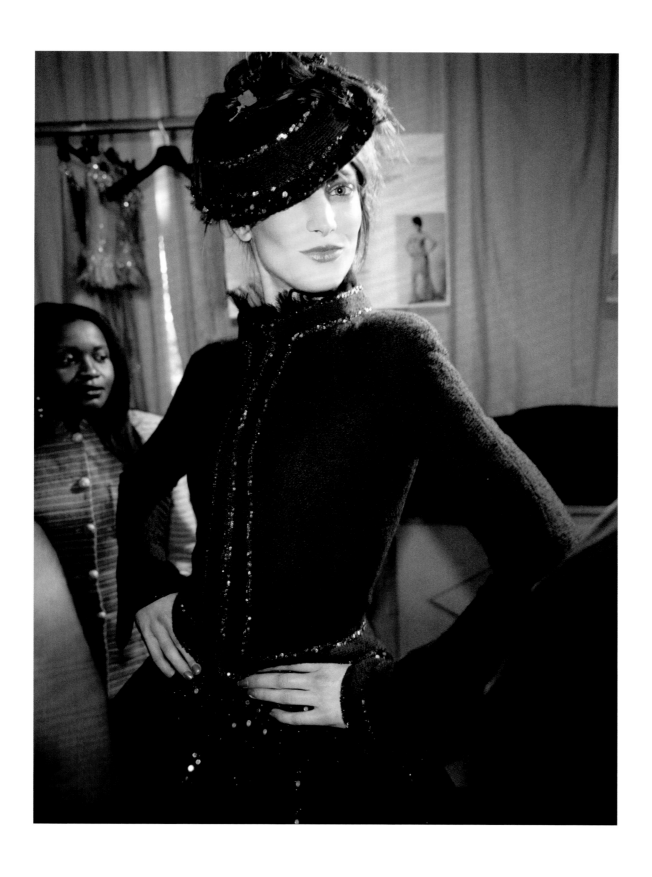

'One look after another demonstrate[s] the incredible craftsmanship of the artisans and experts [that] Chanel has at its fingertips — and that Lagerfeld turns into a unique expression of opulent details on clothes that are modern and accessible'

André Leon Talley

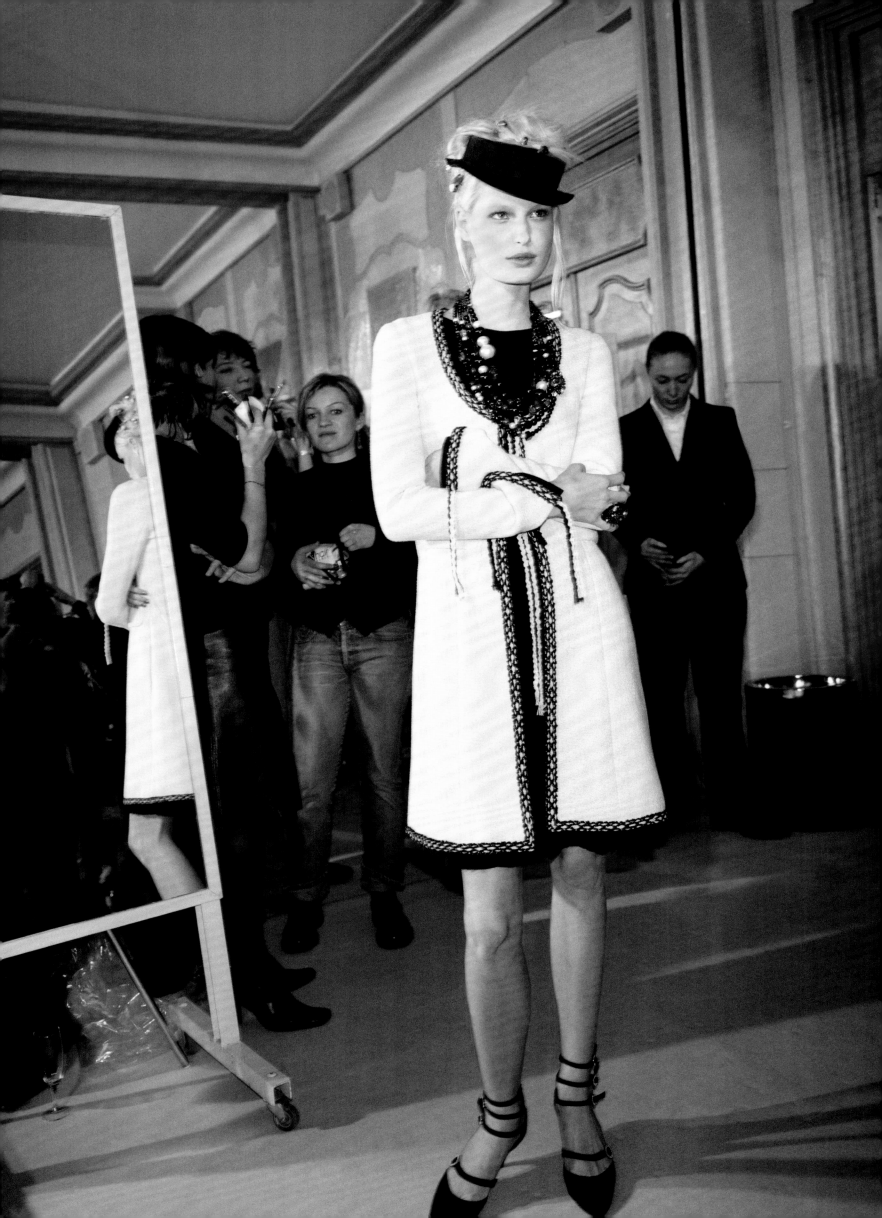

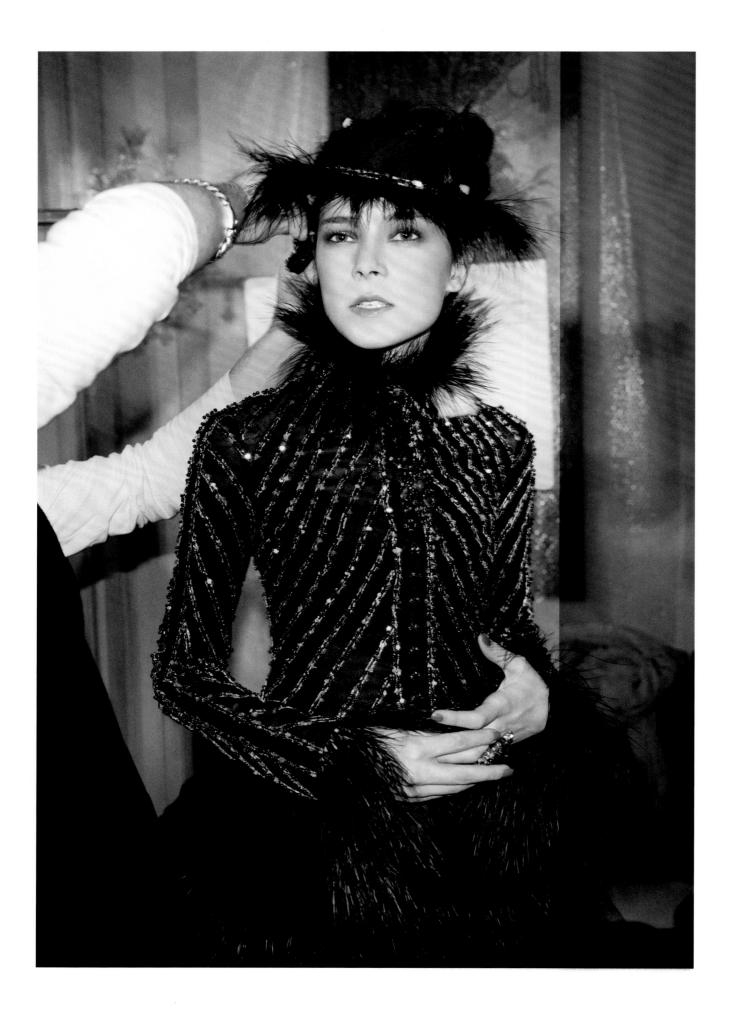

SPRING/SUMMER 2003 HAUTE COUTURE

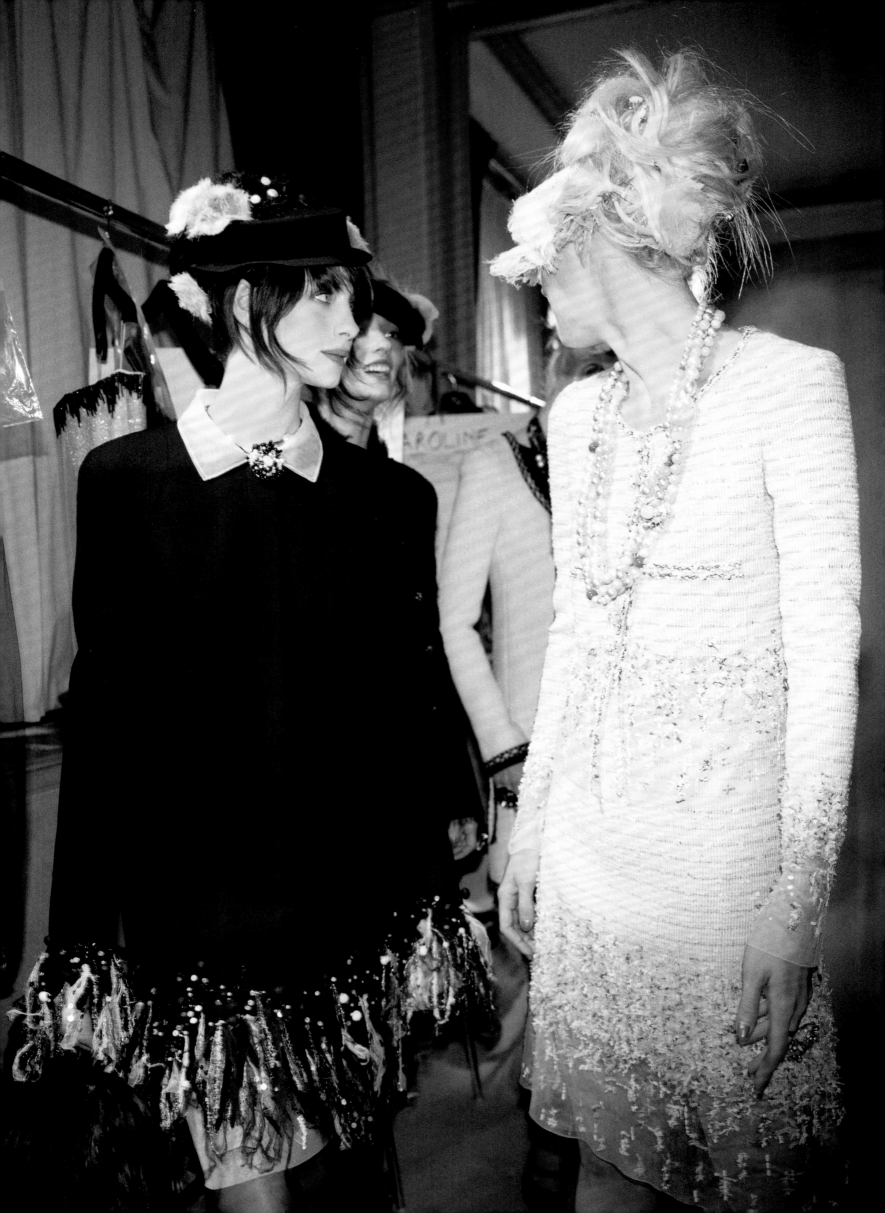

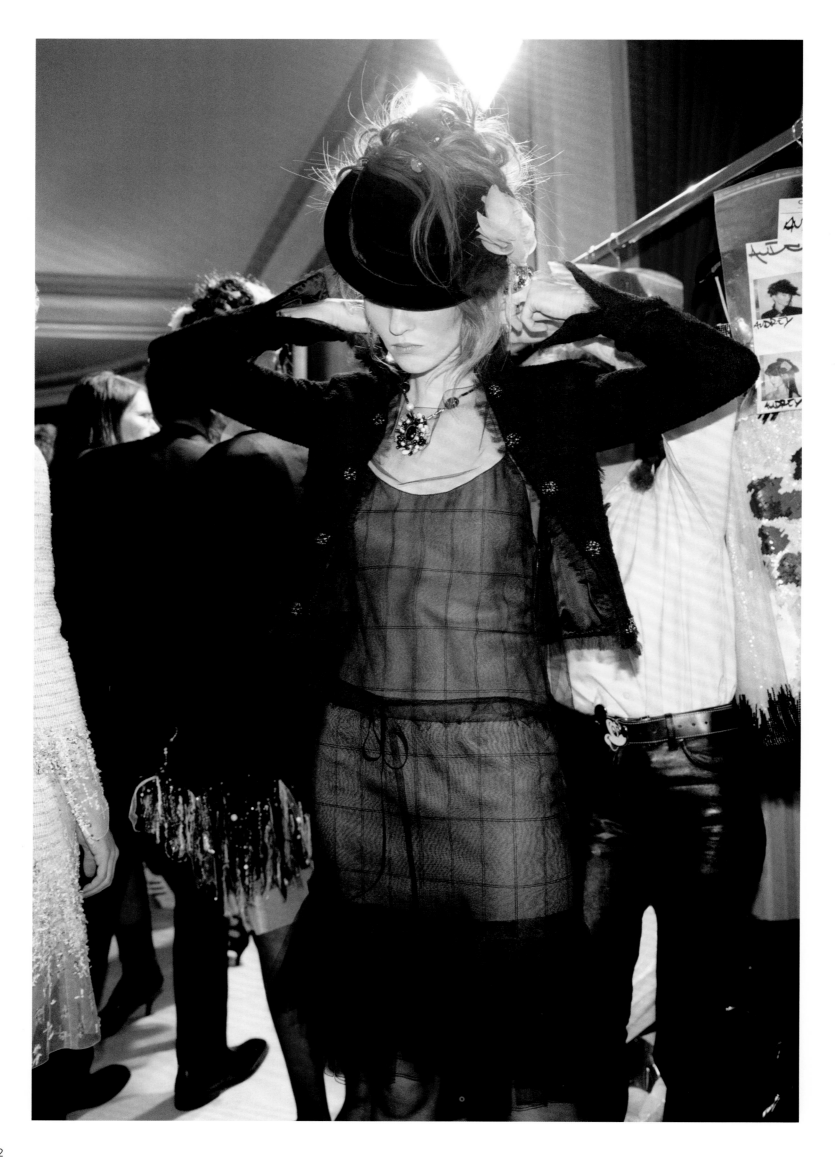

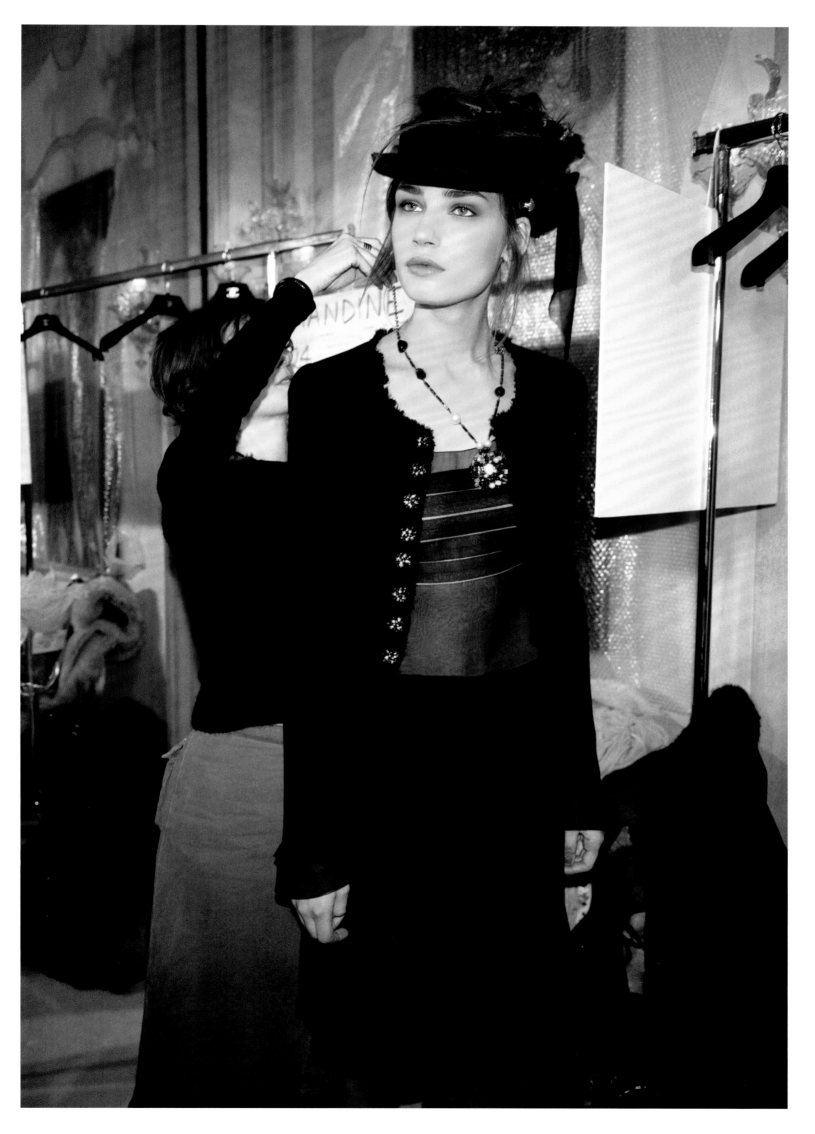

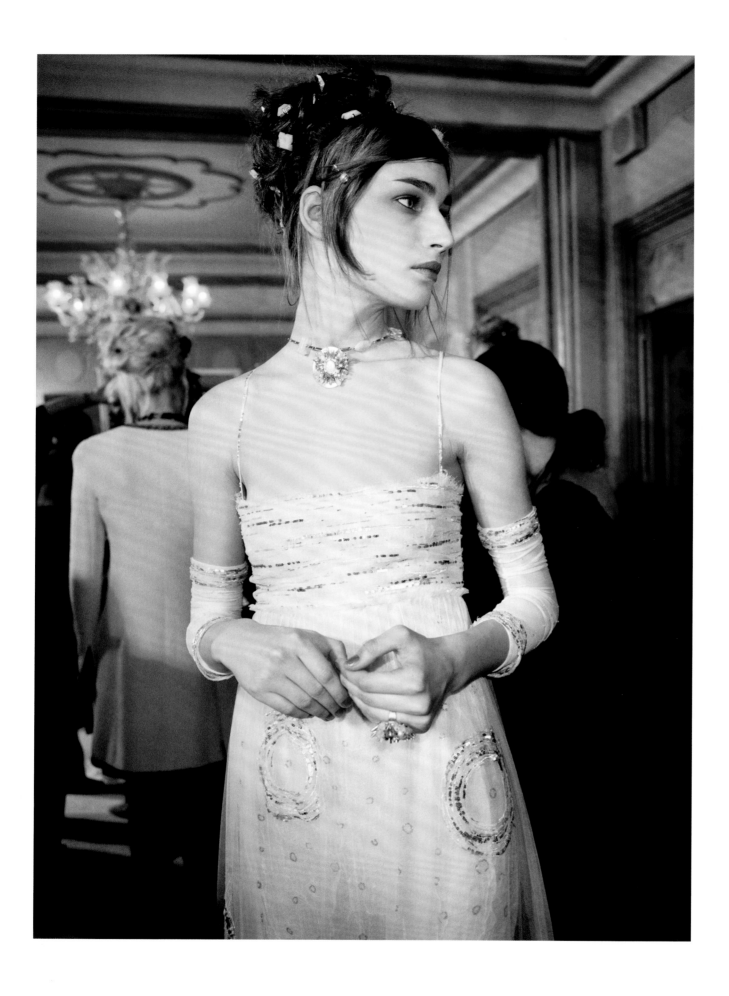

SPRING/SUMMER 2003 HAUTE COUTURE

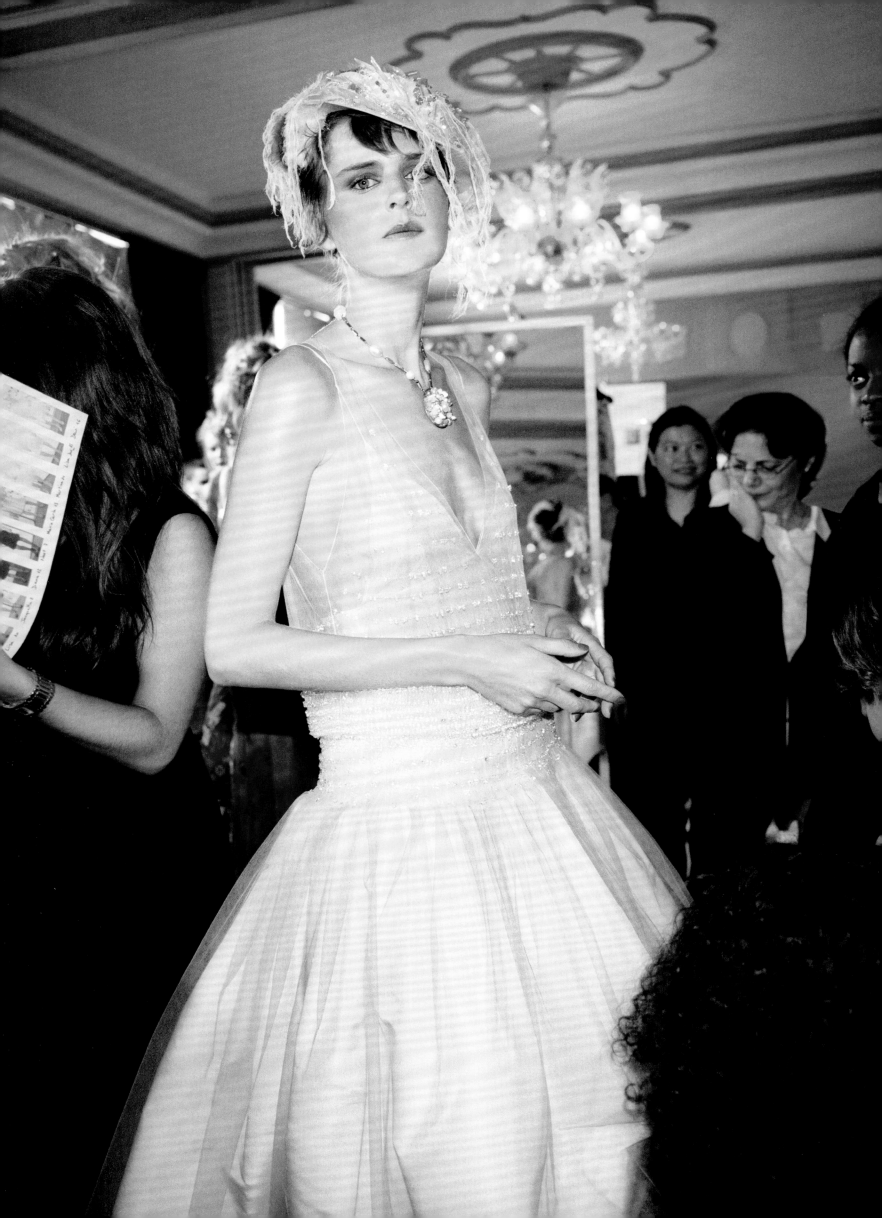

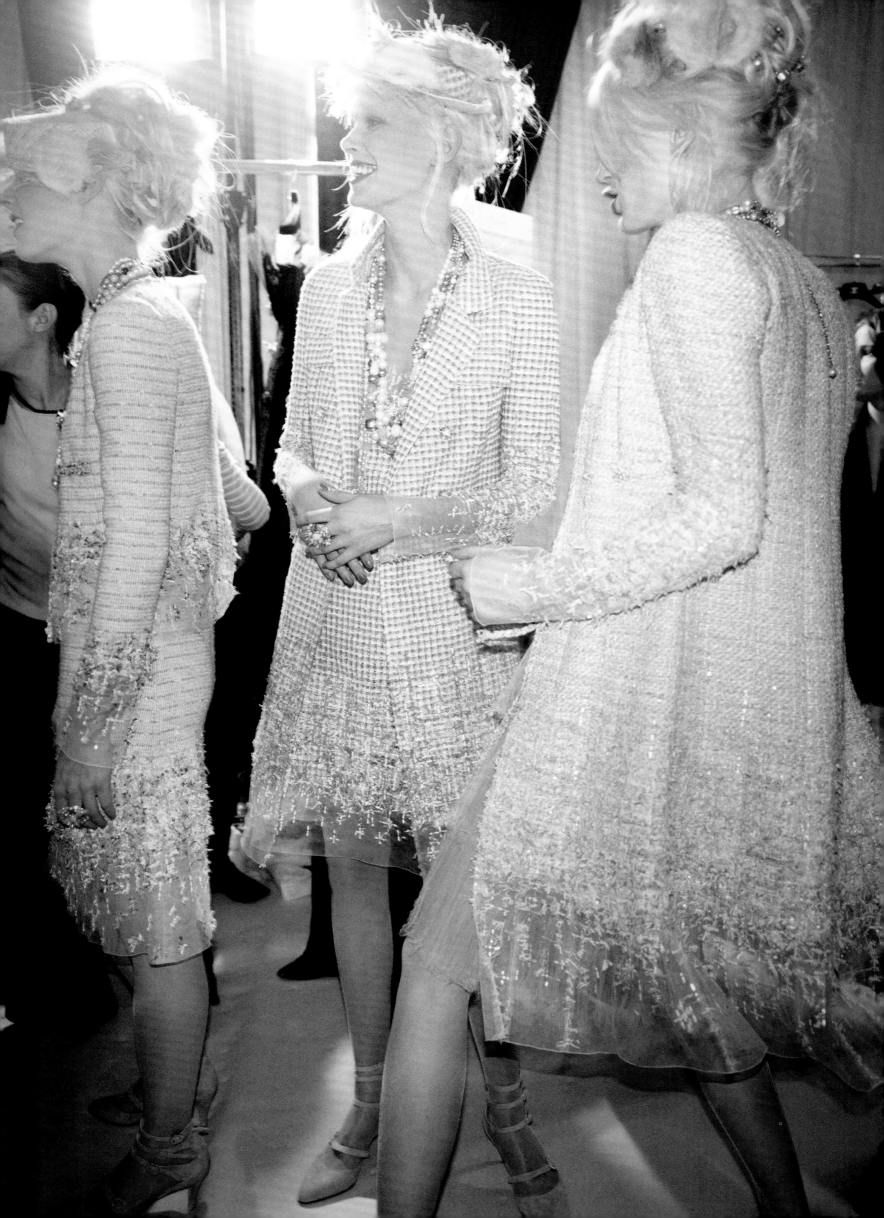

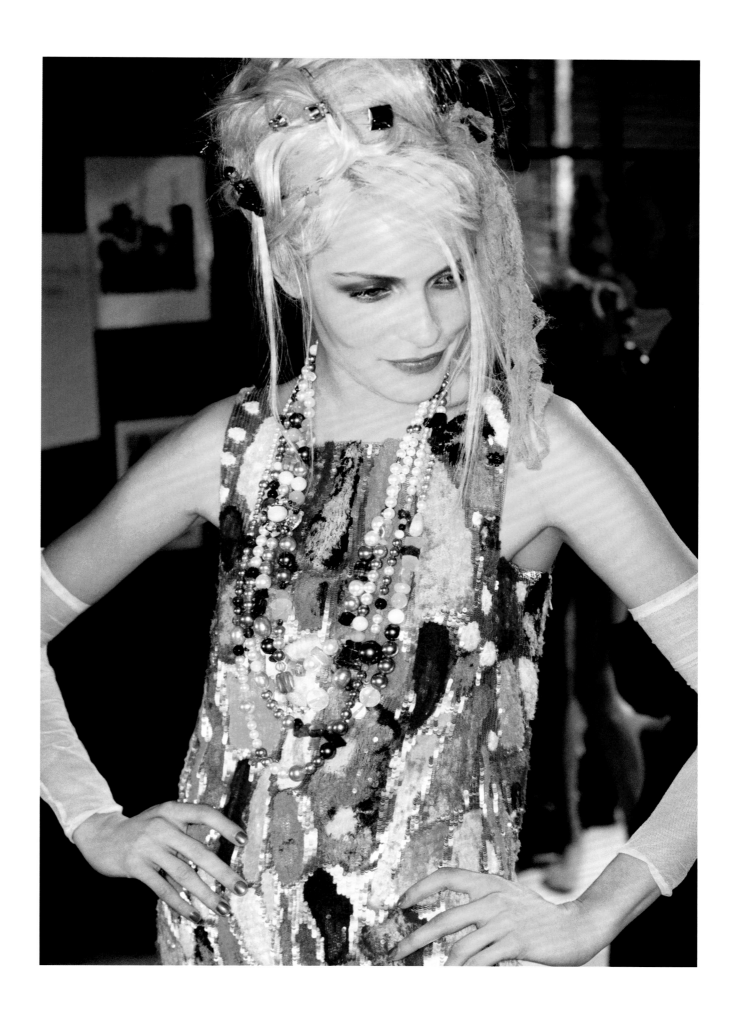

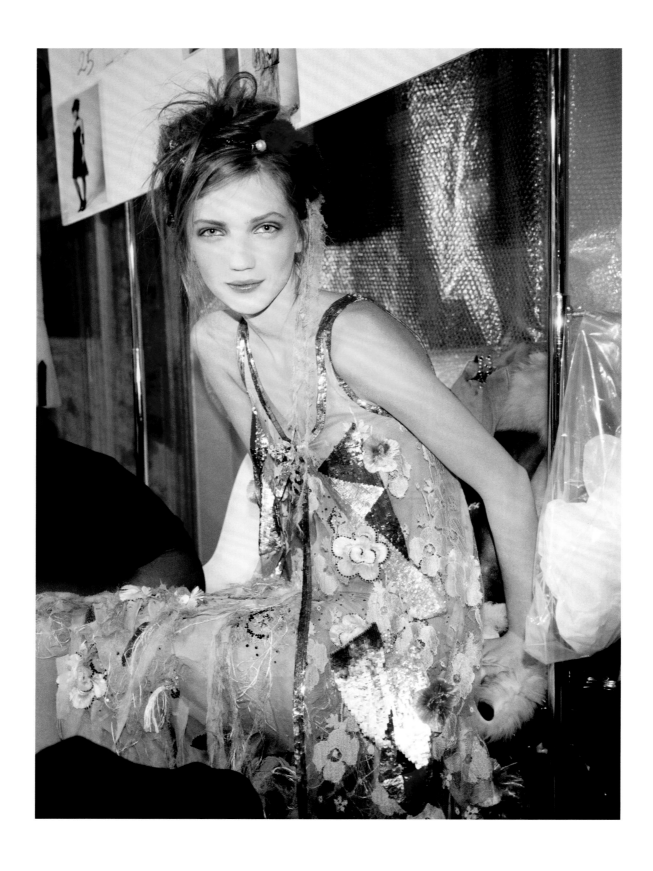

SPRING/SUMMER 2003 HAUTE COUTURE

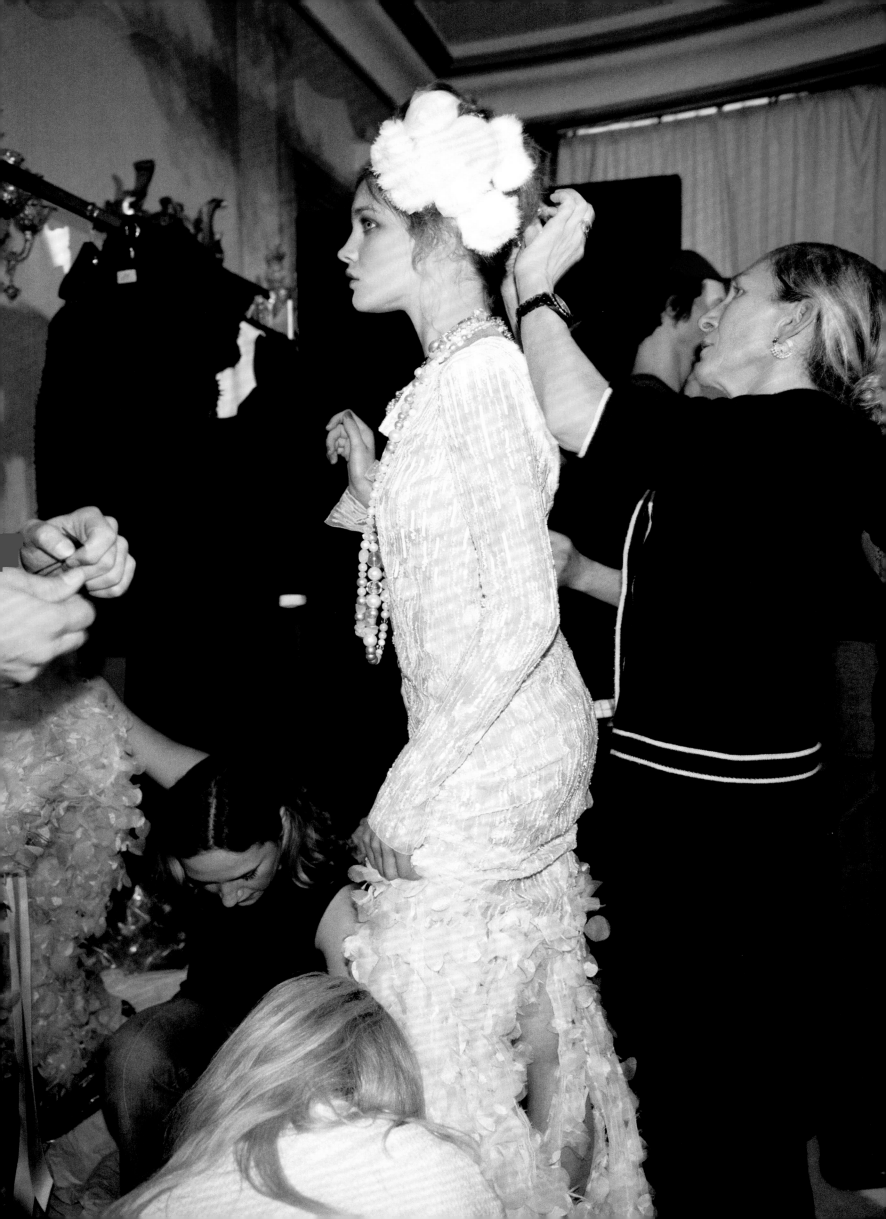

AUTUMN/WINTER 2003–2004
READY-TO-WEAR

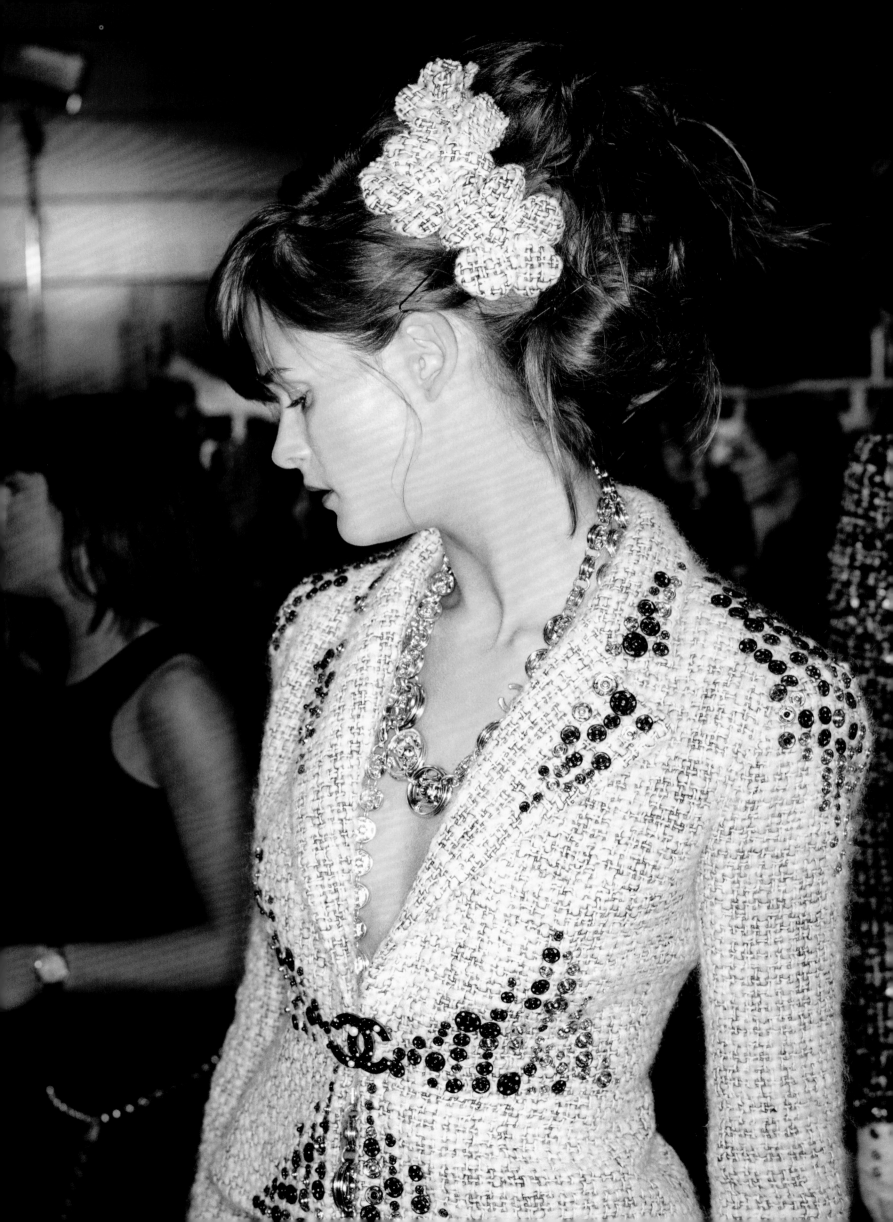

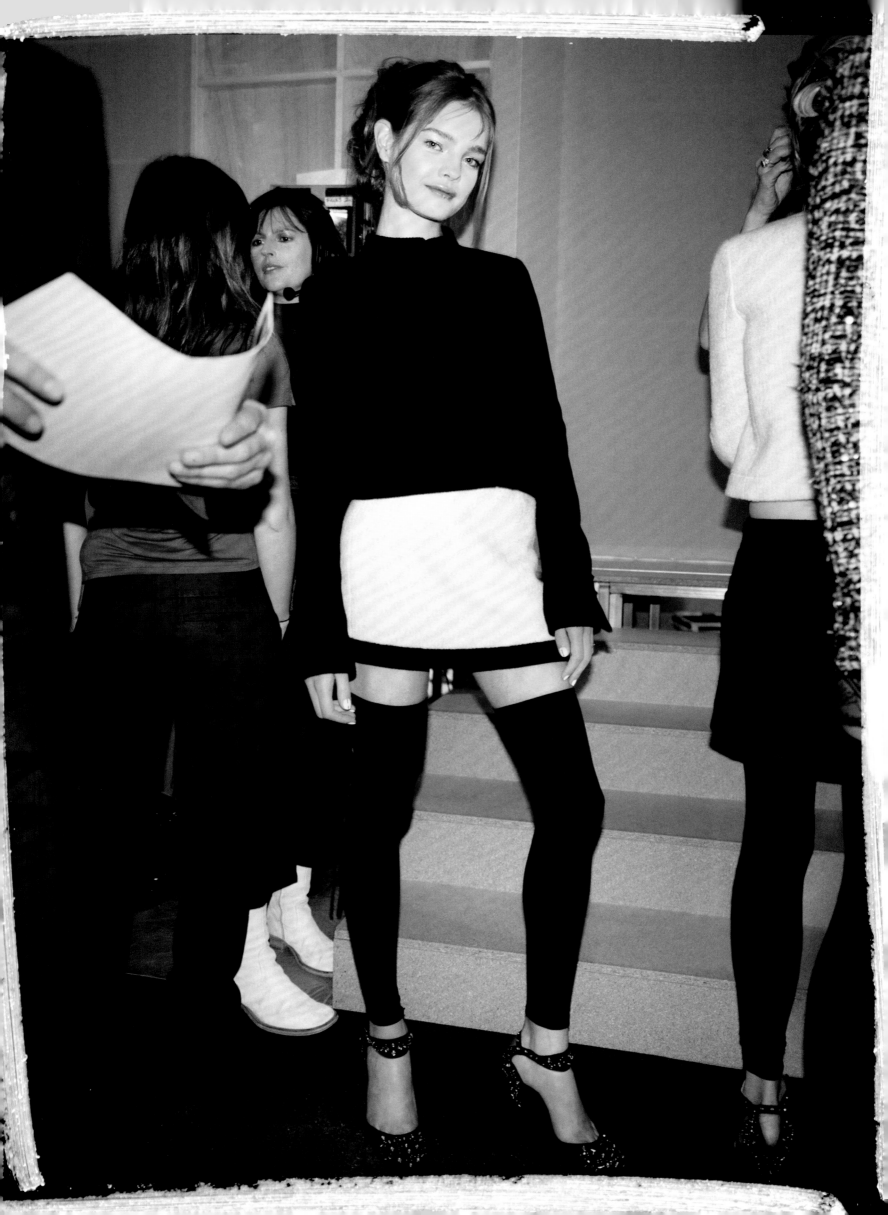

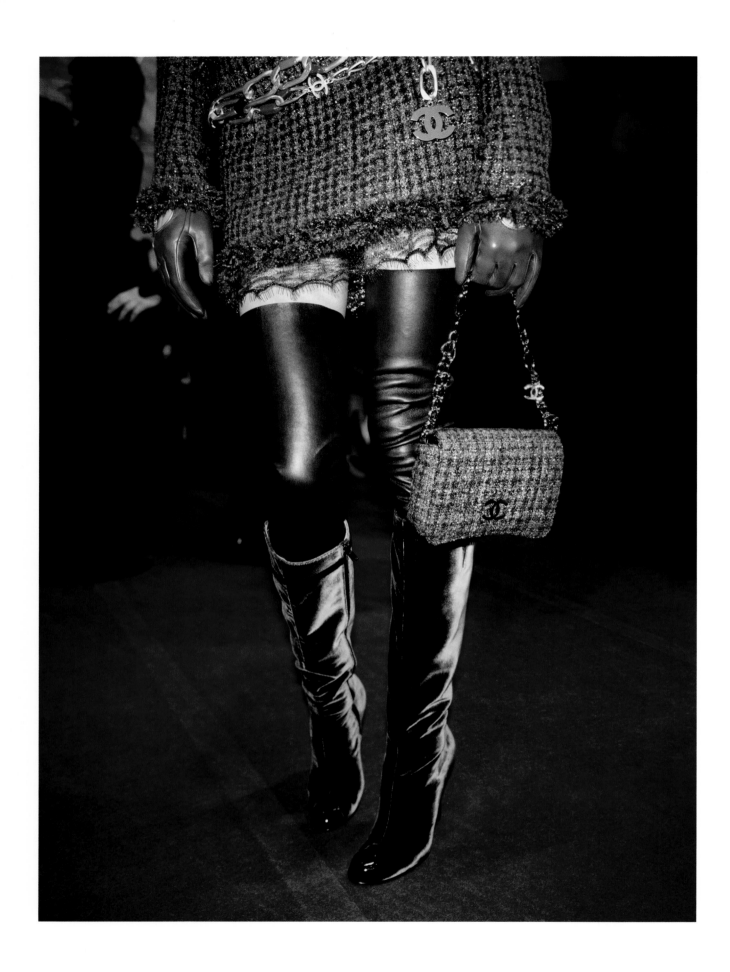

AUTUMN/WINTER 2003–2004 READY-TO-WEAR

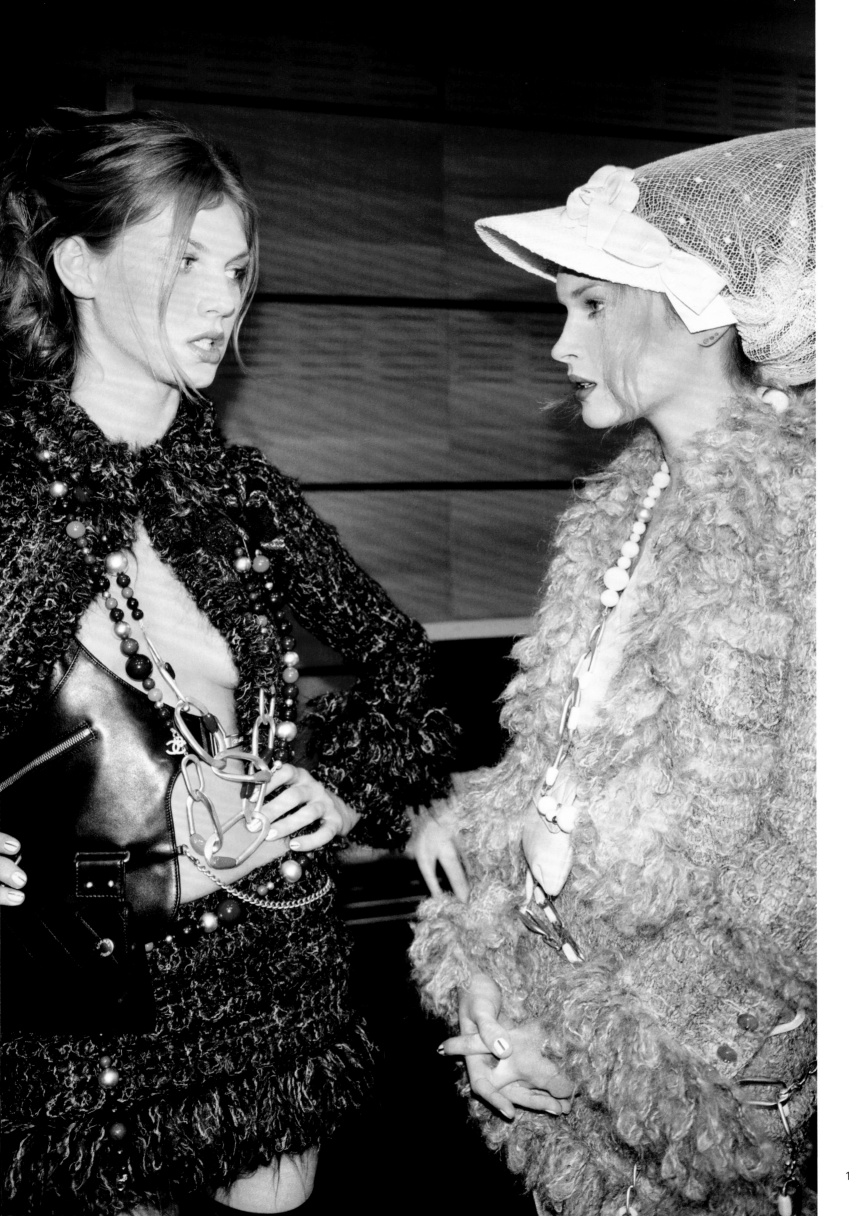

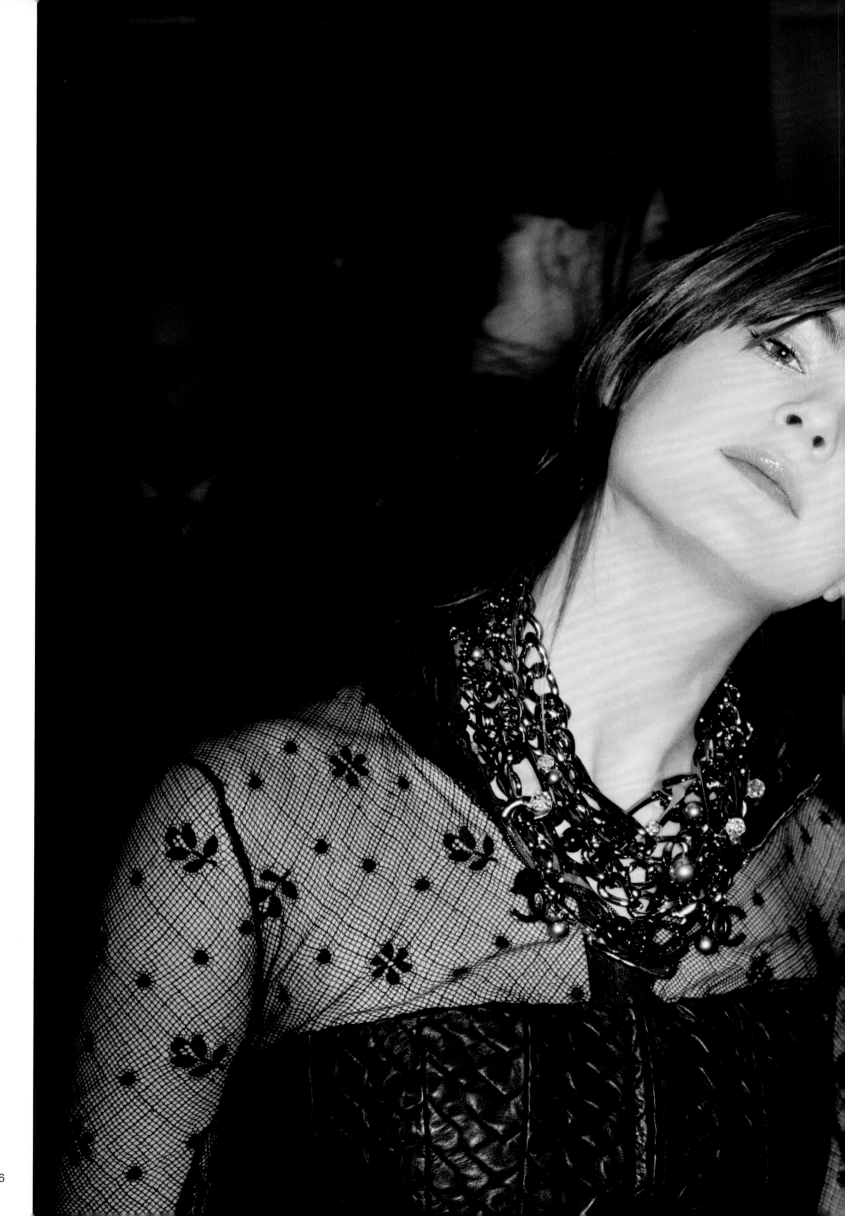

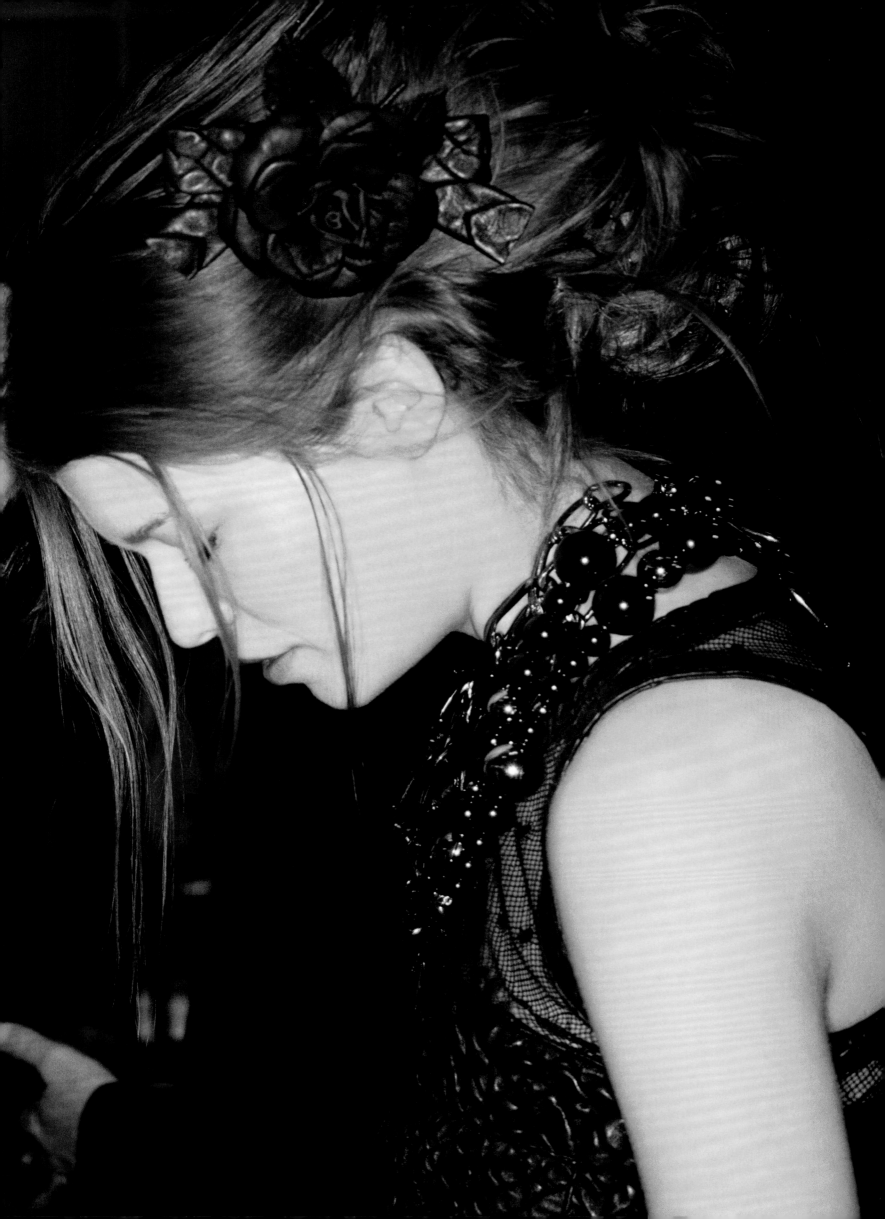

'The mood is in the air...
Nothing is forbidden anymore.'

Karl Lagerfeld

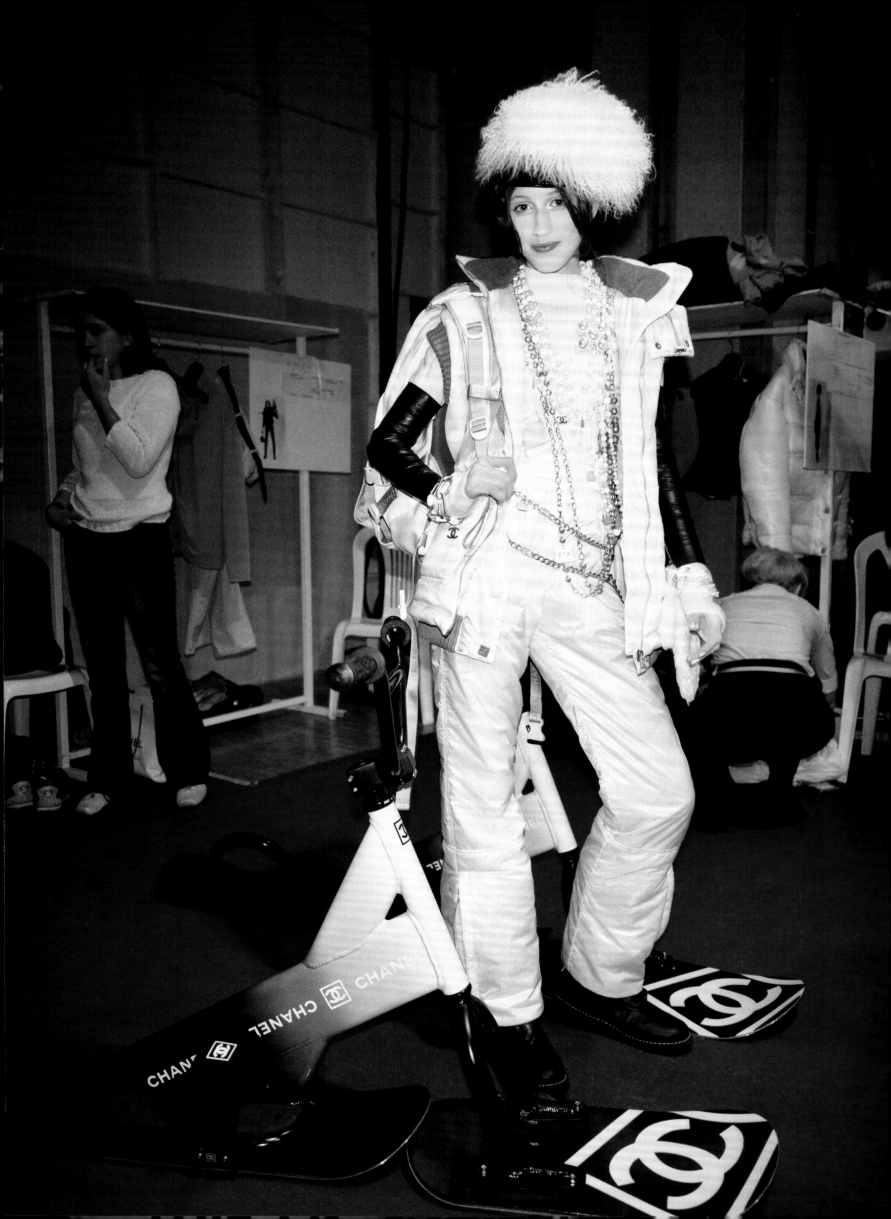

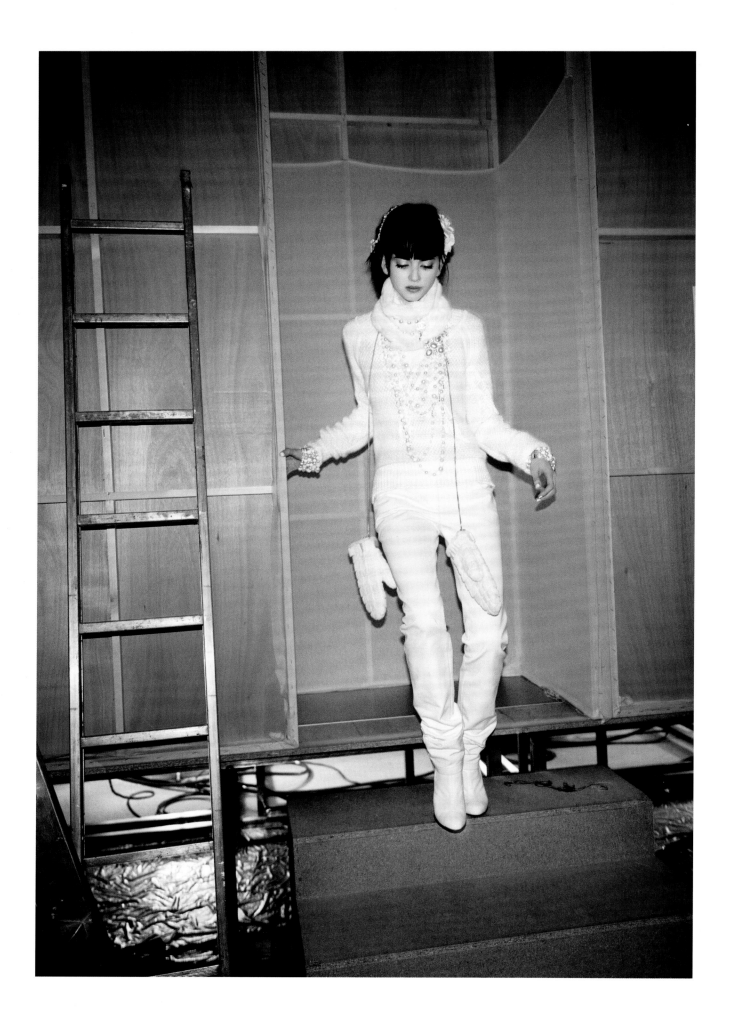

AUTUMN/WINTER 2003–2004 READY-TO-WEAR

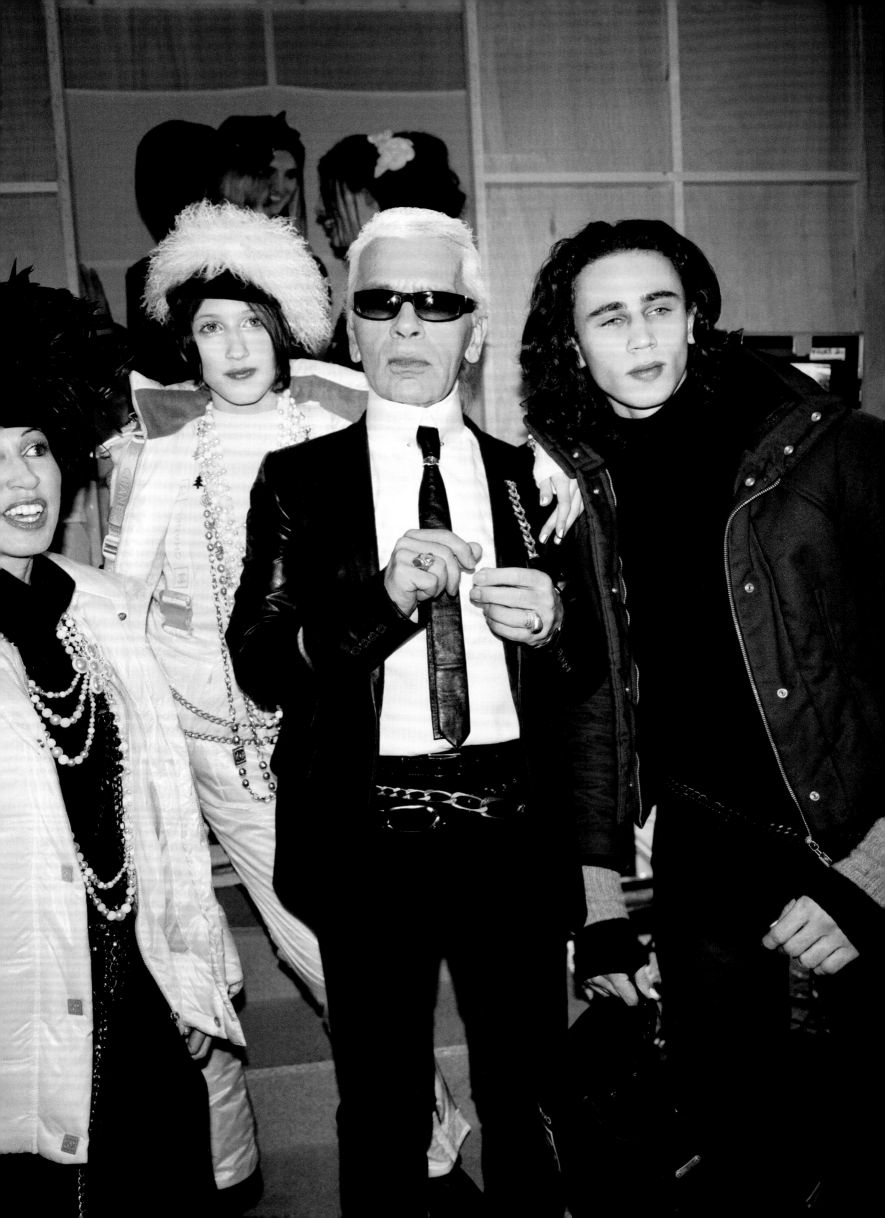

AUTUMN/WINTER 2003–2004
HAUTE COUTURE

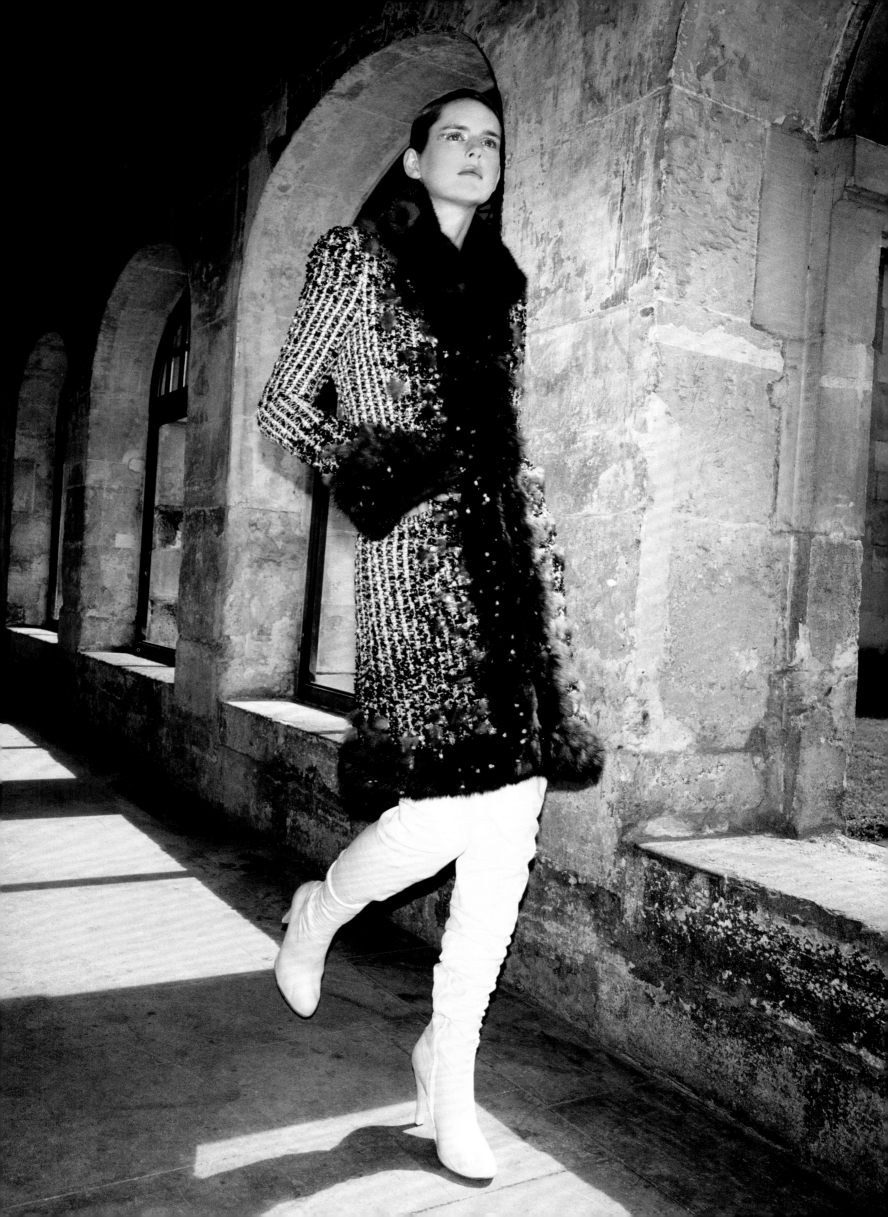

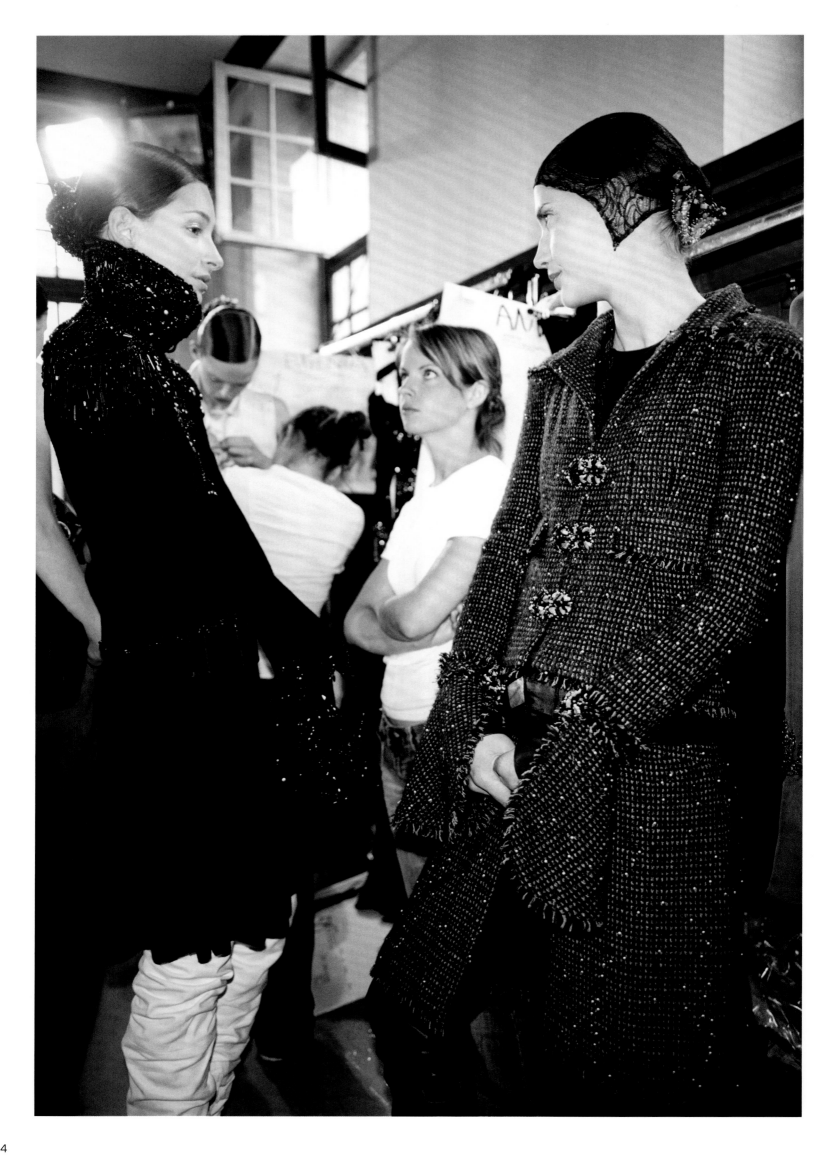

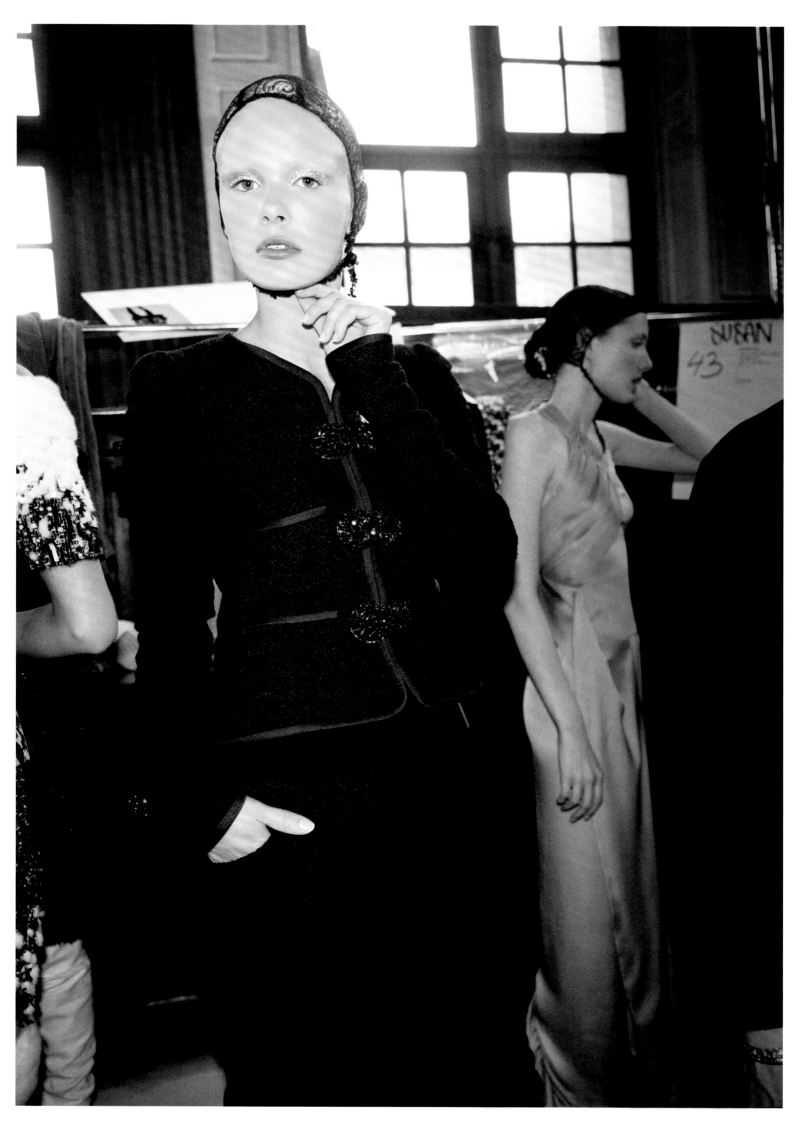

AUTUMN/WINTER 2003–2004 HAUTE COUTURE

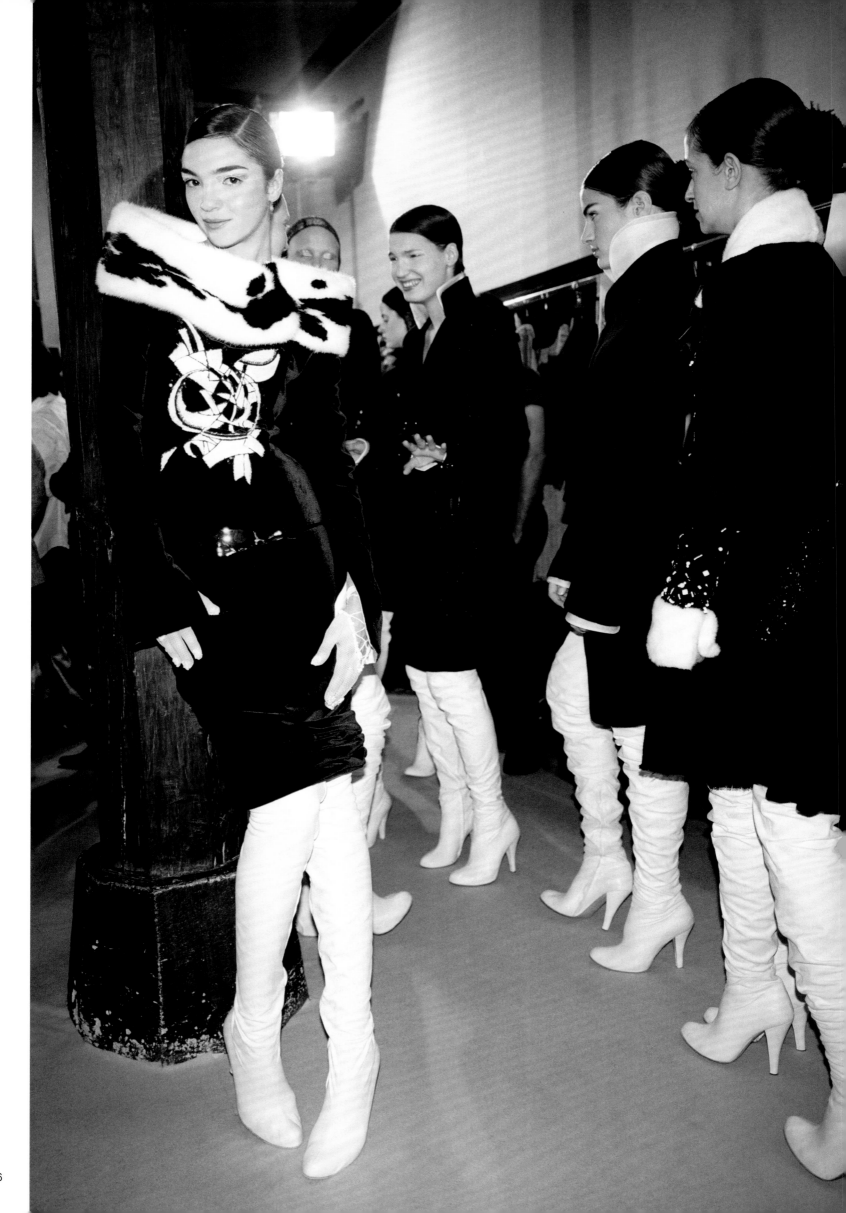

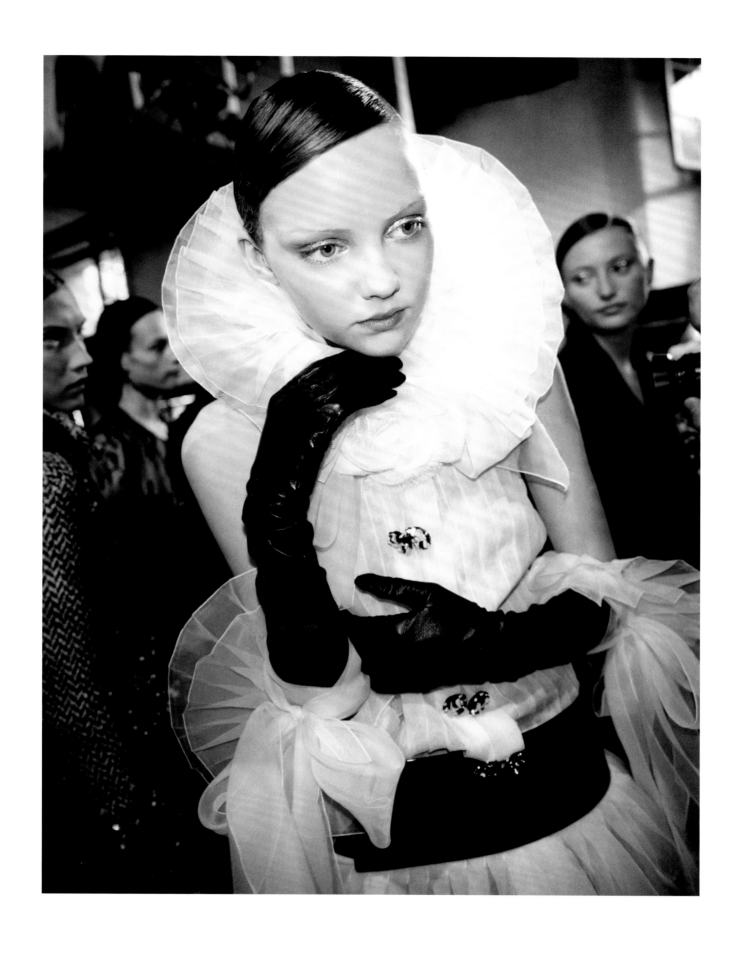

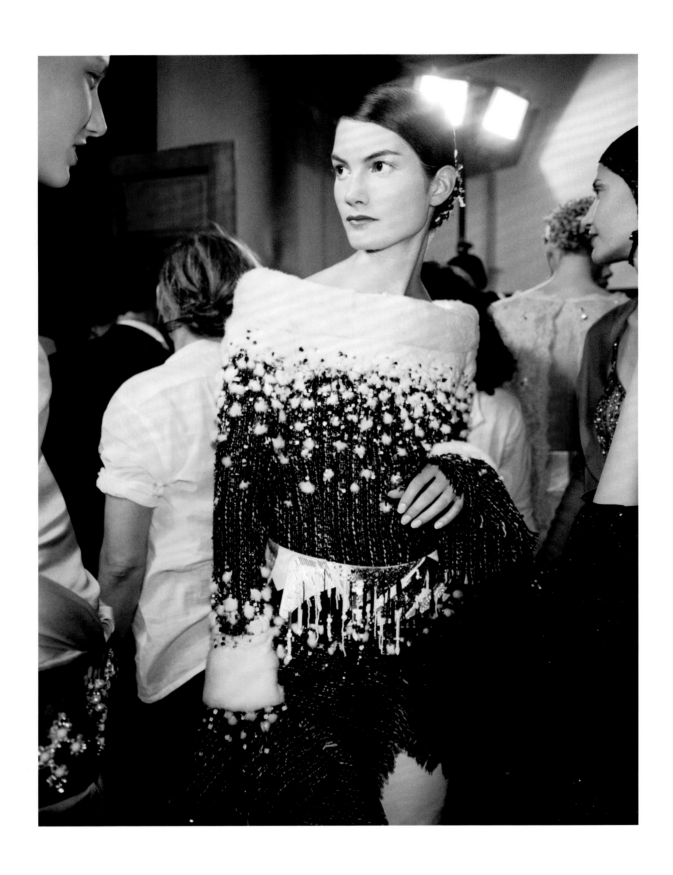

AUTUMN/WINTER 2003–2004 HAUTE COUTURE

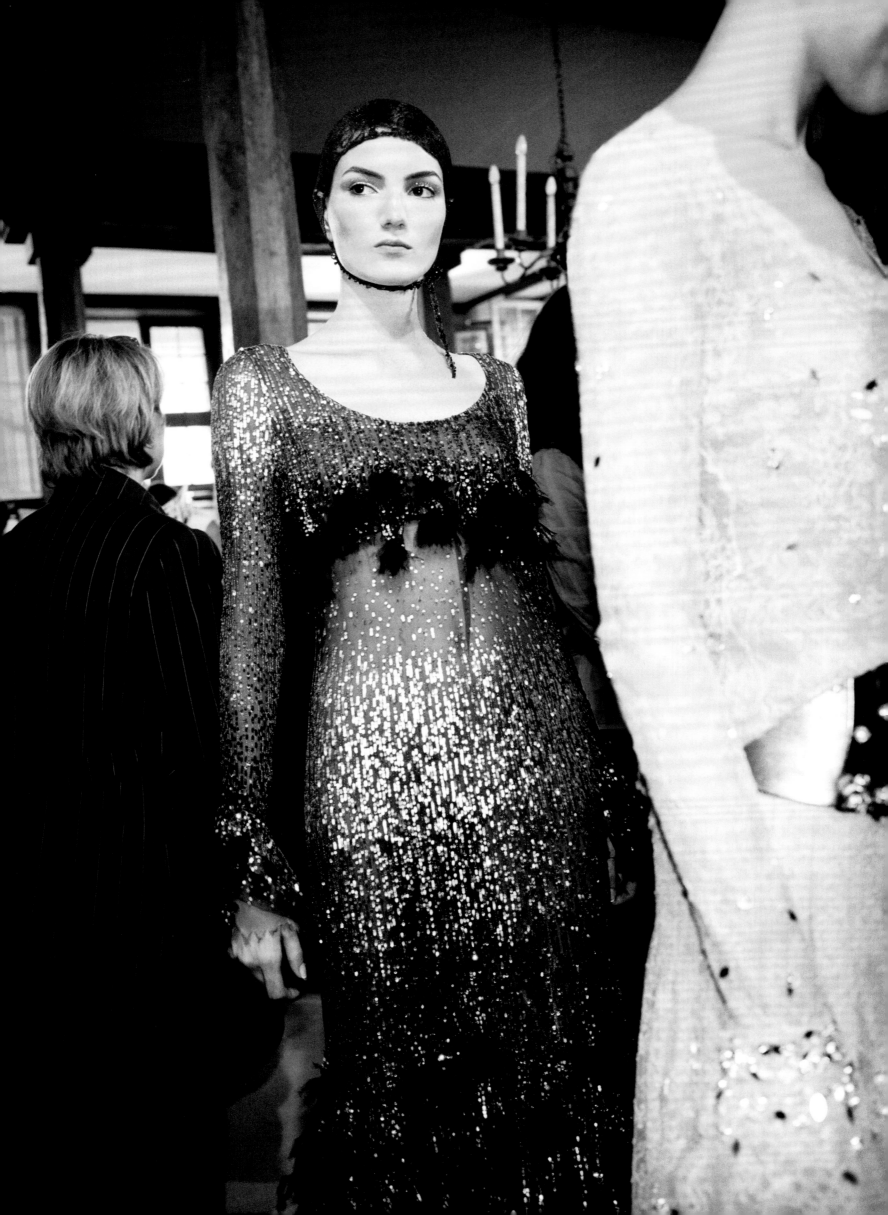

'My job is to propose a fantasy.
Whoever wants it, whoever likes it,
whoever wants to use it …
it's for anyone.'

Karl Lagerfeld

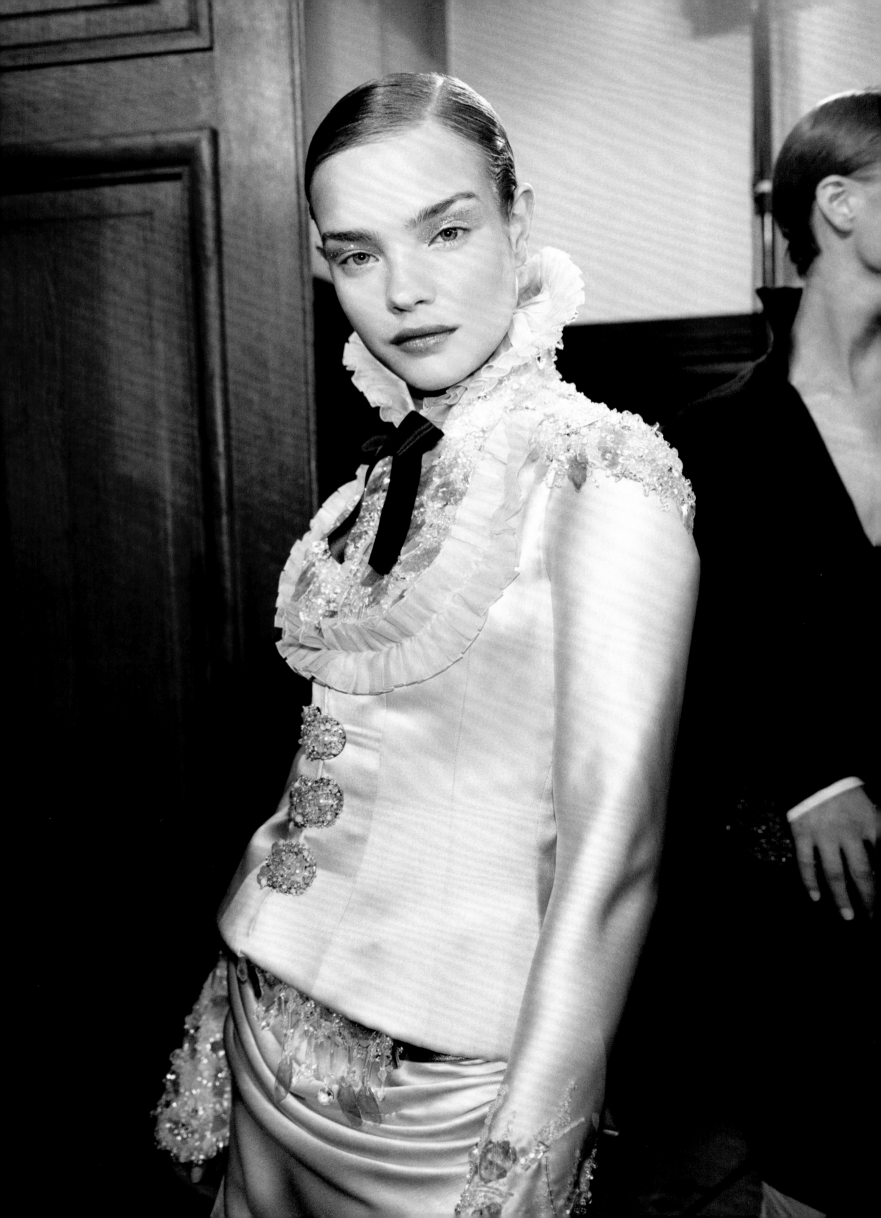

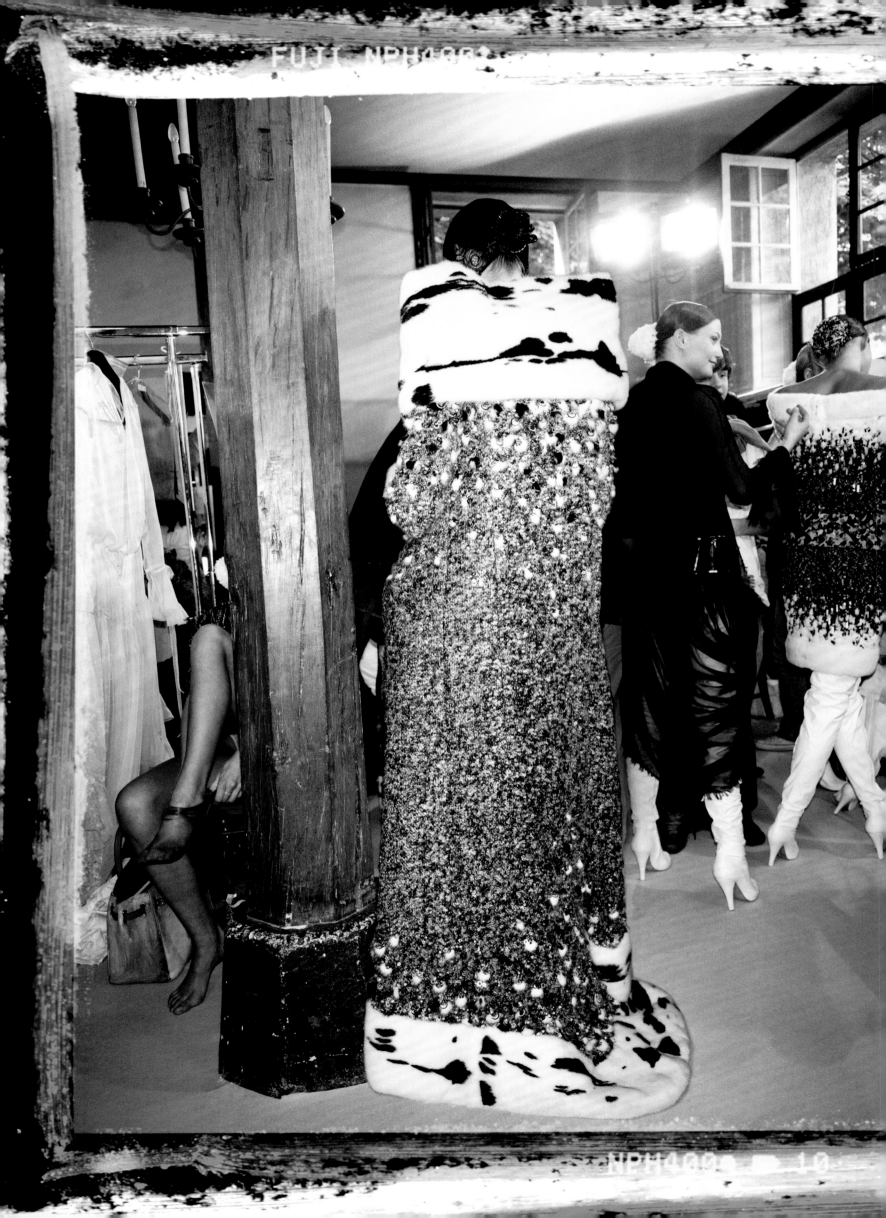

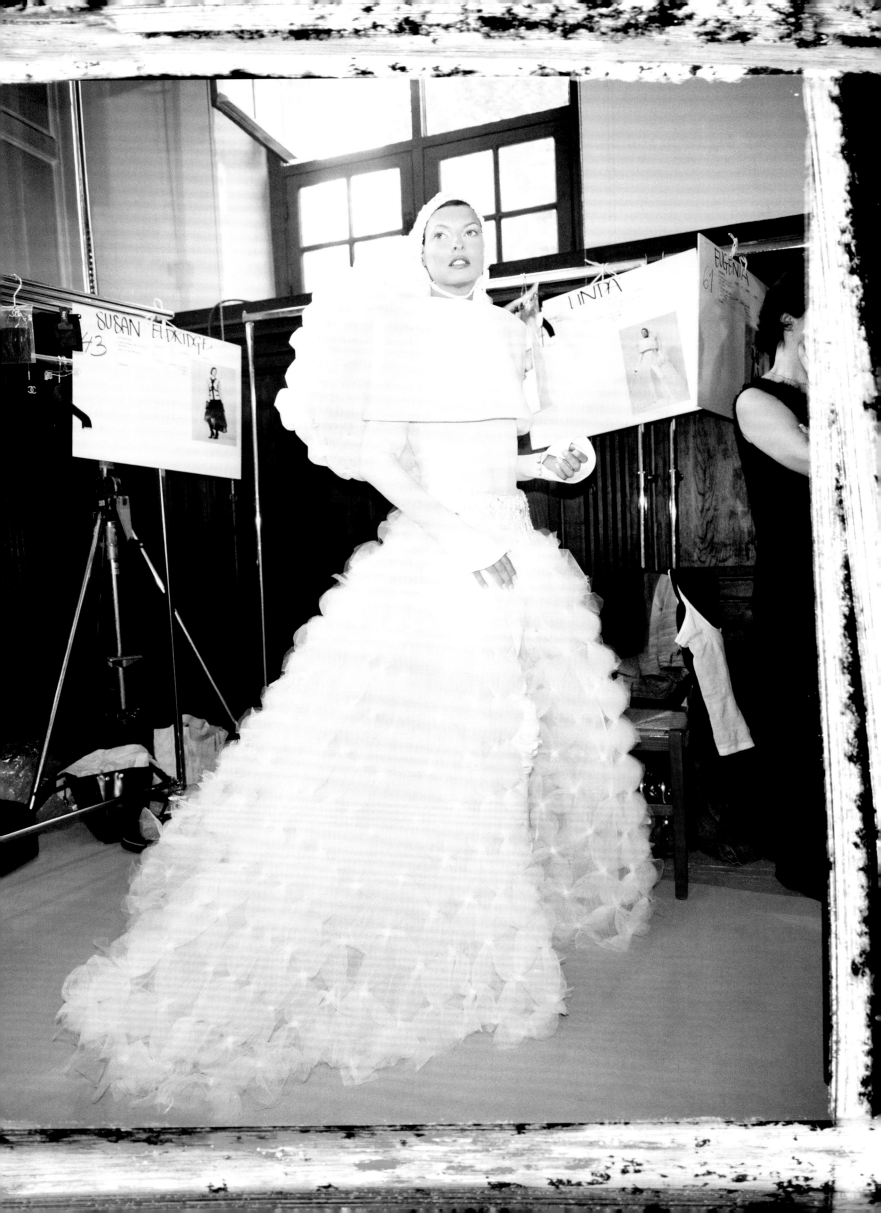

SPRING/SUMMER 2004
HAUTE COUTURE

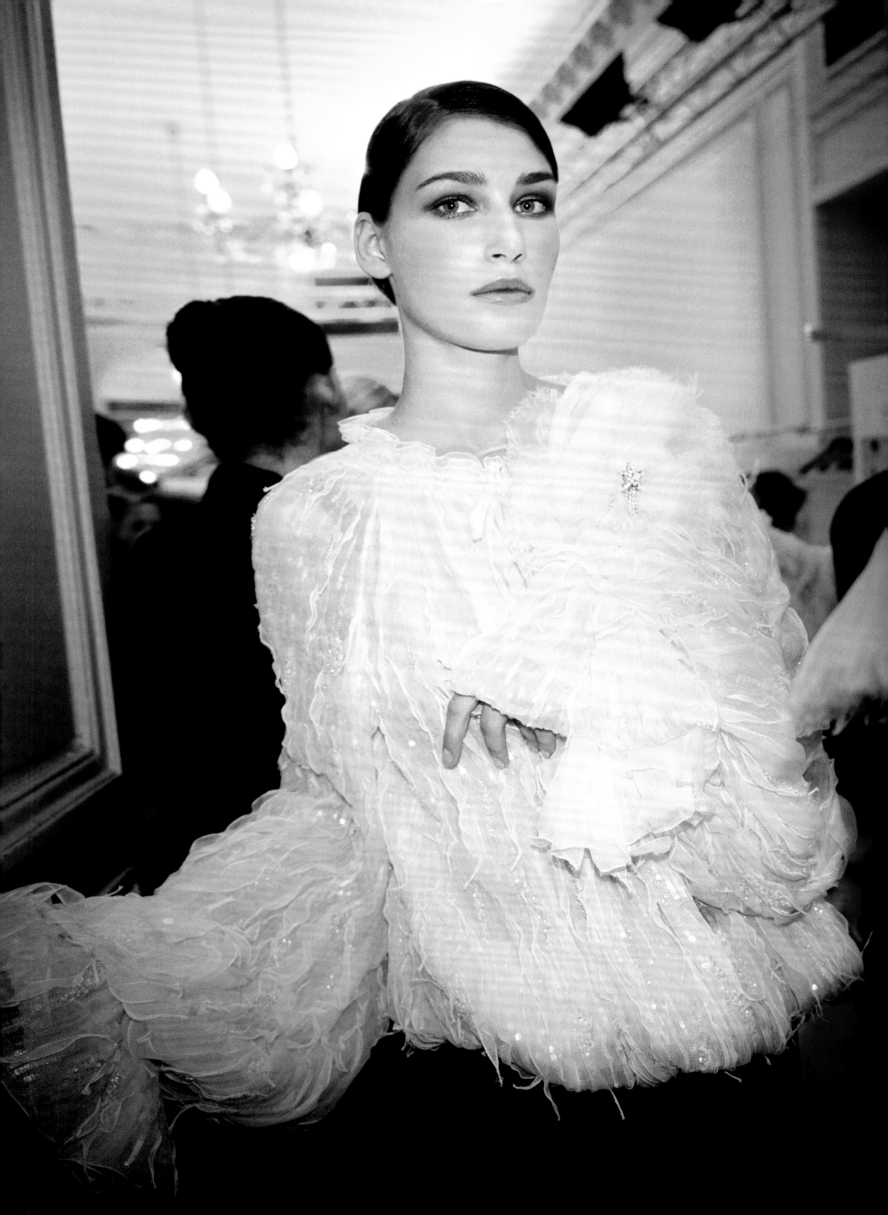

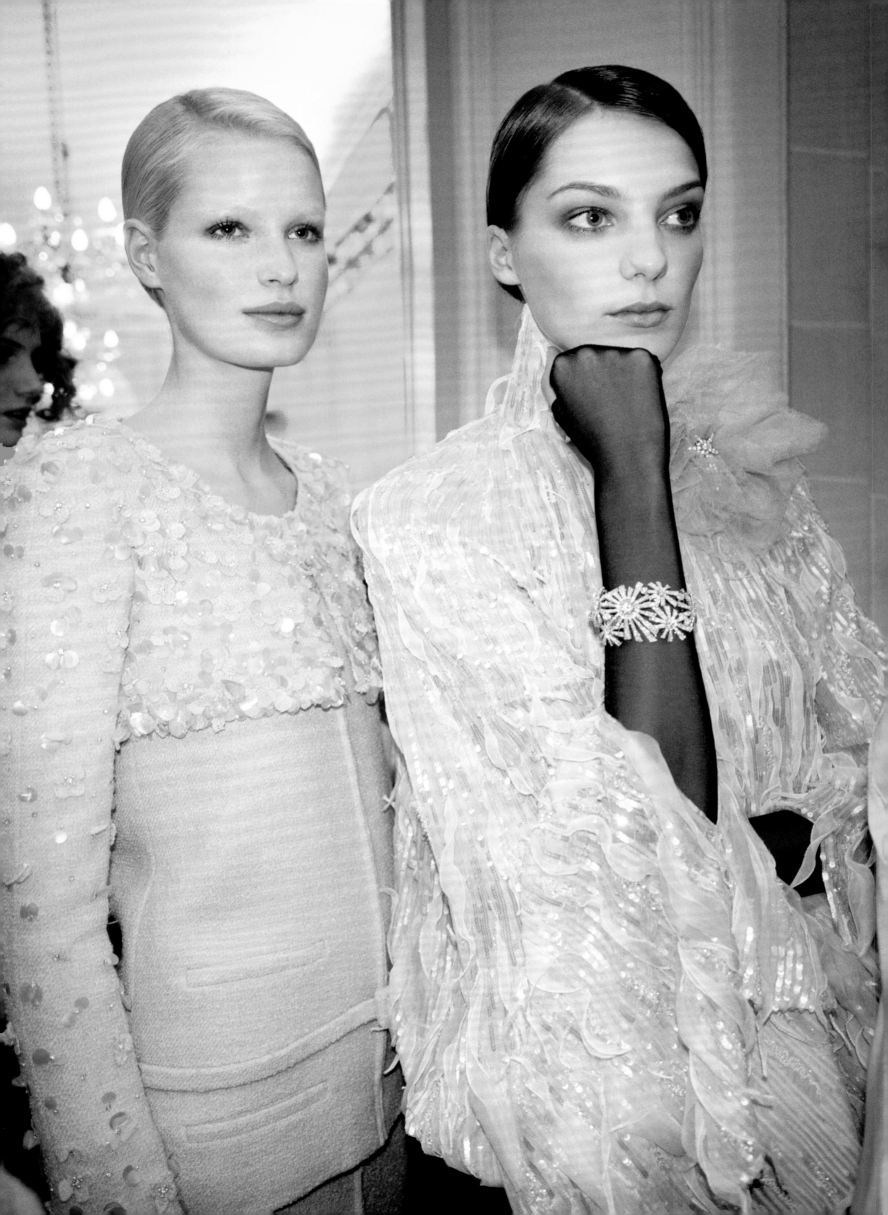

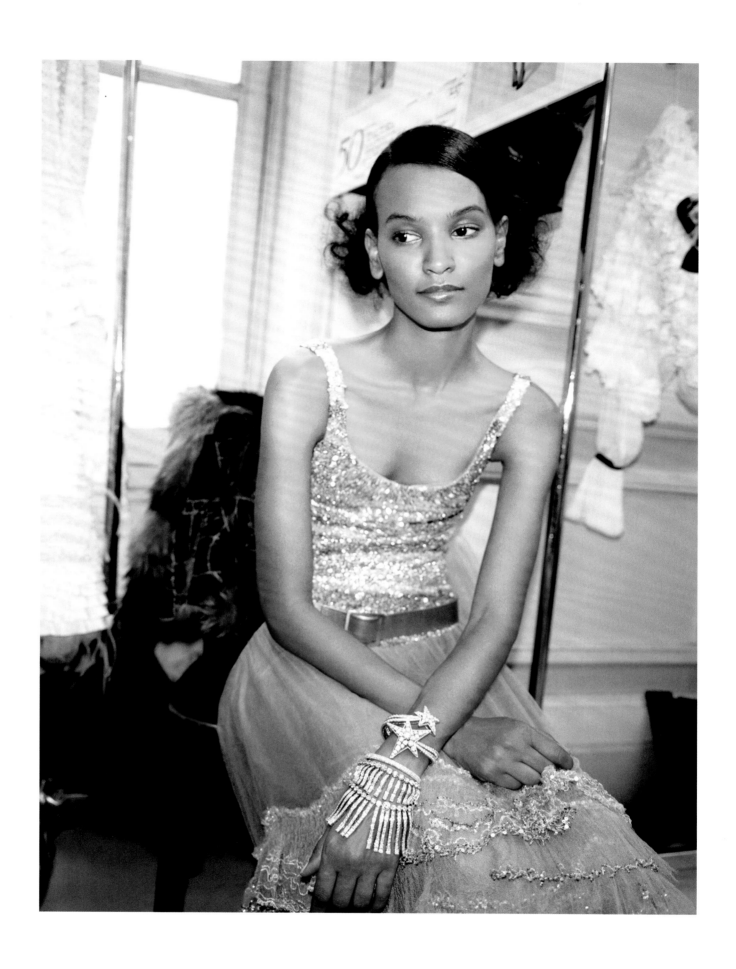

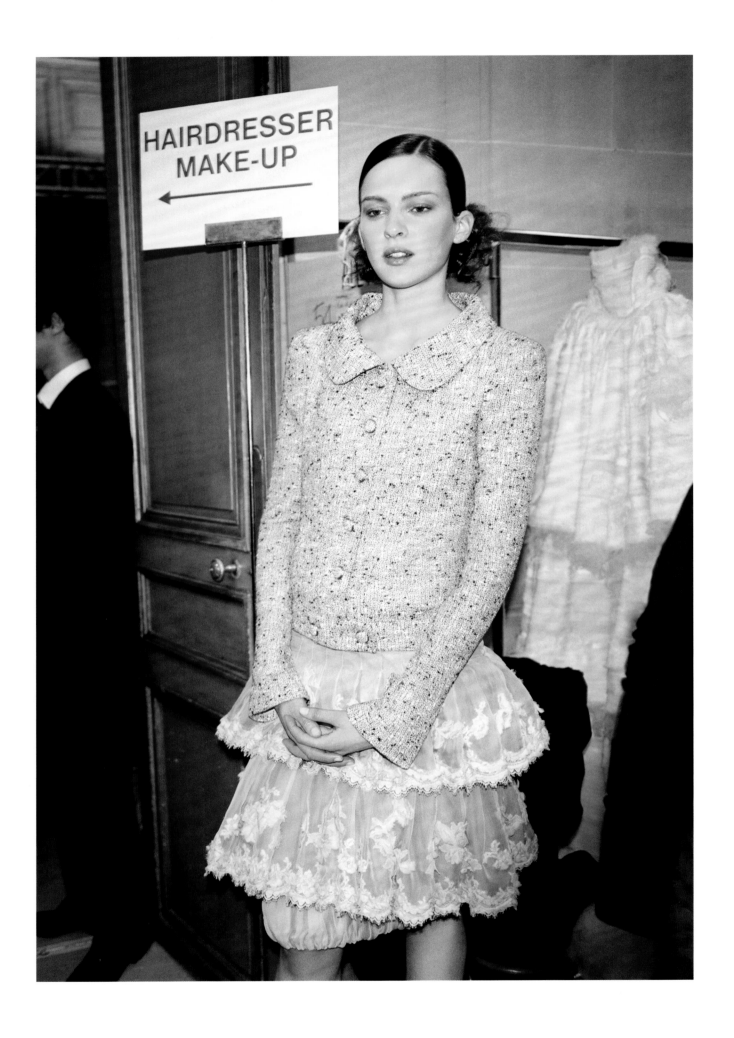

SPRING/SUMMER 2004 HAUTE COUTURE

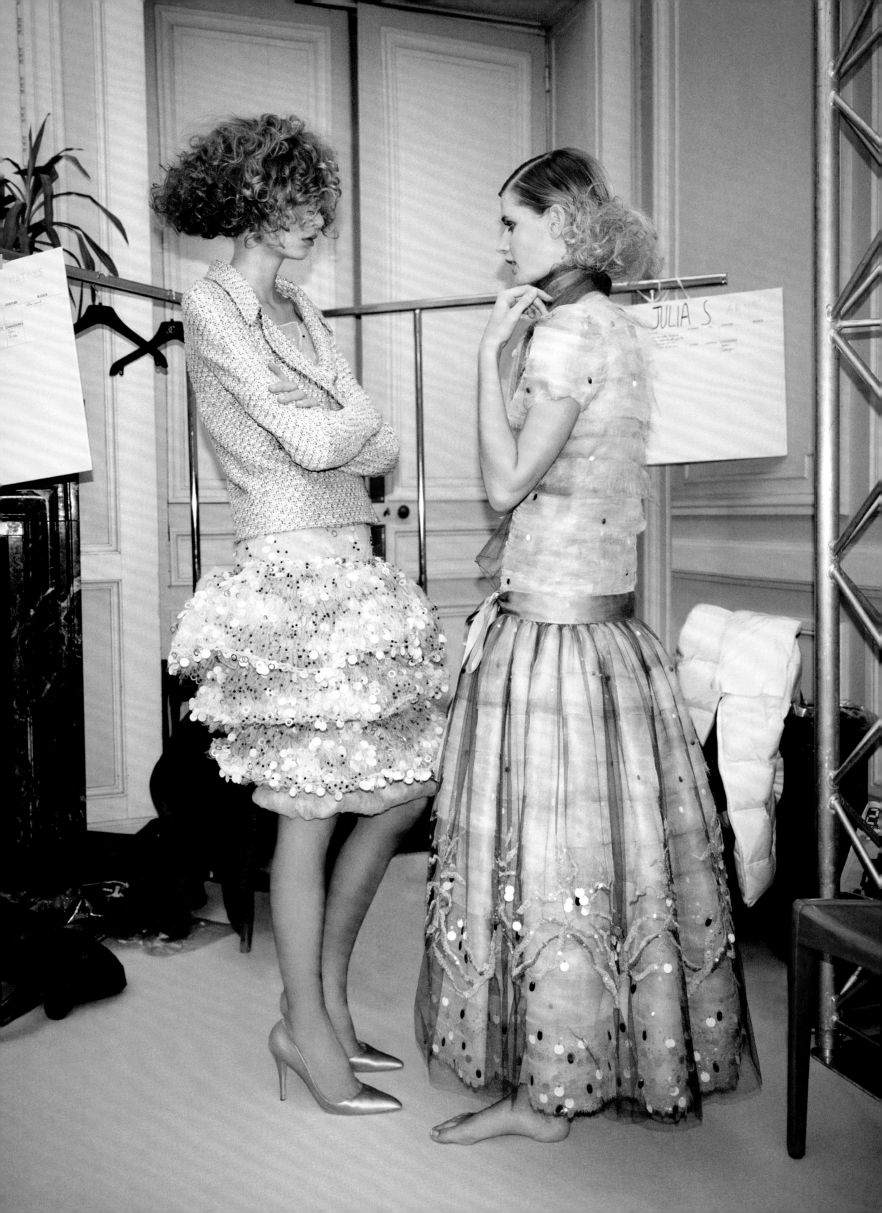

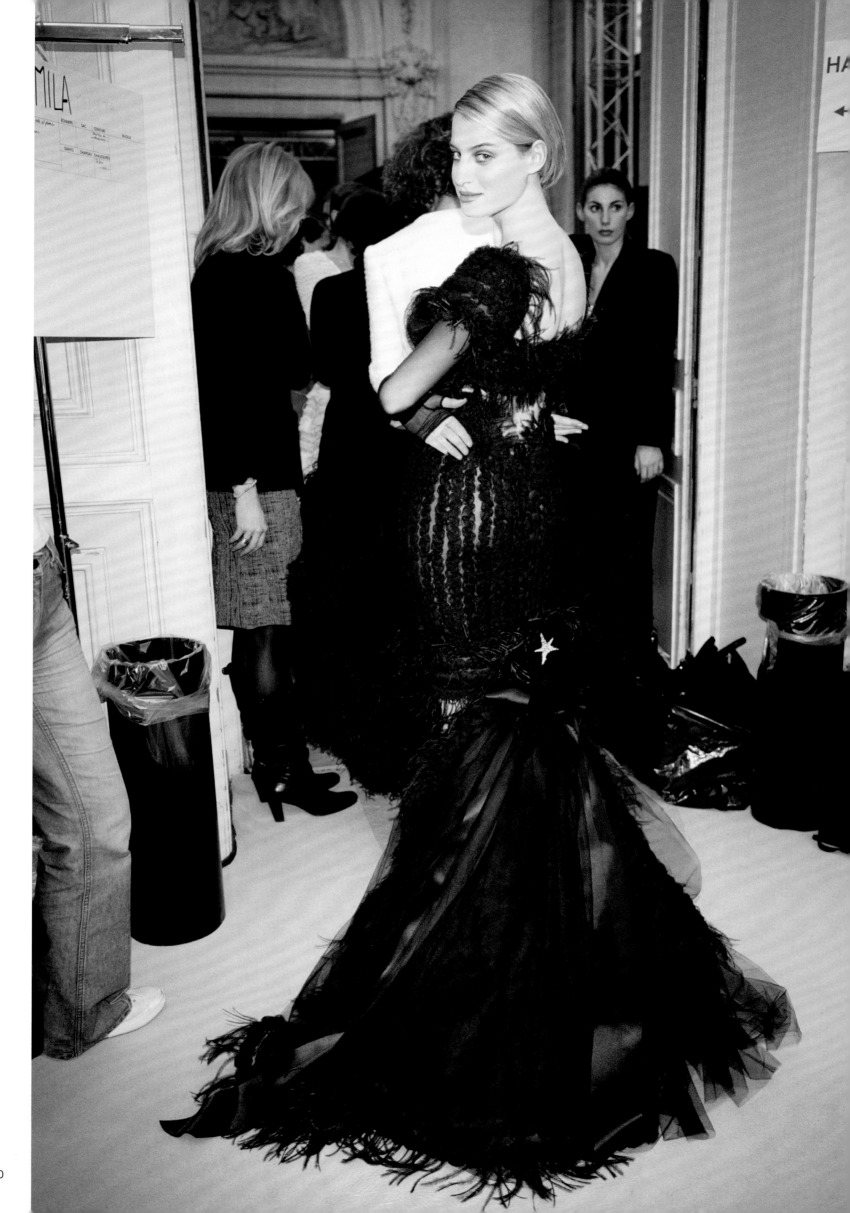

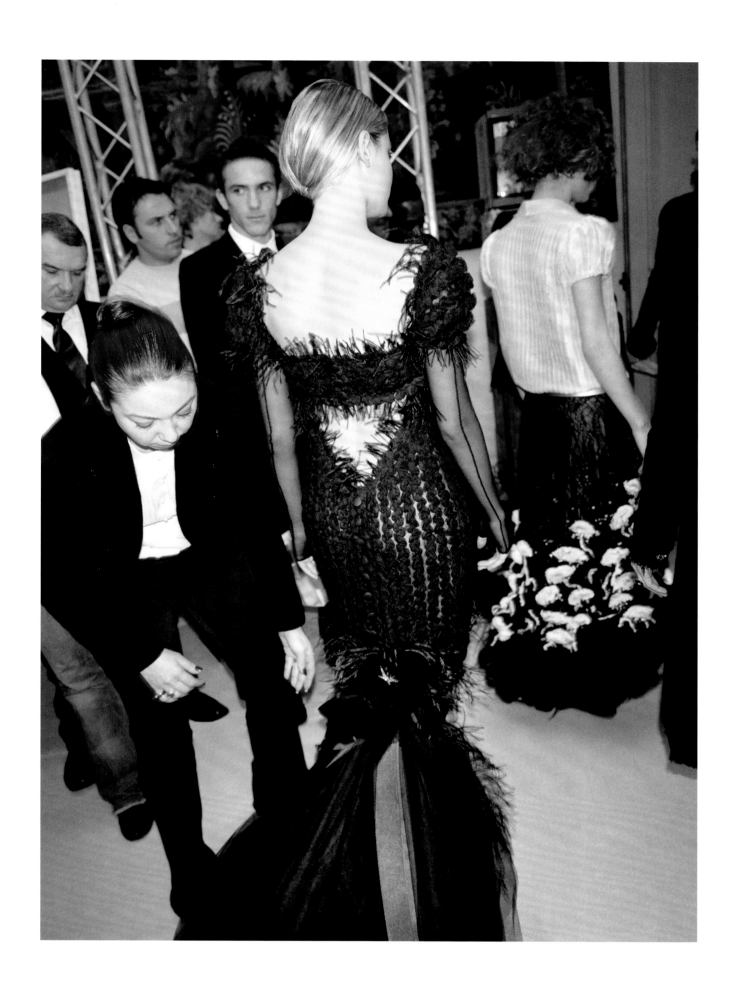

AUTUMN/WINTER 2004–2005
READY-TO-WEAR

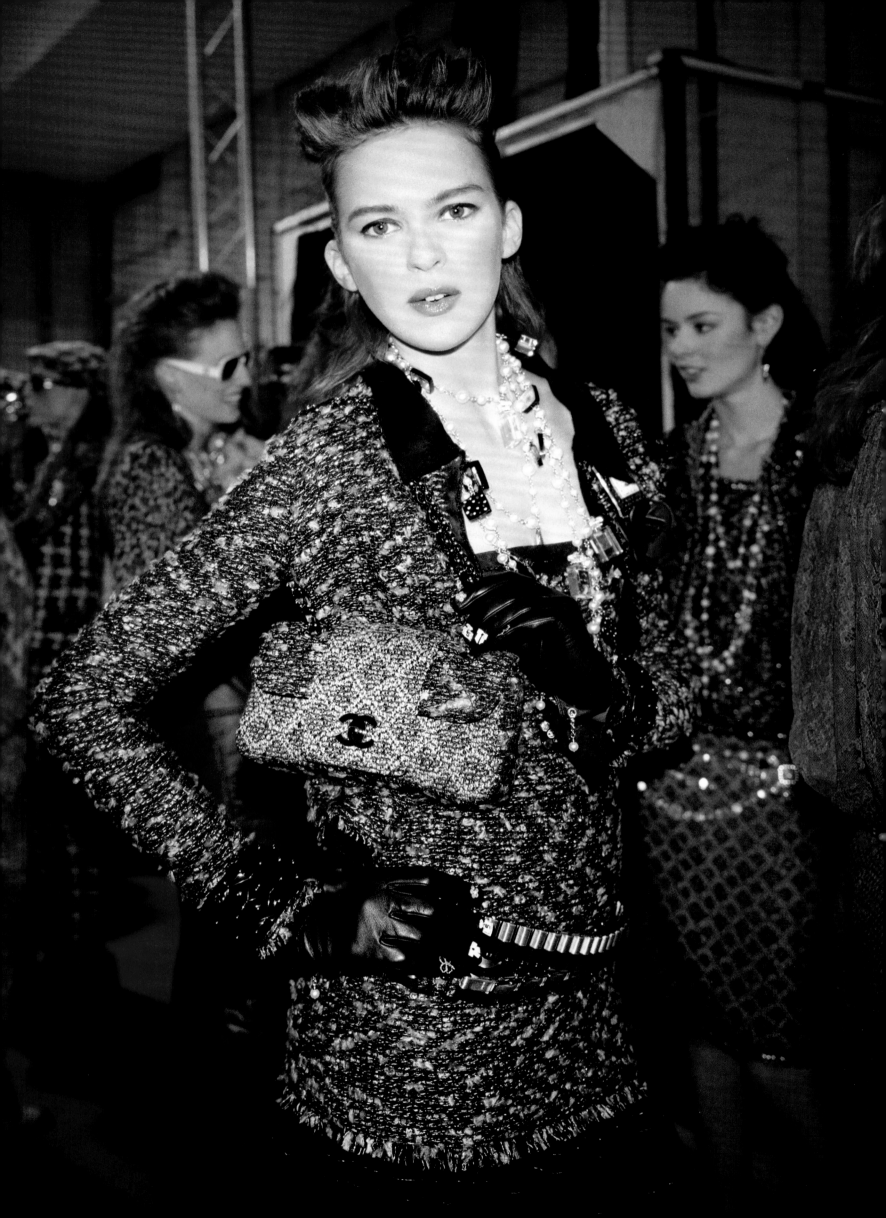

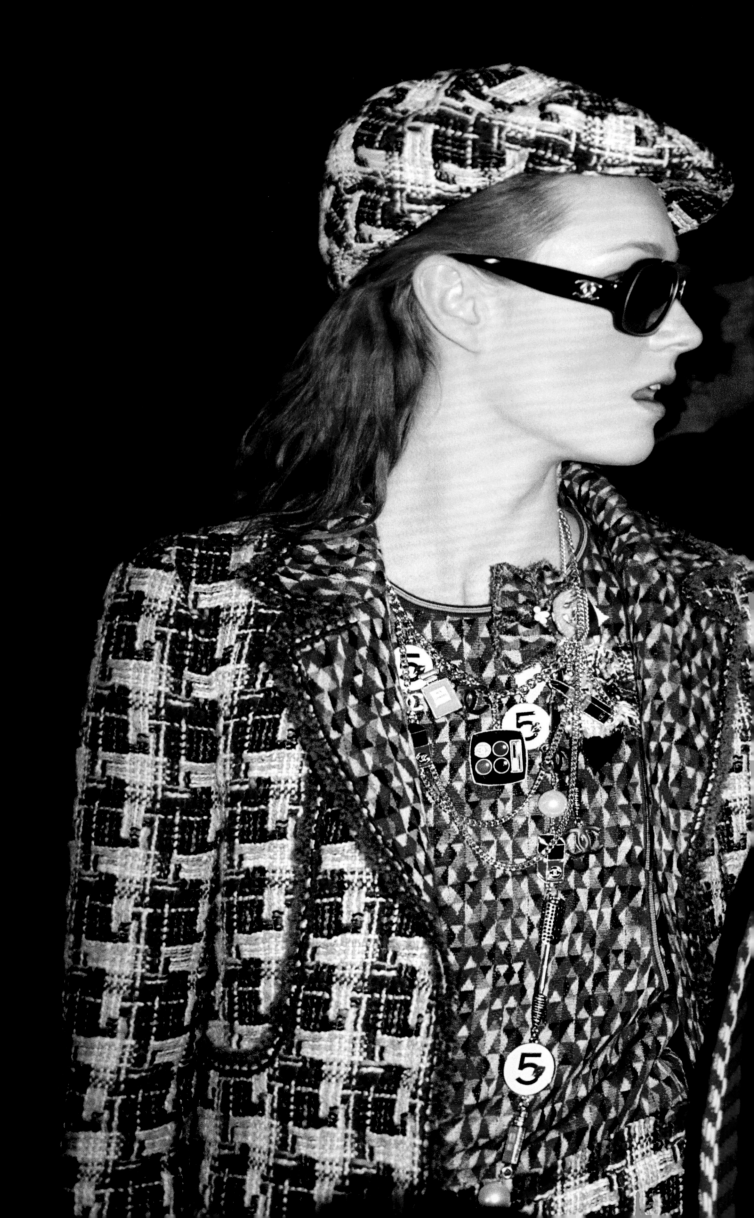

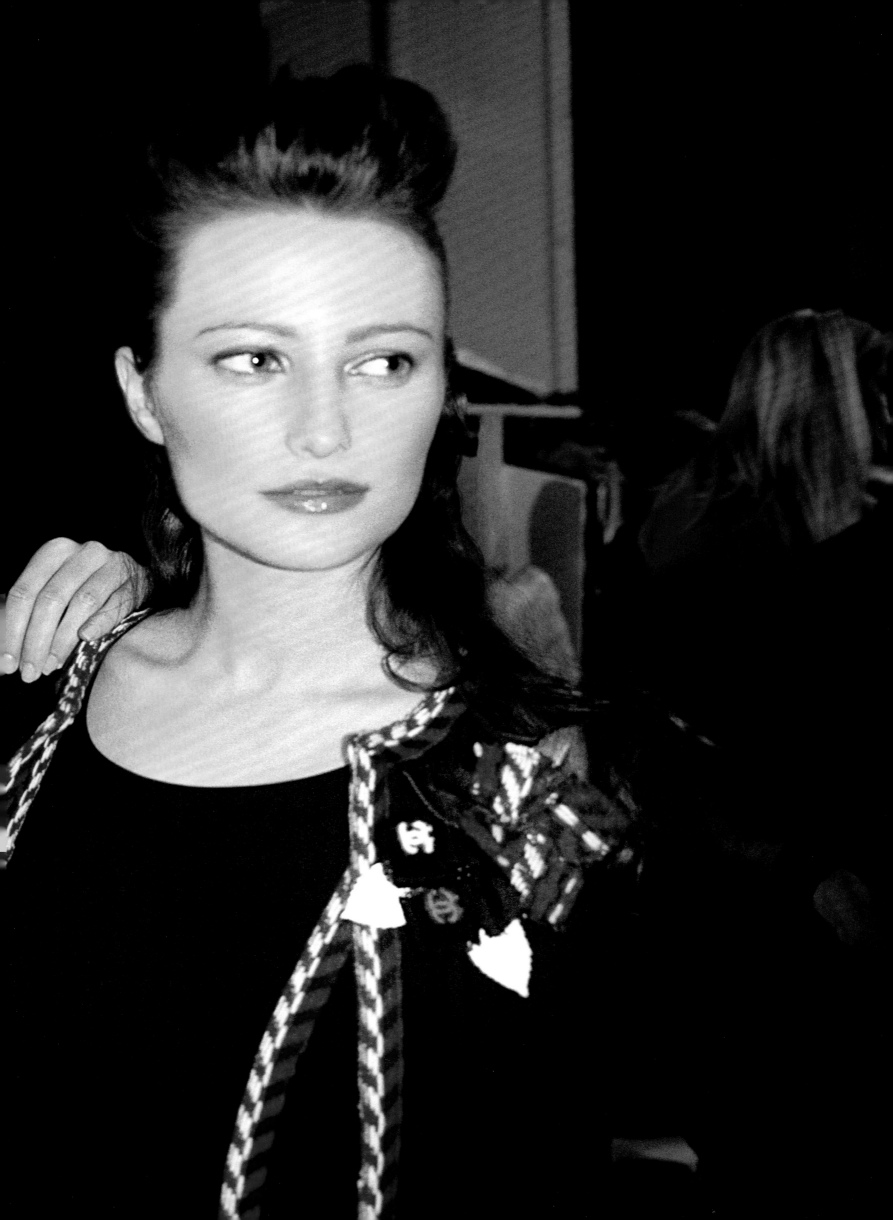

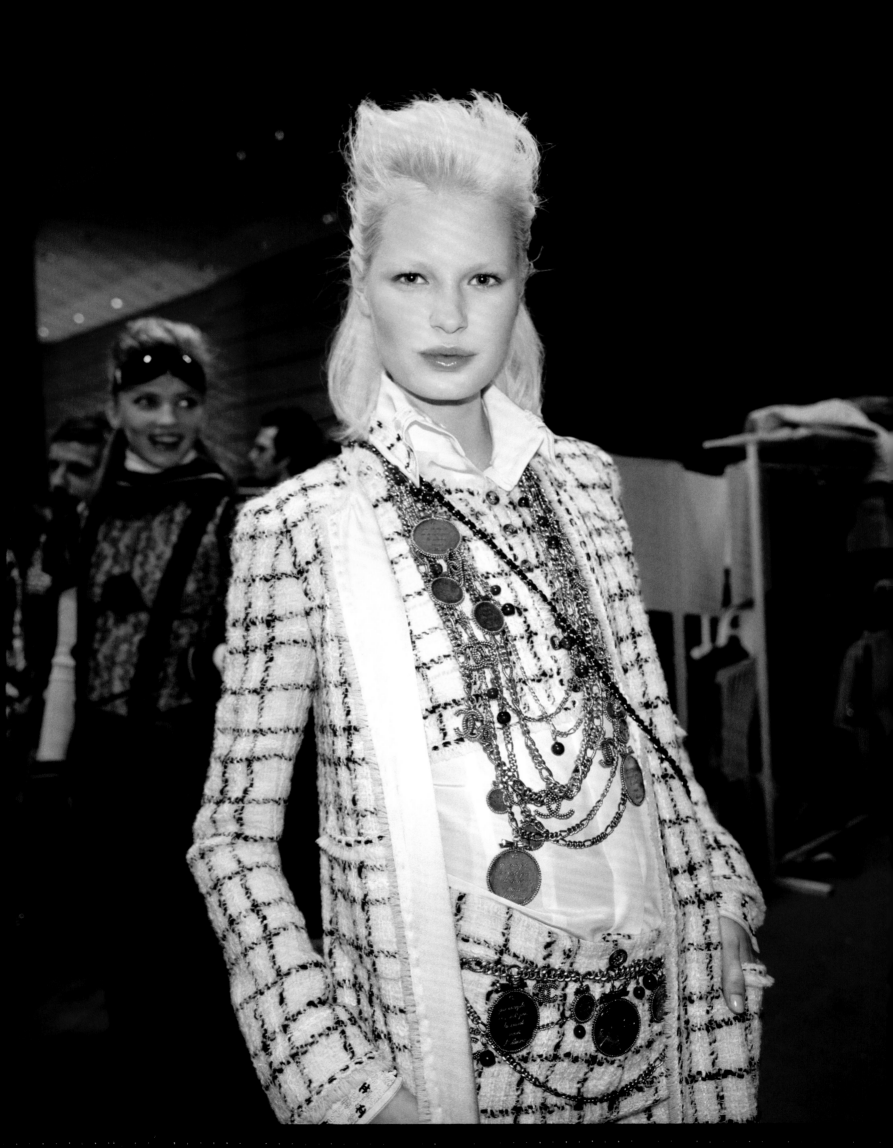

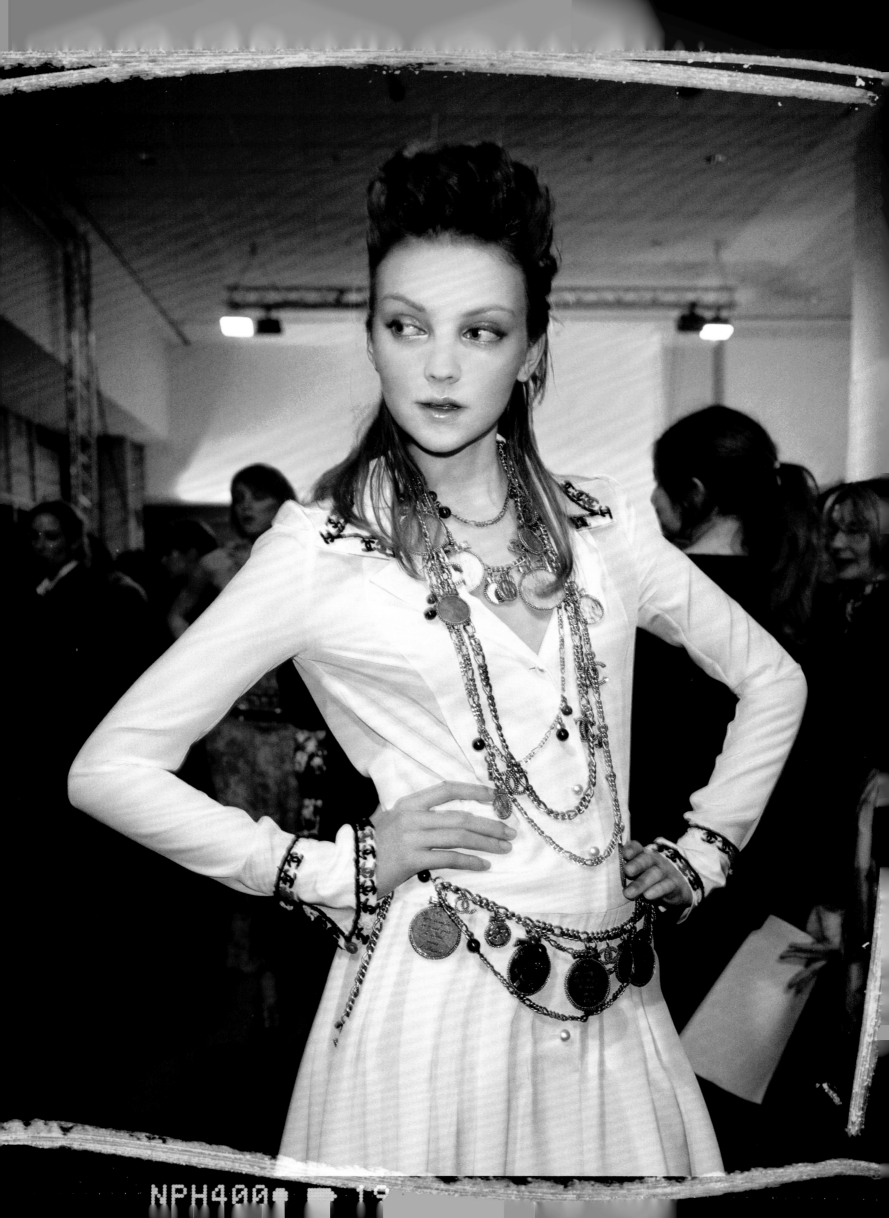

NPH400 19

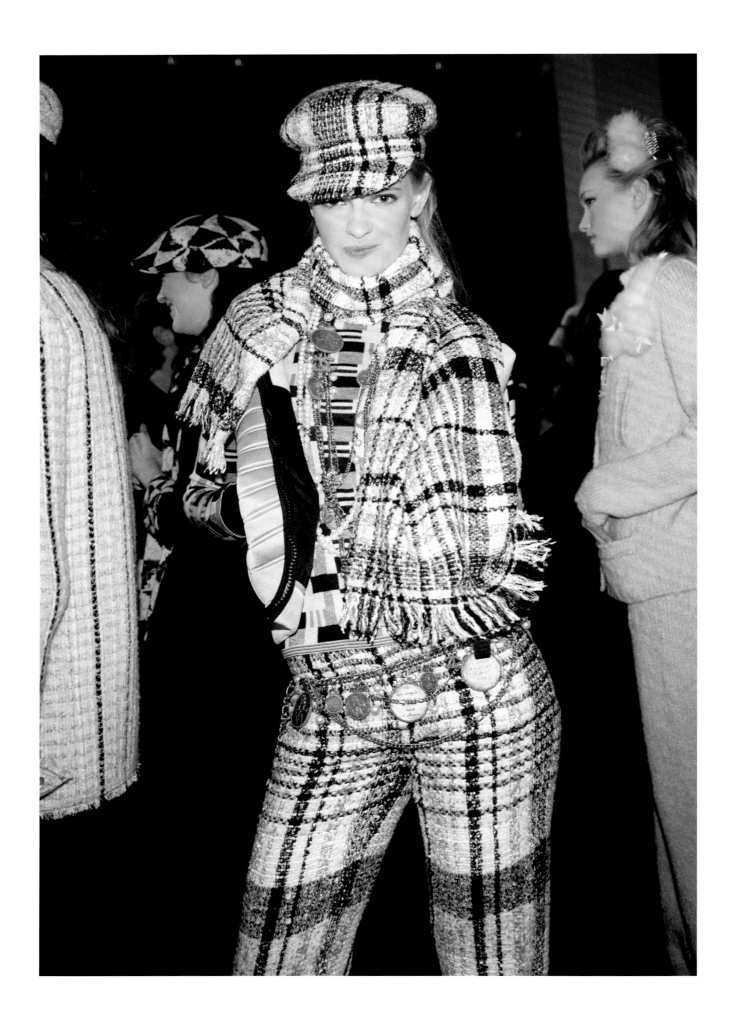

AUTUMN/WINTER 2004–2005 READY-TO-WEAR

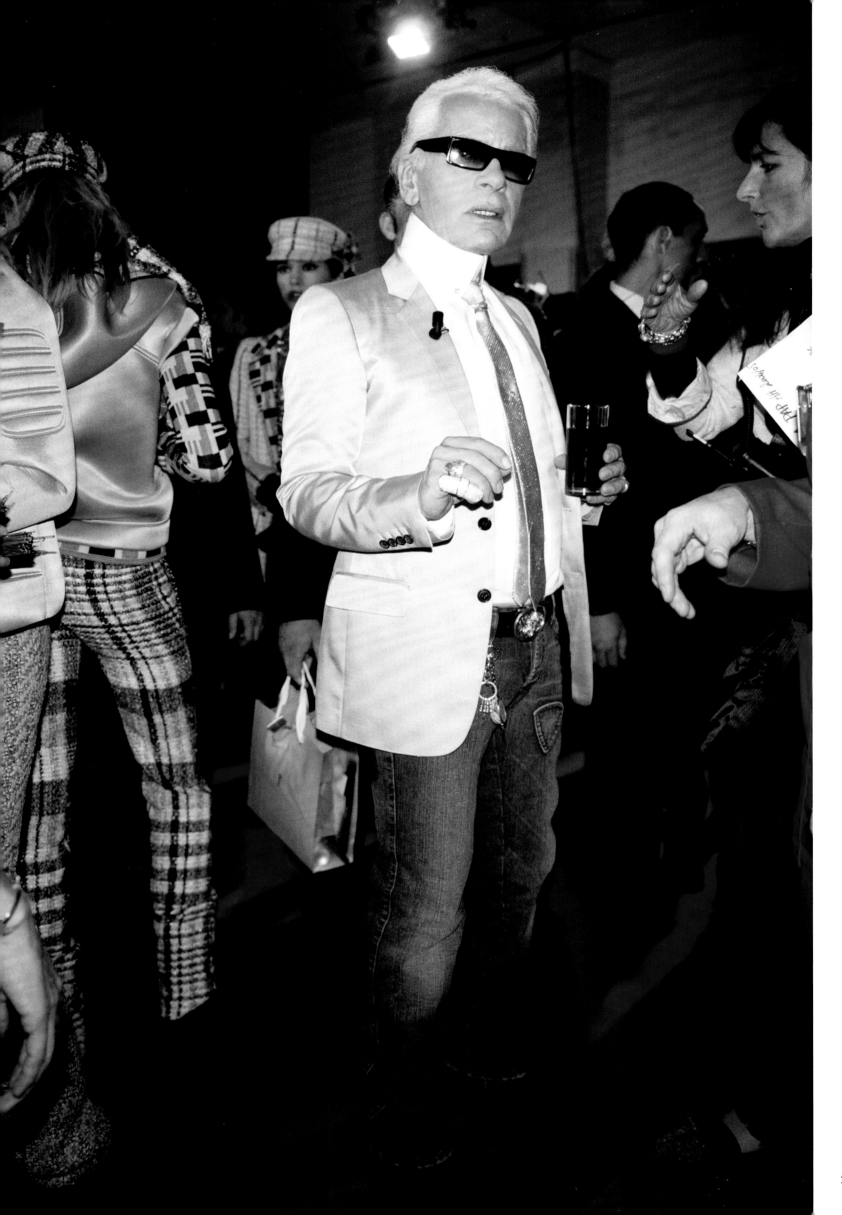

AUTUMN/WINTER 2004-2005
HAUTE COUTURE

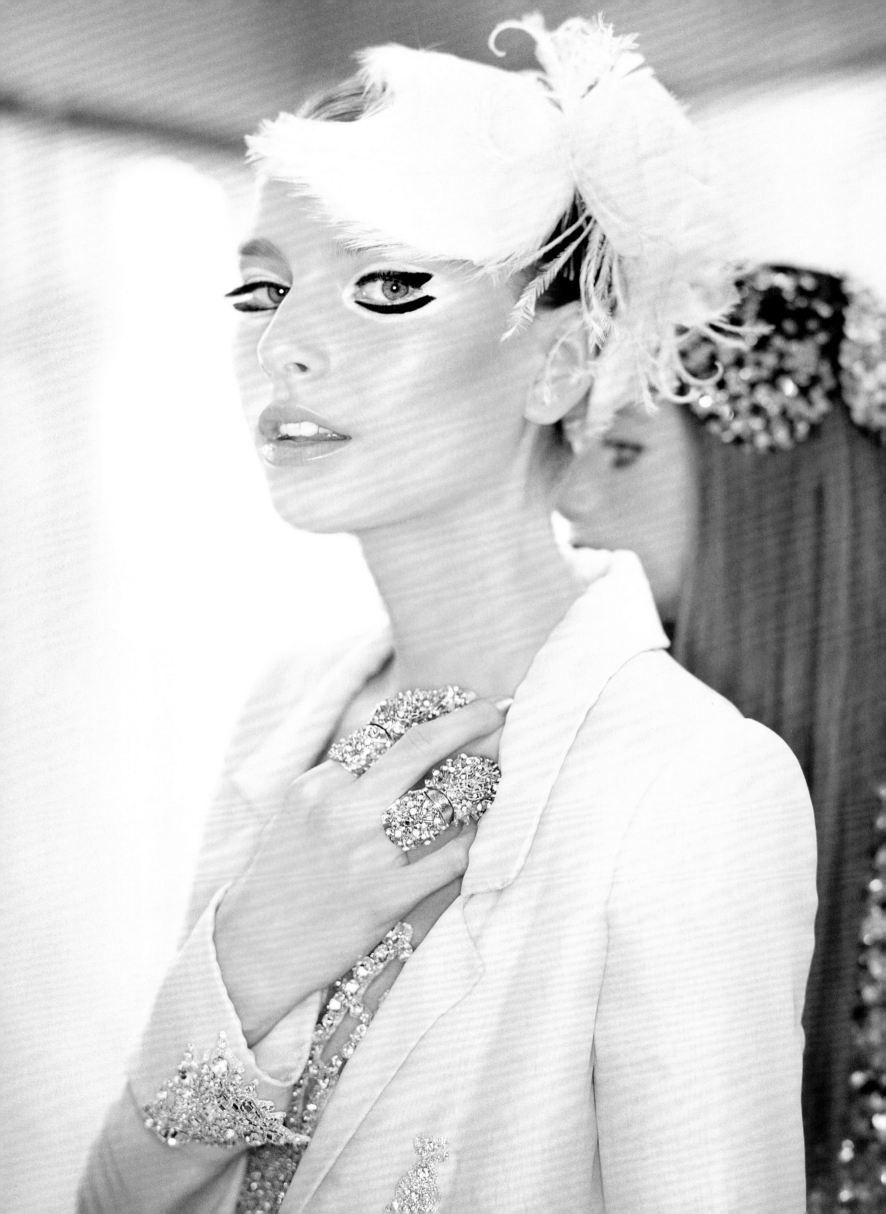

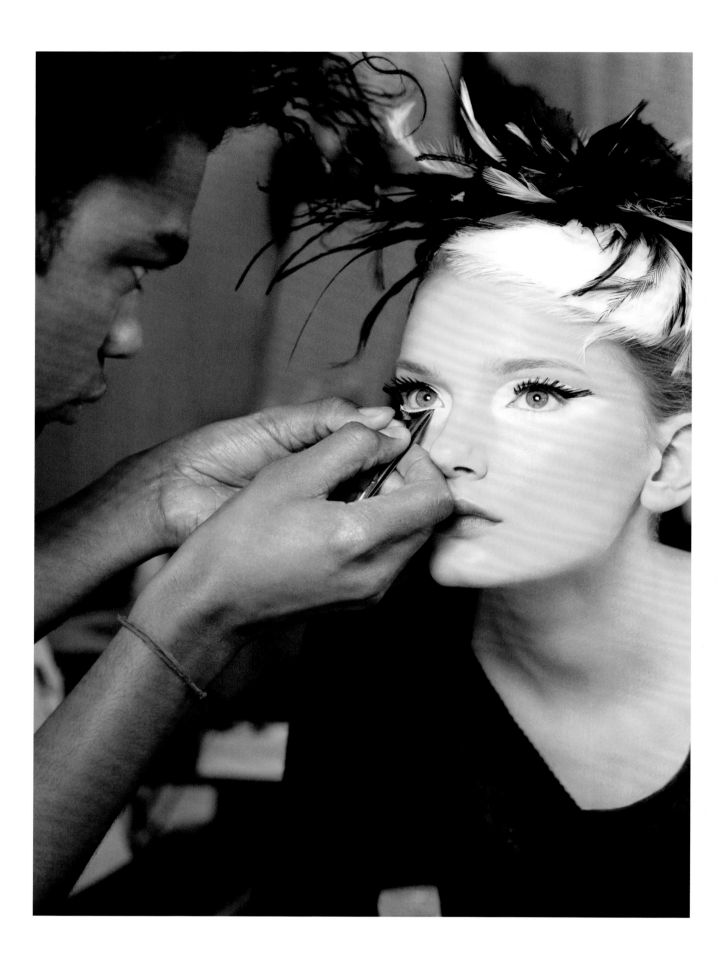

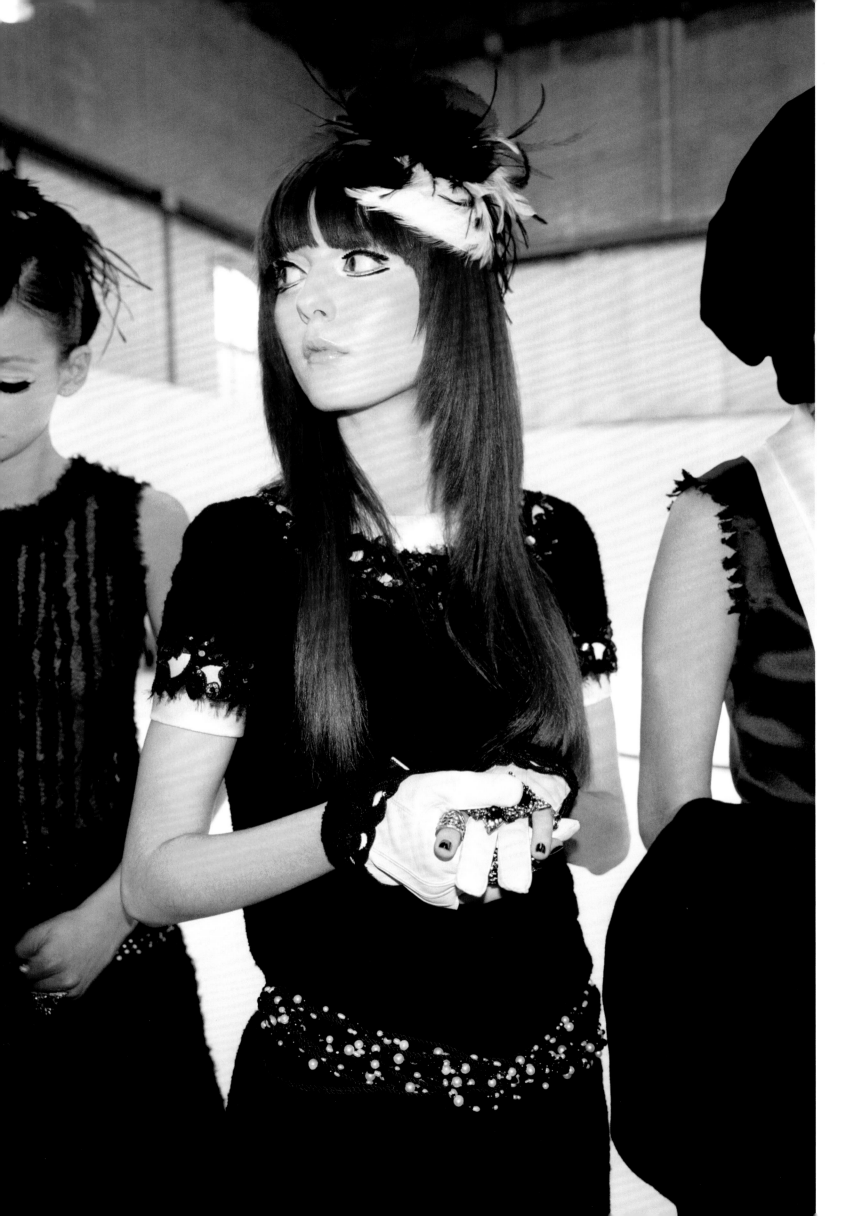

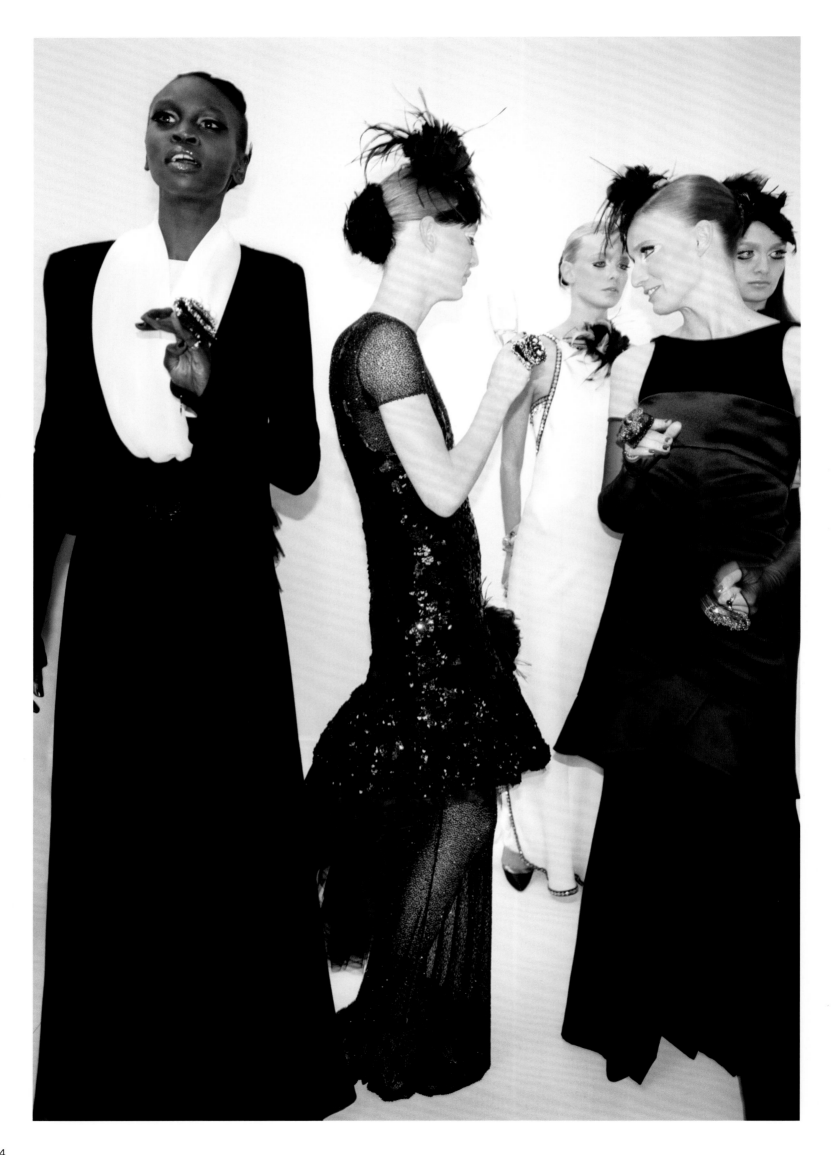

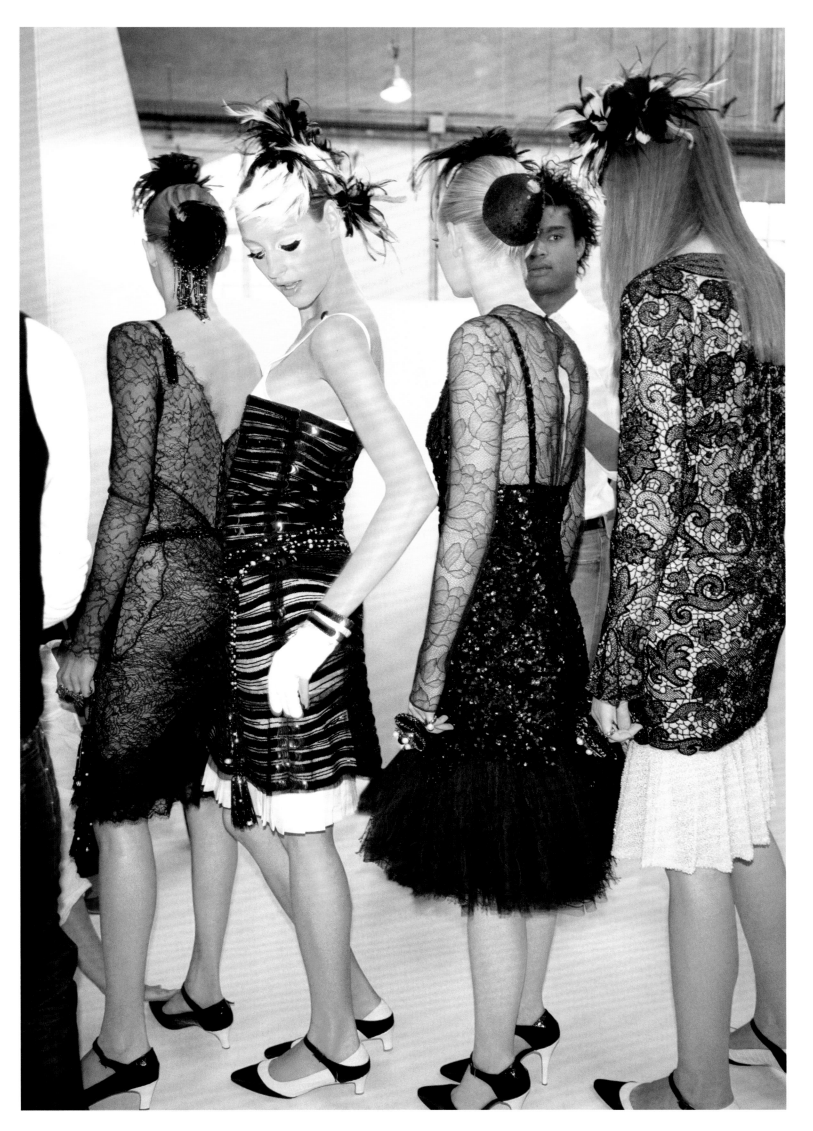

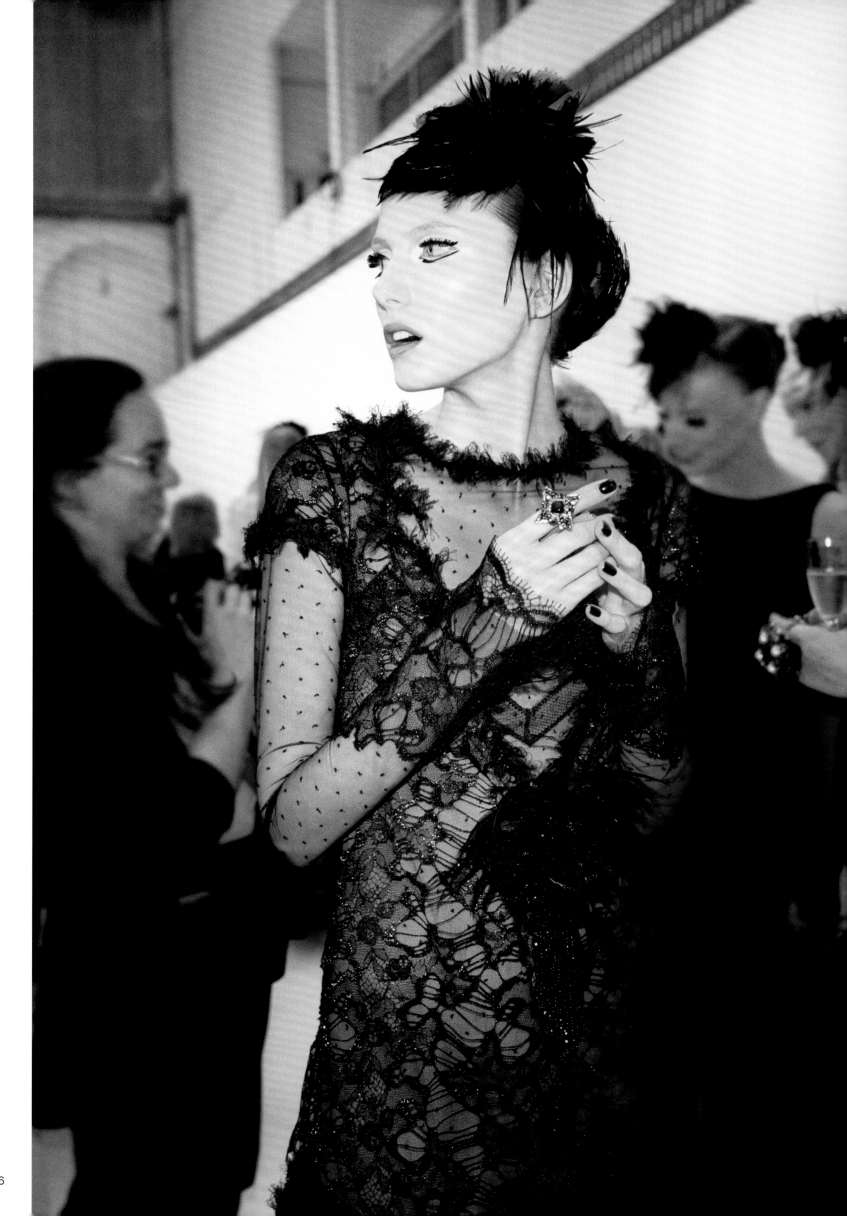

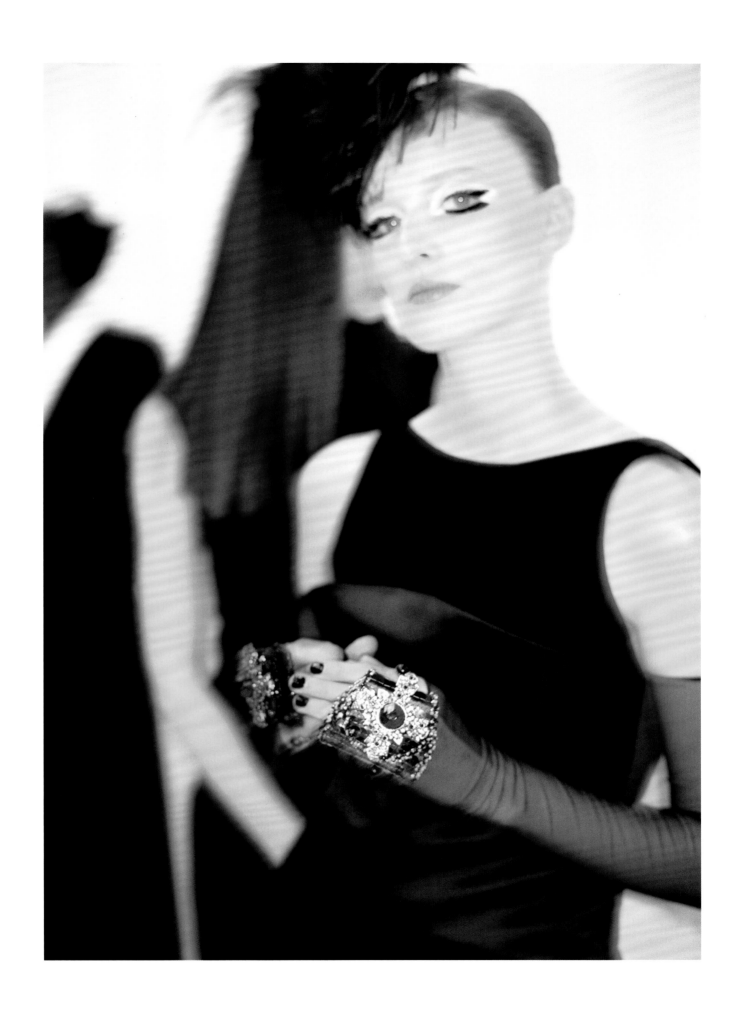

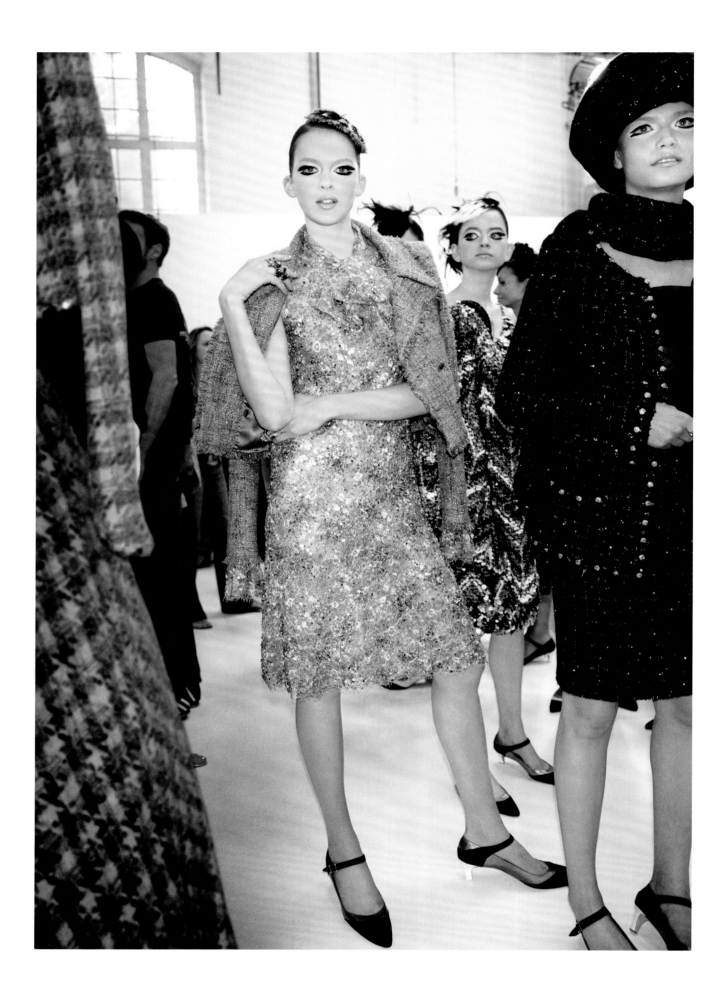

AUTUMN/WINTER 2004–2005 HAUTE COUTURE

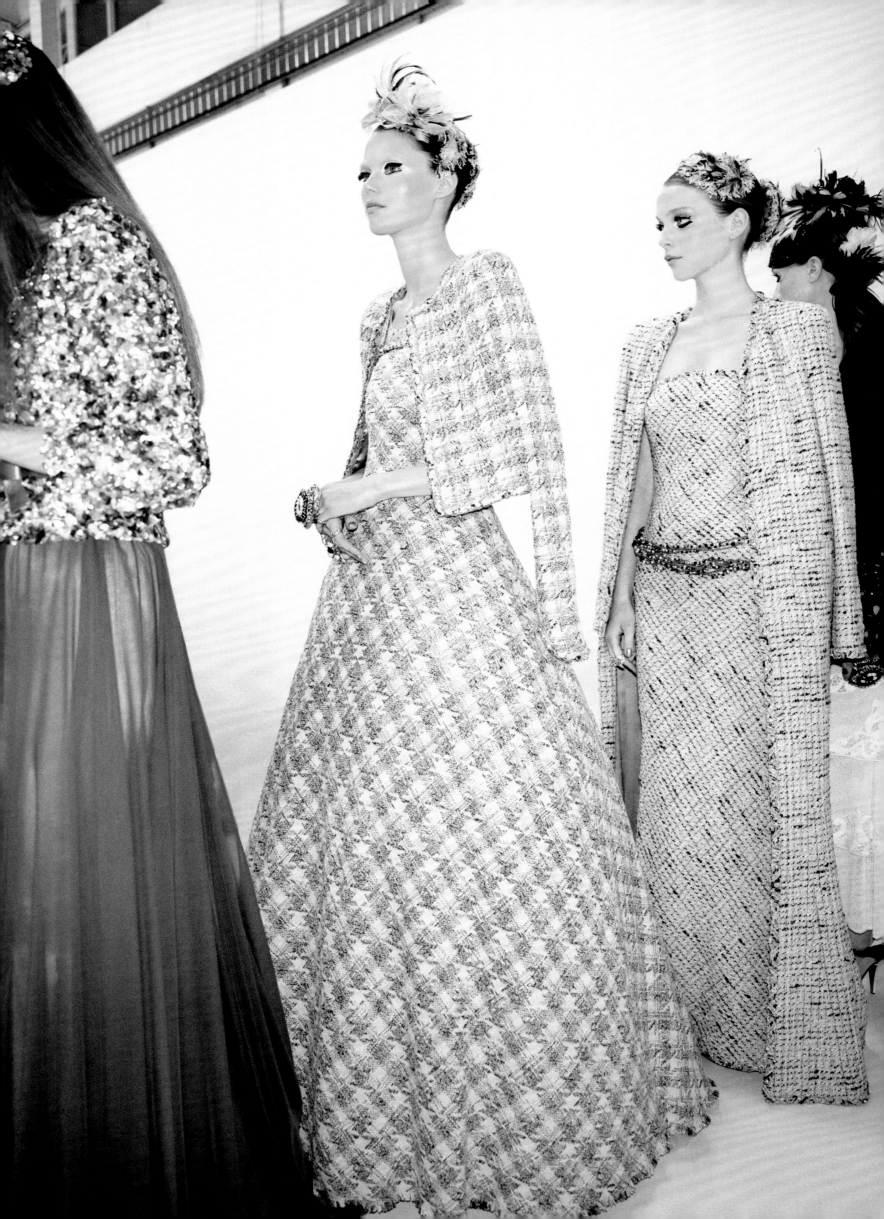

'The suspended instant when what a girl
is wearing suddenly makes sense
and she begins to own the outfit...
A magical moment but as fleeting
as an intake of breath'

Amanda Harlech

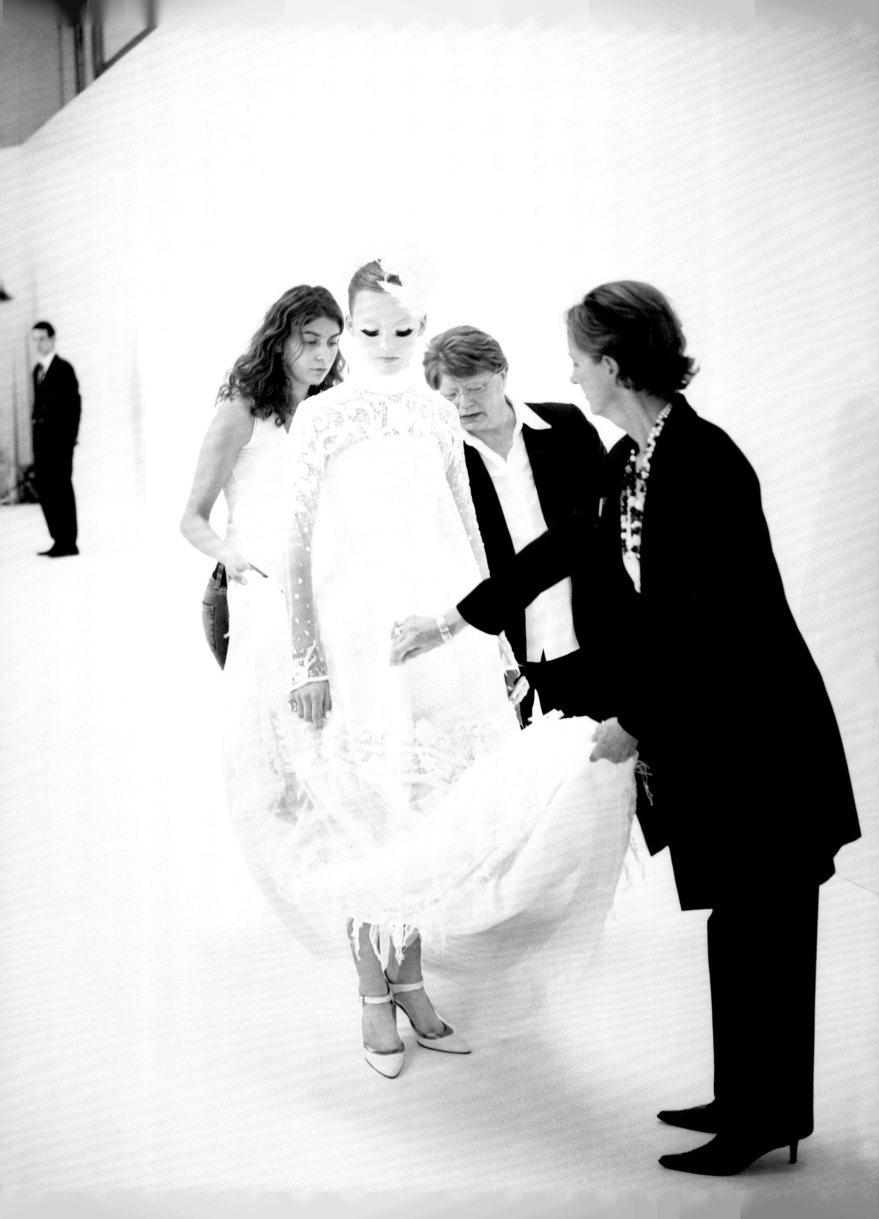

SPRING/SUMMER 2005
READY-TO-WEAR

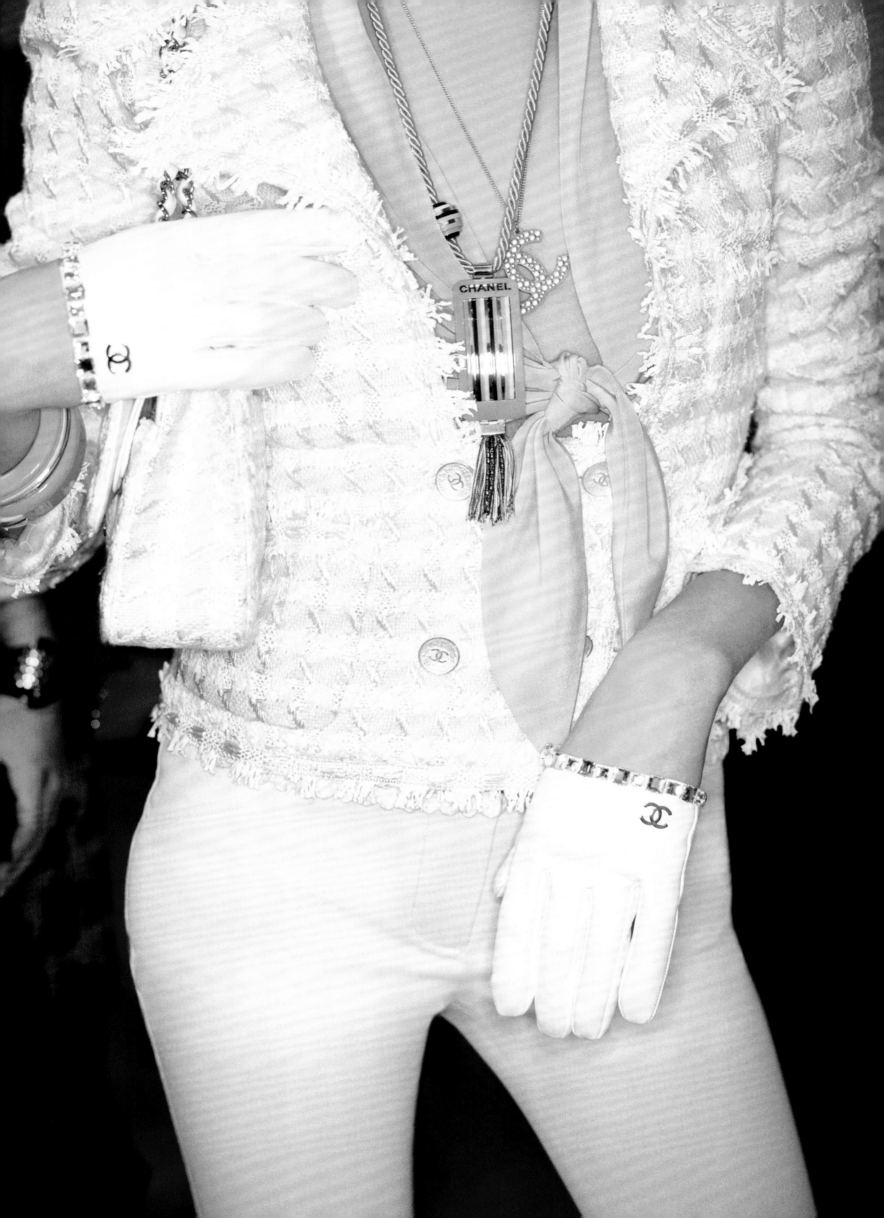

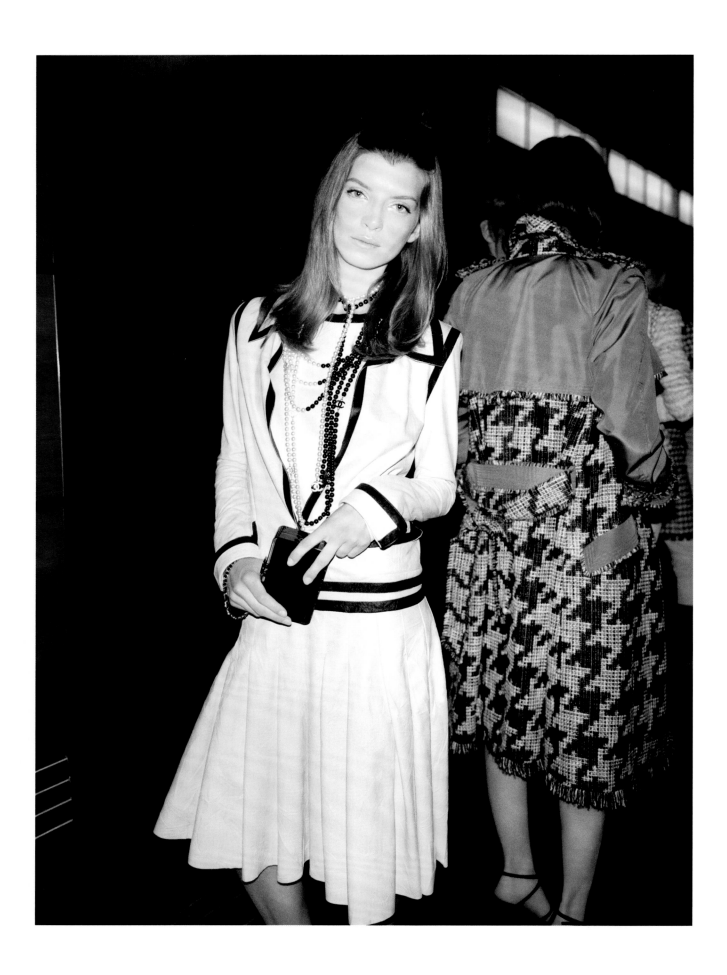

SPRING/SUMMER 2005 READY-TO-WEAR

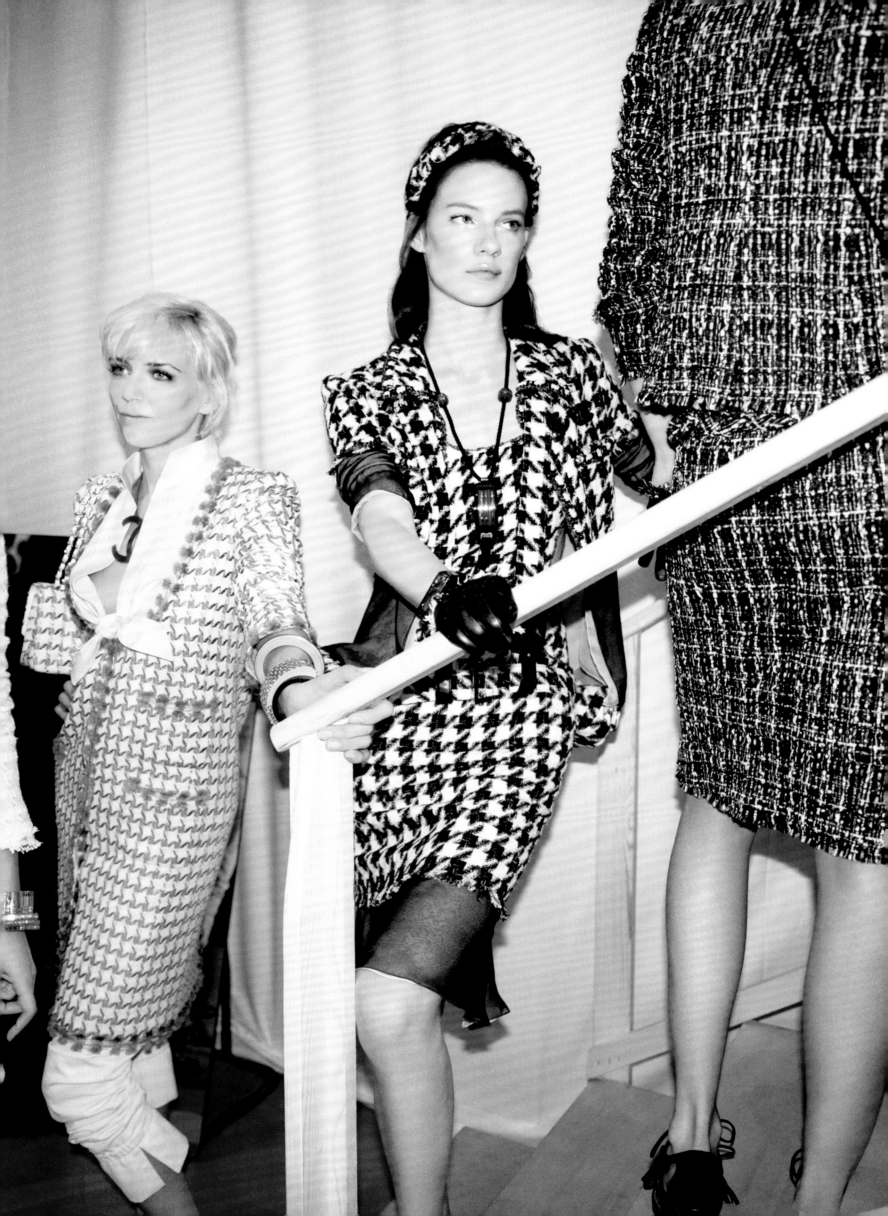

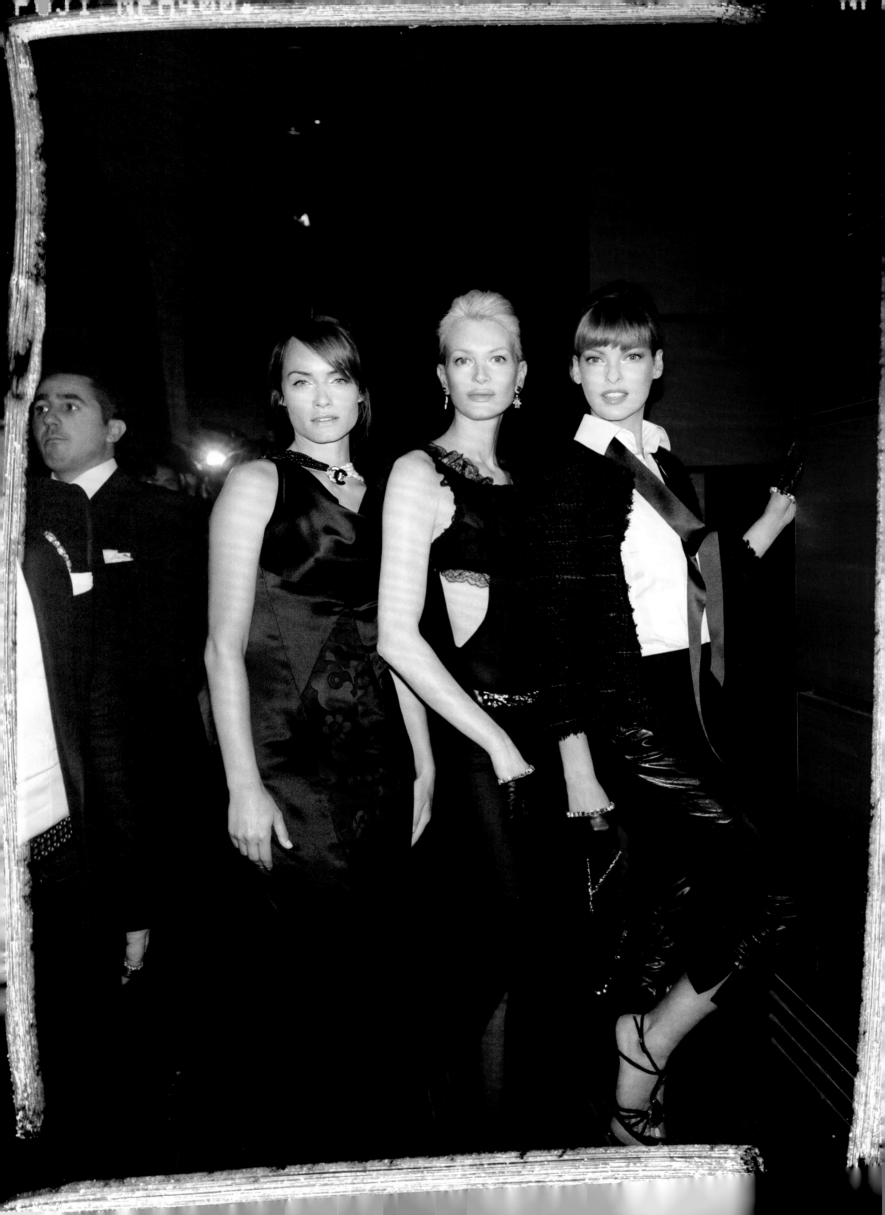

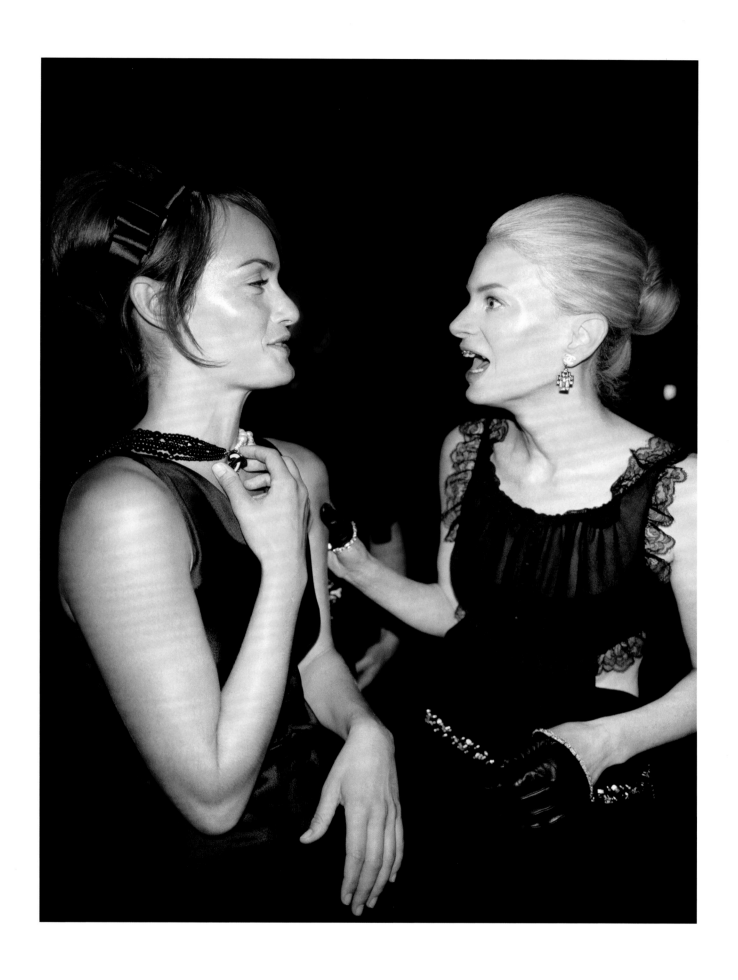

SPRING/SUMMER 2005
HAUTE COUTURE

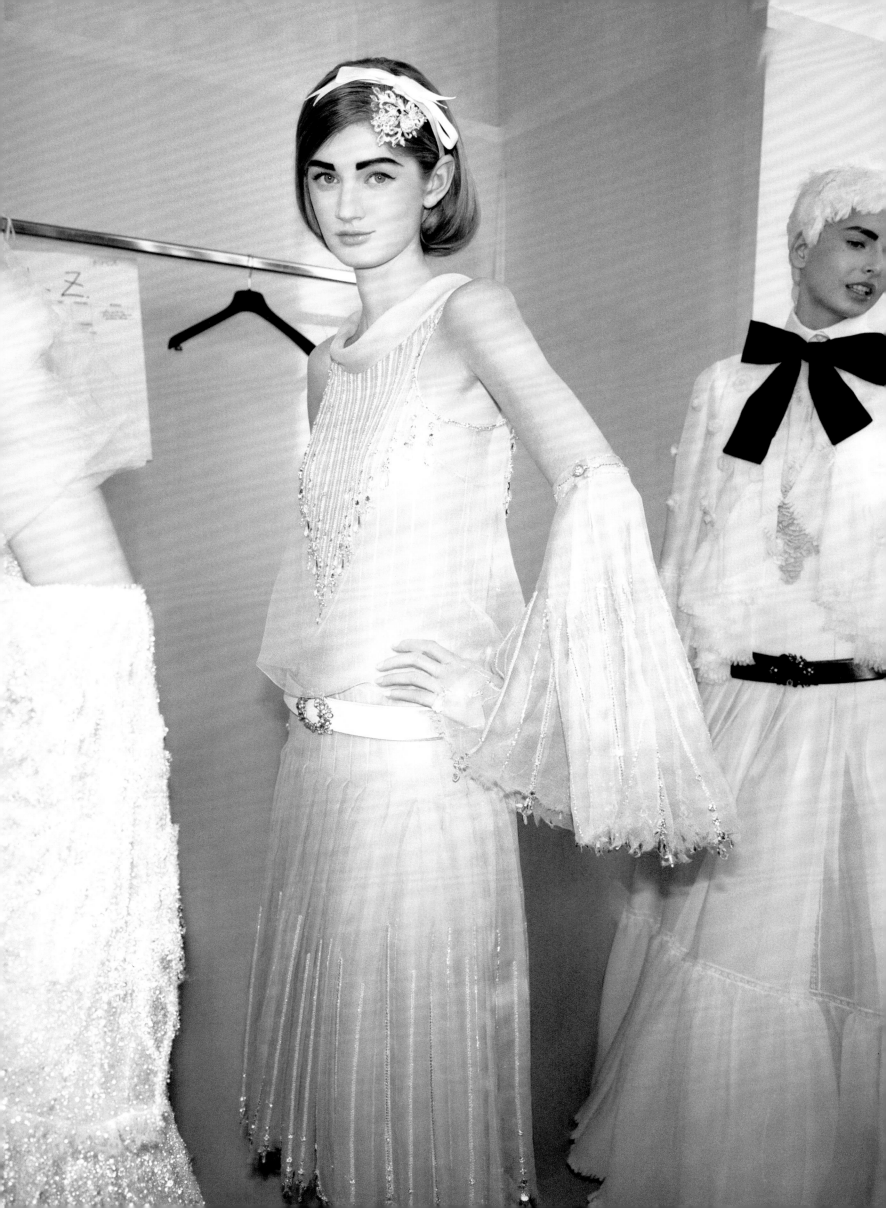

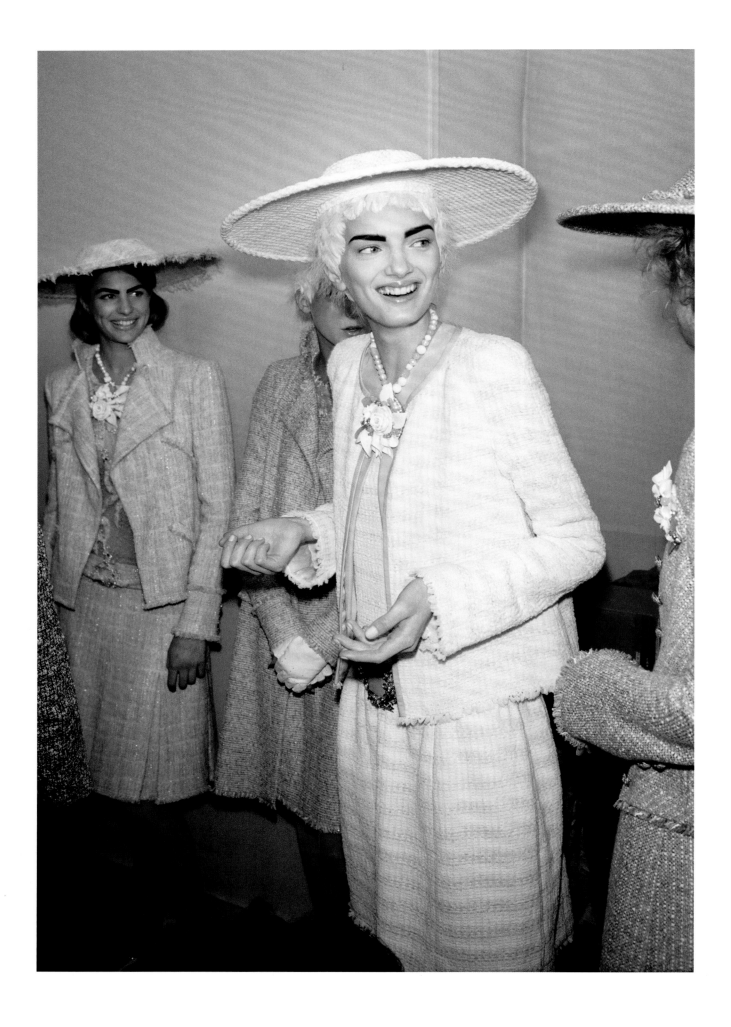

SPRING/SUMMER 2005 HAUTE COUTURE

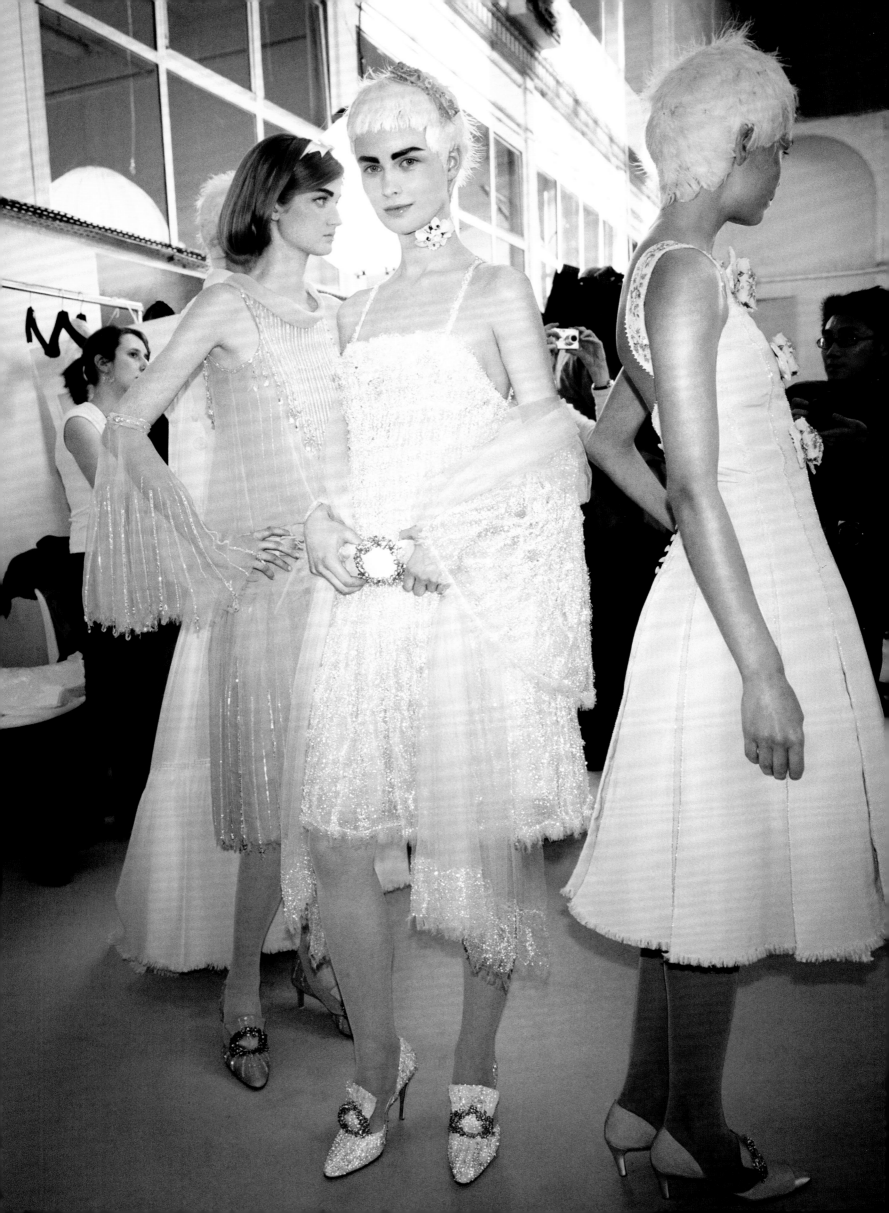

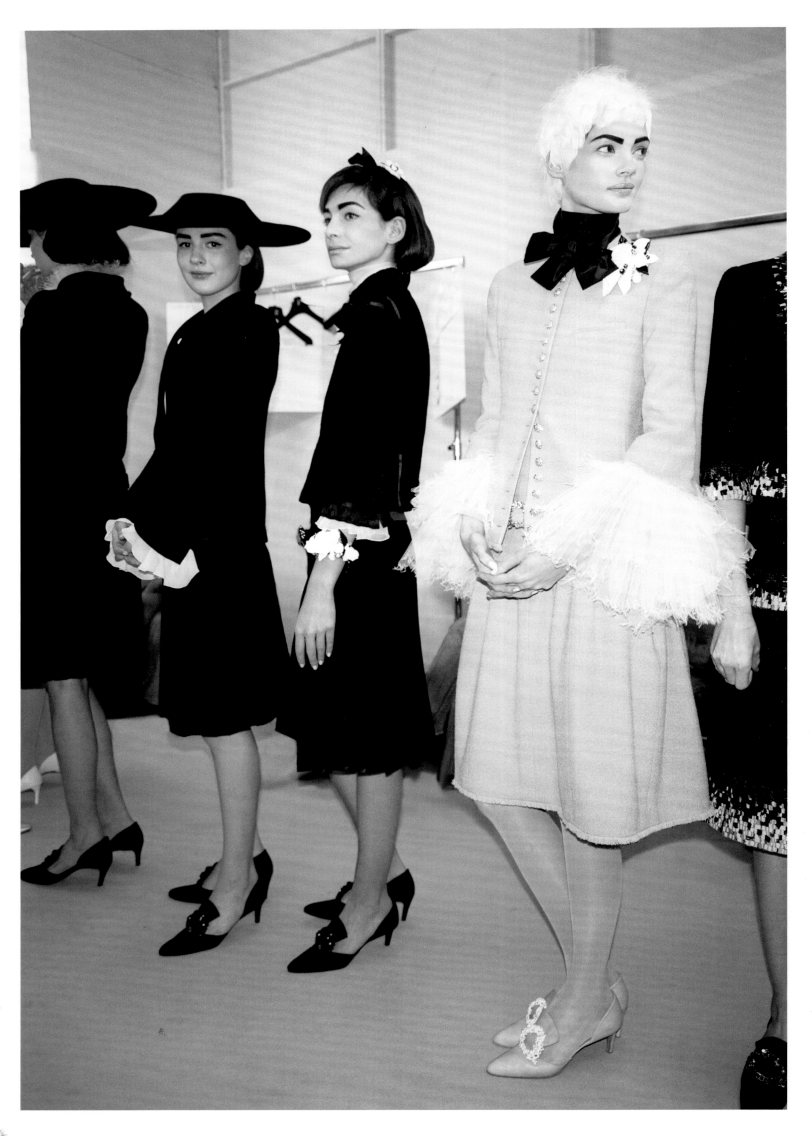

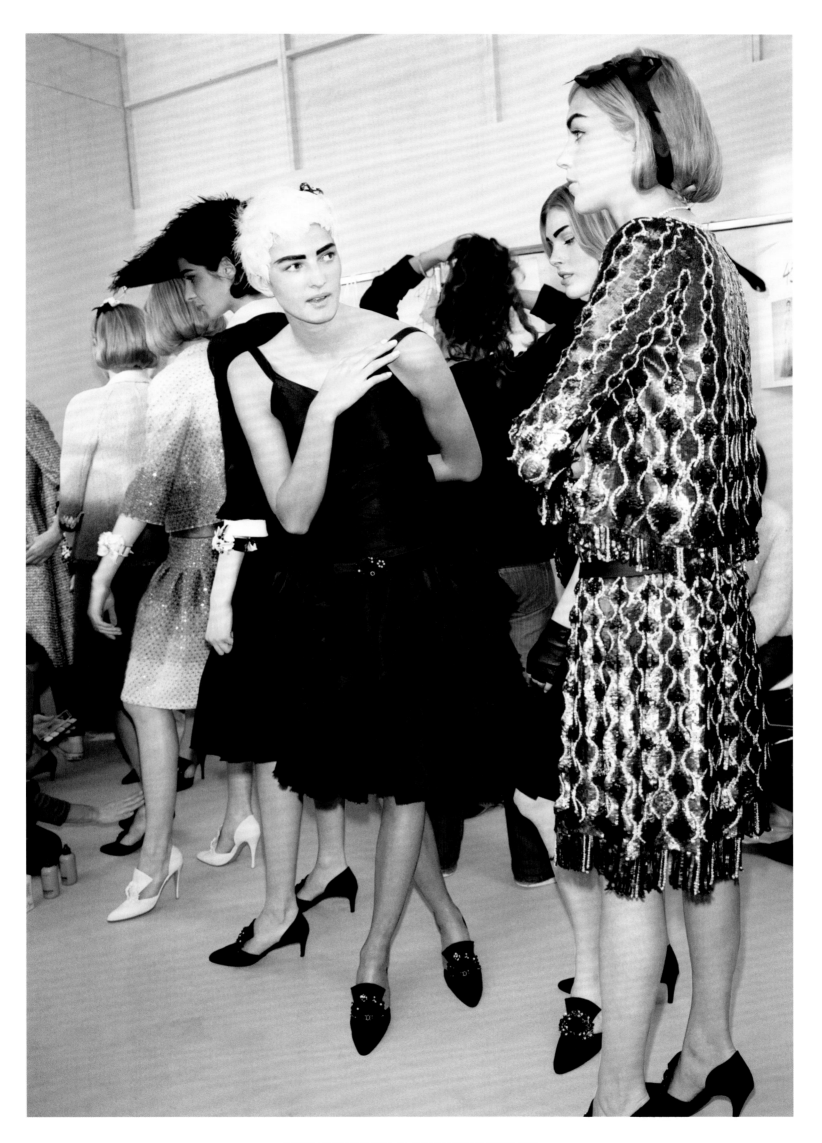

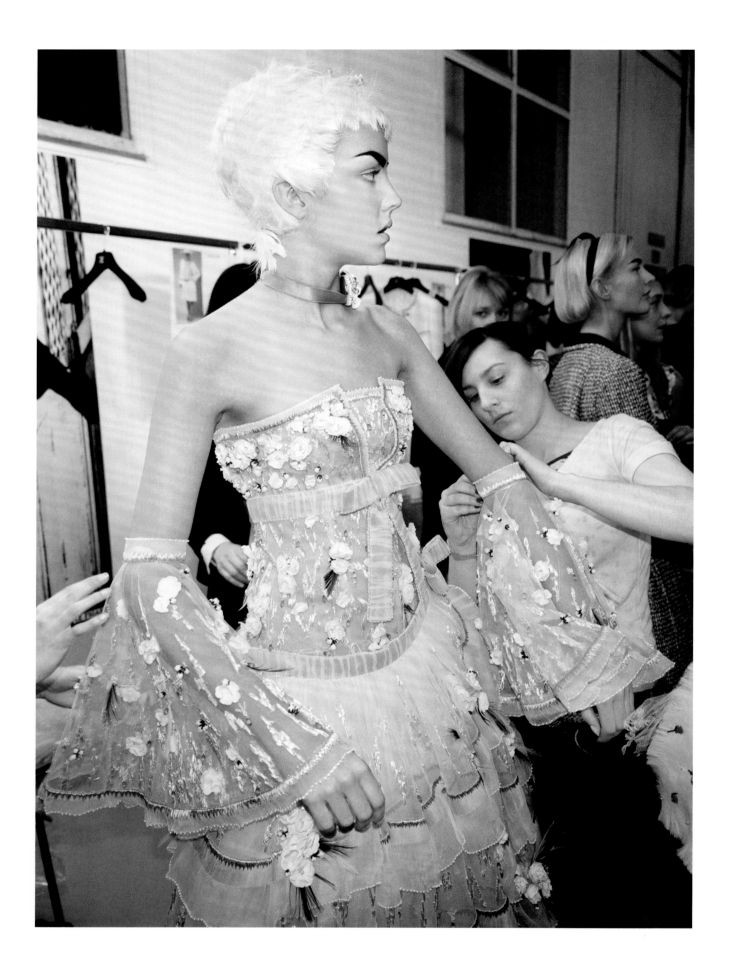

SPRING/SUMMER 2005 HAUTE COUTURE

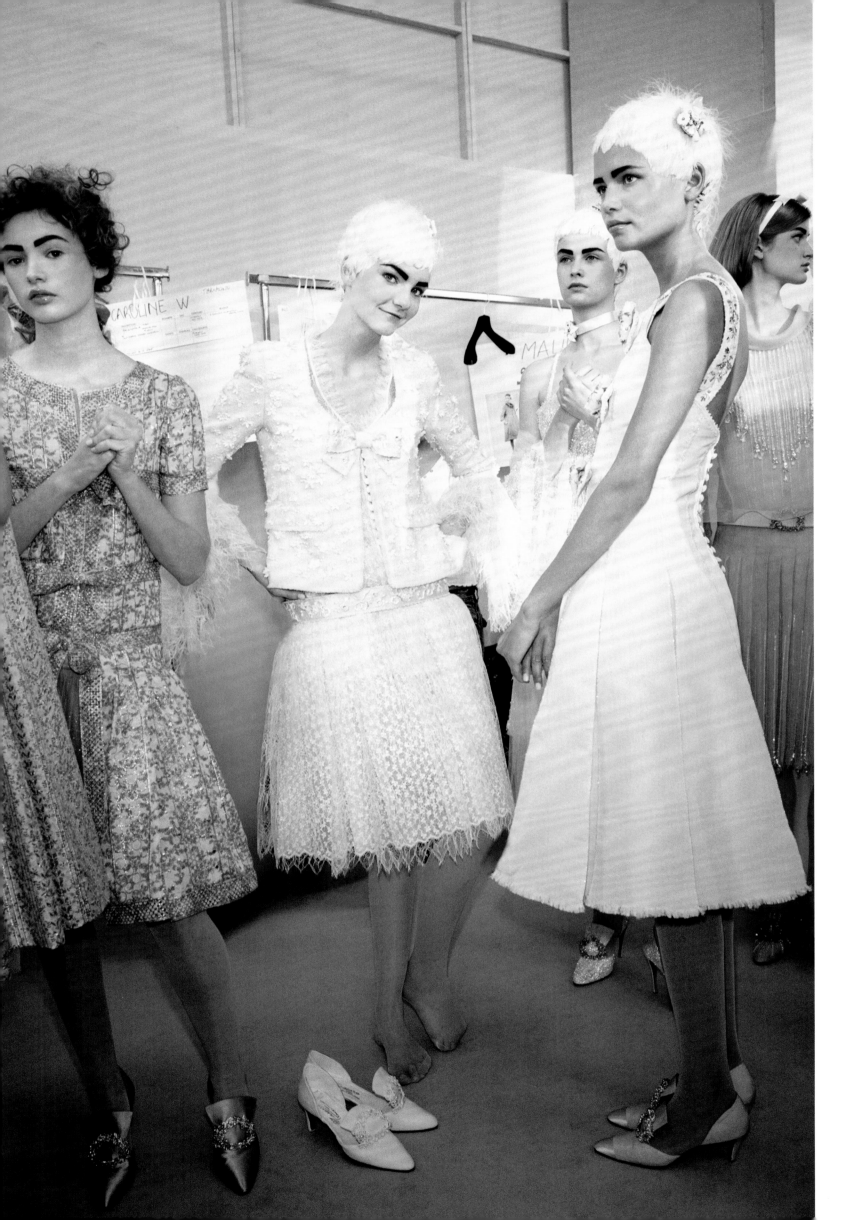

'I so admired Karl for his complete and unfaltering respect for technique and craftsmanship in his profession.
I also admired how his mind worked, aligning world history with the history of modern cinema, literature, and poetry. Every moment with Karl was an exciting tutorial.'

André Leon Talley

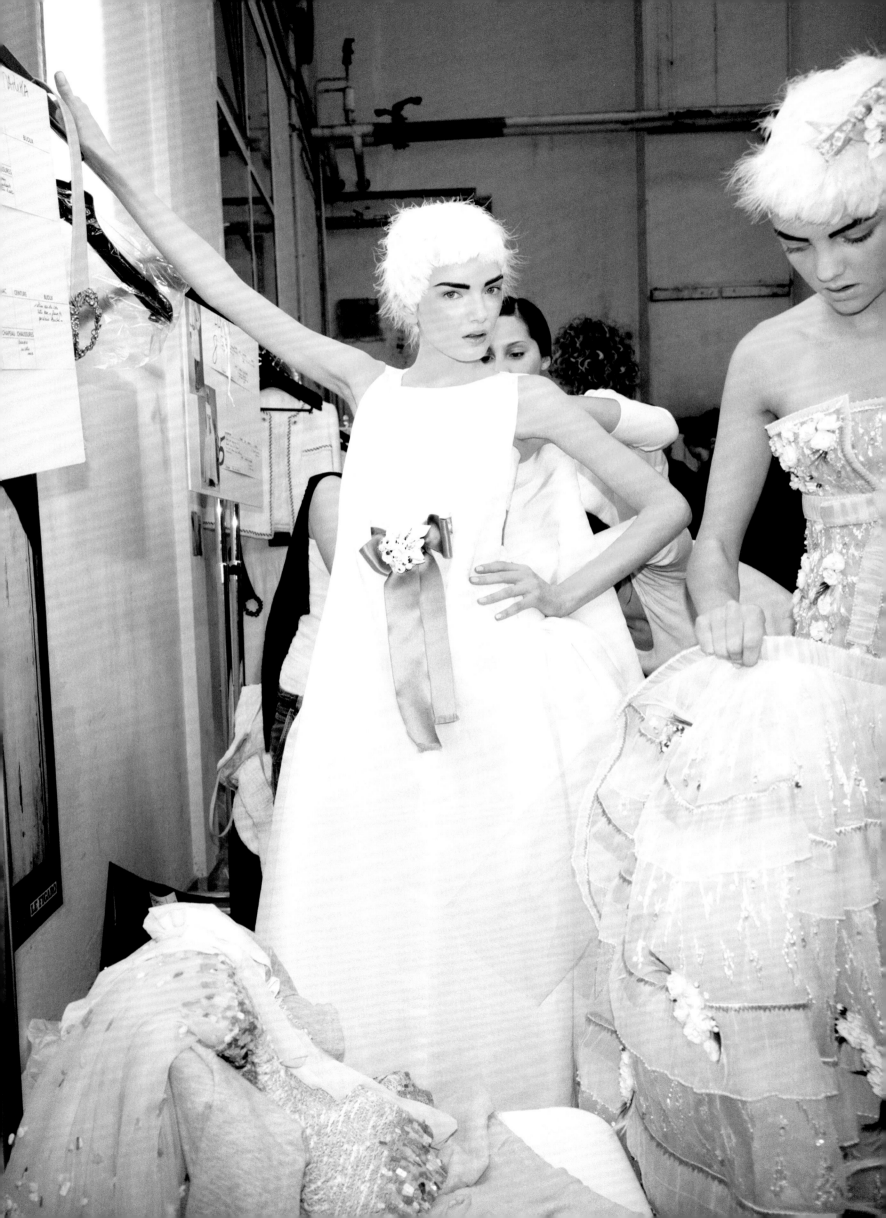

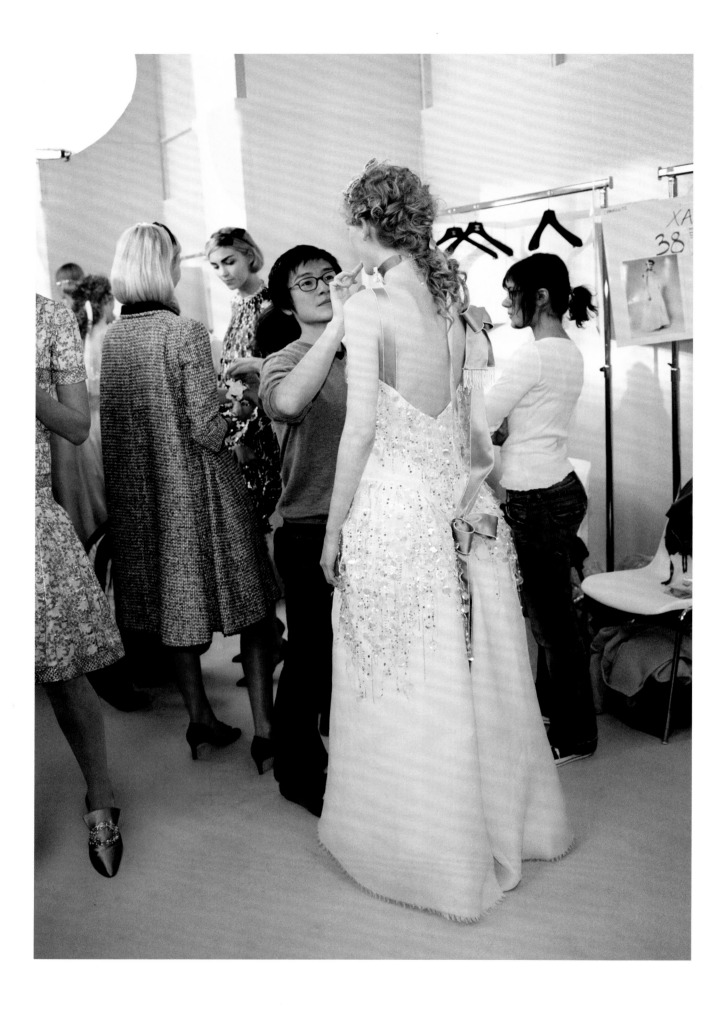

SPRING/SUMMER 2005 HAUTE COUTURE

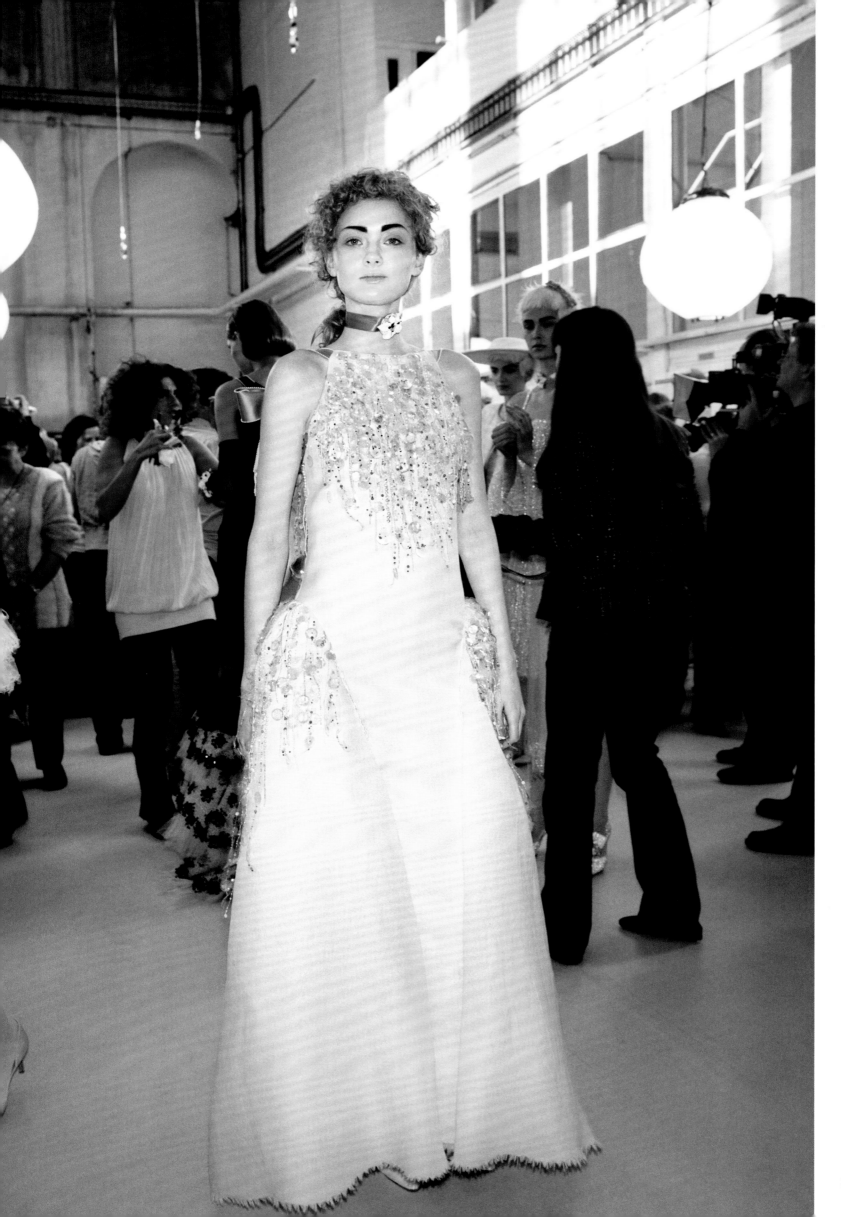

AUTUMN/WINTER 2005–2006
HAUTE COUTURE

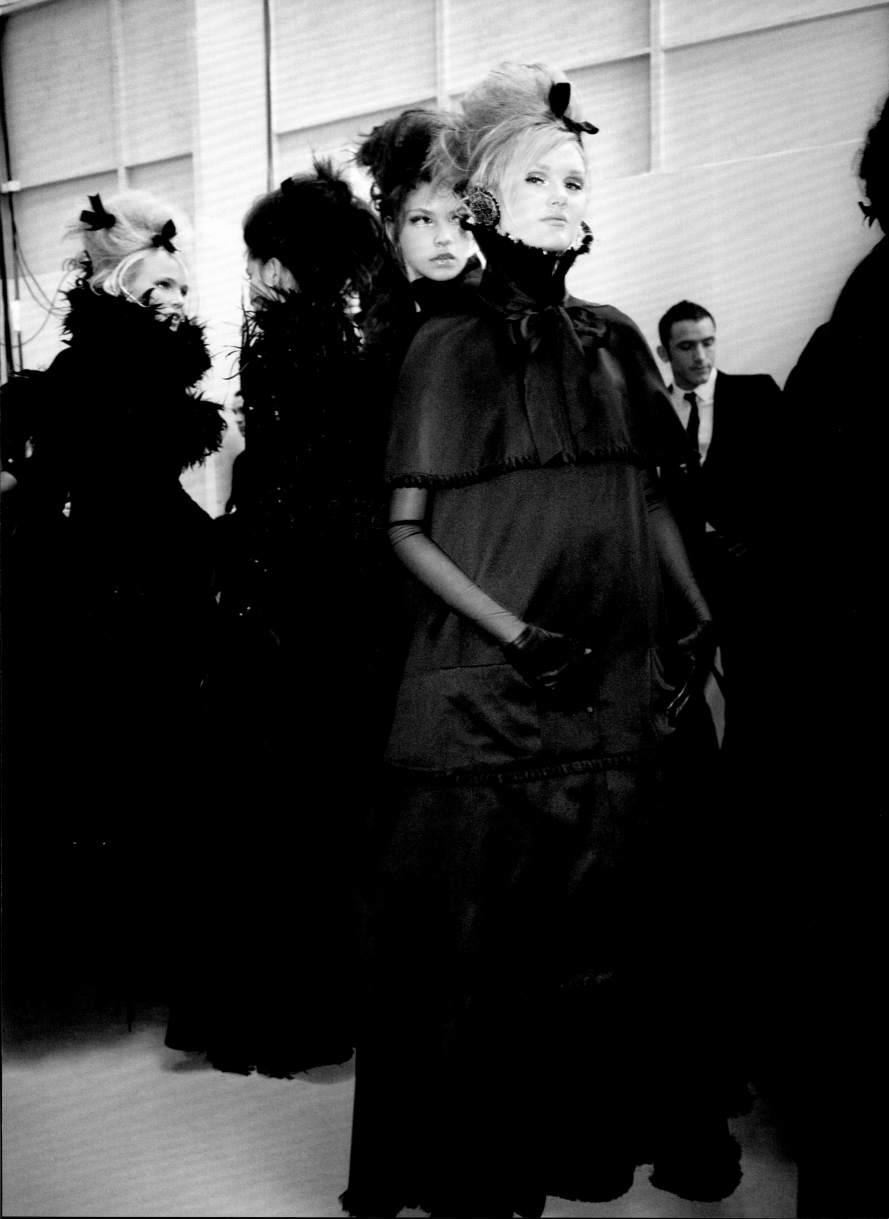

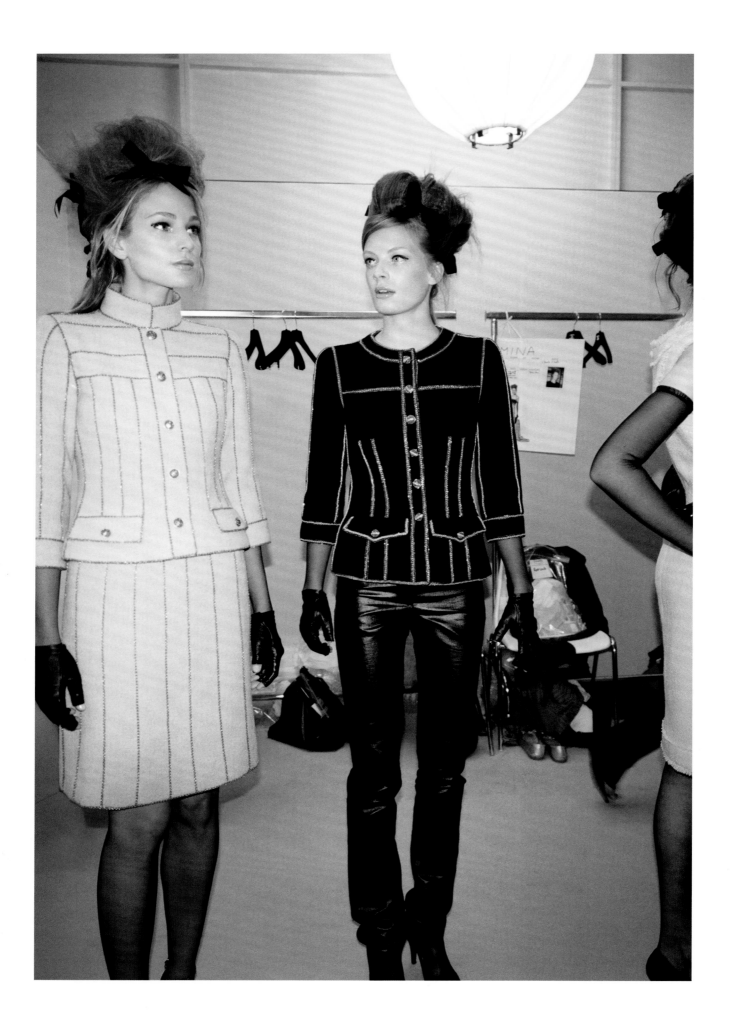

AUTUMN/WINTER 2005-2006 HAUTE COUTURE

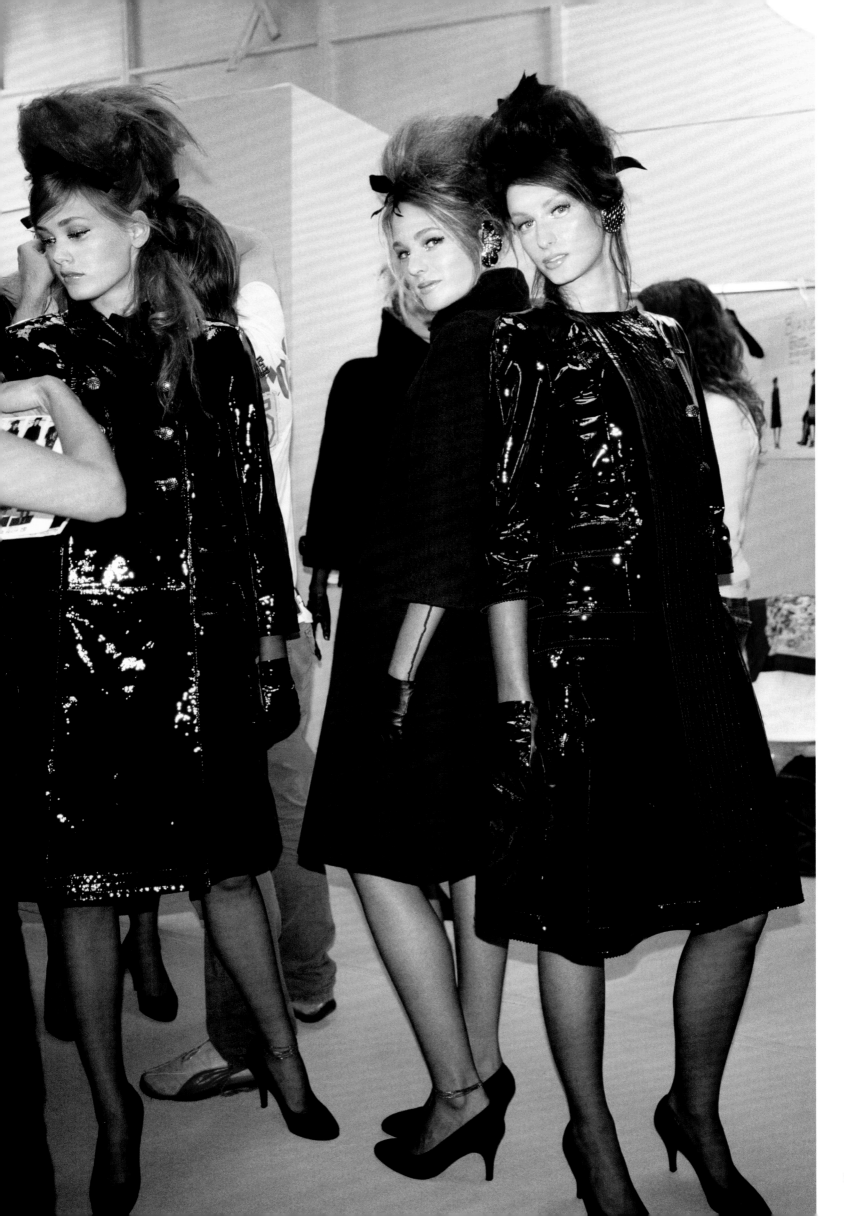

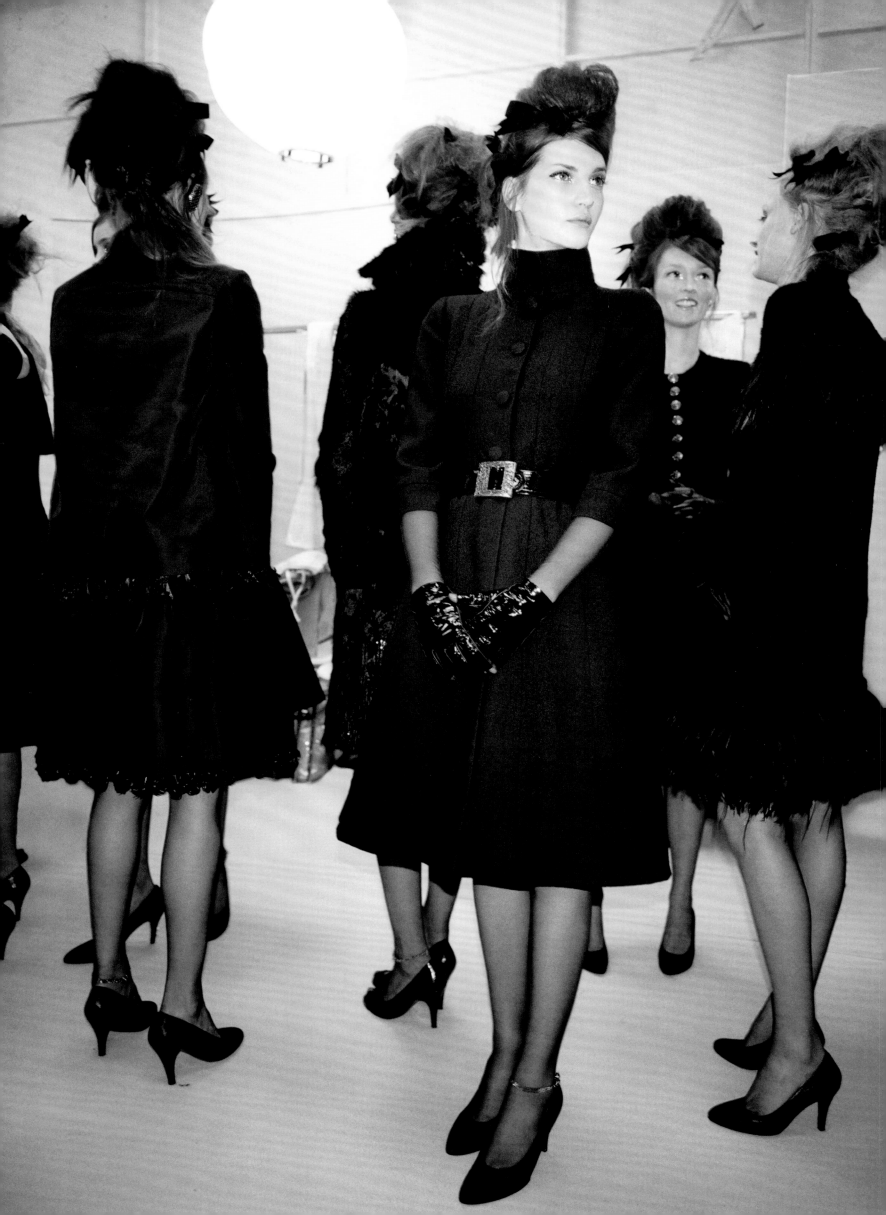

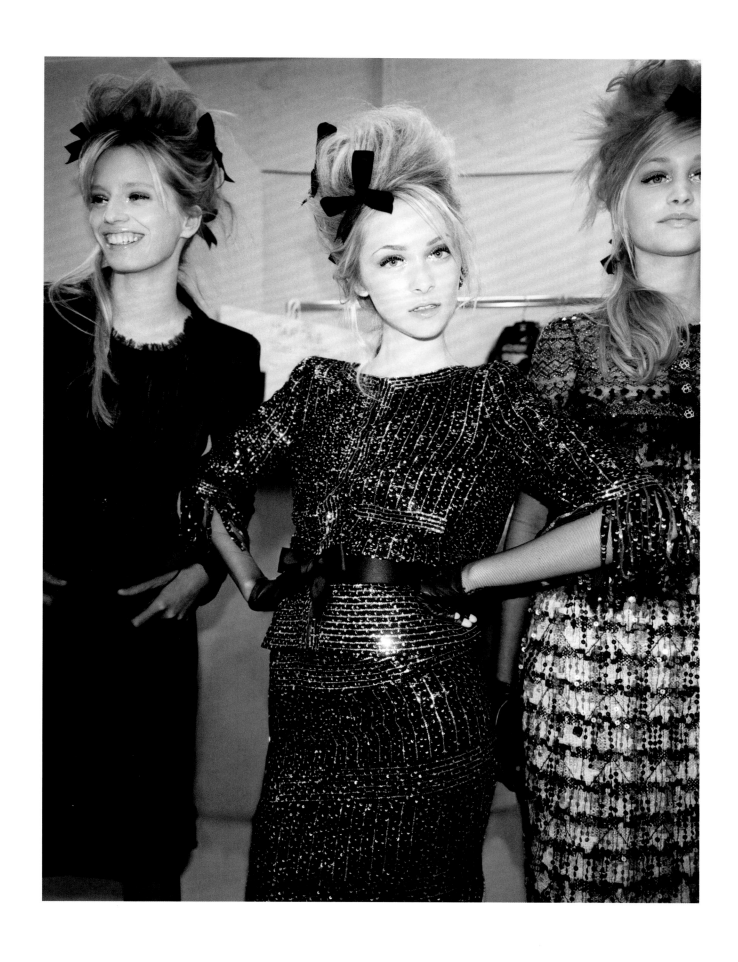

'Extraordinary images of extraordinary girls in extraordinary situations'

Amanda Harlech

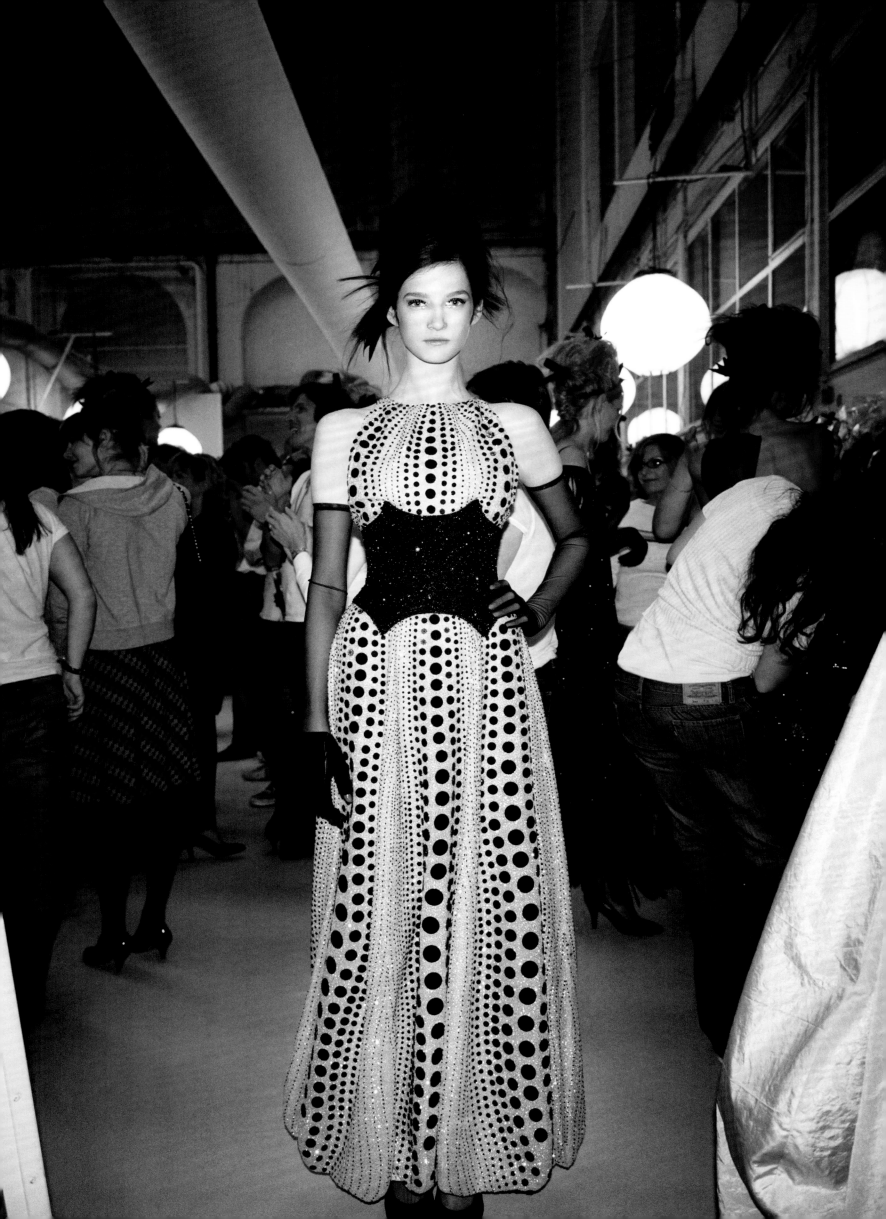

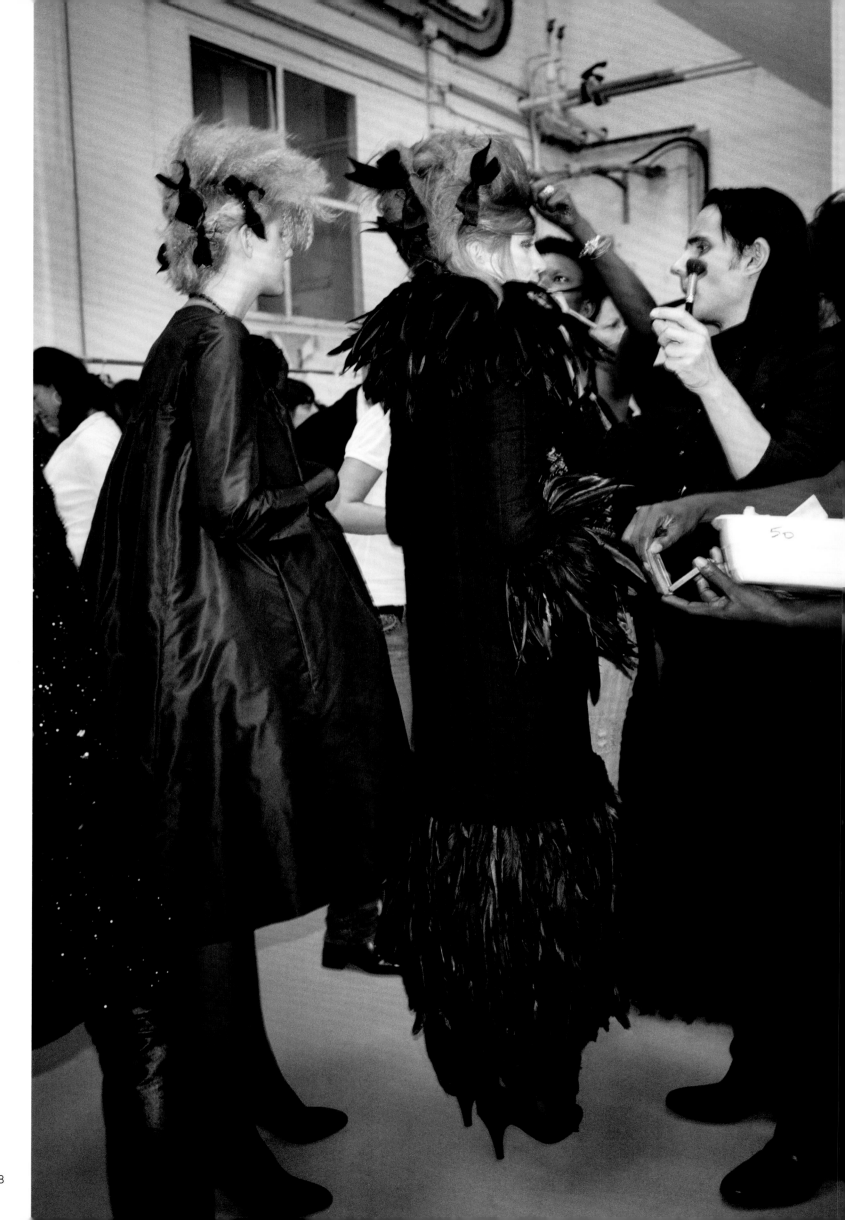

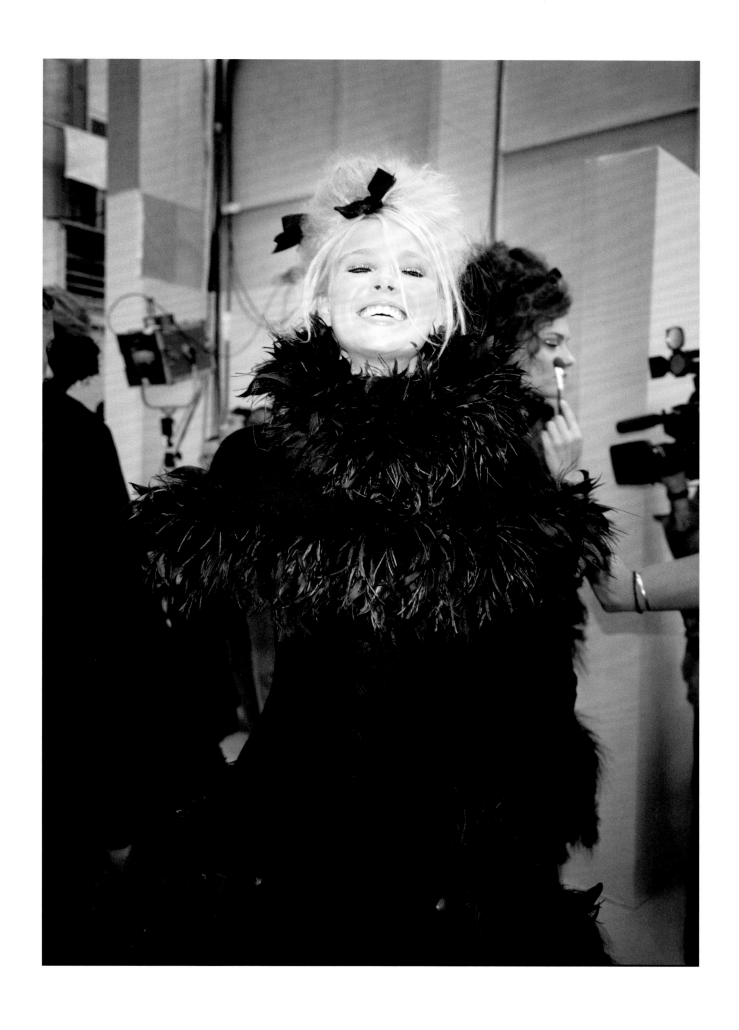

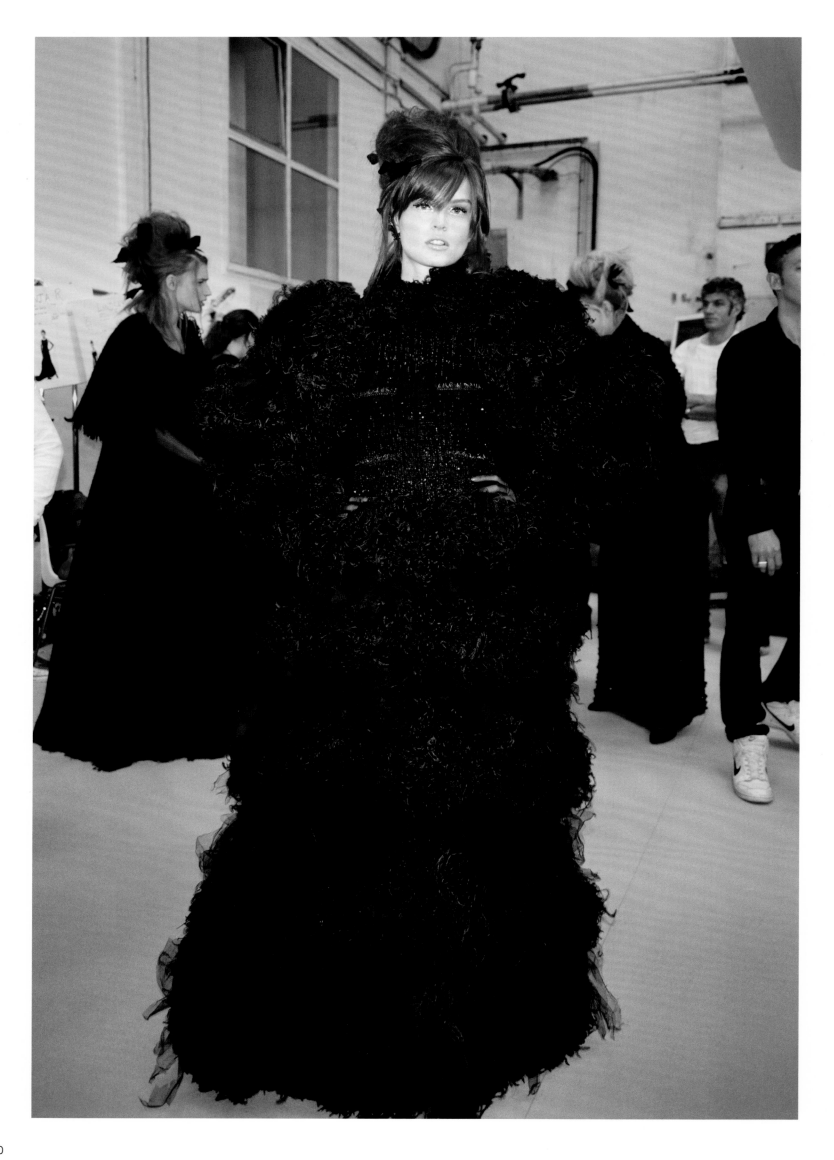

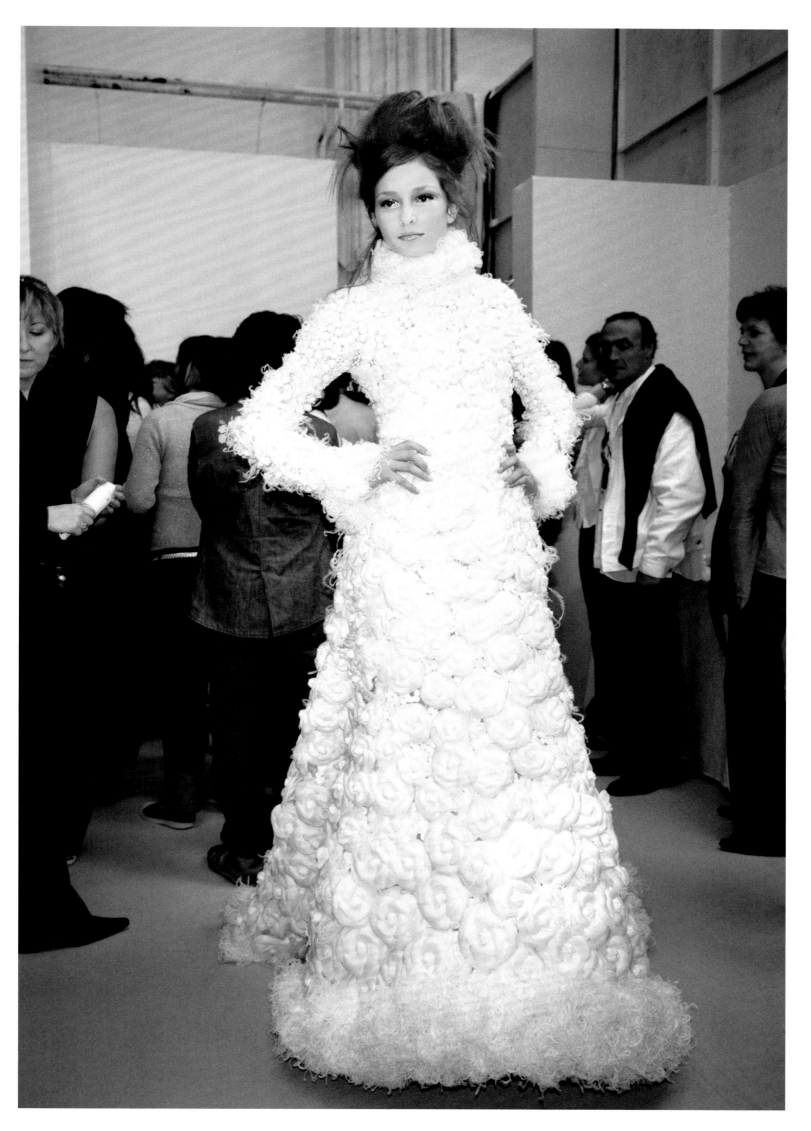

AUTUMN/WINTER 2005–2006 HAUTE COUTURE

SPRING/SUMMER 2006
READY-TO-WEAR

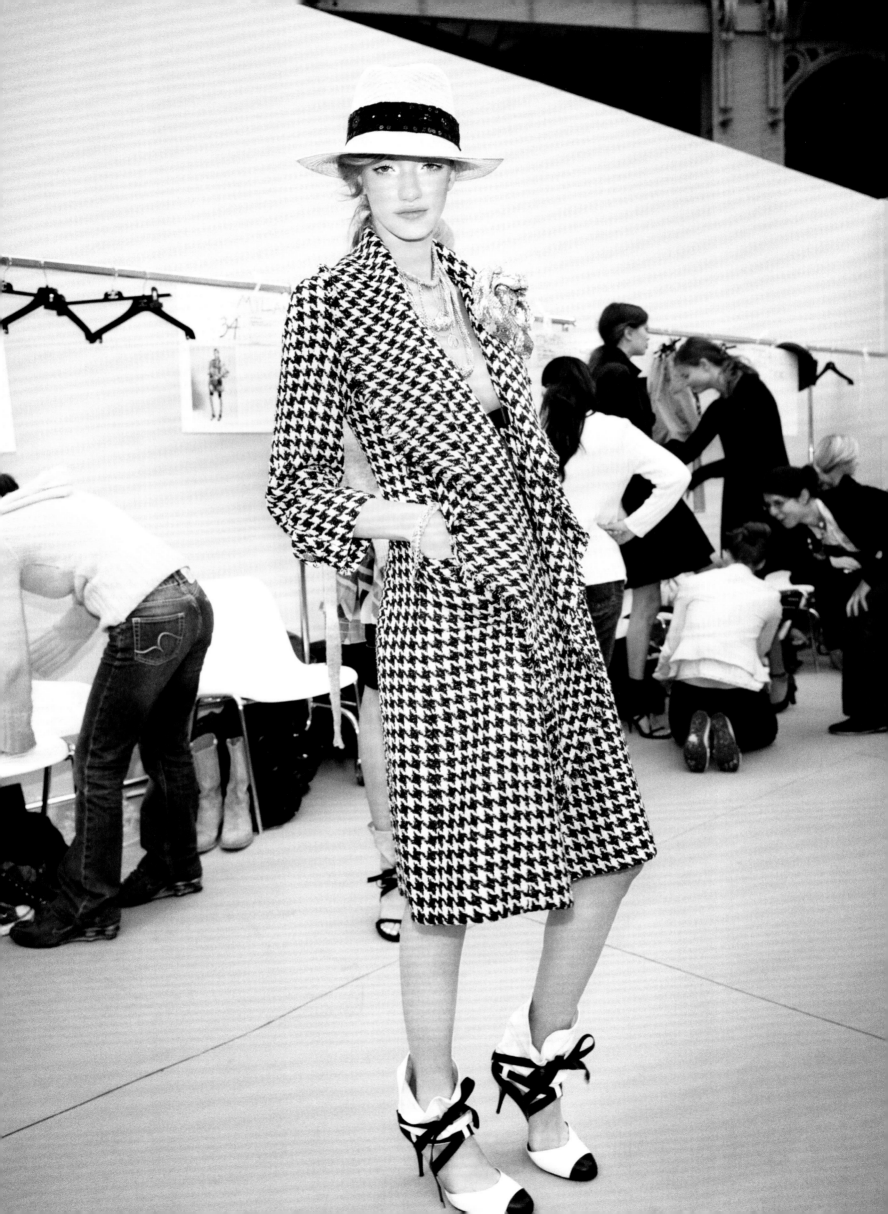

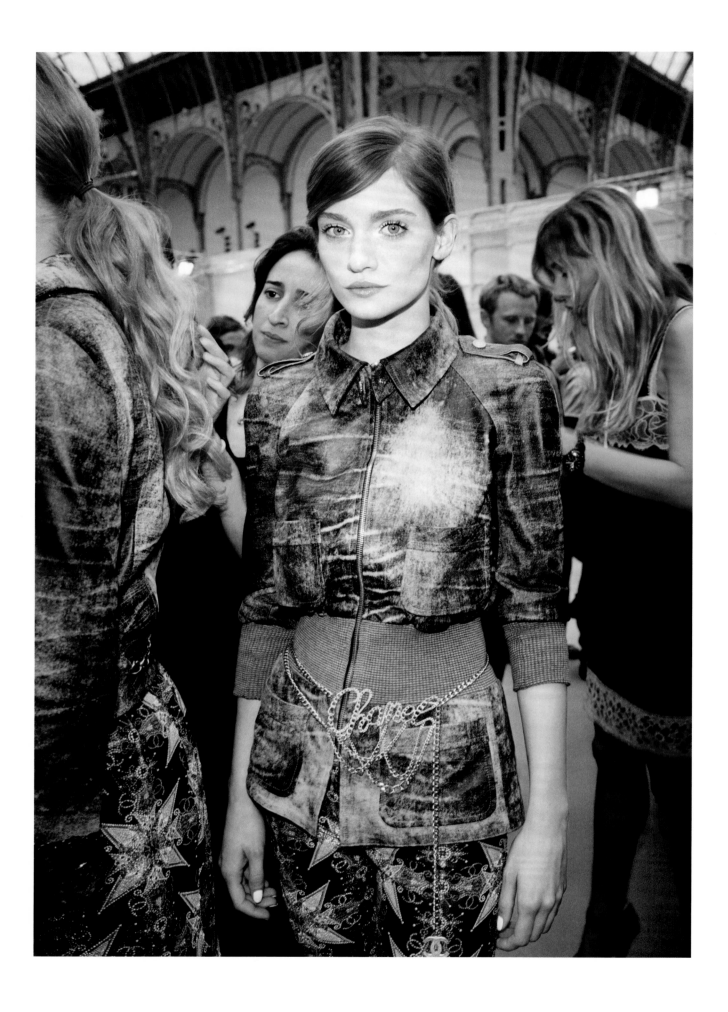

SPRING/SUMMER 2006 READY-TO-WEAR

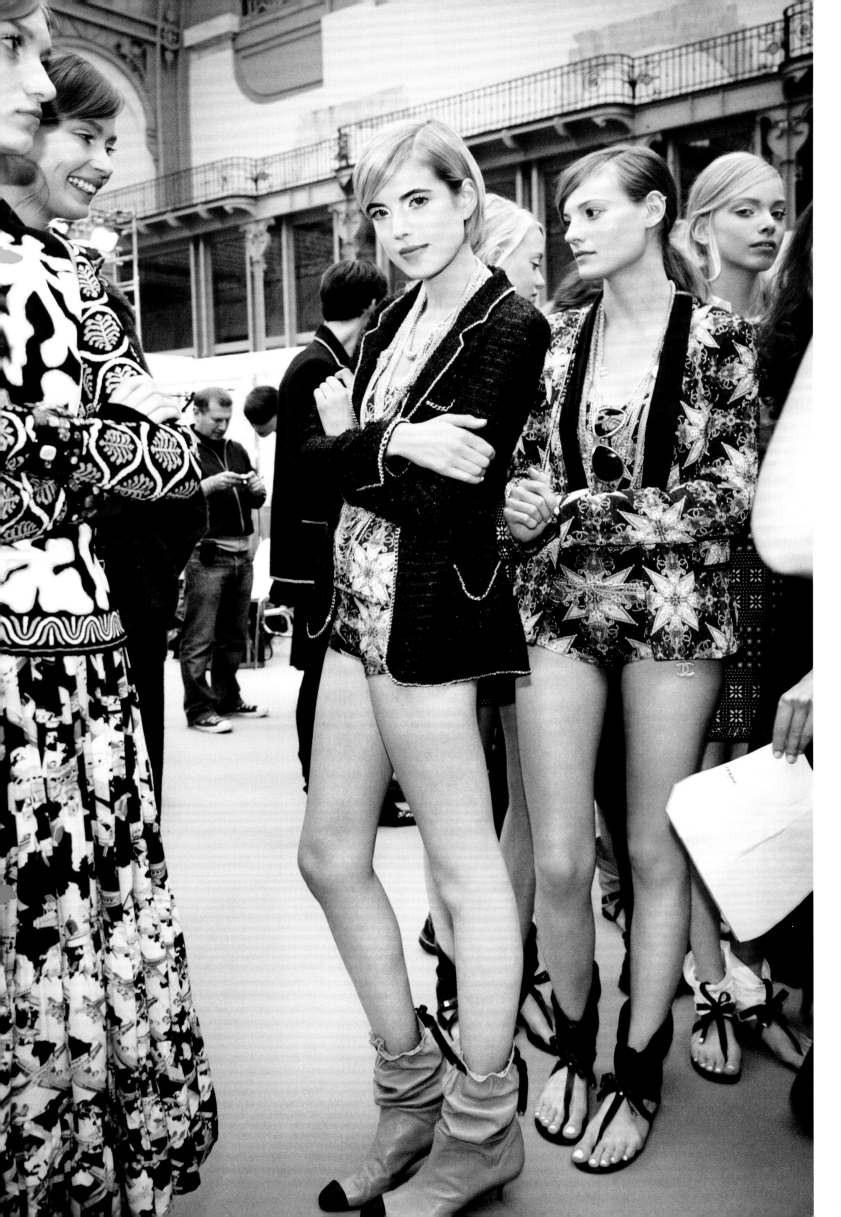

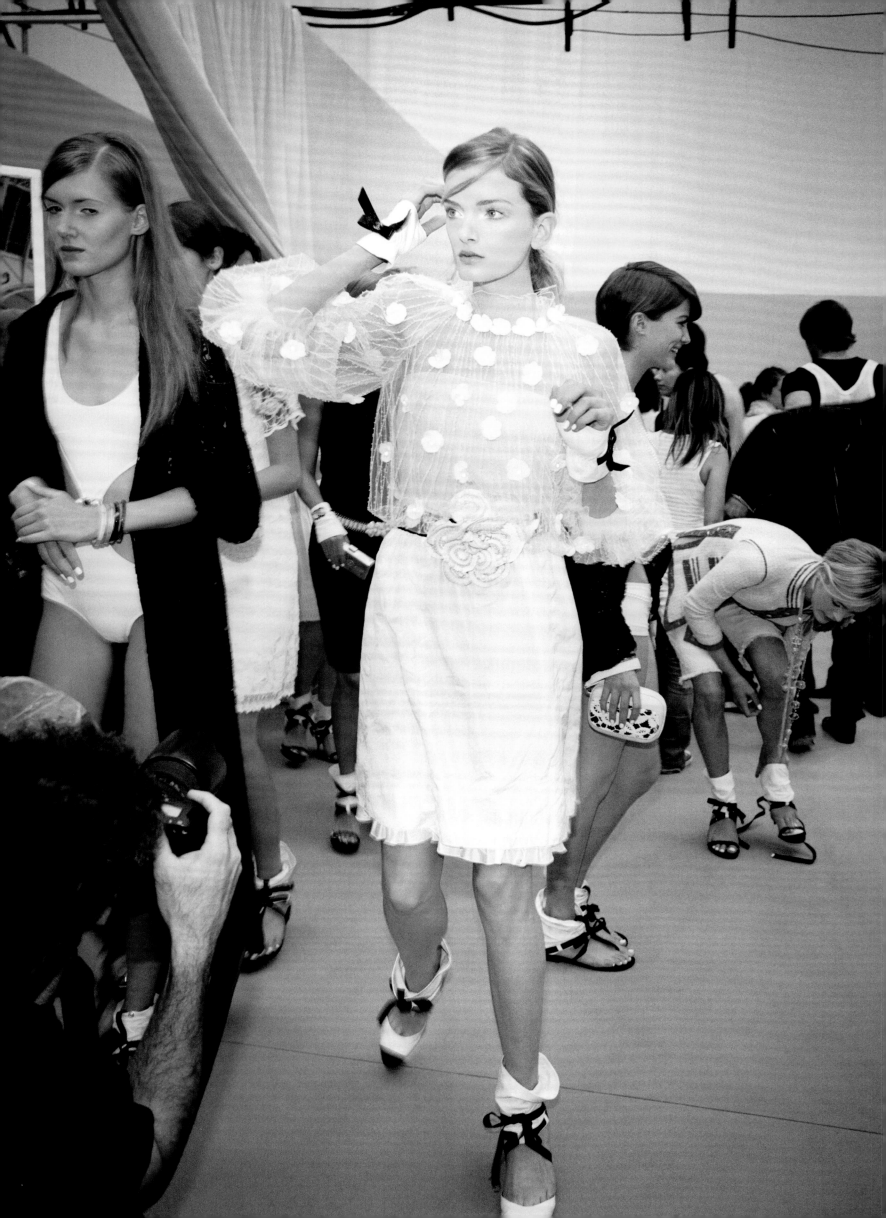

'From hats to shoes, from chain-belts
to camellias, from bows to bags,
Chanel transformed the accessory;
she turned the trivial into the essential'

Karl Lagerfeld

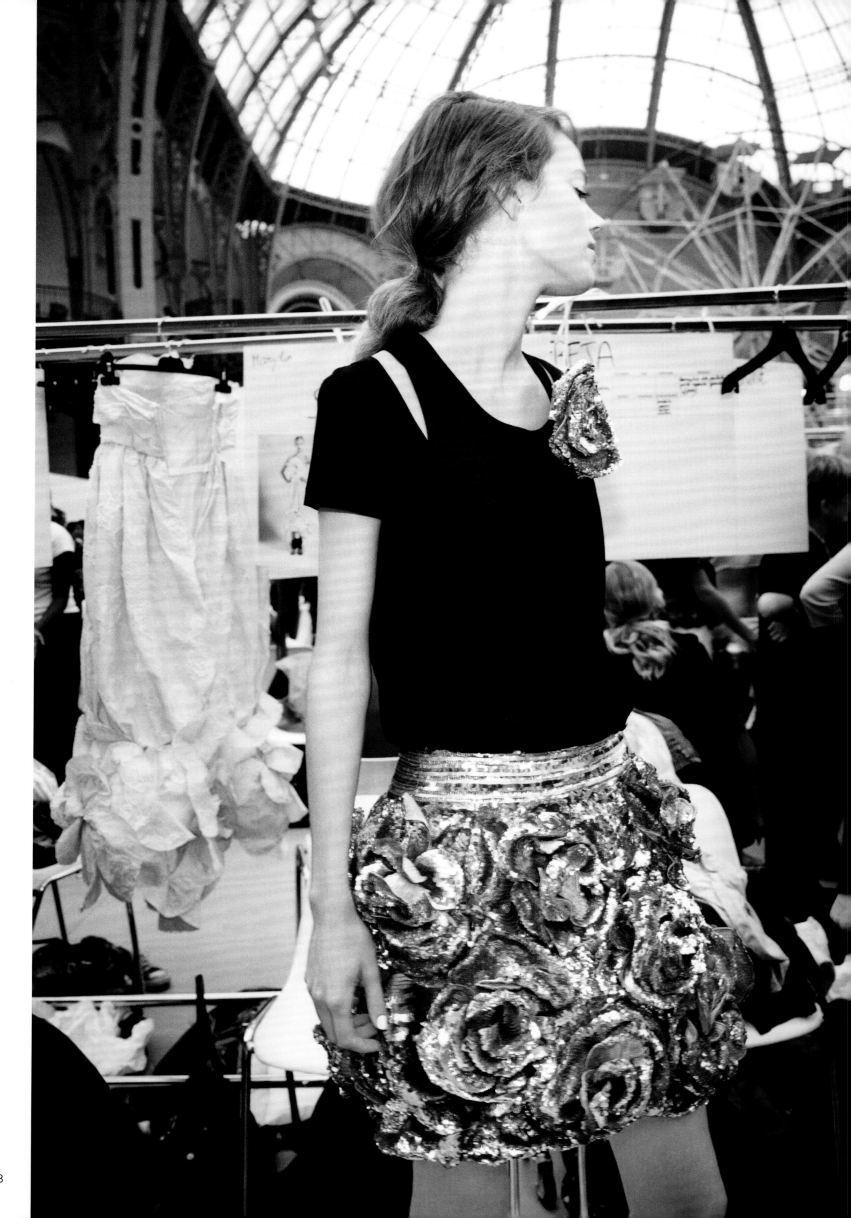

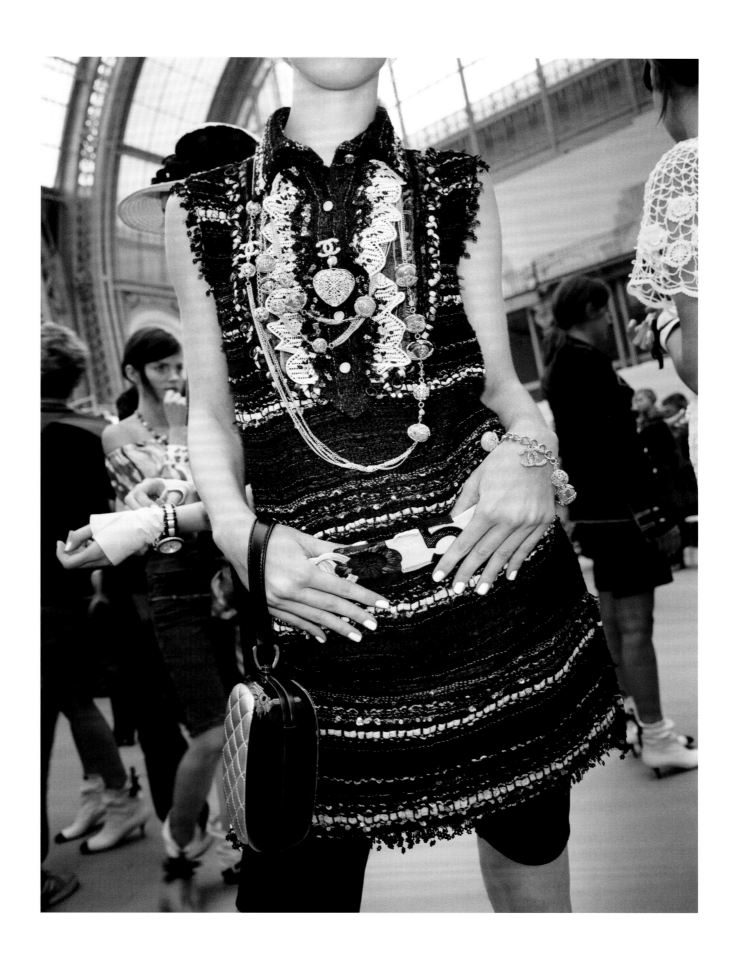

SPRING/SUMMER 2006
HAUTE COUTURE

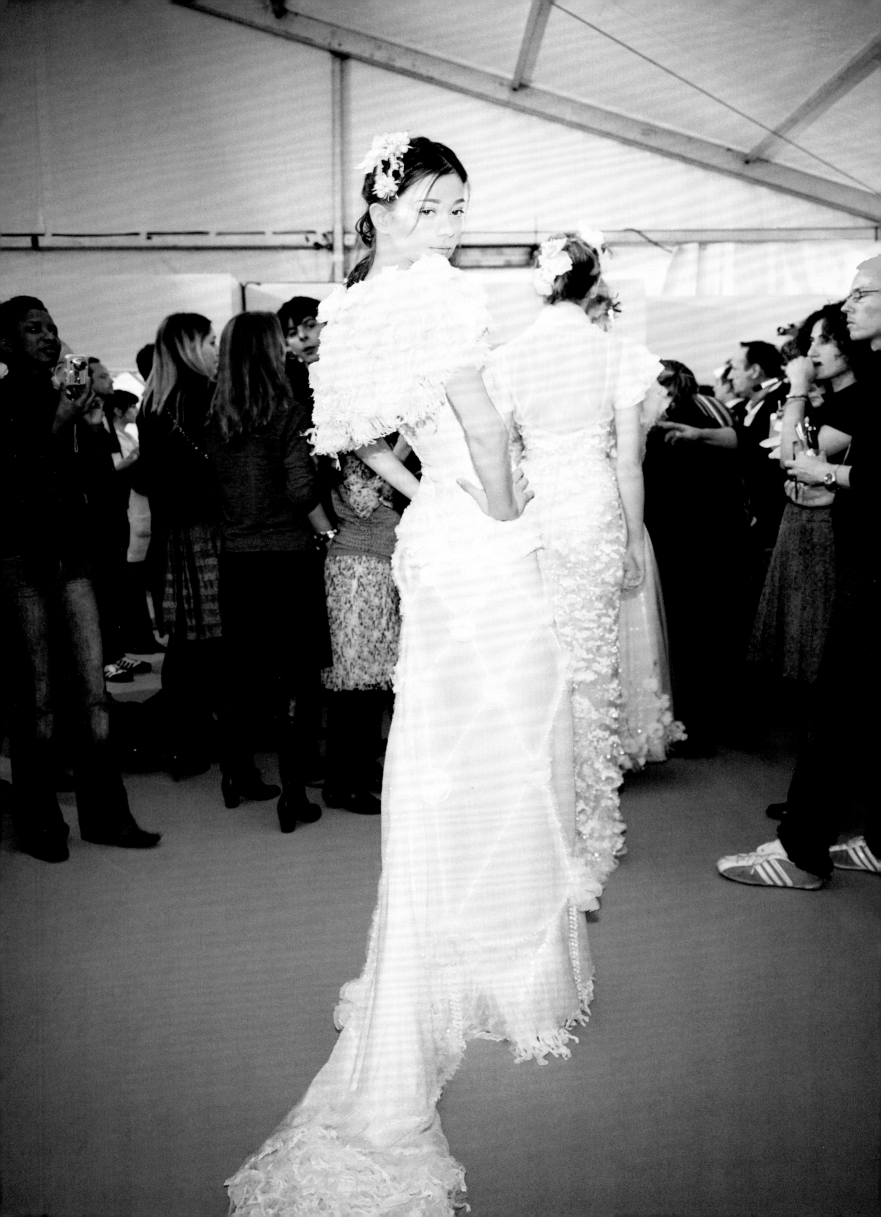

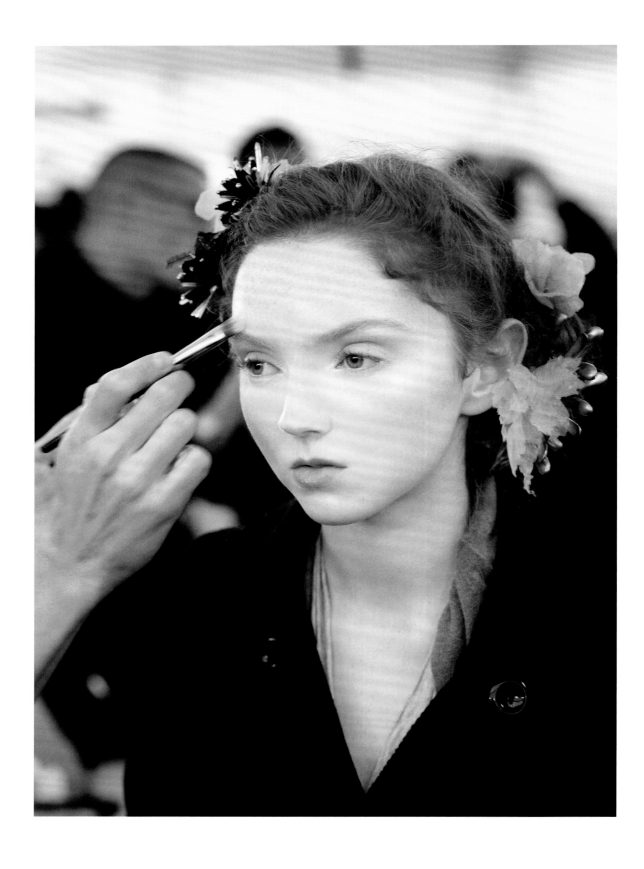

SPRING/SUMMER 2006 HAUTE COUTURE

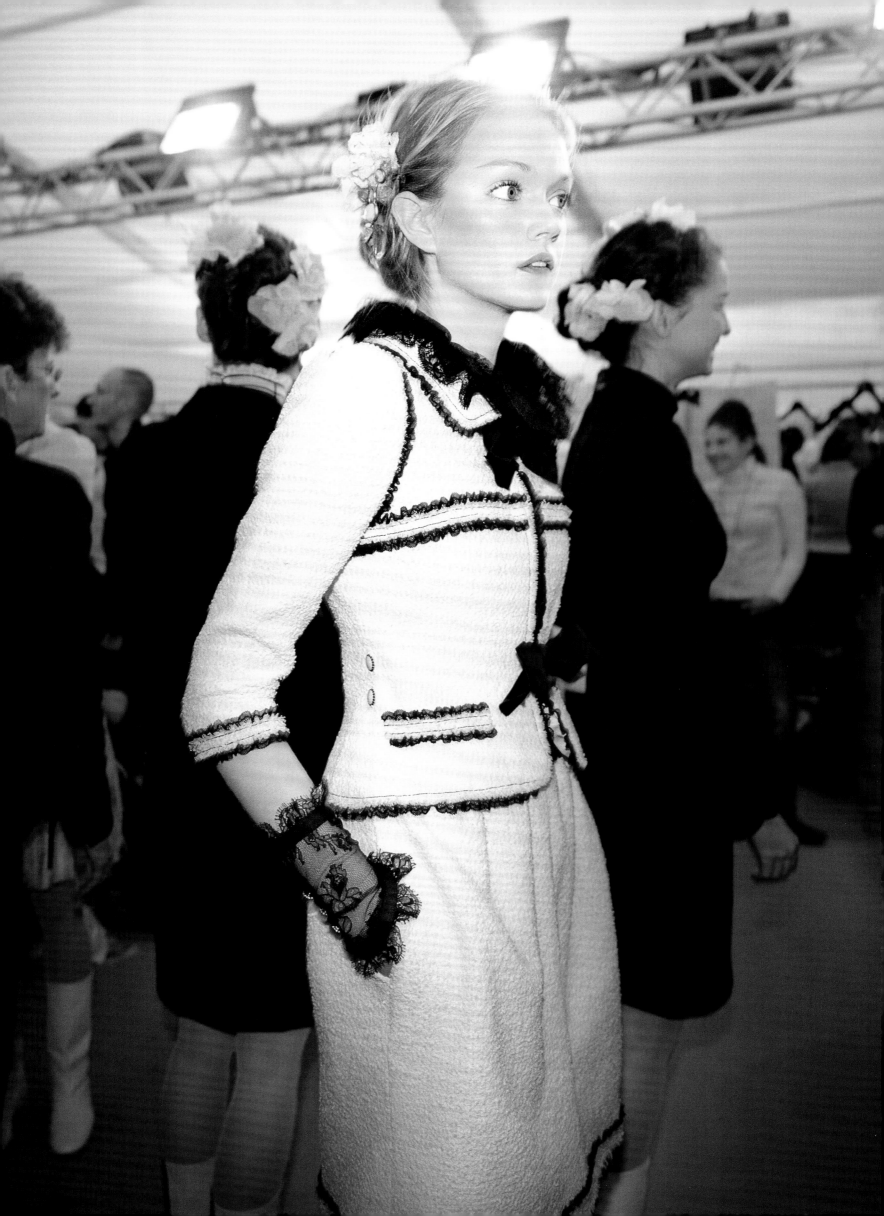

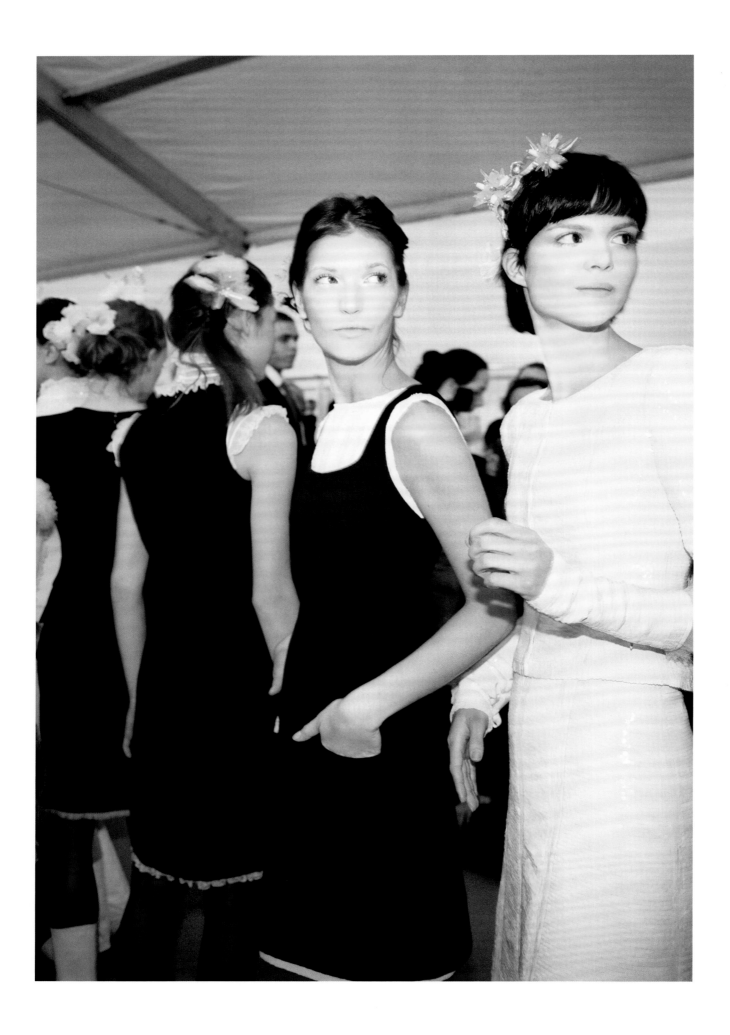

SPRING/SUMMER 2006 HAUTE COUTURE

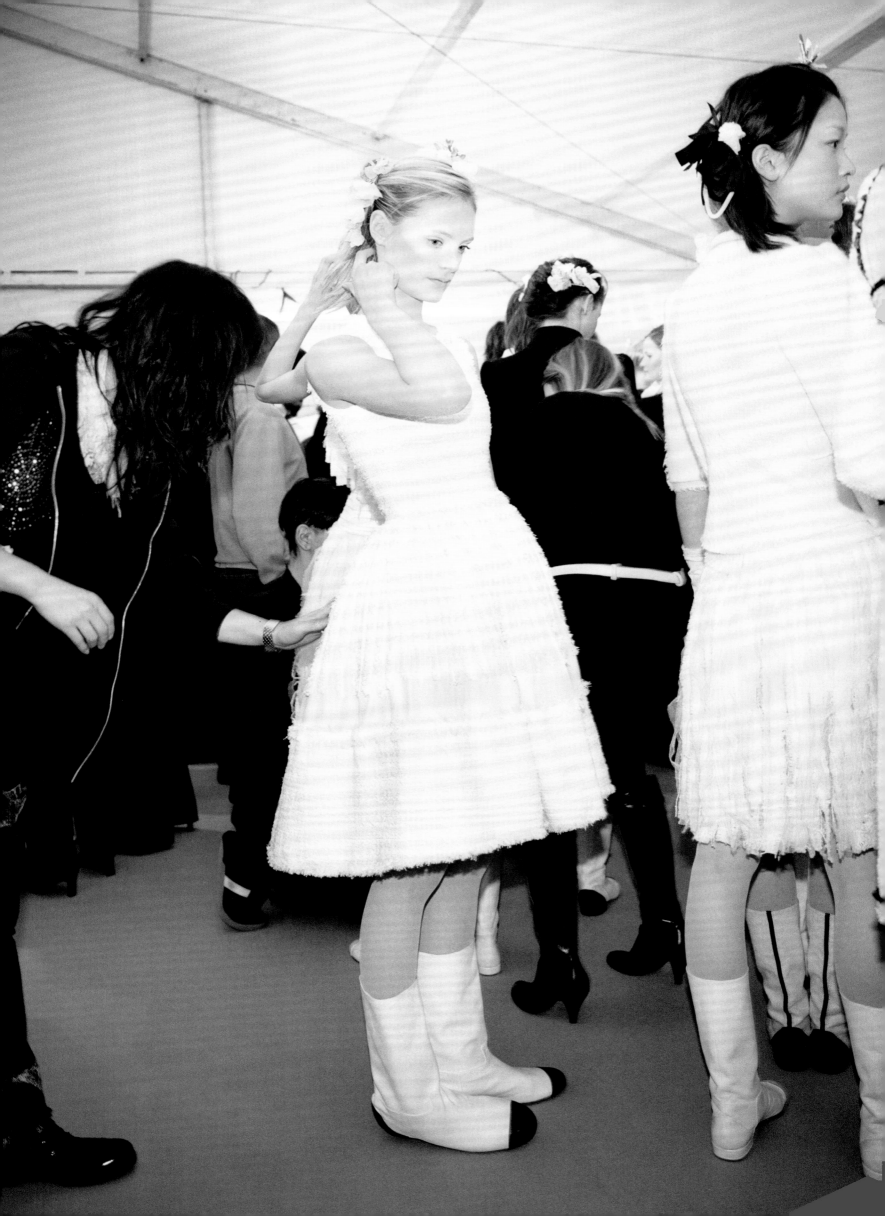

'Every moment with Karl was
a master class in refinement'

André Leon Talley

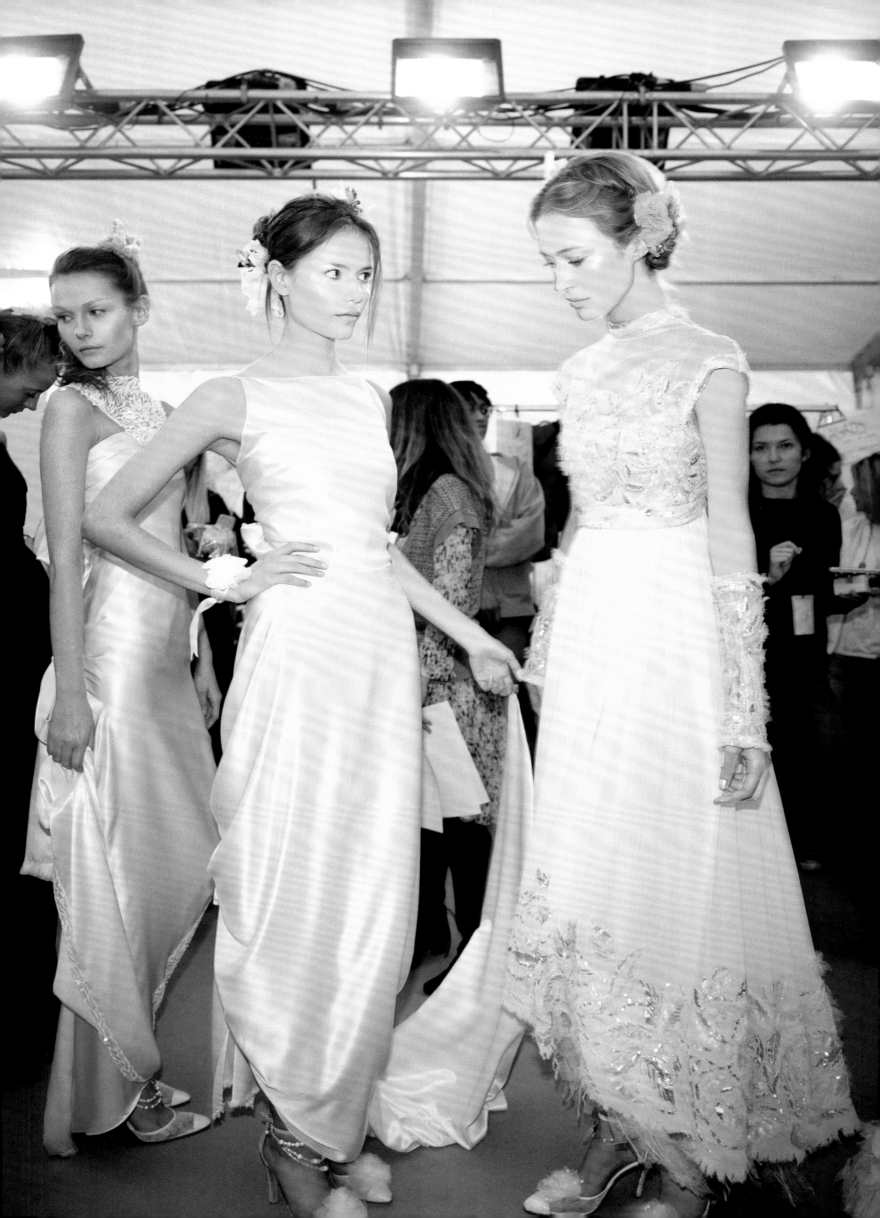

AUTUMN/WINTER 2006–2007
READY-TO-WEAR

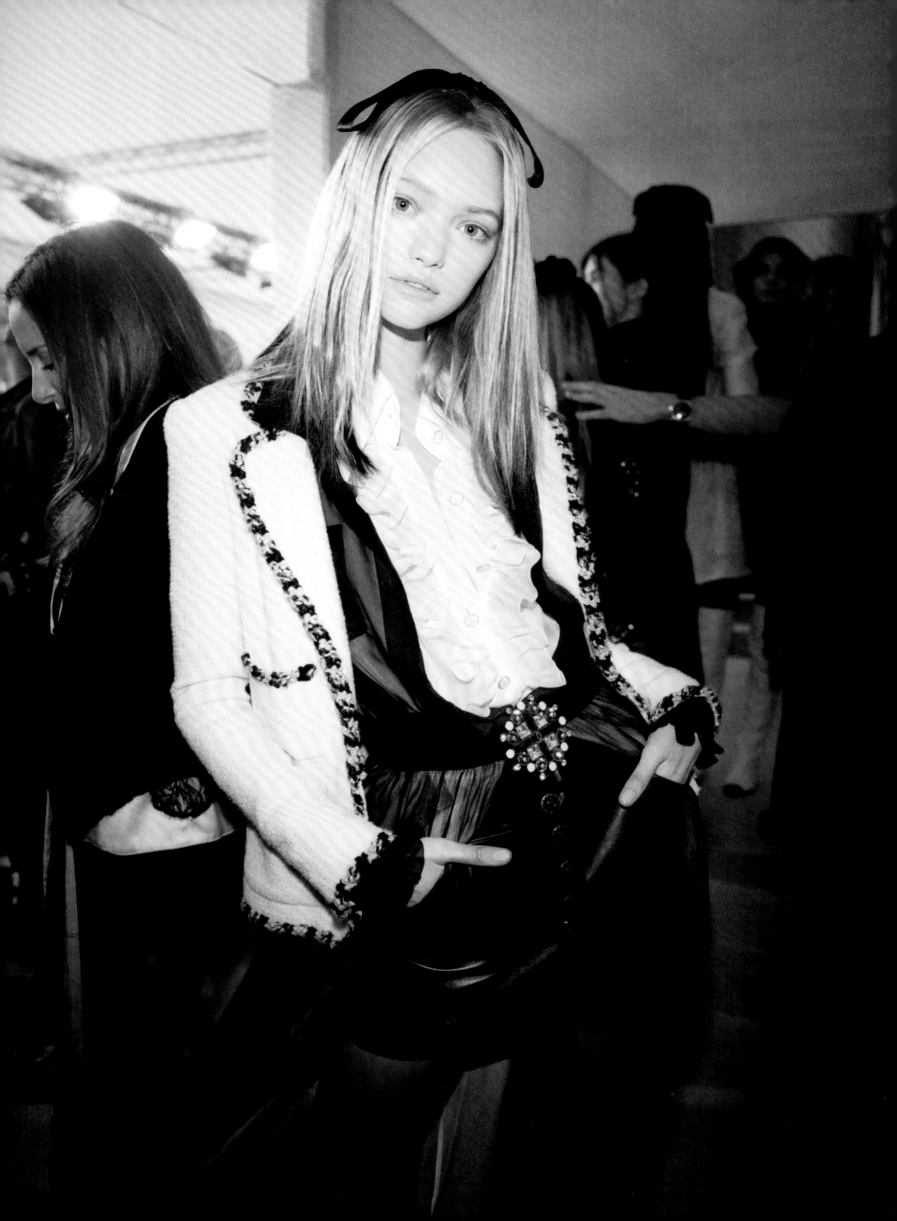

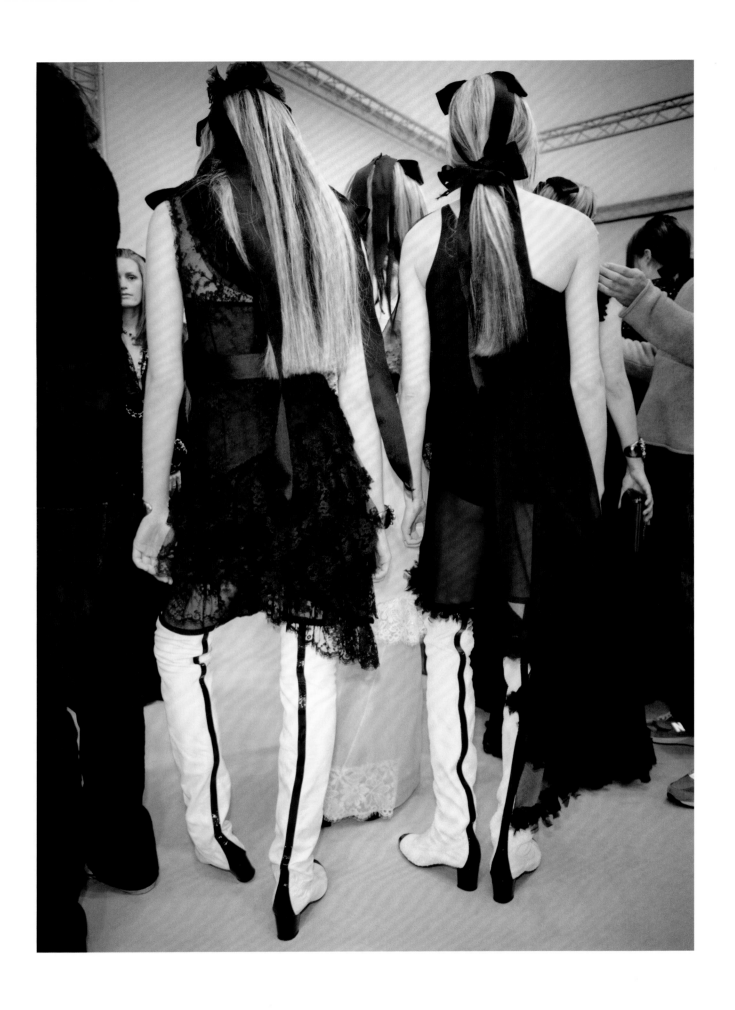

AUTUMN/WINTER 2006–2007 READY-TO-WEAR

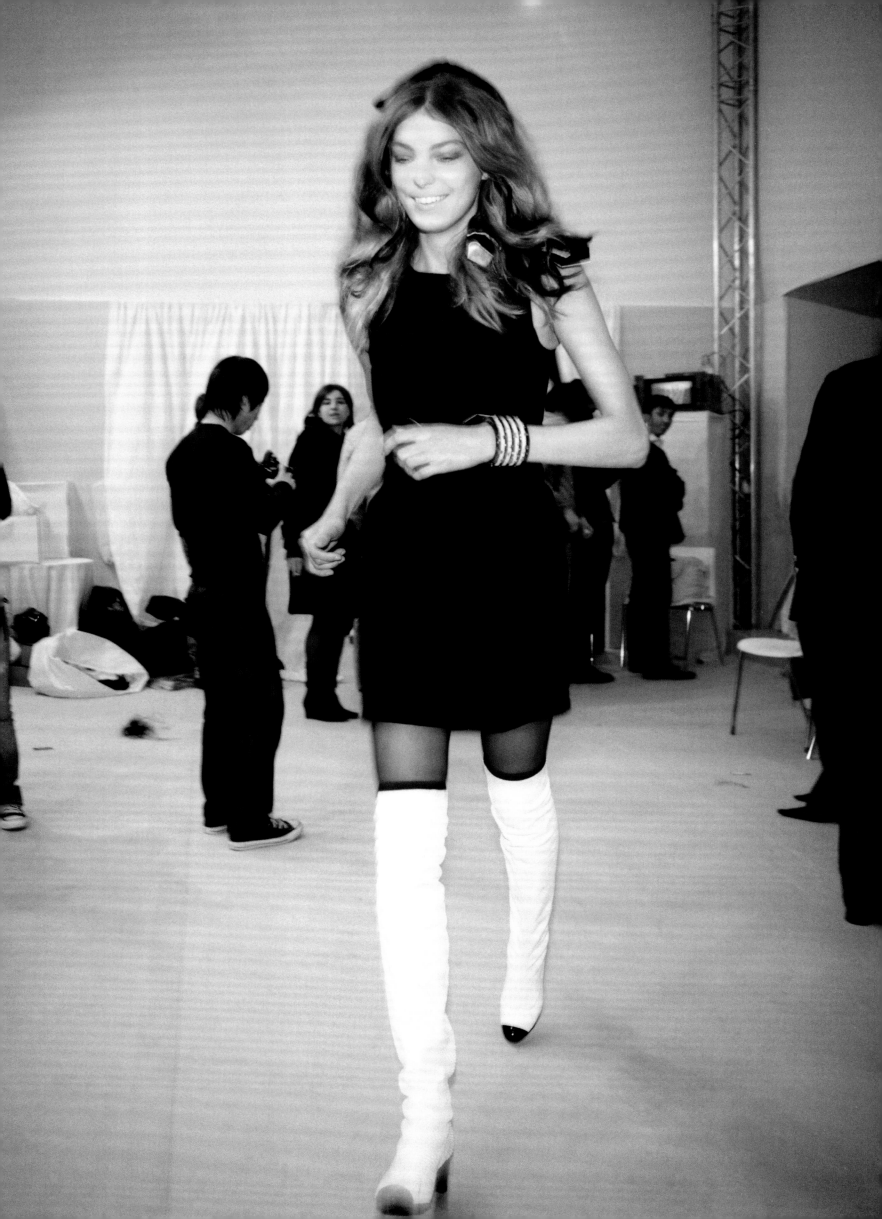

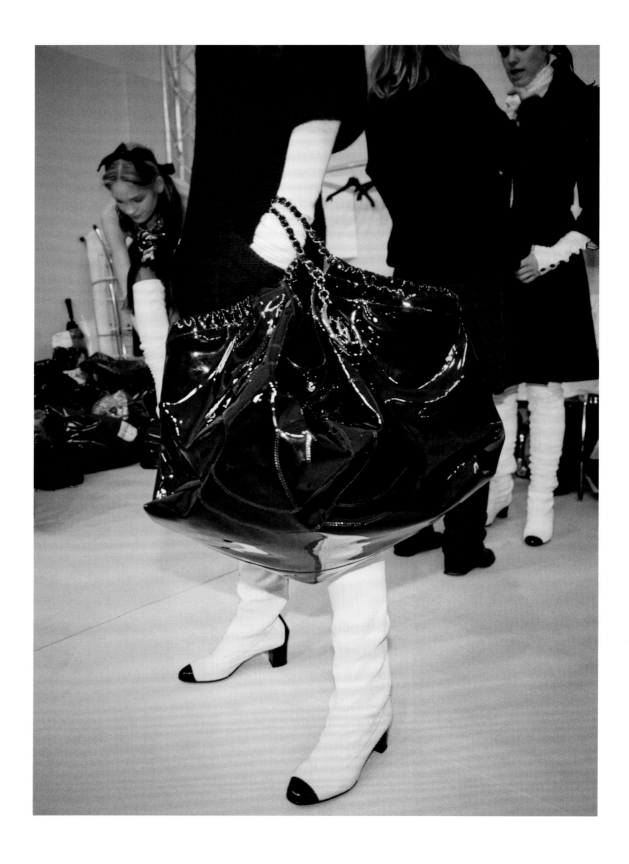

AUTUMN/WINTER 2006–2007 READY-TO-WEAR

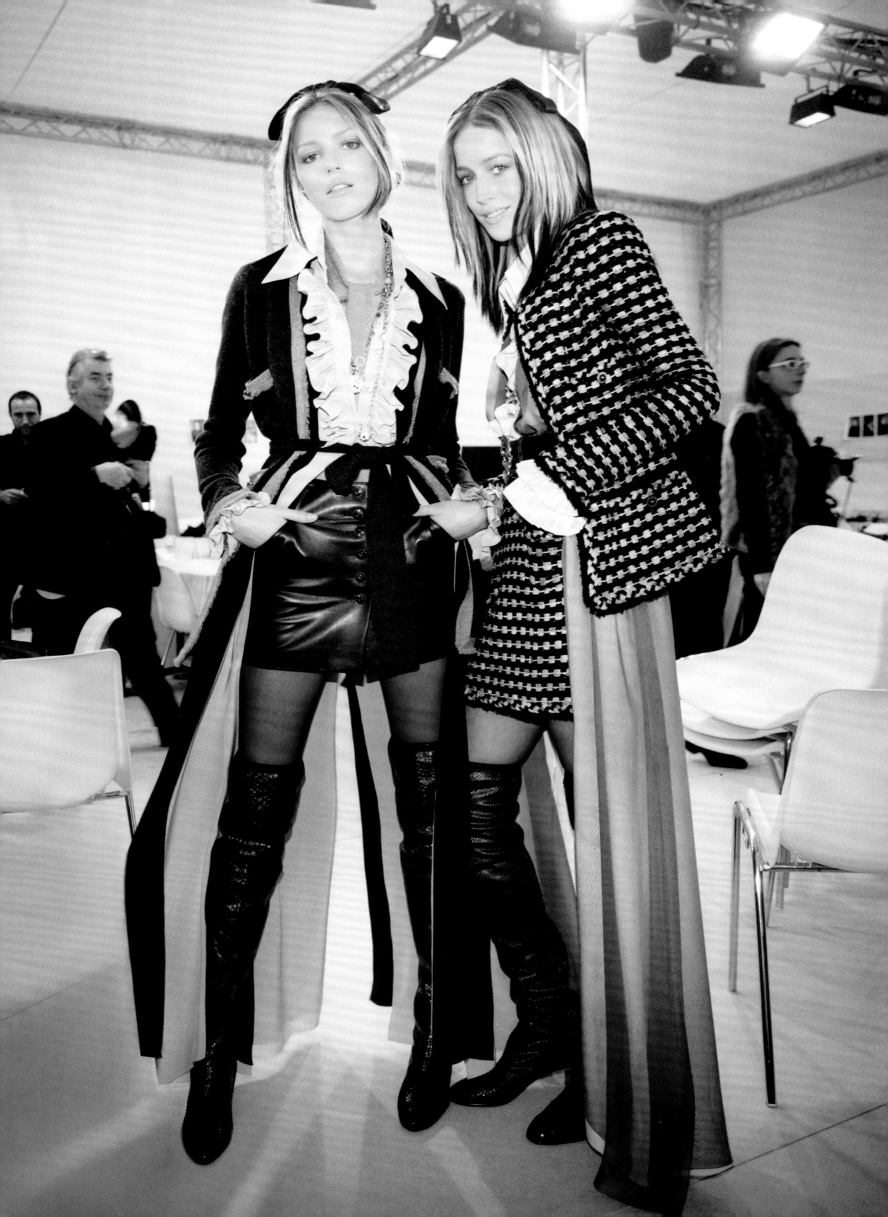

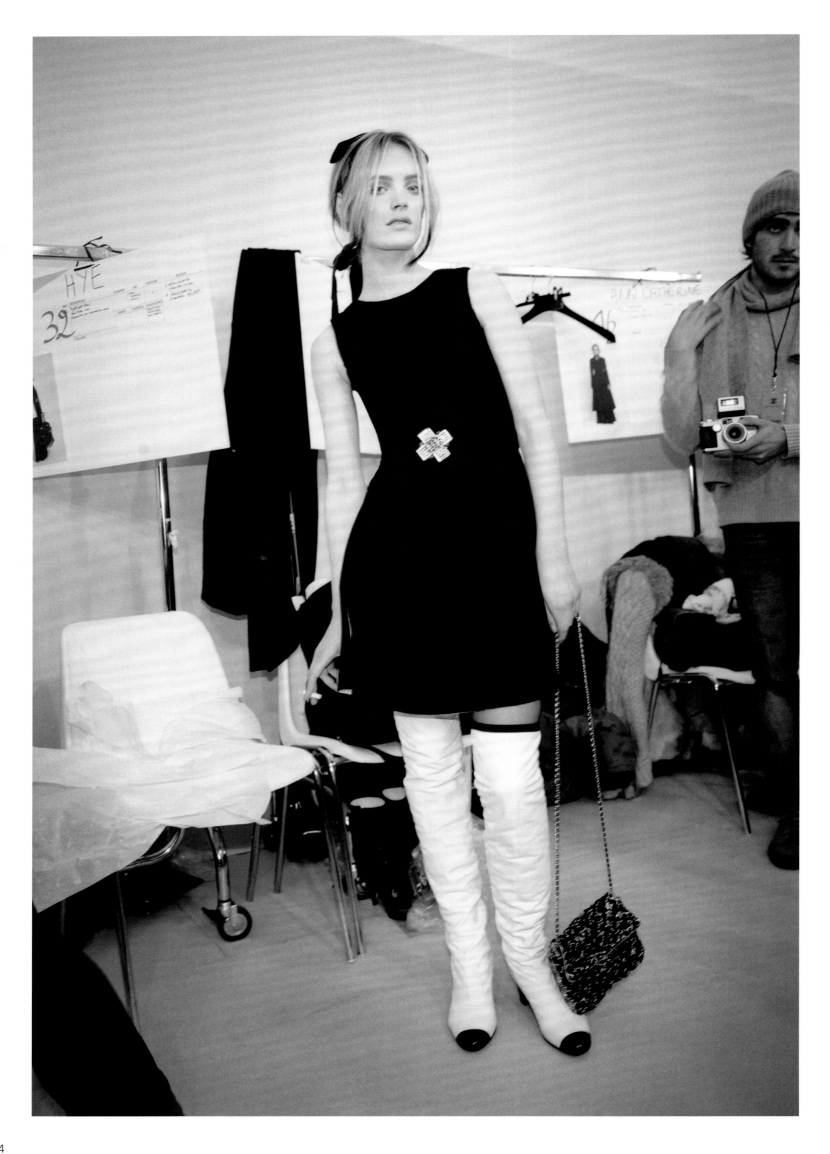

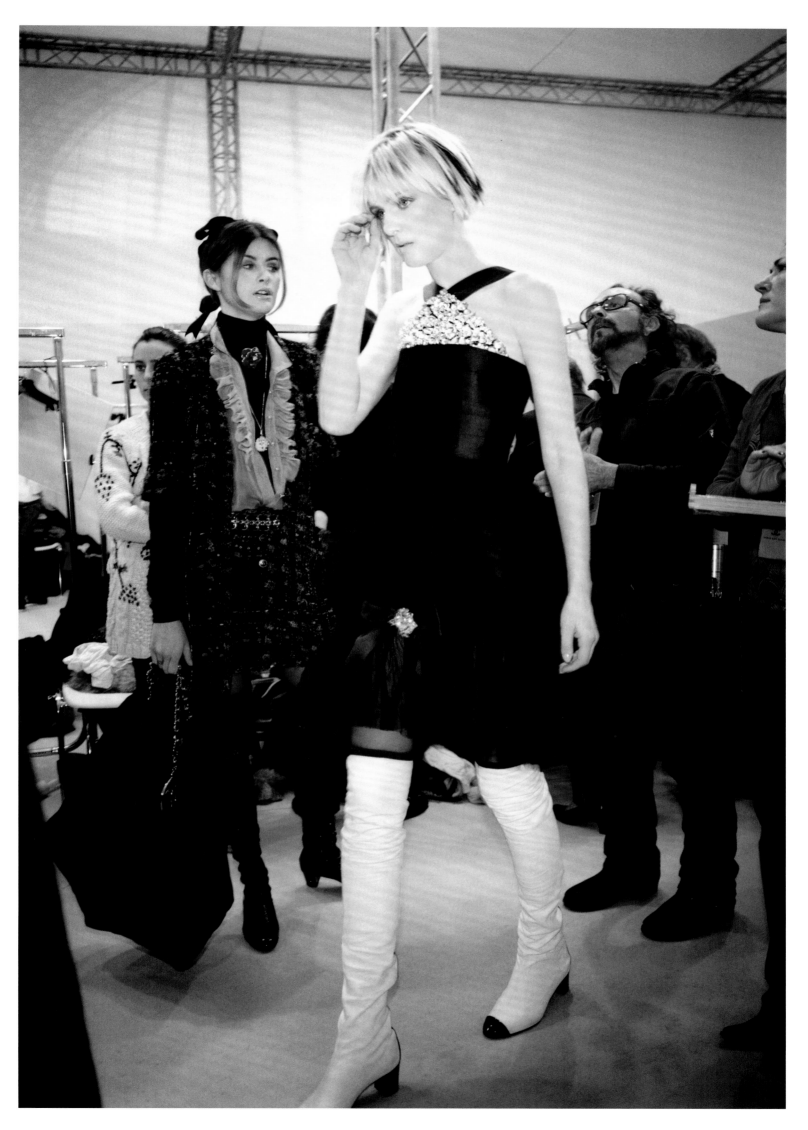

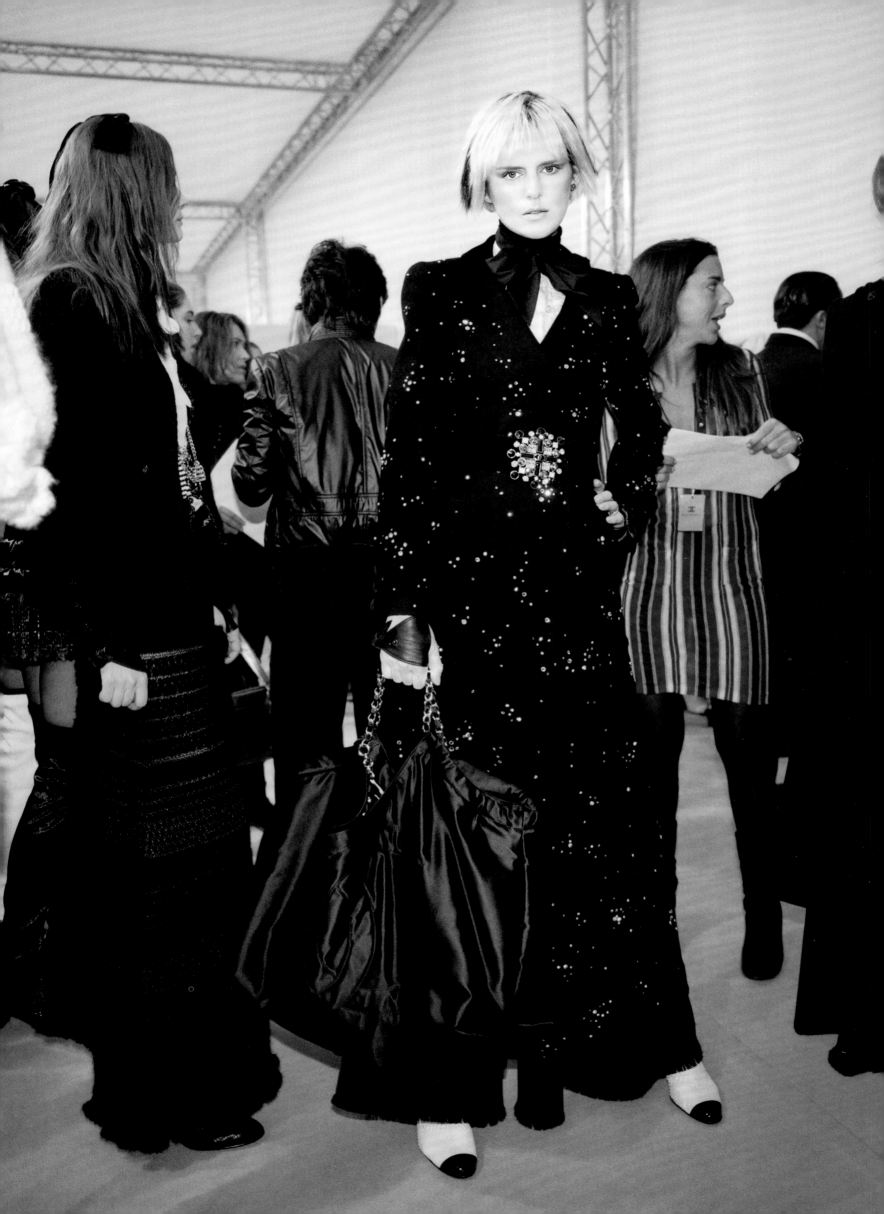

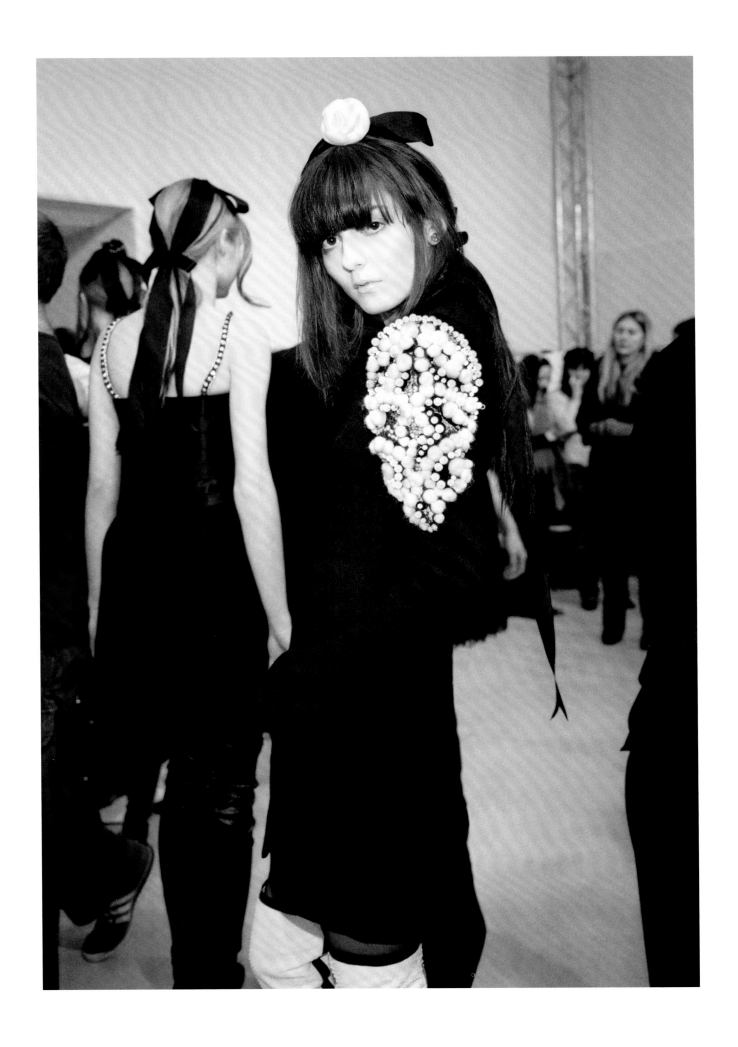

AUTUMN/WINTER 2006-2007
HAUTE COUTURE

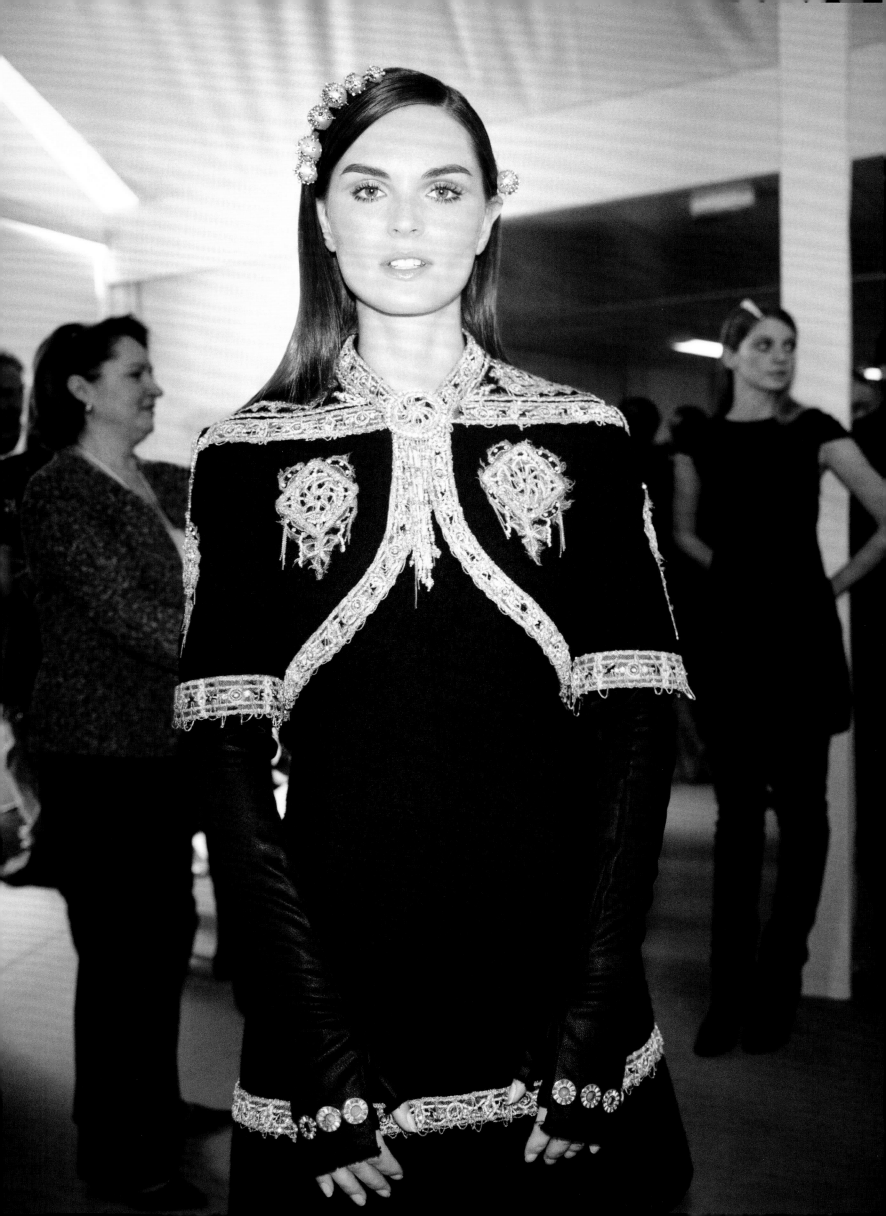

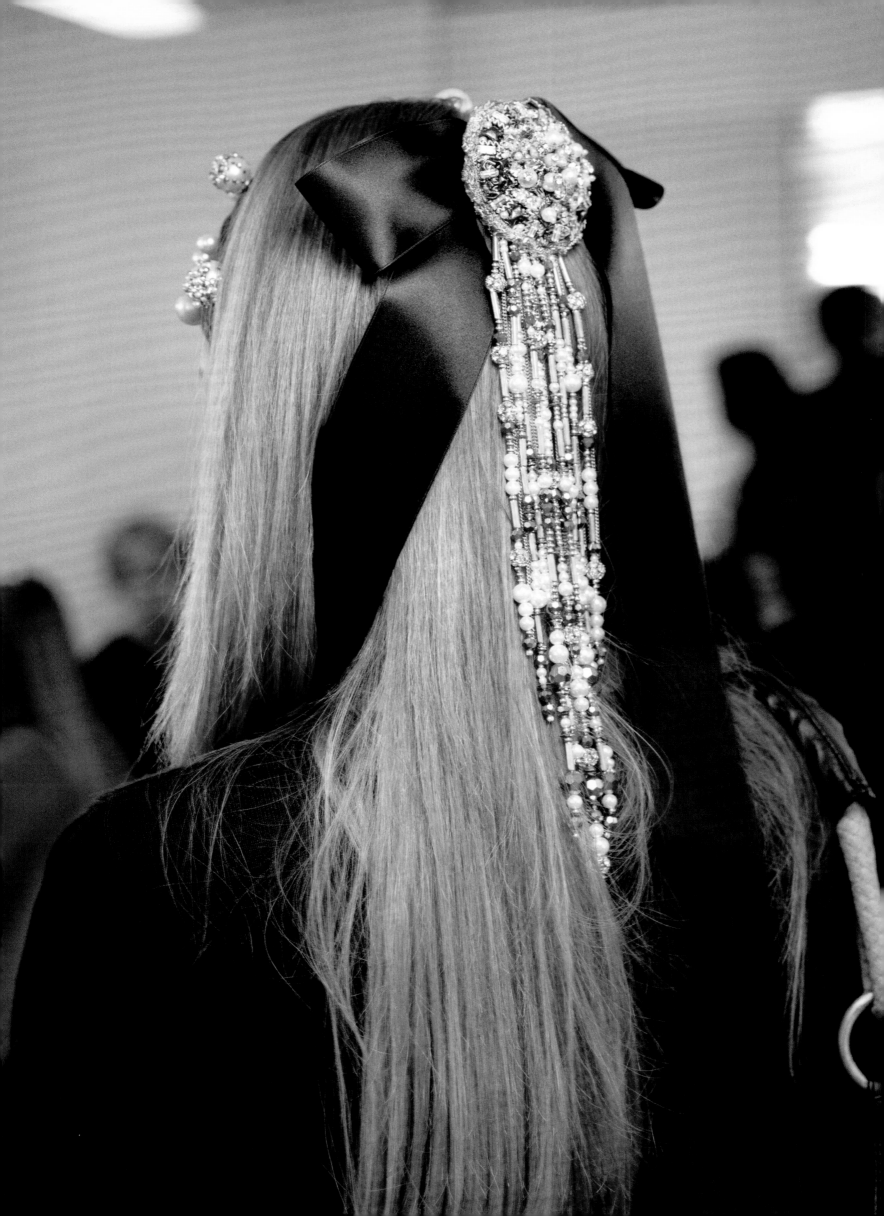

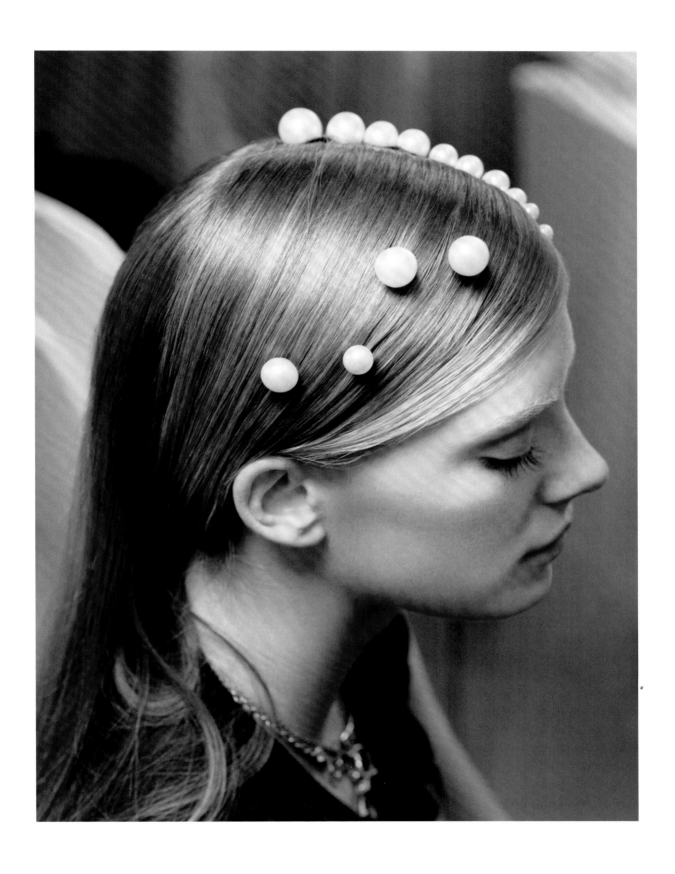

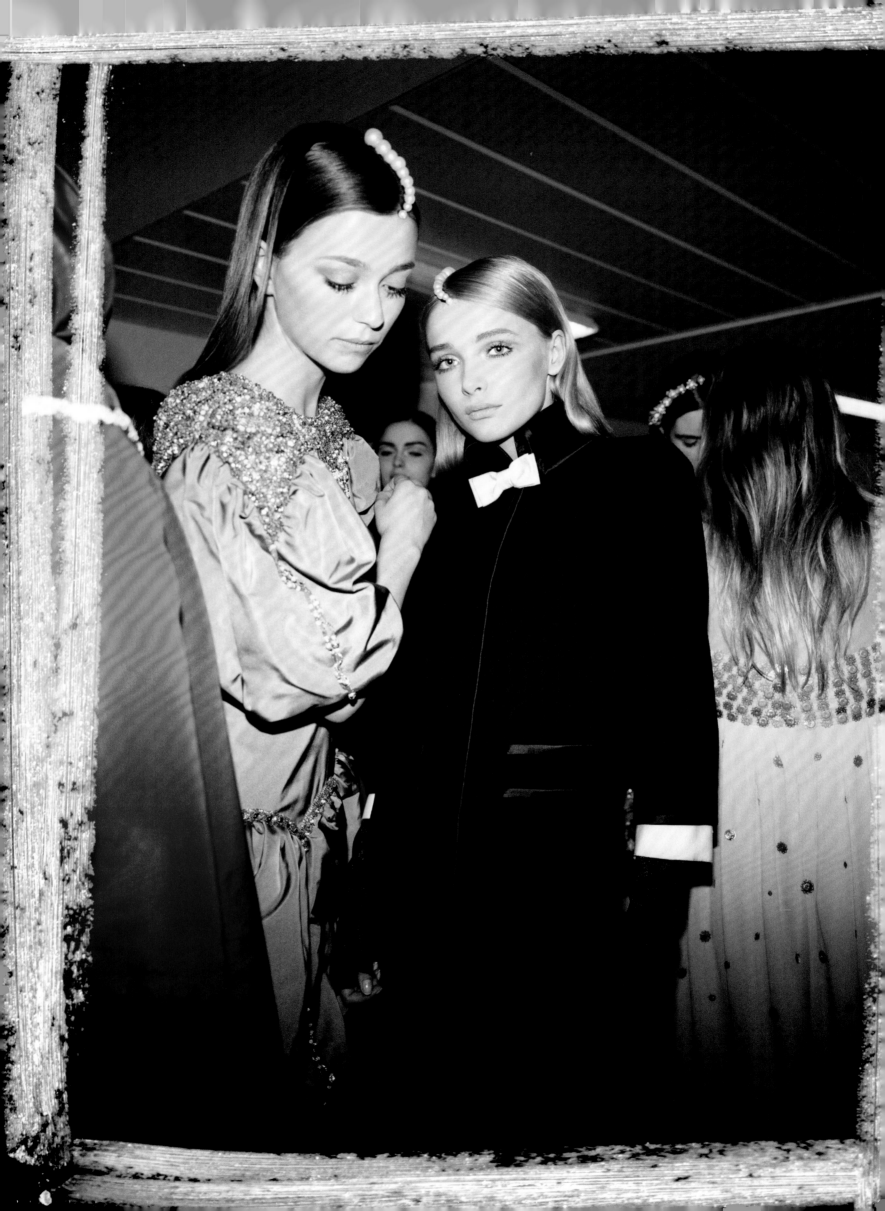

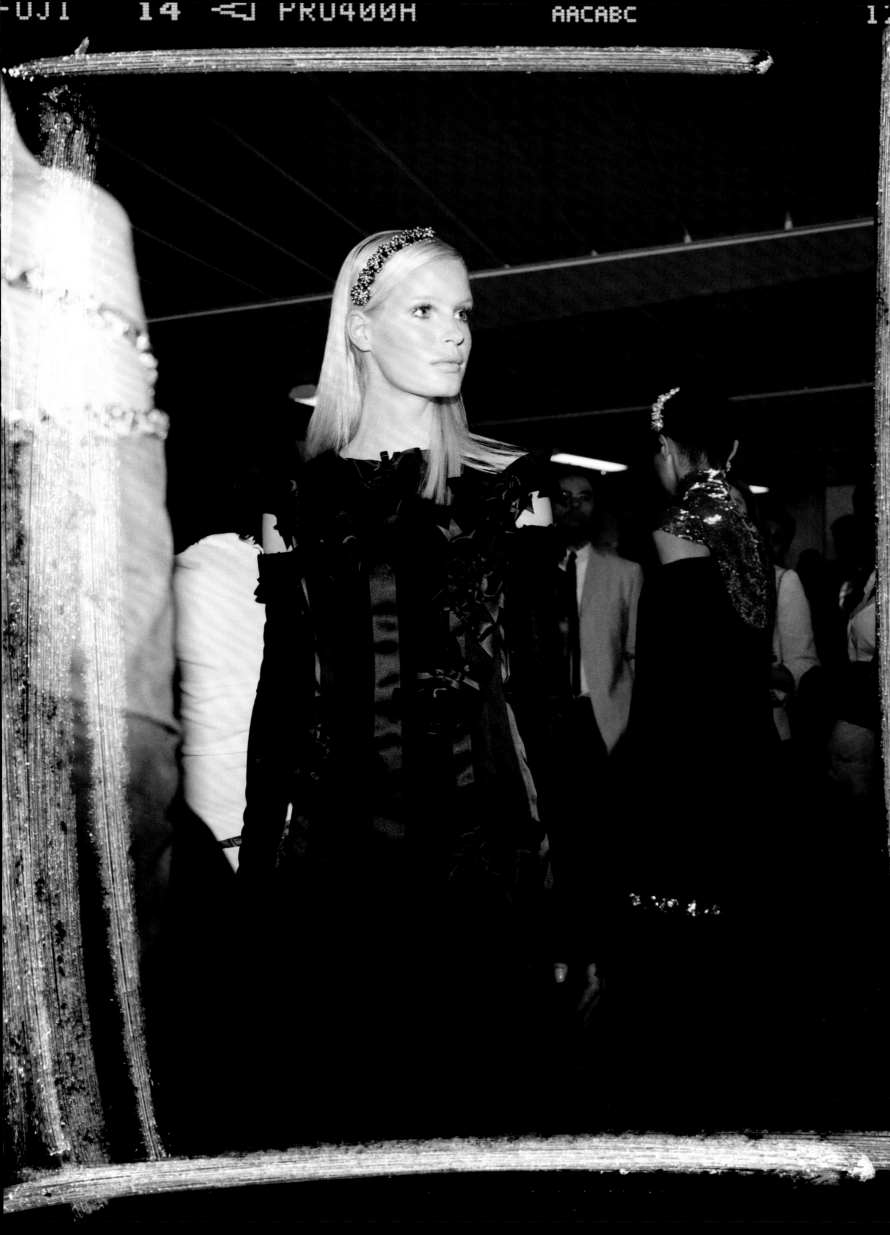

'Karl was the king of fashion!'

Philip Treacy

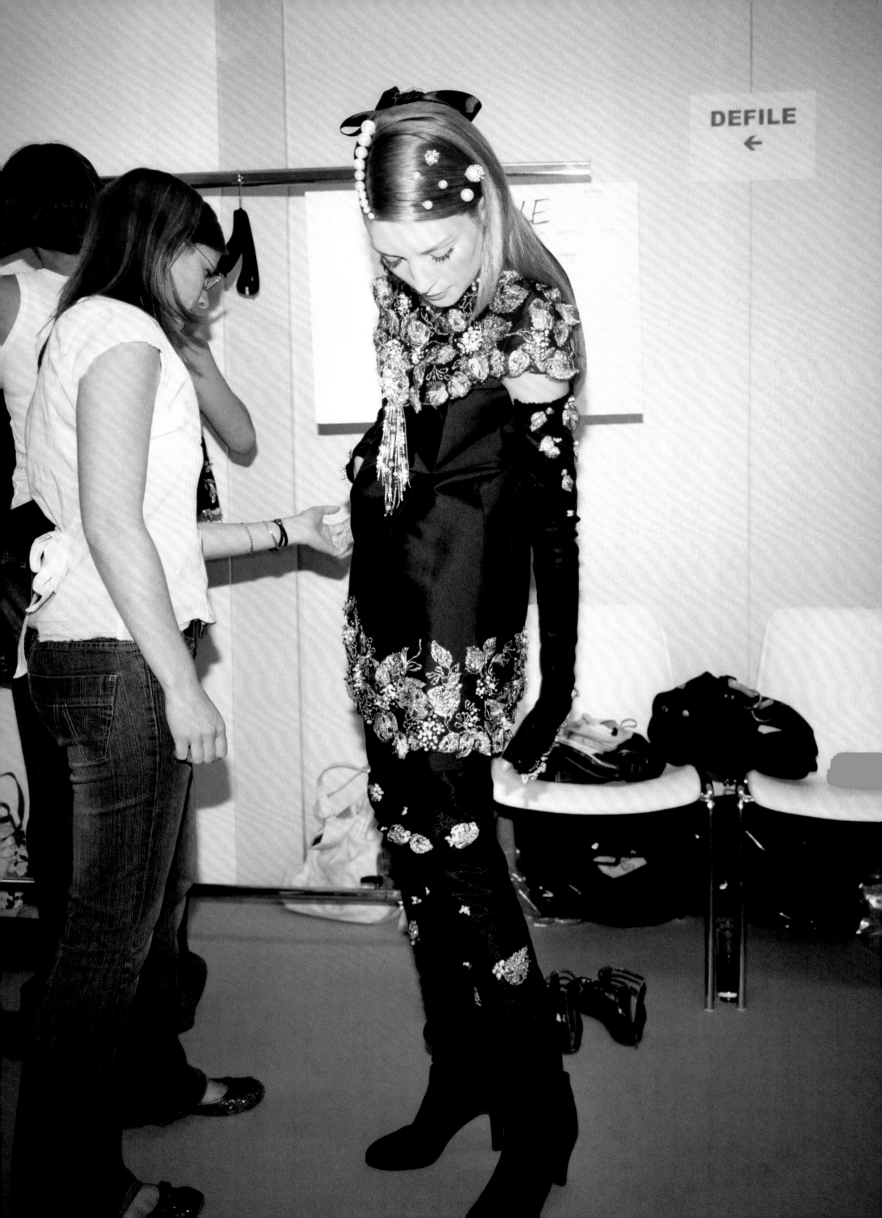

DEFILE
←

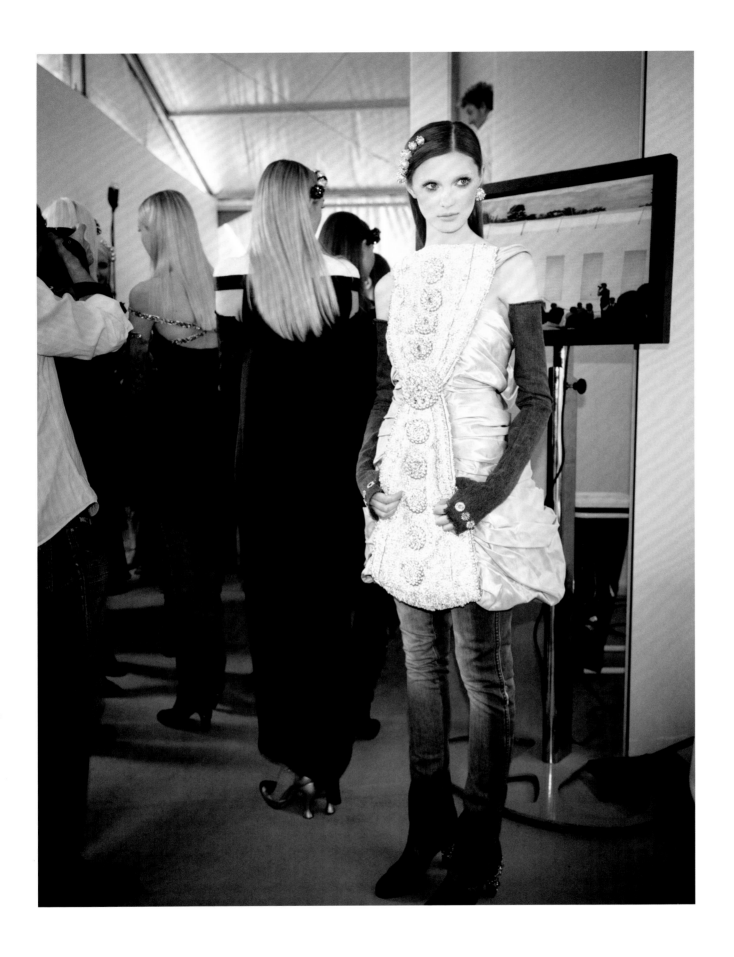

AUTUMN/WINTER 2006–2007 HAUTE COUTURE

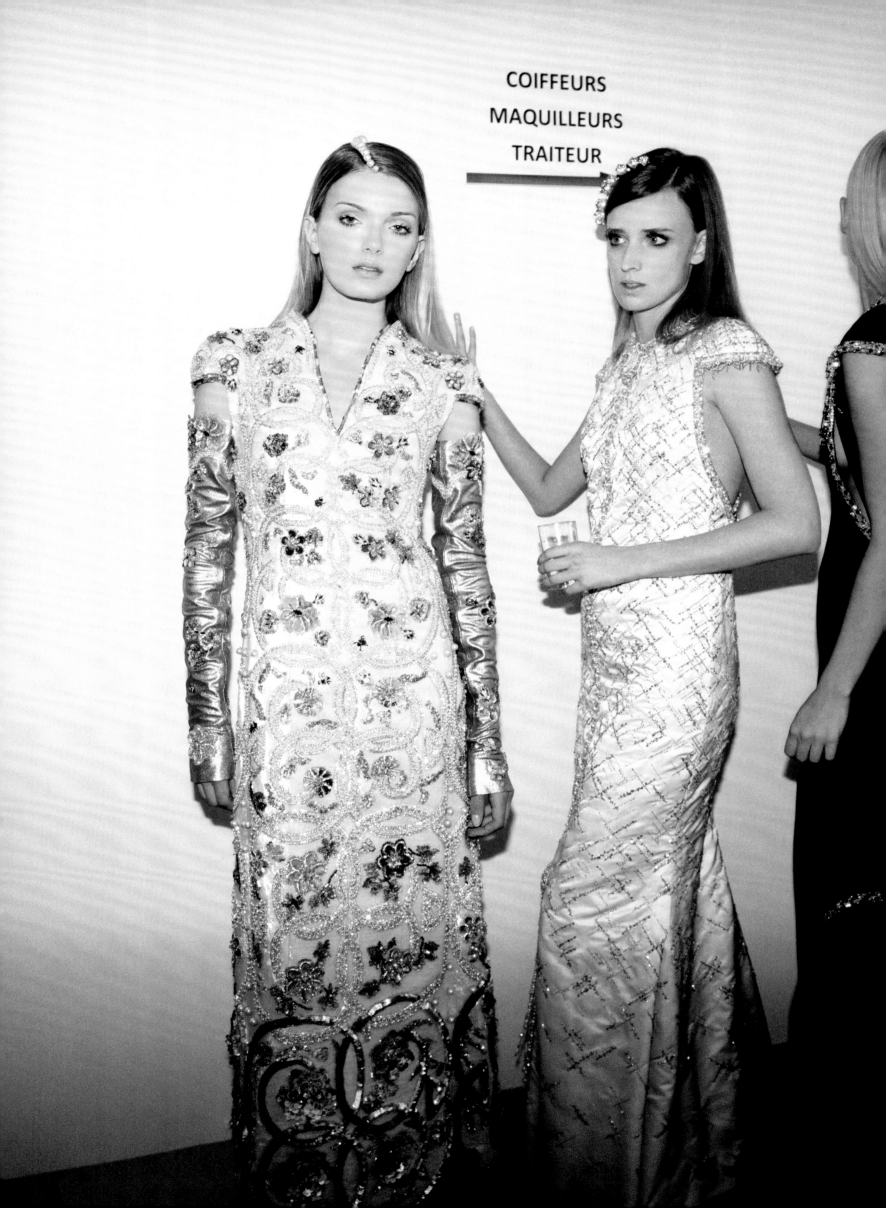

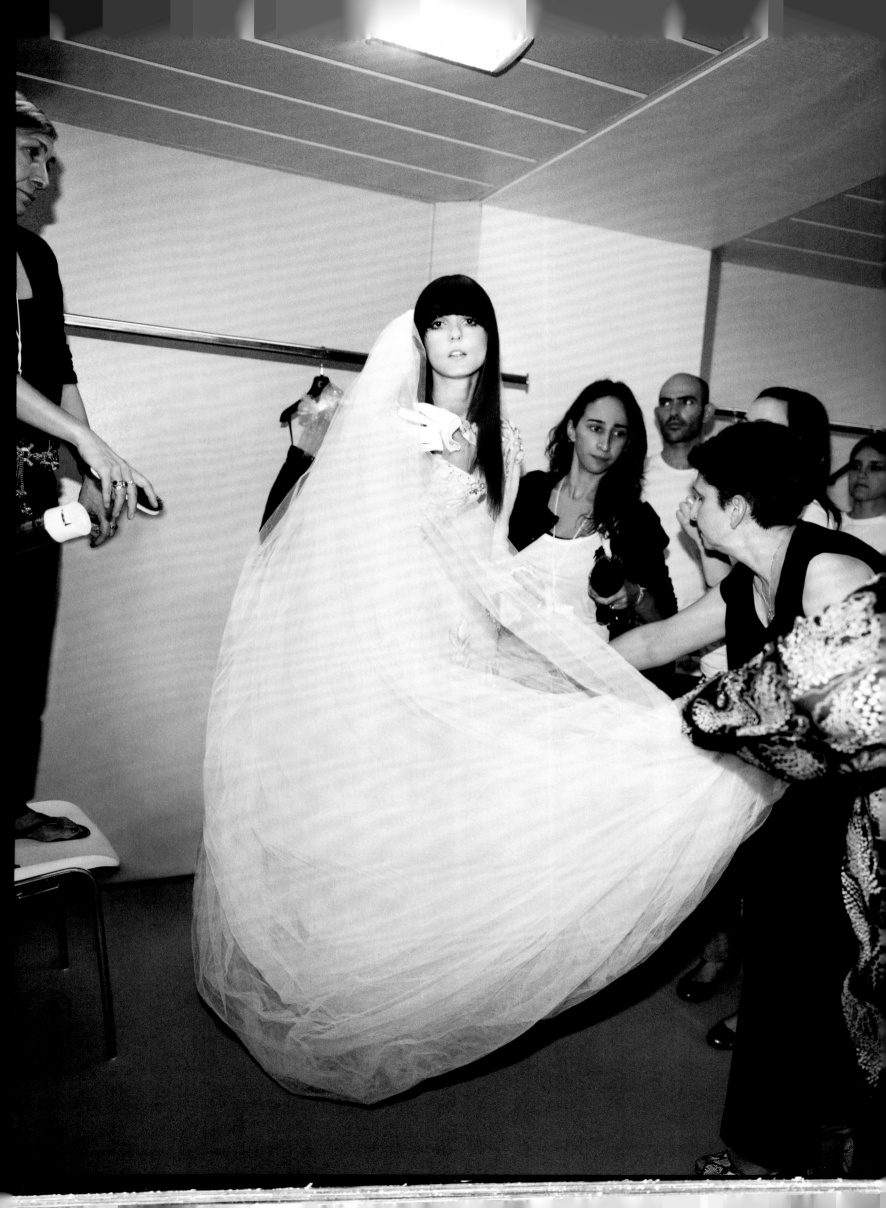

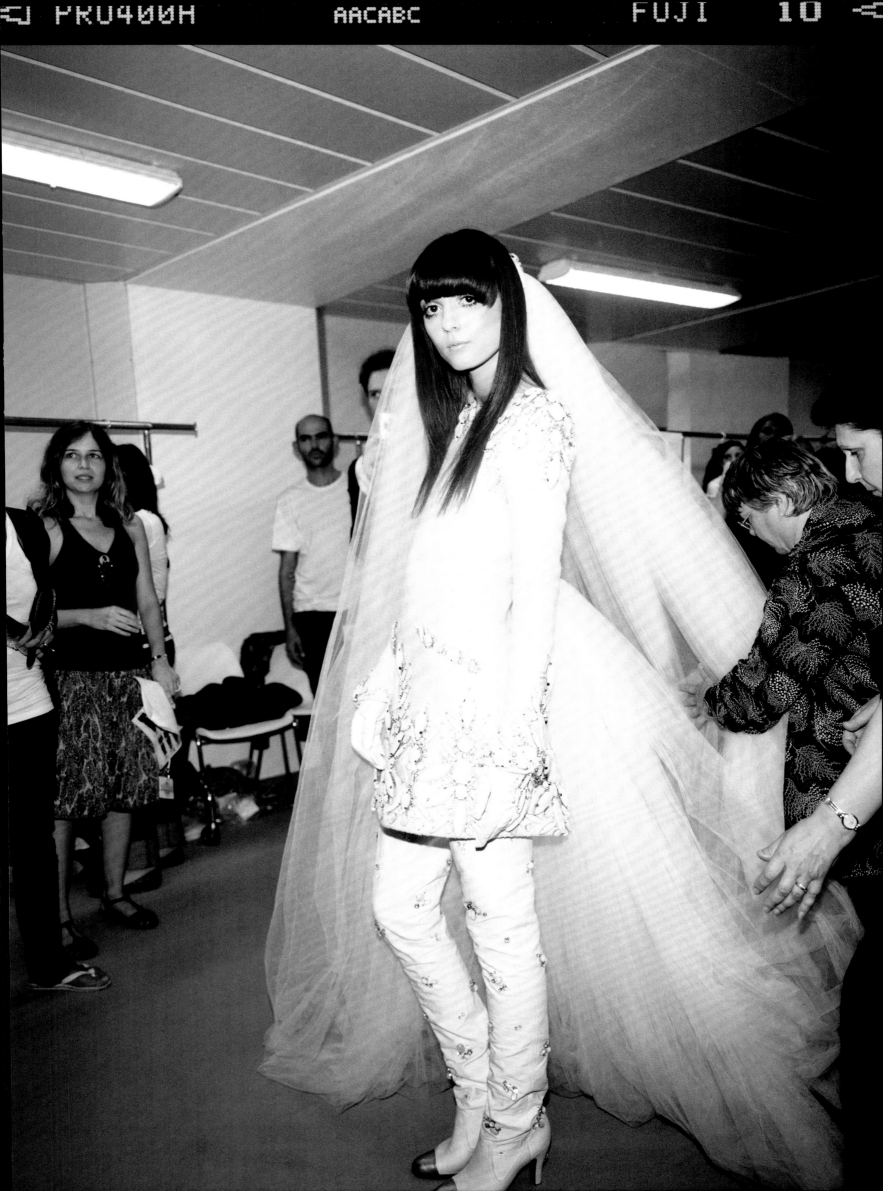

RUE CAMBON

A COUTURE BRIDE:
SILK, SATIN AND SPECTACULAR SLEEVES

Robert Fairer

In the summer of 2012 at Chilham Castle, Kent, while I was photographing the wedding of the English model Jacquetta Wheeler for American *Vogue*, Caro — a guest, Chanel Ambassador and contributing editor at American *Vogue* — smiled and whispered to me, 'Robert, I may be calling you soon...'

A few months later, I received a call from my *Vogue* photography director, Ivan Shaw, asking if I would be in Paris in January, and would I like to shoot a wedding dress fitting at the Chanel couture salon. The bride, of course, was Caro Sieber. Accompanied by sittings editor Hamish Bowles for two of the fittings with Chanel atelier chief Madame Cécile, I watched as Caro's dream wedding dress slowly began its construction.

Caro had long been inspired by a famous portrait of Empress Elisabeth of Austria, painted by Winterhalter in 1865. What struck her in particular was the romantic Worth gown that Empress Sissi was wearing, with its silvery off-the-shoulder balloon sleeves. Caro had always planned on wearing couture Chanel when she married, so she sent a picture of the portrait to the atelier, along with a copy of the 1955 film *Sissi*, which starred Viennese-born Romy Schneider as the empress.

She also sent a picture of the Winterhalter portrait to Hamish, to see if he could give her any advice. He remembered that Karl Lagerfeld had designed a similar sleeve for Chanel's Spring/Summer 1985 'Ode to Watteau' haute couture collection. Plum Sykes reported for *Vogue* on what happened next: 'On a visit to Paris, Caro tried the 1985 dress, went wild about the sleeves, and adored the Lesage embroidery of curling vine leaves that encircled the bodice, commissioning the same for her own dress.'

Eleven fittings later, Chanel delivered a dramatic heirloom of a gown: narrow at the front, with those imperial Austrian sleeves, a pale blue satin sash and bow (blue is Caro's favourite colour), a vast net veil by Maison Michel which covered the whole dress, and a billowing train.

The July wedding weekend in Austria, at one of Vienna's oldest churches, Michaelerkirche, was sealed with a kiss and ten flower girls and page boys plus their teddy bears standing beautifully by, as an enormous crowd gathered. 'That night,' Plum wrote, '200 guests were driven to a dreamy *Schloss* an hour from Vienna.' Caro's new husband, Fritz von Westenholz, had arranged for the soundtrack to *The Sound of Music* to play on the coaches that twisted up the mountain roads. Once there, amid the silver-birch trees in a candlelit courtyard, Caro called out, 'You must stay until dawn... Austrians stay up all night!'

Caro and Fritz's wedding was described by my editor-in-chief as 'a veritable fairytale of Mitteleuropean castles, ball gowns and dirndls'. American *Vogue* gave it eight pages, and hailed it as 'The Wedding of the Year' on the cover of its September issue.

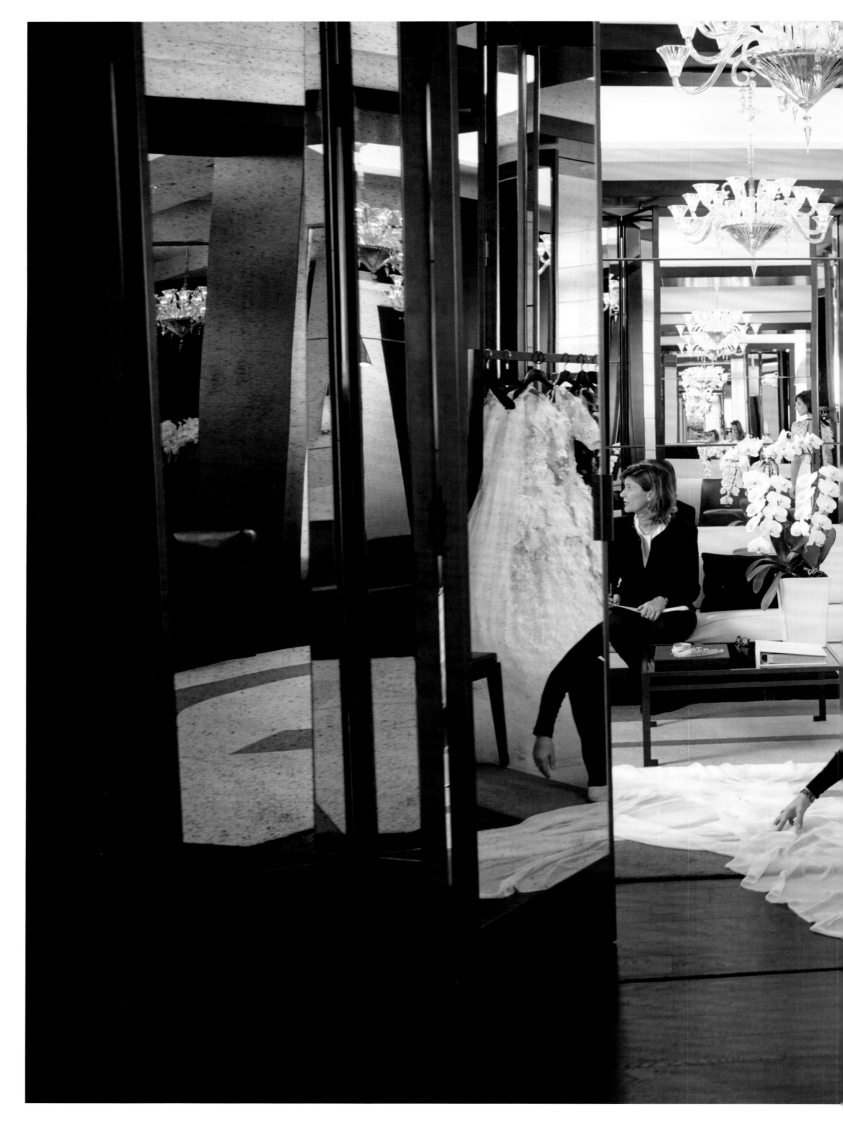

ROBERT FAIRER

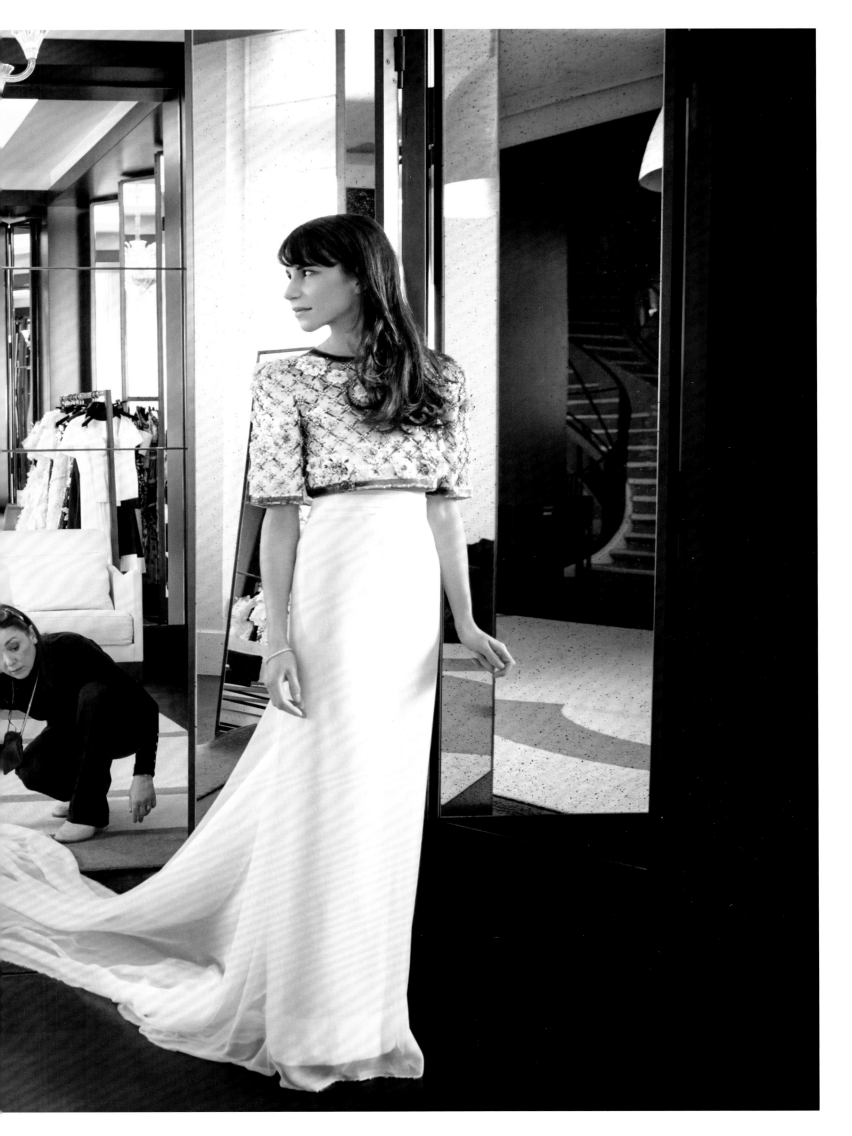

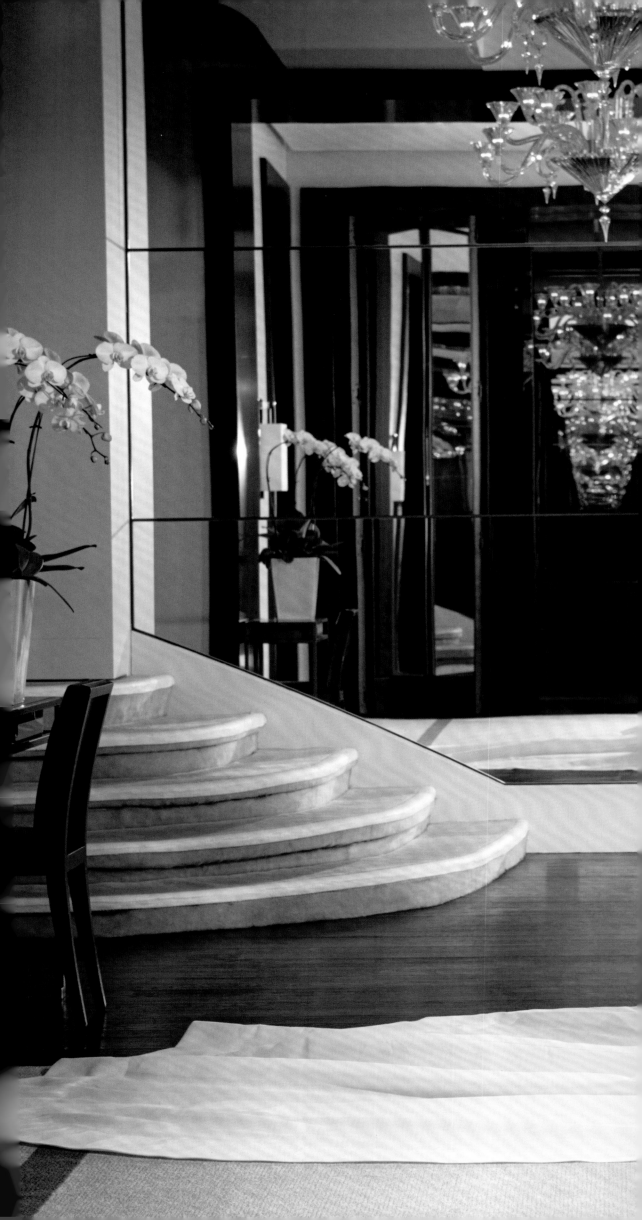

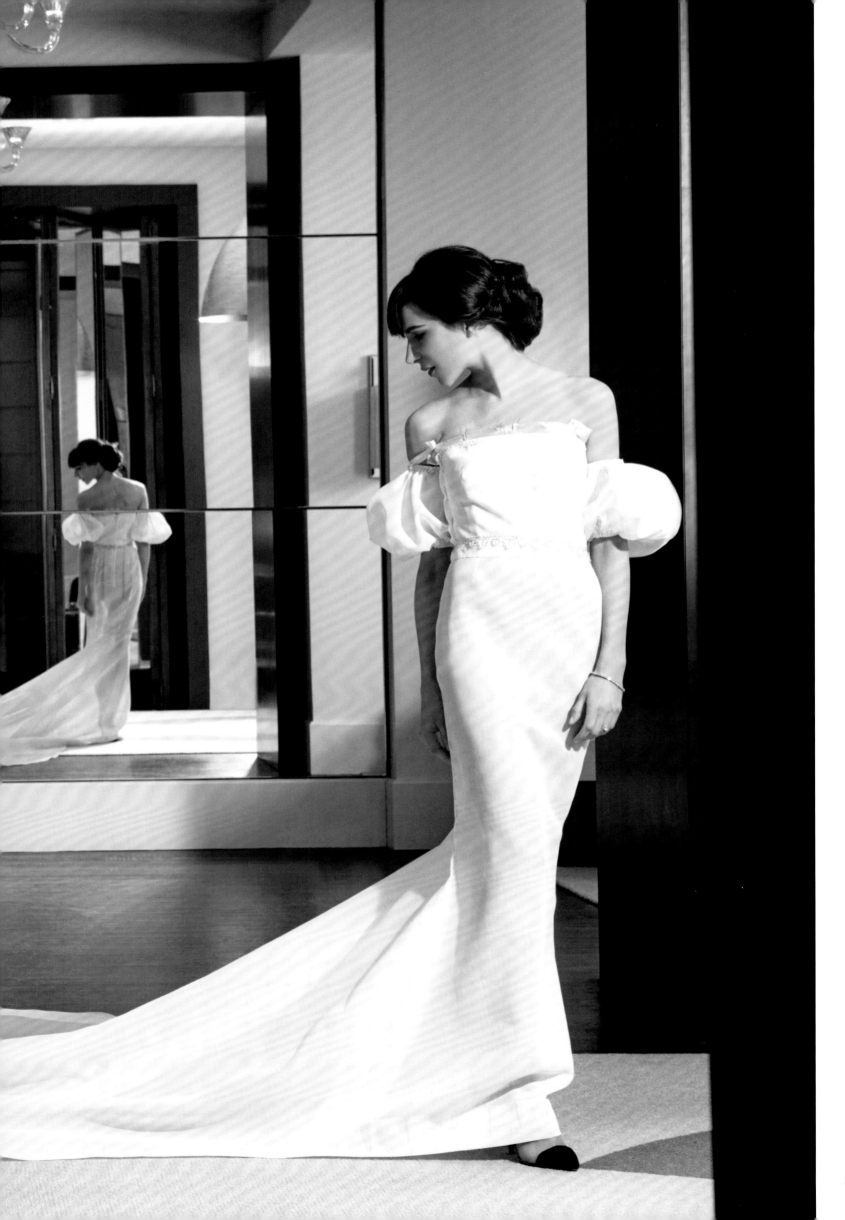

'With thirty-eight yards of silk
and eleven atelier fittings, Chanel
delivered a dramatic heirloom of a
wedding dress: narrow at the front,
with imperial Austrian sleeves'

Robert Fairer

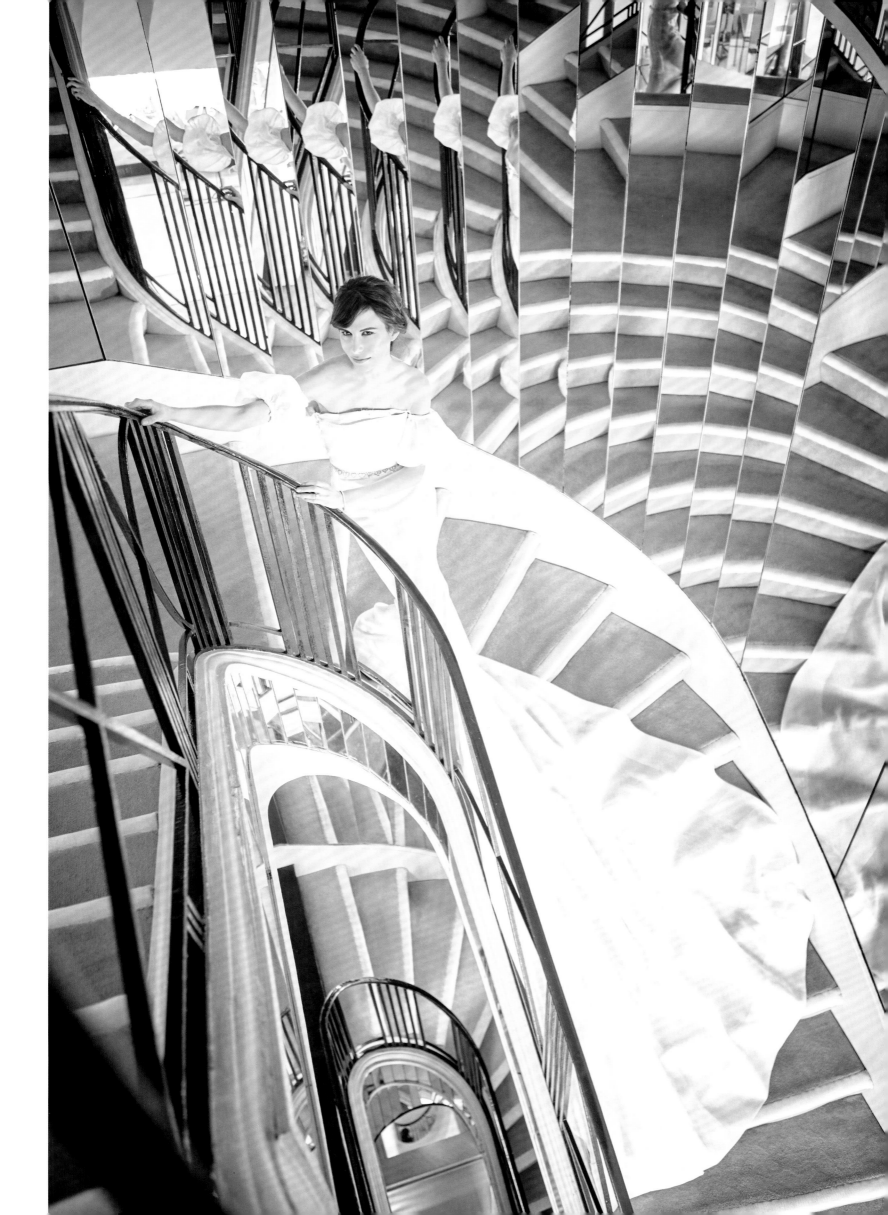

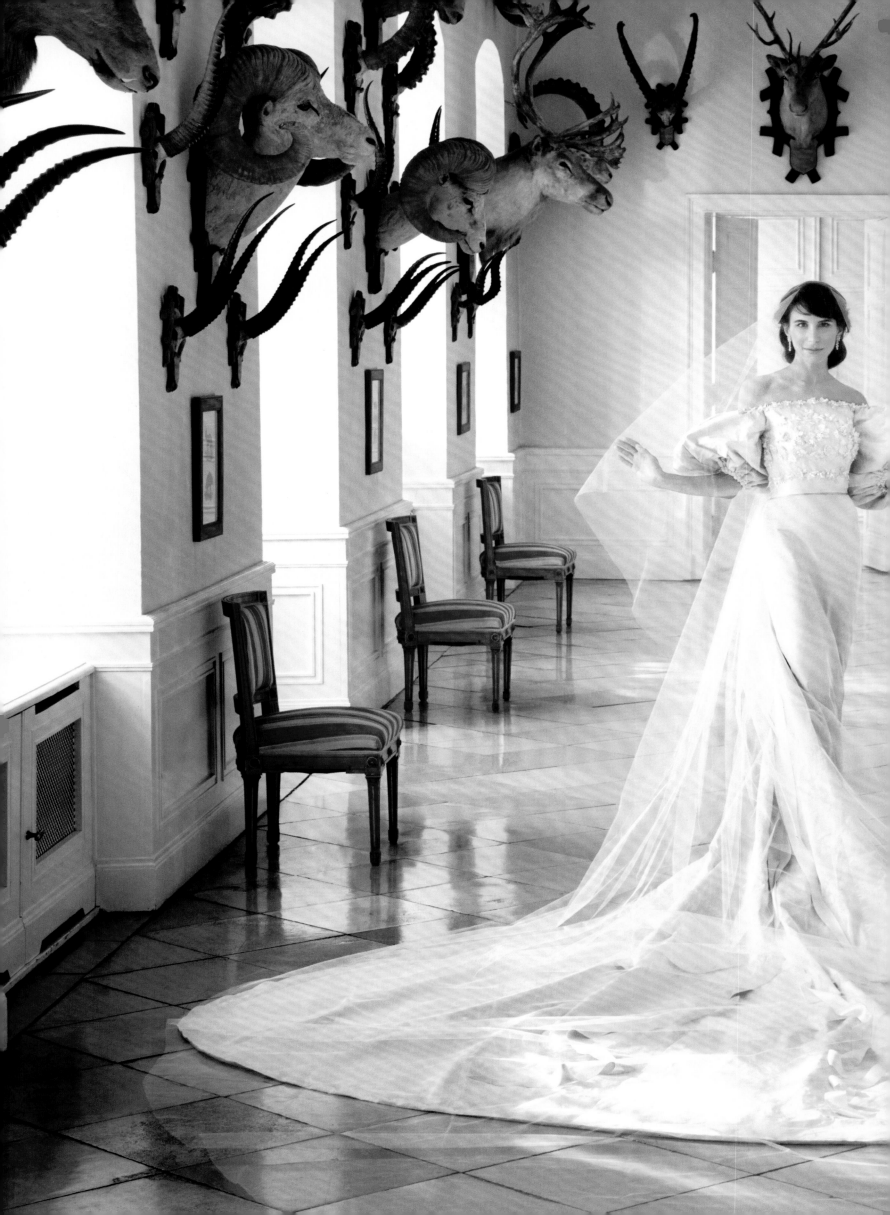

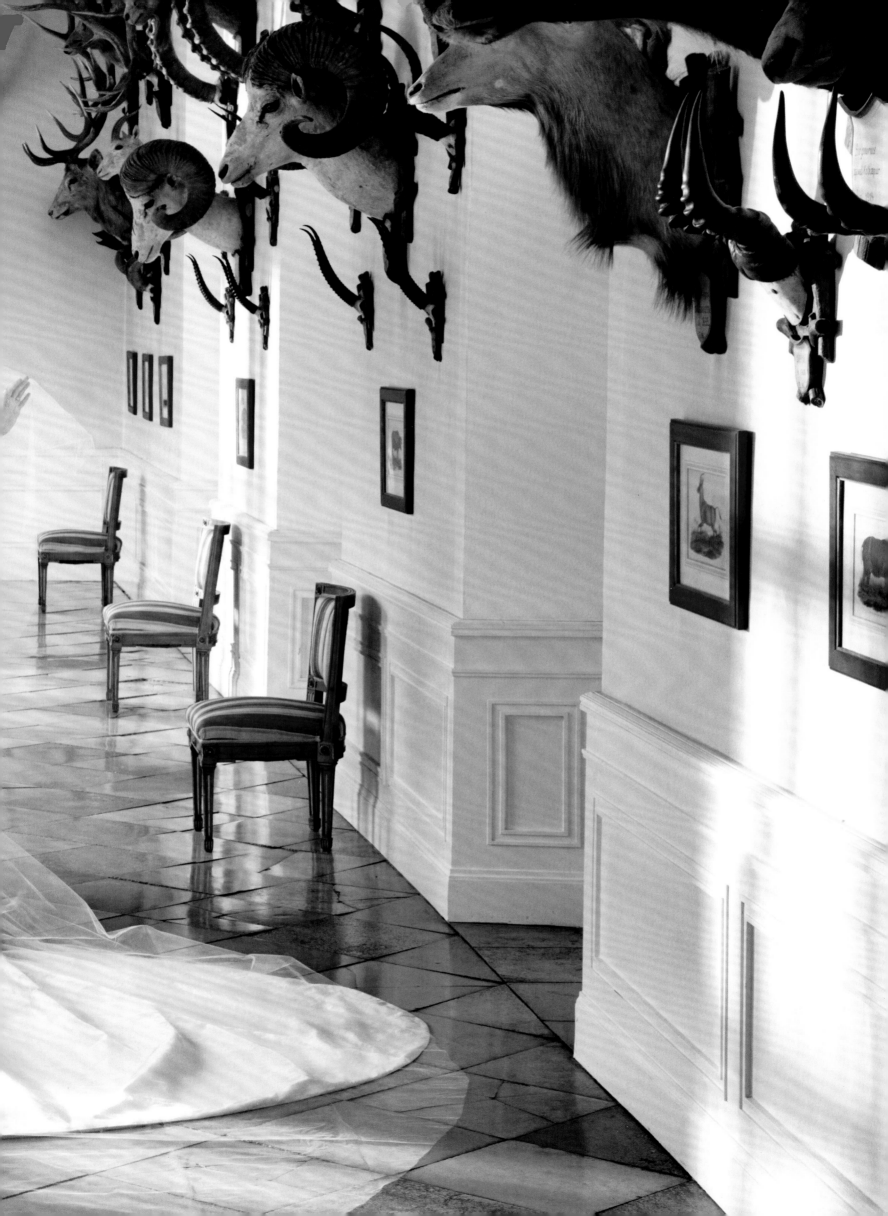

A DAY AT THE ATELIER:
COUTURE, DIET COKE AND CHOUPETTE

Elisabeth von Thurn und Taxis

I remember visiting Karl a few years ago at the Chanel atelier on 31 rue Cambon as though it were yesterday. There he sat in his light-filled office, behind a desk stacked with piles and piles of books, papers, magazines and knick-knacks, animatedly chatting to assistants, famous guests and elegant ladies dressed in black, flitting in and out of his vicinity, while models in delicate lace and silk gowns strutted around the room. It was, after all, just days before his couture show, during final fittings. Nonetheless he seemed to exude nothing but his usual animation. His show, so it seemed, was but one of a gazillion mental preoccupations that flooded his consciousness that day. The monumental endeavour — it ate up a small fortune each season, and involved weeks of planning and complex set-building, and gowns that could each take the atelier well over a thousand hours to make — was business as usual for Mr Lagerfeld.

One moment he was flipping enthusiastically through a book on Picasso, showing me images that had inspired the collection. Next, seamlessly, he began telling me about his cat Choupette, while glancing sideways at a willowy Lindsey Wixson wearing a stunning grey, jewelled, low-cut gown. He briefly interrupted our conversation to motion at one of his seamstresses to ever so slightly shorten the hem of said dress, and then continued our chat.

As you can imagine, I was awestruck. A wide-eyed young *Vogue* writer on assignment, I sat there inhaling as much of Karl's incredible knowledge and wit as I could. Every second felt exciting, too much to take in. Gowns covered in feathers, paillettes and jewels, each more perfect than the last, floated past. Later, walking around the atelier, where his loyal seamstresses pored over each piece in total silence, along tables covered in crisp white tablecloths, the atmosphere felt sacred. Had I been granted a peek behind the 'Wizard of Oz' curtain?

Being in the vicinity of Karl was electrifying; as though all his curiosity and insatiable appetite could seep into anyone close enough, by osmosis. Despite his age, he exploded with energy and lust for life. He had strong opinions on any topic, and knew more about pop music and social media than most people my own age. But it was his wicked sense of humour and sharp soundbites that made him so entertaining to be around. And, unlike most of us, he was not afraid to think for himself. In a world that is more and more conformist, Karl seemed invincible.

This made him a magnet for talented people of all ages, who flocked to him continuously. That day Gwyneth Paltrow arrived, seated herself next to him and excitedly watched his every move, as he pulled out his iPhone to show her the set of his next show. On his other side the famous fashion critic Suzy Menkes was attentively taking notes of each dress, while also engaged in Karl's chats. Karl continued talking at a ferocious speed, jumping from topic to topic, pointing to the bee-shaped brooches in coloured stones — accessories for the show — that lay in a big tray in front of us. Then followed an inevitable round of selfies: even at Maison Chanel the selfie was a must. Suzy gets going first, capturing Gwyneth and Karl. But I want a shot, too, and so does Karl. Karl knows the workings of a great selfie. The lighting needs to be right, he says. No, not that angle. No, no, no … not there. No, Elisabeth, flatten your jacket! Finally, he is happy. A delicate sip from his big crystal glass of ice-cold Diet Coke, which is magically refilled, and on he snaps.

Karl told me that day, when I asked about the relevance of couture, that it had to fuel today because otherwise there was no reason for it to exist. Somehow, I felt that was a great analogy for his entire genius. He managed to make everything he touched feel relevant, fresh, trailblazing. When I look through the pictures in this beautiful book, even decades later his pieces feel fresh. If I could magically snap my fingers and be dressed head to toe in one of the looks, I would happily step right out into the night. Karl managed the impossible: he was the zeitgeist and yet he was also ahead of his time, defying age, trends and borders.

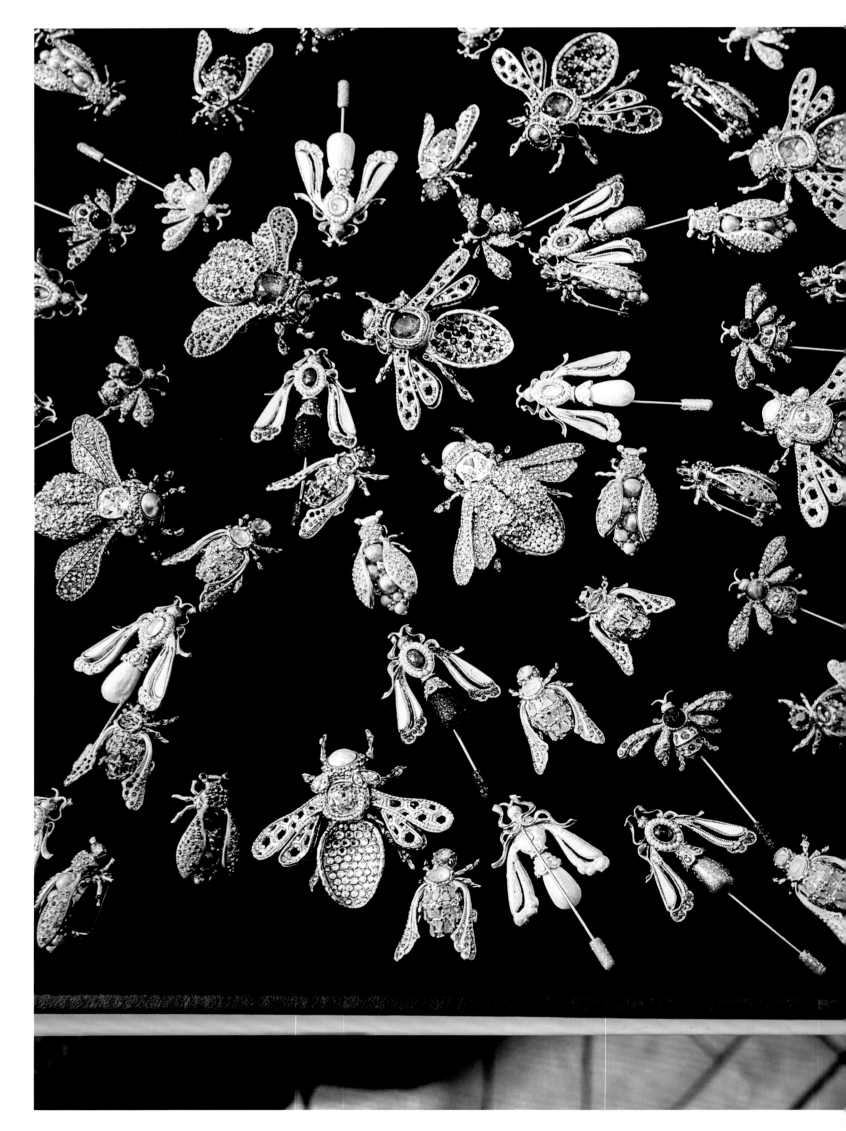

ELISABETH VON THURN UND TAXIS

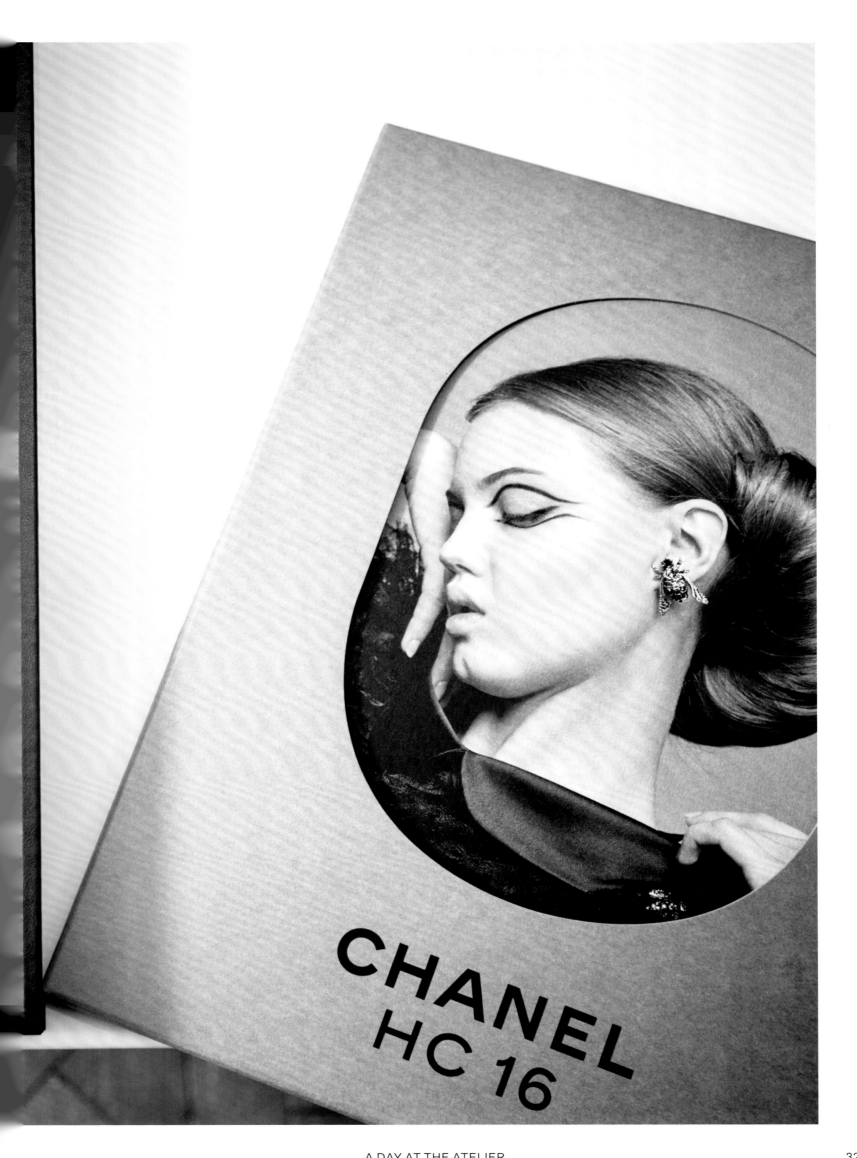

CHANEL
HC 16

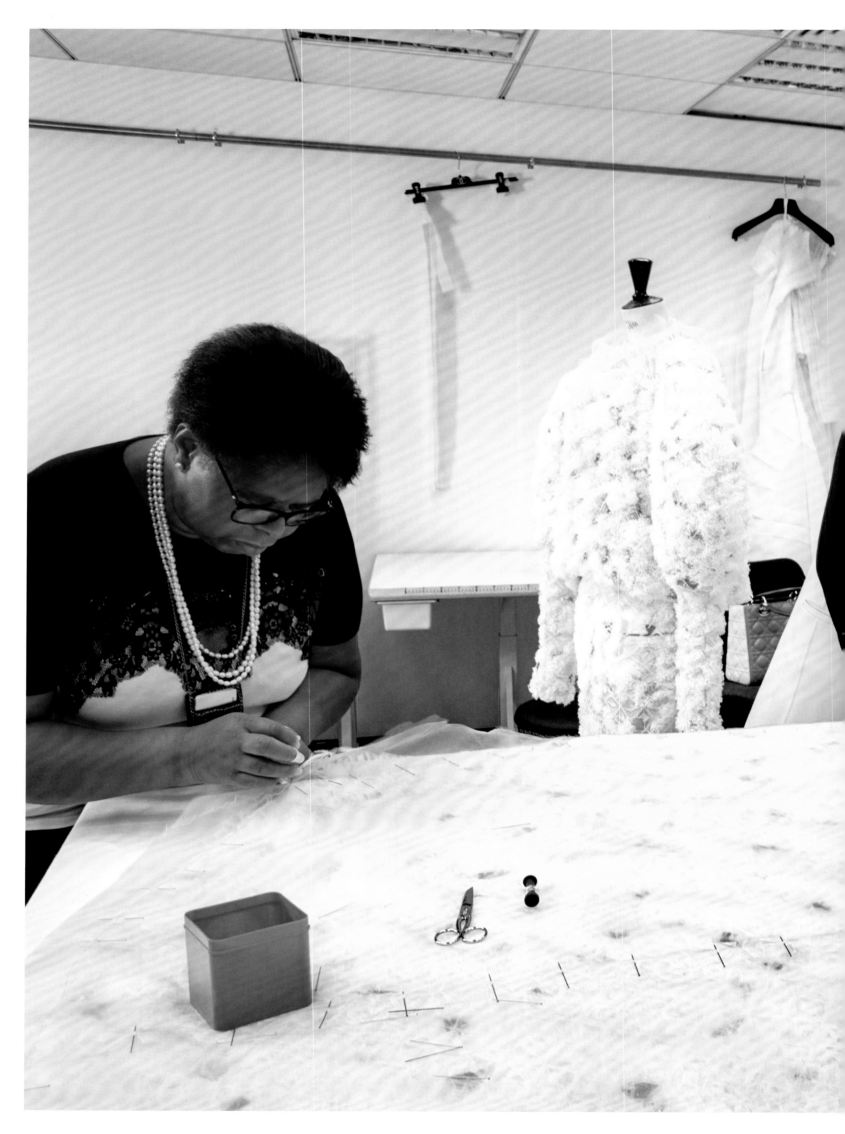

ELISABETH VON THURN UND TAXIS

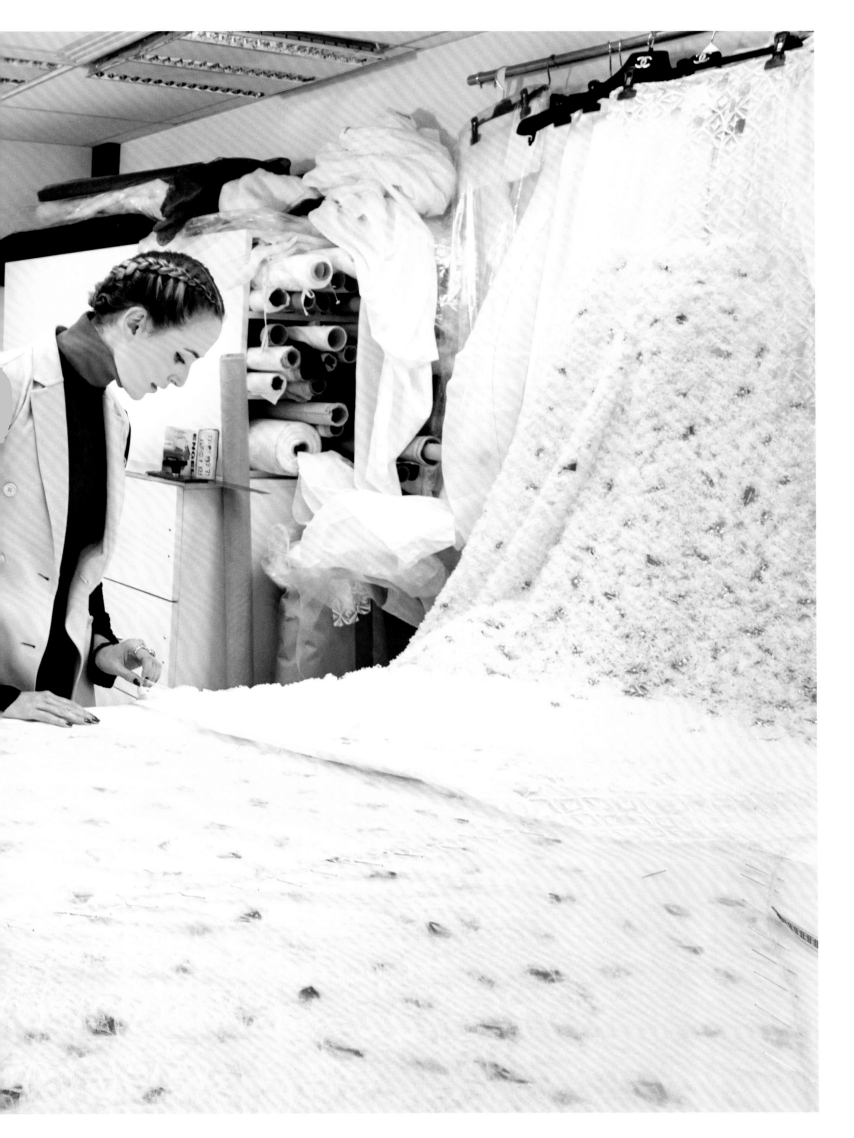

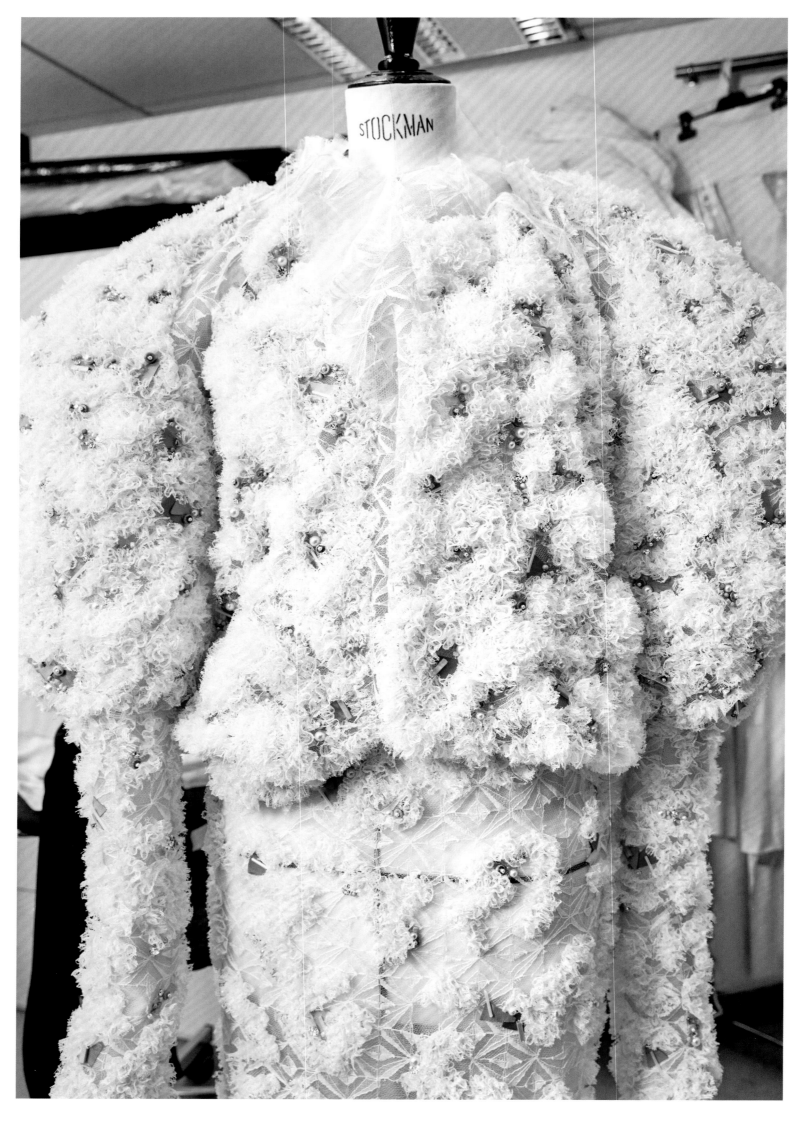

ELISABETH VON THURN UND TAXIS

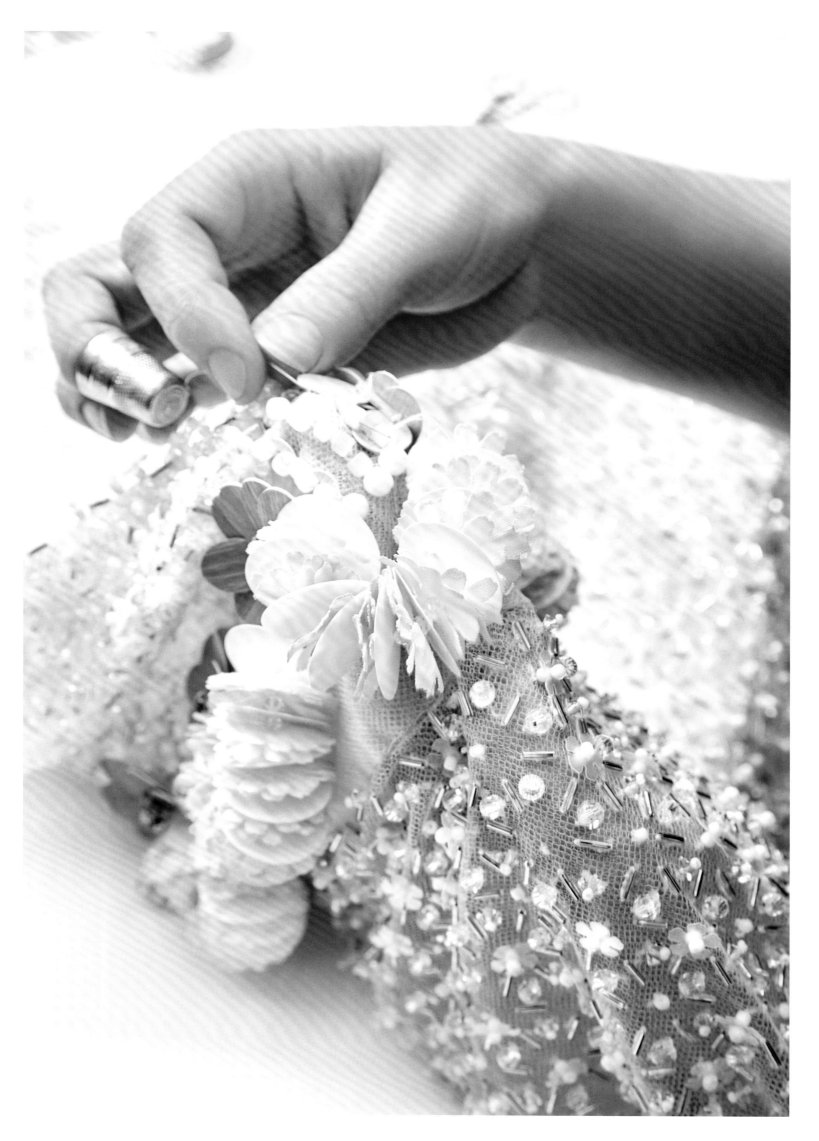

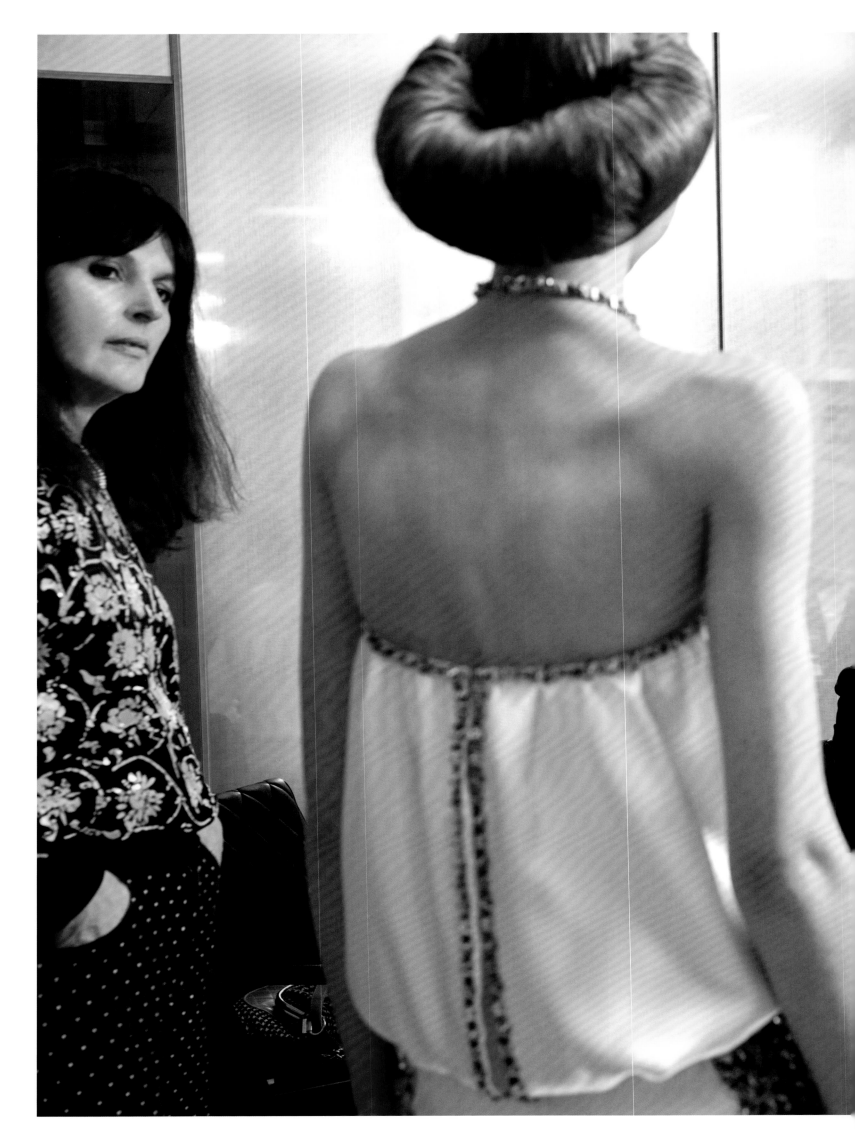

ELISABETH VON THURN UND TAXIS

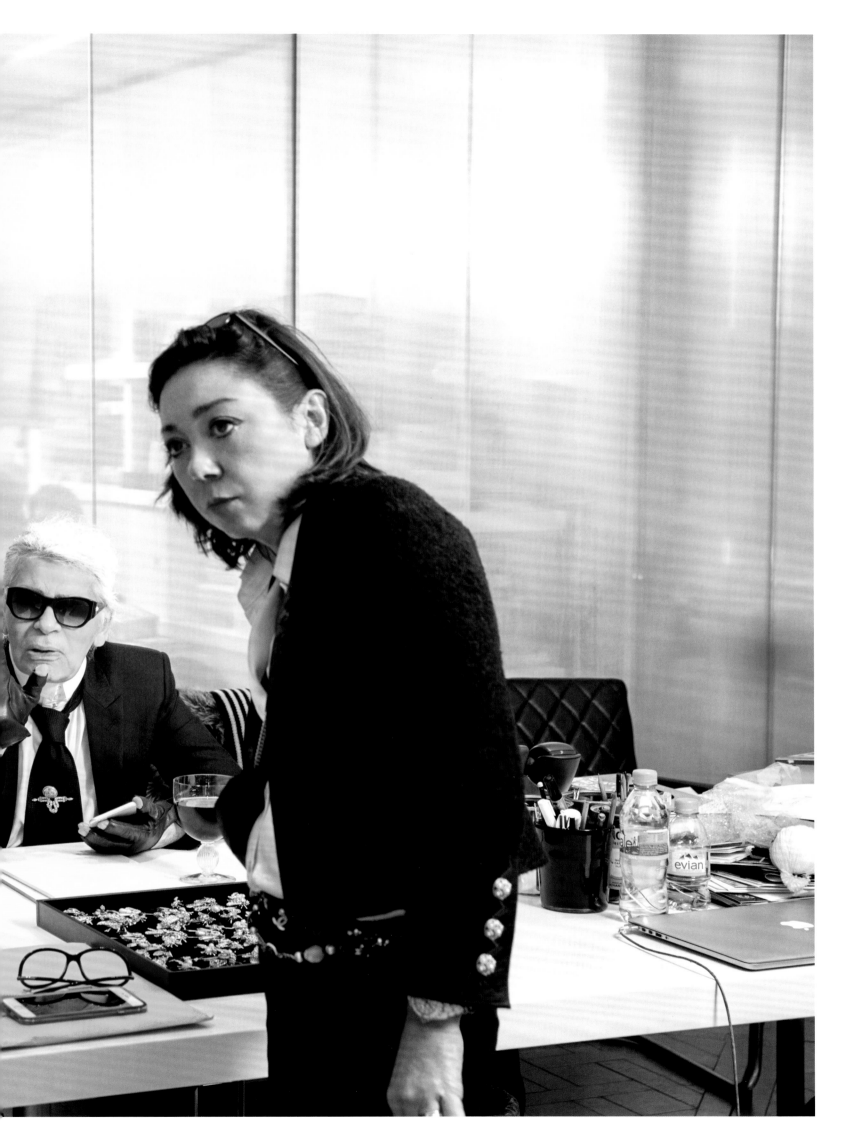

'That was the show with a beautiful simple Japanese zen house and garden set. Karl had drawn the hair for me on the back of an envelope on a photoshoot a few weeks before. Sometimes his hair inspiration sketches were just that — to inspire me to interpret the drawing in my own way — but this was one of those sketches that I knew he wanted me to translate perfectly into hair, and he laughed his deep loud laugh when he was pleased with himself, and christened it the Chanel Croissant.'

Sam McKnight

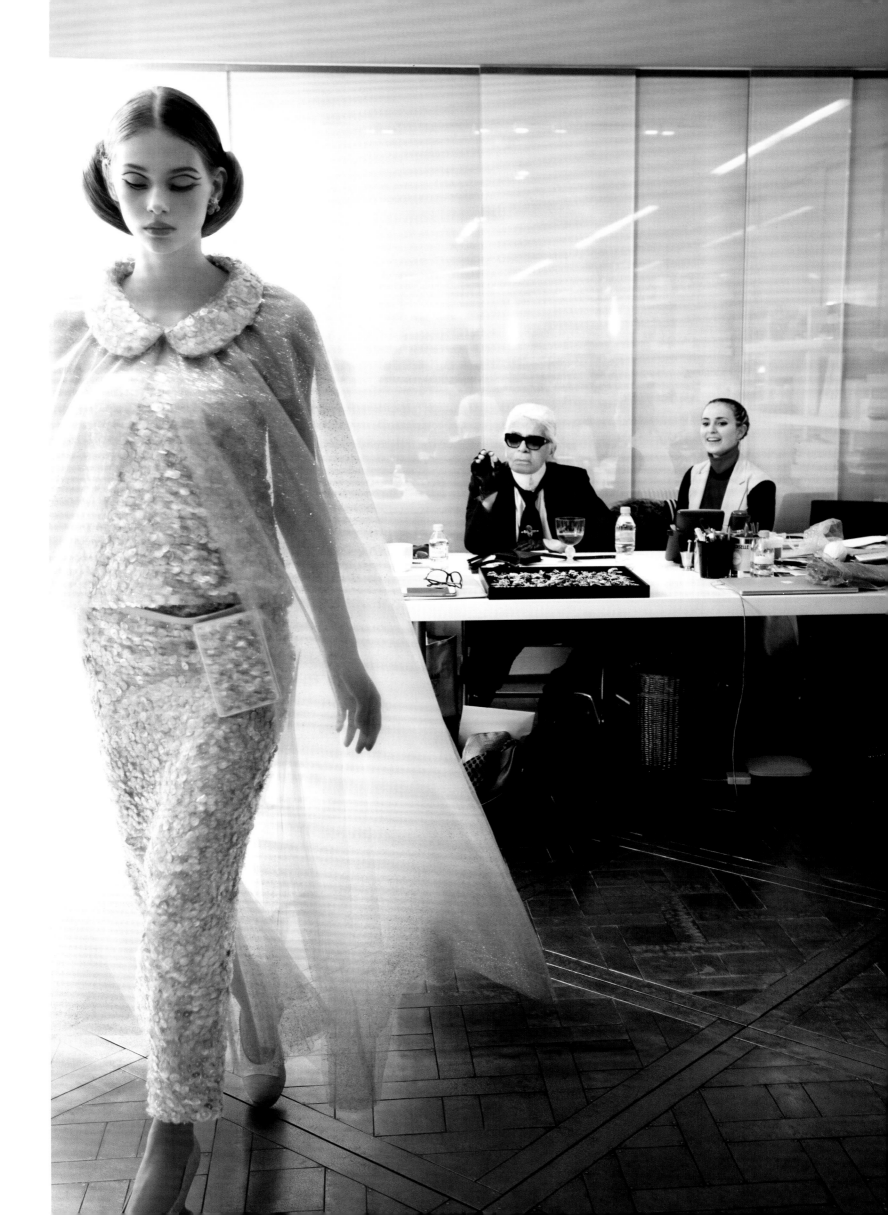

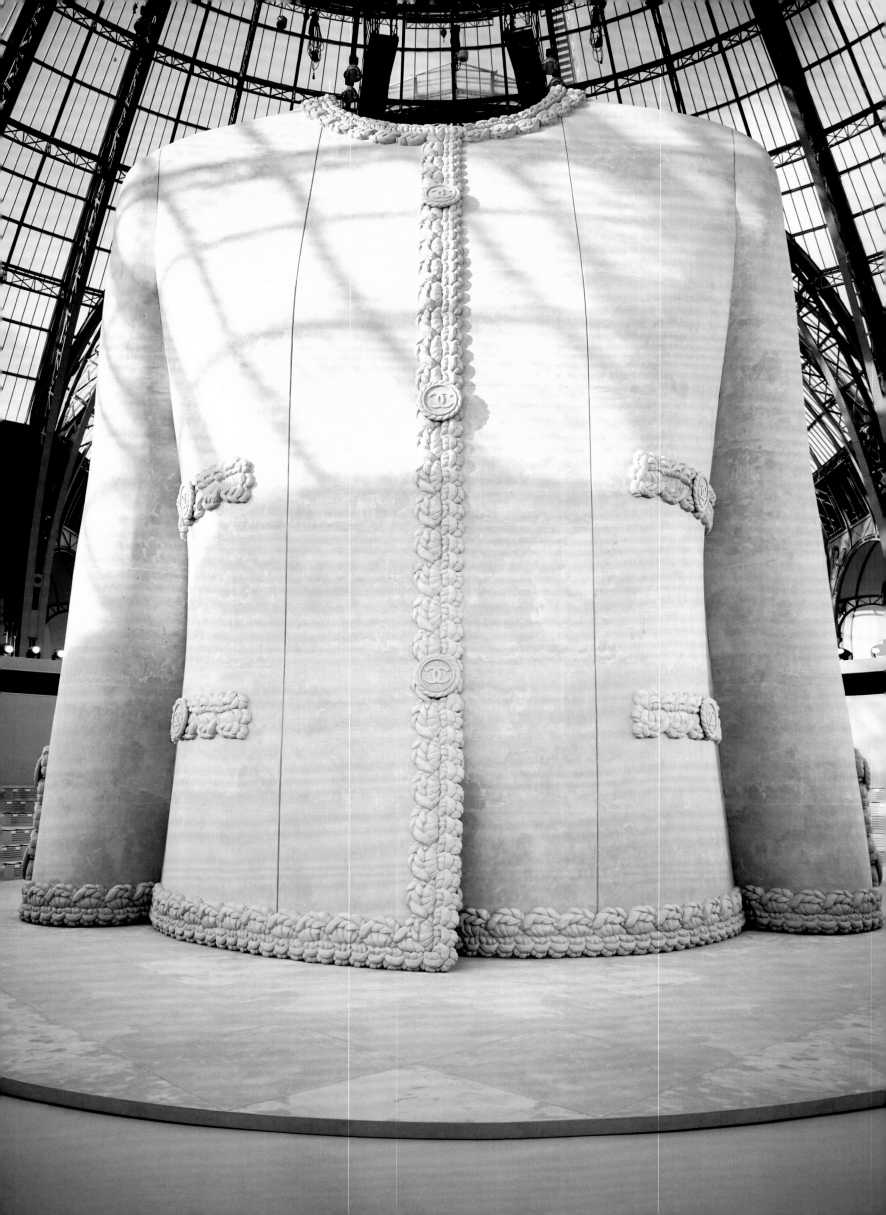

'The way I was brought into Chanel is one of the strongest proofs of trust I was ever granted, and sums up the relationship I shared with Karl.

It was the last days of fashion week. At 2am the phone rang, and it was Karl asking me to help him for the Chanel show that was going to happen at 10am the same morning, because he didn't like the music that his team had prepared.

I told him I had taken a sleeping pill and he told me not to worry; what I would come up with would still be better than what they had. I ended up spending the rest of the night at Diane de Beauvau's apartment listening to music and doing my best to sort out what to do in such a short time.

I arrived at the show with no sleep but a strong adrenaline flow that made me very aware of that special moment. The show was a success — the models walked in front of a giant Chanel purse [Autumn/Winter 1990–1991 ready-to-wear; reminiscent of the giant Chanel jacket opposite] — and I was proud of this achievement. The music was mostly Lil Louis.

Karl Lagerfeld took a gamble because he knew I would deliver, we trusted each other implicitly, and that was the beginning of our story.'

Michel Gaubert

AUTUMN/WINTER 1994–1995 READY-TO-WEAR

SPRING/SUMMER 1995 READY-TO-WEAR

AUTUMN/WINTER 1995–1996 READY-TO-WEAR

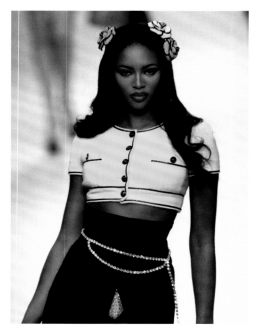

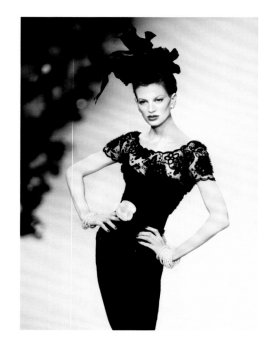

March 1994
Paris

HAIR: Odile Gilbert
MAKE-UP: Stéphane Marais
HATS: Philip Treacy
MODELS: Claudia Schiffer (pp. 19 &
22); Linda Evangelista (p. 20); Stella
Tennant (p. 21); Kate Moss (pp. 23 & 25);
Naomi Campbell (p. 24)

October 1994
Paris

HAIR: Orlando Pita
MAKE-UP: Stéphane Marais
MODELS: Naomi Campbell (pp. 27 &
29); Trish Goff (p. 28); Linda Evangelista
(p. 30); Carla Bruni (p. 31); Debbie
Deitering (p. 32 back left); Kristen
McMenamy (p. 32 centre); Karen
Mulder (p. 33)

March 1995
Paris

HAIR: Odile Gilbert
MAKE-UP: Stéphane Marais
MANICURE: Dominique Moncourtois
HEADPIECES: Philip Treacy
MODELS: Kristen McMenamy
(pp. 35 & 41); Stella Tennant (p. 36);
Eva Herzigova (pp. 37 & 39 left);
Amber Valletta (p. 38); Karen Mulder
(p. 39 right); Kirsty Hume (p. 42)

SPRING/SUMMER 1996 READY-TO-WEAR

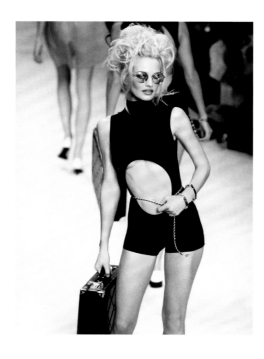

October 1995
Paris

HAIR: Odile Gilbert
MAKE-UP: Stéphane Marais
MODELS: Karen Mulder (p. 45);
Eva Herzigova (p. 46); Claudia Schiffer
(p. 47); Stella Tennant (pp. 48 & 49);
Karen Mulder (p. 50); Kate Moss (p. 51)

AUTUMN/WINTER 1996–1997 READY-TO-WEAR

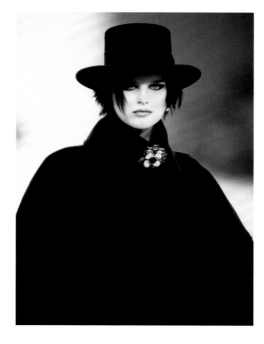

March 1996
Paris

HAIR: Odile Gilbert
MAKE-UP: Stéphane Marais
HATS: Philip Treacy
MODELS: Stella Tennant (pp. 53, 58,
61 & 62); Rosemarie Wetzel (p. 54);
Kylie Bax (p. 55 front); Kate Moss
(p. 56); Trish Goff (p. 57); Shalom
Harlow (pp. 60 & 63)

AUTUMN/WINTER 1997–1998 READY-TO-WEAR

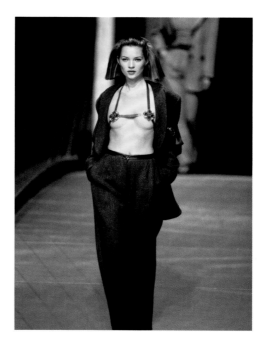

March 1997
Paris

HAIR: Odile Gilbert
MAKE-UP: Stéphane Marais
MODELS: Kate Moss (p. 65); Kirsty
Hume (p. 66); Naomi Campbell (p. 67)

SPRING/SUMMER 1998 READY-TO-WEAR

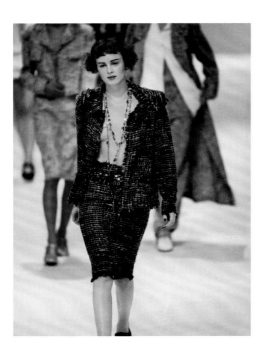

October 1997
Paris

HAIR: Odile Gilbert
MAKE-UP: Stéphane Marais
MODELS: Karen Elson (pp. 69 & 71 fourth left); Michele Hicks (p. 70 left); Laetitia Casta (p. 70 second left); Kate Moss (p. 70 right); Georgina Grenville (p. 71 left); Astrid Muñoz (p. 71 second left); Tomiko Fraser-Hines (p. 71 third left); Kylie Bax (p. 71 right)

SPRING/SUMMER 2000 READY-TO-WEAR

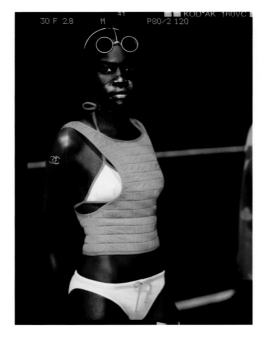

October 1999
Paris

HAIR: Odile Gilbert
MAKE-UP: Stéphane Marais
MODELS: Alek Wek (p. 75); Teresa Lourenco (p. 76); Marianne Schröder (p. 77); Diana Gärtner (p. 79); Tanga Moreau (p. 82)

AUTUMN/WINTER 2000–2001 READY-TO-WEAR

March 2000
Paris

HAIR: Odile Gilbert
MAKE-UP: Stéphane Marais
MODELS: Maggie Rizer (p. 85 left); Erin O'Connor (p. 85 right); Danita Angell (p. 87)

AUTUMN/WINTER 2000–2001 HAUTE COUTURE

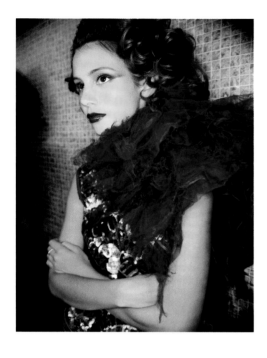

July 2000
Piscine Keller, Paris

HAIR: Odile Gilbert
MAKE-UP: Stéphane Marais
MODELS: Angie Schmidt (p. 89);
An Oost (pp. 90 & 91 right); Malin
Persson (p. 91 left); Carmen Kass
(p. 93); Devon Aoki (p. 94); Colette
Pechekhonova (p. 96)
BACKSTAGE: Odile Gilbert (p. 93 right)

SPRING/SUMMER 2001 READY-TO-WEAR

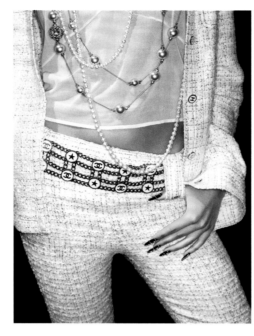

October 2000
Carrousel du Louvre, Paris

HAIR: Odile Gilbert
MAKE-UP: Stéphane Marais
MODELS: Isabeli Fontana (pp. 102 &
105); Liberty Ross (p. 107 left); Lida
Egorova (p. 107 right); Gisele Bündchen
(p. 108); Jenny Vatheur (p. 109)

SPRING/SUMMER 2001 HAUTE COUTURE

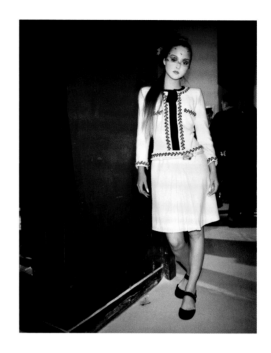

January 2001
Paris

HAIR: Odile Gilbert
MAKE-UP: Stéphane Marais
MODELS: Devon Aoki (p. 115); Erin
O'Connor (pp. 116 & 123); Caroline
Ribeiro (p. 117 back); Alek Wek (p. 117
front); Kirsten Owen (p. 118 front);
Delfine Bafort (p. 118 back); Karen Elson
(p. 119); Colette Pechekhonova (p. 121)
BACKSTAGE: Virginie Viard (p. 120
centre); Amanda Harlech (p. 120 right);
Karl Lagerfeld (p. 122 left)

AUTUMN/WINTER 2001–2002 READY-TO-WEAR

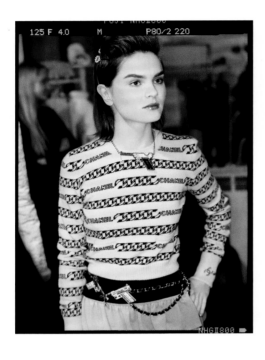

SPRING/SUMMER 2002 READY-TO-WEAR

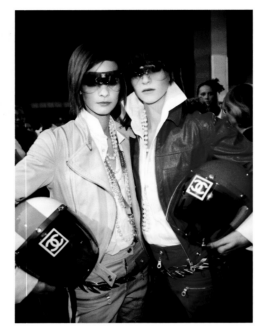

SPRING/SUMMER 2002 HAUTE COUTURE

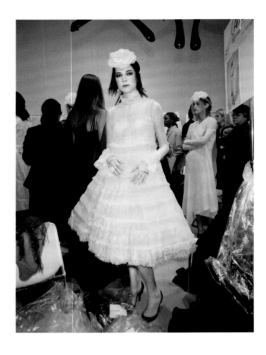

March 2001
Paris

HAIR: Odile Gilbert
MAKE-UP: Stéphane Marais
MODELS: Anouck Lepère (p. 125);
Maggie Rizer (pp. 126 & 127); Erin
Wasson (p. 129 left); Erin O'Connor
(pp. 129 right & 133 right); Karolína
Kurková (p. 130 centre); Angela Lindvall
(p. 130 right); Devon Aoki (pp. 132 right
& 135 centre); Stella Tennant (p. 133 left)
BACKSTAGE: Odile Gilbert (pp. 126
back & 135 right); Karl Lagerfeld
(p. 132 left)

October 2001
Paris

HAIR: Odile Gilbert
MAKE-UP: Stéphane Marais
MODELS: Kristina Chrastekova
(p. 137 left); Mariacarla Boscono
(p. 137 right); Maggie Rizer (pp. 138
& 146); Kirsten Owen (p. 140); Erin
Wasson (p. 141 left); Audrey Marnay
(p. 141 right); Malin Persson (p. 142);
Jeisa Chiminazzo (p. 143 left); Carmen
Maria Hillestad (p. 143 centre); Diane
Meszaros (p. 143 right); Delfine Bafort
(p. 144 left); An Oost (p. 144 centre);
Mayana Moura (p. 144 right); Marcelle
Bittar (p. 147 right)
BACKSTAGE: Amanda Harlech (p. 143
back right)

January 2002
Jardin des Tuileries, Paris

HAIR: Odile Gilbert
MAKE-UP: Stéphane Marais
MODELS: Caitriona Balfe (p. 150);
Jeisa Chiminazzo (p. 151); Juliette
Linget (p. 153); Stella Tennant (pp. 154
& 155); Karolína Kurková (pp. 156 & 157)
BACKSTAGE: Madame Martine (p. 149
right); Amanda Harlech (p. 158 left);
André Leon Talley (p. 158 right); Karl
Lagerfeld (p. 159 centre); Virginie Viard
(p. 159 right)

AUTUMN/WINTER 2002–2003 HAUTE COUTURE

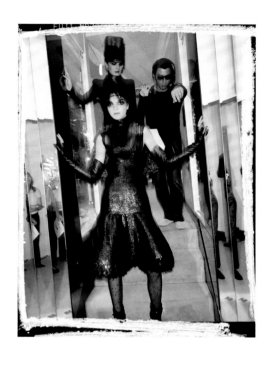

July 2002
31 rue Cambon, Paris

HAIR: Odile Gilbert
MAKE-UP: Stéphane Marais
MODELS: Mariacarla Boscono
(p. 161 front); Marcelle Bittar (p. 161
back left); Yasmin Warsame (p. 164);
Ira (p. 165)

SPRING/SUMMER 2003 READY-TO-WEAR

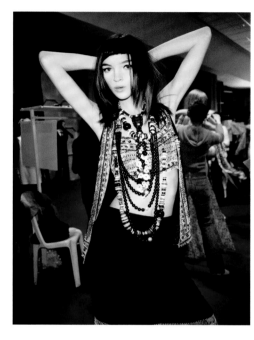

October 2002
Paris

HAIR: Odile Gilbert
MAKE-UP: Stéphane Marais
MODELS: Mariacarla Boscono (p. 167);
Natalia Vodianova (p. 168); Marija
Vujović (p. 172); Erin Wasson (p. 173
left); Jacquetta Wheeler (p. 173 right)

SPRING/SUMMER 2003 HAUTE COUTURE

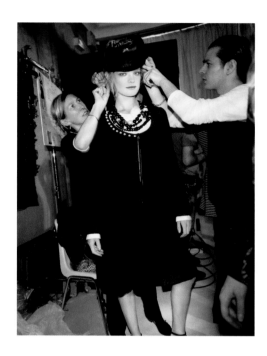

January 2003
Paris

HAIR: Odile Gilbert
MAKE-UP: Stéphane Marais
MODELS: Natalia Vodianova (pp. 175
centre & 189 centre); Elise Crombez
(p. 176); Jessica Miller (p. 177); Caroline
Winberg (p. 179); Amandine (p. 180);
Caitriona Balfe (p. 181 left); Audrey
Marnay (pp. 181 back centre & 182);
Eugenia Volodina (p. 184); Stella
Tennant (p. 185); Dewi Driegen
(p. 186 centre); Nataša Vojnović
(p. 186 right); Rie Rasmussen (p. 187);
Tetyana Brazhnyk (p. 188)
BACKSTAGE: Odile Gilbert (pp. 175 left
& 189 right)

AUTUMN/WINTER 2003–2004 READY-TO-WEAR

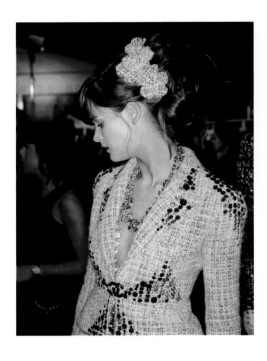

March 2003
Paris

HAIR: Odile Gilbert
MAKE-UP: Stéphane Marais
MODELS: Carmen Kass (p. 191);
Caroline Ribeiro (p. 192 left); Liliane
Ferrarezi (p. 192 centre); Natalia
Vodianova (p. 193); Angela Lindvall
(p. 195 left); Erin Wasson (p. 195 right);
Anouck Lepère (p. 196); Anna van
Ravenstein Cleveland (pp. 199 & 201
second left); Ciara Nugent (p. 200);
Pat Cleveland (p. 201 left)
BACKSTAGE: Virginie Viard (p. 193
left); Karl Lagerfeld (p. 201 centre);
Noel van Ravenstein (p. 201 right)

AUTUMN/WINTER 2003–2004 HAUTE COUTURE

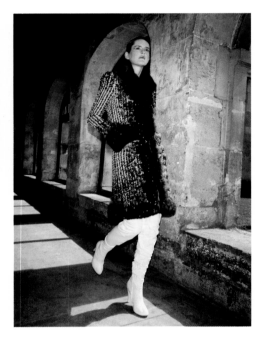

July 2003
Cloister, Port-Royal Abbey, Paris

HAIR: Odile Gilbert
MAKE-UP: Stéphane Marais
MODELS: Stella Tennant (p. 203);
Amanda Sanchez (p. 204 left);
Dewi Driegen (p. 205); Mariacarla
Boscono (p. 206 left); Heather Marks
(p. 207); Natalia Vodianova (p. 211);
Linda Evangelista (p. 213)

SPRING/SUMMER 2004 HAUTE COUTURE

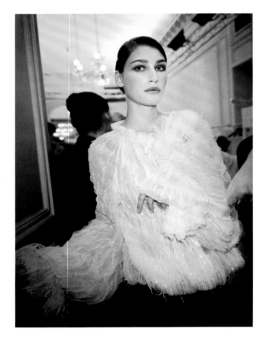

January 2004
Paris

HAIR: Odile Gilbert
MAKE-UP: Stéphane Marais
MODELS: Eugenia Volodina (p. 215);
Caroline Winberg (p. 216 left); Daria
Werbowy (p. 216 right); Liya Kebede
(p. 217); Elise Crombez (p. 218); Hana
Soukupová (p. 219 left); Julia Stegner
(p. 219 right); Mor Katzir (pp. 220 & 221)
BACKSTAGE: Madame Cécile
(p. 221 left)

AUTUMN/WINTER 2004–2005 READY-TO-WEAR

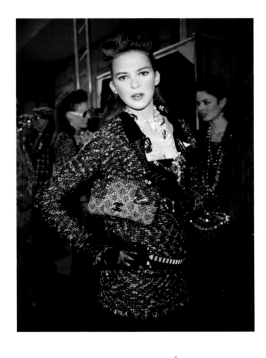

March 2004
Carrousel du Louvre, Paris

HAIR: Odile Gilbert
MAKE-UP: Stéphane Marais
MODELS: Elise Crombez (p. 223
centre); Nicole Trunfio (p. 223 right);
Lisa Davies (p. 224); Noot Seear
(p. 225); Tetyana Brazhnyk (p. 226 back
left); Caroline Winberg (p. 226 centre);
Heather Marks (p. 227); Julia Stegner
(pp. 228 & 229 left)
BACKSTAGE: Karl Lagerfeld (p. 229
centre); Virginie Viard (p. 229 right)

AUTUMN/WINTER 2004–2005 HAUTE COUTURE

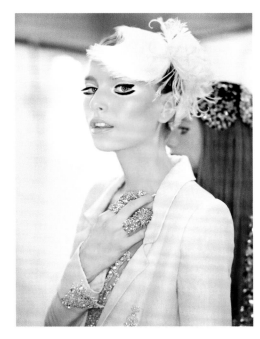

July 2004
Ateliers Berthier, Paris

HAIR: Odile Gilbert
MAKE-UP: Stéphane Marais
MODELS: Hana Soukupová (p. 231);
Lily Donaldson (p. 232); Martina
Pavlovska (p. 233 left); Irina Lazareanu
(p. 233 centre); Alek Wek (p. 234 left);
Nataša Vojnović (p. 234 centre);
Anne-Catherine Lacroix (pp. 234 right
& 237); Vanessa Perron (p. 235 centre);
Mateja Penava (p. 236); Elise Crombez
(p. 238 centre); Ciara Nugent (p. 238
back); Natasha Poly (p. 238 right);
Diana Gärtner (p. 239 centre); Kim
Noorda (p. 239 right)
BACKSTAGE: Madame Martine (p. 241
second right)

SPRING/SUMMER 2005 READY-TO-WEAR

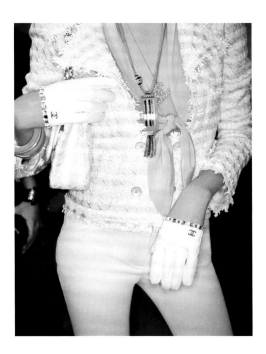

October 2004
Carrousel du Louvre, Paris

HAIR: Odile Gilbert
MAKE-UP: Stéphane Marais
MODELS: Luca Gadjus (p. 244);
Hannelore Knuts (p. 245 left); Querelle
Jansen (p. 245 centre); Amber Valletta
(pp. 246 left & 247 left); Kristen
McMenamy (pp. 246 centre & 247
right); Linda Evangelista (p. 246 right)

SPRING/SUMMER 2005 HAUTE COUTURE

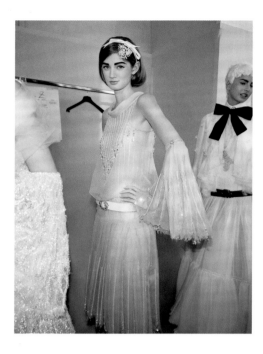

AUTUMN/WINTER 2005–2006 HAUTE COUTURE

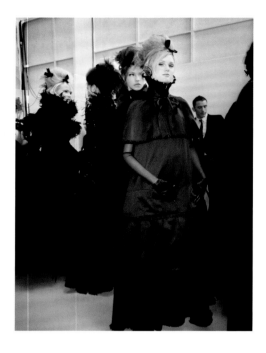

SPRING/SUMMER 2006 READY-TO-WEAR

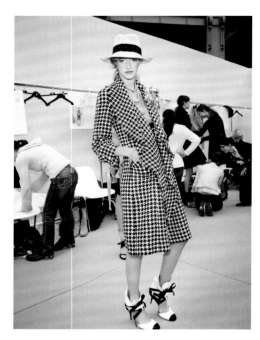

January 2005
Ateliers Berthier, Paris

HAIR: Odile Gilbert
MAKE-UP: James Kaliardos
MODELS: Melody Woodin (pp. 249 left
& 251 left); Hana Soukupová (p. 249
right); Cameron Russell (p. 250 left);
Lily Donaldson (pp. 250 centre & 257
centre); Iza Olak (p. 251 centre); Dasha
V. (p. 252 left); Amanda Sanchez (p. 252
centre); Natalia Belova (p. 252 right);
Kamila Szczawińska (p. 253 left); Anja
Rubik (p. 253 right); Heather Marks
(pp. 254 & 257 right); Caroline Trentini
(p. 255 centre); Natasha Poly (p. 255
front right); Xanthi (pp. 258 & 259)

July 2005
Ateliers Berthier, Paris

HAIR: Odile Gilbert
MAKE-UP: James Kaliardos
MODELS: Brandi Brechbiel (p. 261);
Marta Español (p. 262 left); Diana
Dondoe (p. 264 centre); Audrey Marnay
(p. 264 second right); Constance
Jablonski (p. 264 right); Portia Freeman
(p. 265 centre); Emma (p. 265 right);
Marta Berzkalna (p. 267); Dewi Driegen
(p. 269 centre); Shalom Harlow (p. 269
back); Anouck Lepère (p. 270); Solange
Wilvert (p. 271)
BACKSTAGE: James Kaliardos
(p. 268 right)

October 2005
Grand Palais, Paris

HAIR: Odile Gilbert
MAKE-UP: James Kaliardos
MODELS: Milagros Schmoll
(p. 273); Lesly Masson (p. 274);
Tatiana Lyadochkina (p. 275 left);
Solange Wilvert (p. 275 second left);
Agyness Deyn (p. 275 centre);
Fabiana Semprebom (p. 275 second
right); Tanya Dziahileva (p. 275 right);
Lily Donaldson (p. 276); Freja Beha
Erichsen (p. 278)

SPRING/SUMMER 2006 HAUTE COUTURE

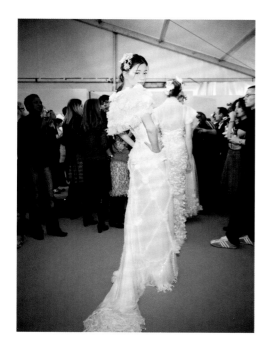

AUTUMN/WINTER 2006–2007 READY-TO-WEAR

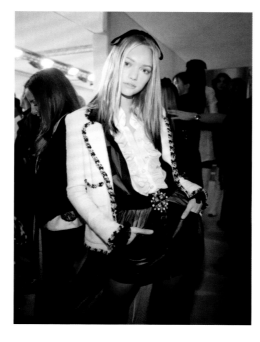

AUTUMN/WINTER 2006–2007 HAUTE COUTURE

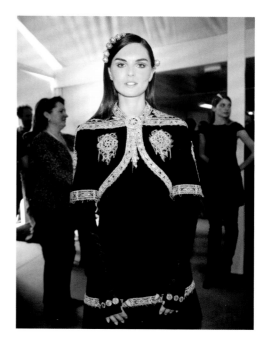

January 2006
Grand Palais, Paris

HAIR: Odile Gilbert
MAKE-UP: James Kaliardos
MODELS: Morgane Dubled (p. 281);
Lily Cole (p. 282); Lindsay Ellingson
(p. 283); Diana Dondoe (p. 284 centre);
Patricia Schmid (p. 284 right); Leah
de Wavrin (p. 285 centre); Du Juan
(p. 285 right); Tatyana Yusova (p. 287
left); Natasha Poly (p. 287 centre);
Raquel Zimmermann (p. 287 right)

March 2006
Grand Palais, Paris

HAIR: Odile Gilbert
MAKE-UP: James Kaliardos
MODELS: Gemma Ward (p. 289);
Daria Werbowy (p. 291); Anja Rubik
(p. 293 left); Raquel Zimmermann
(p. 293 right); Leah de Wavrin (p. 294);
Trish Goff (p. 295 left); Stella Tennant
(pp. 295 centre & 296); Irina Lazareanu
(p. 297)
BACKSTAGE: Max Farago (p. 294 right)

July 2006
Bois de Boulogne, Paris

HAIR: Odile Gilbert
MAKE-UP: James Kaliardos
MODELS: Anouck Lepère (p. 299);
Julia Dunstall (p. 301); Morgane Dubled
(p. 302 centre left); Snejana Onopka
(p. 302 centre right); Caroline Winberg
(p. 303); Isabel (p. 305); Olga Sherer
(p. 306); Lily Donaldson (p. 307 left);
Anne-Catherine Lacroix (p. 307 right);
Irina Lazareanu (pp. 308 & 309)
BACKSTAGE: Madame Jacqueline
(p. 299 left); Odile Gilbert (p. 308 left);
Madame Martine (p. 309 second right)

A COUTURE BRIDE

A DAY AT THE ATELIER

PAGES 314–15: Caroline Sieber trying on an option, with Madame Cécile (centre), at the Chanel haute couture salon, 31 rue Cambon, Paris

PAGES 316–17: Caroline Sieber wearing a *toile* version in plain fabric, during a fitting at the Chanel salon

PAGE 319: Caroline Sieber in a *toile* on the mirrored staircase that leads to Coco Chanel's private apartment at 31 rue Cambon

PAGES 320–21: Caroline Sieber in finished Chanel haute couture dress, at Schloss Gutenstein, Austria, July 2013

PAGE 324: As Chanel stated: 'Bees characterize the Spring-Summer 2016 collection, whether they be embroidered onto tulle or mounted as costume jewellery'

PAGE 325: Lindsey Wixson on the cover of Chanel's Spring/Summer 2016 haute couture lookbook

PAGES 326–27: Elisabeth von Thurn und Taxis and a seamstress at the Chanel atelier, 31 rue Cambon, Paris

PAGE 328: The bridal look for Chanel Spring/Summer 2016 haute couture, modelled on the runway by Mica Argañaraz

PAGE 329: Hand-sewing beading, paillettes and wooden discs on a couture garment at the atelier

PAGES 330–31: Virginie Viard, model Paula Galecka, Karl Lagerfeld and Madame Cécile during haute couture fittings

PAGE 333: Model Lauren de Graaf with Karl Lagerfeld and Elisabeth von Thurn und Taxis at the Chanel atelier

PAGE 334: A giant sculpture of a classic Chanel jacket: the set for the Spring/Summer 2008 haute couture show

CREDITS

MODEL AGENCIES: CAA, New York; City, Paris; DNA, New York; Dominique, Brussels; Elite, Paris; Ford, Paris and New York; IMG, Paris; Marilyn, Paris; Models 1, London; New Madison, Paris; Next, Paris; One, New York; Oui, Paris; Premium Models, Paris; SAFE Management, Paris; Select Model Management, London; Storm, London; Supreme Management, Paris; The Lions, New York; Viva, Paris; Why Not Model Management, Milan; Wilhelmina, New York; Women Management, Paris

MODELS: Amandine, Danita Angell, Devon Aoki, Delfine Bafort, Caitriona Balfe, Kylie Bax, Natalia Belova, Marta Berzcalna, Marcelle Bittar, Mariacarla Boscono, Tetyana Brazhnyk, Brandi Brechbiel, Carla Bruni, Gisele Bündchen, Naomi Campbell, Laetitia Casta, Jeisa Chiminazzo, Kristina Chrastekova, Anna van Ravenstein Cleveland, Pat Cleveland, Lily Cole, Elise Crombez, Lisa Davies, Lauren de Graaf, Debbie Deitering, Agyness Deyn, Lily Donaldson, Diana Dondoe, Dewi Driegen, Du Juan, Morgane Dubled, Julia Dunstall, Tanya Dziahileva, Lida Egorova, Lindsay Ellingson, Karen Elson, Emma, Freja Beha Erichsen, Marta Español, Linda Evangelista, Liliane Ferrarezi, Isabeli Fontana, Tomiko Fraser-Hines, Portia Freeman, Luca Gadjus, Paula Galecka, Diana Gärtner, Trish Goff, Georgina Grenville, Shalom Harlow, Eva Herzigova, Michele Hicks, Carmen Maria Hillestad, Kirsty Hume, Ira, Isabel, Constance Jablonski, Querelle Jansen, Carmen Kass, Mor Katzir, Liya Kebede, Hannelore Knuts, Karolína Kurková, Anne-Catherine Lacroix, Irina Lazareanu, Anouck Lepère, Angela Lindvall, Juliette Linget, Teresa Lourenco, Tatiana Lyadochkina, Heather Marks, Audrey Marnay, Lesly Masson, Kristen McMenamy, Diane Meszaros, Jessica Miller, Tanga Moreau, Kate Moss, Mayana Moura, Karen Mulder, Astrid Muñoz, Kim Noorda, Ciara Nugent, Erin O'Connor, Iza Olak, Snejana Onopka, An Oost, Kirsten Owen, Martina Pavlovska, Colette Pechekhonova, Mateja Penava, Vanessa Perron, Malin Persson, Natasha Poly, Rie Rasmussen, Caroline Ribeiro, Maggie Rizer, Liberty Ross, Anja Rubik, Cameron Russell, Amanda Sanchez, Claudia Schiffer, Patricia Schmid, Angie Schmidt, Milagros Schmoll, Marianne Schröder, Noot Seear, Fabiana Semprebom, Olga Sherer, Hana Soukupová, Julia Stegner, Kamila Szczawińska, Stella Tennant, Caroline Trentini, Nicole Trunfio, Dasha V., Amber Valletta, Jenny Vatheur, Natalia Vodianova, Nataša Vojnović, Eugenia Volodina, Marija Vujović, Gemma Ward, Yasmin Warsame, Erin Wasson, Leah de Wavrin, Alek Wek, Daria Werbowy, Rosemarie Wetzel, Jacquetta Wheeler, Solange Wilvert, Caroline Winberg, Lindsey Wixon, Melody Woodin, Xanthi, Tatyana Yusova, Raquel Zimmermann

Names have been listed where identification was possible at the time of publication. The publisher will be pleased to add further credits in any subsequent reprints of this book.

TEXTS: pp. 40 from 'Thank You Karl Lagerfeld', Chanel.com, 19 February 2019; 59 and 198 from *Chanel Catwalk* (London: Thames & Hudson, 2020), pp. 382 and 206; 80, 97, 110, 152, 170 and 277 from *The World According to Karl* (London: Thames & Hudson, 2013), pp. 32, 57, 72, 77, 80 and 74; 178 from 'André Leon Talley on Chanel Pre-Fall 2011: Good as Gold', Vogue.com, 8 December 2010; 210 from Chanel 3.55 podcast series; 256 from André Leon Talley, *The Chiffon Trenches* (New York: HarperCollins, 2021), p. 53; 286 from 'André Leon Talley Remembers Karl Lagerfeld', Vogue.com, 19 February 2019. All other quotations and texts were supplied for the present publication.

ABOUT THE CONTRIBUTORS AND COMMENTATORS:

NATASHA A FRASER is an author, journalist and expert on Paris, luxury and lifestyle. Her books include *Chanel Fashion*, *Monsieur Dior* and *After Andy: Adventures in Warhol Land*. She has also taught at the American University in Paris and is the co-producer of *Inside Dior*, the two-part television series.

MICHEL GAUBERT is a sound illustrator in the fashion industry, creating custom runway soundtracks. He collaborated with Karl Lagerfeld for almost thirty years.

ODILE GILBERT is a hairstylist, celebrated for her editorial work and advertising campaigns as well as her runway looks. She is to date the only female hairstylist to have received France's prestigious Ordre des Arts et des Lettres.

AMANDA HARLECH is a creative consultant and writer. Renowned as one of the fashion industry's leading authorities on style, she worked alongside Karl Lagerfeld at Chanel and Fendi for over twenty years.

SAM McKNIGHT is a prominent hairstylist, who has worked in fashion for more than four decades. His most iconic session work was celebrated in a 2016 career retrospective at London's Somerset House.

SALLY SINGER is head of fashion direction at Amazon. Her previous roles have included creative director of American *Vogue* and editor-in-chief of *T: The New York Times Style Magazine*.

ANDRÉ LEON TALLEY was a pioneering fashion journalist. Having begun his career interning with Diana Vreeland, he rose to become creative director and then editor-at-large at American *Vogue*.

ELISABETH VON THURN UND TAXIS is a freelance writer, columnist and editor for international publications. Formerly style editor-at-large at American *Vogue*, she has designed and collaborated with both fashion brands and art institutions.

PHILIP TREACY is a milliner who has worked with the greatest designers of our age. Awarded an OBE for his service to the British fashion industry, he has won the British Fashion Awards title of British Accessory Designer of the Year five times.

ACKNOWLEDGMENTS

André Leon Talley
'Books are jewels,' André wrote back to me, when I asked if he might write an introduction to my second tome, *John Galliano Unseen*. This became the beginning of an exciting new adventure for Vanessa and me — to have André send his lightning-bolt emails in batches of ten, detailing his thoughts and memories, full of pronouncements, new expressions and fact-checking queries, which required an immediate response. No one could keep up with André and his razor-sharp fashion history references and perfect recall of the newly fabled Golden Age. It was high drama for André, for more than four decades, in an industry of the arts, performance, imagery, narration and creation, over which he reigned supreme, firstly at Warhol's *Interview* magazine, then at John Fairchild's *WWD* in Paris, and finally with Anna Wintour at American *Vogue*. André said in his documentary 'The Gospel According to André' that he had three angels watching over him in this life: his grandmother, Diana Vreeland and Andy Warhol. Of course he had so many more, and I doubt he would ever have fully believed the outpouring of emotion on the news of his sudden death, or the heartfelt tributes from all his friends and colleagues. He was an irreplaceable man in an unrepeatable moment in time. In loving memory of you, André.

Karl Lagerfeld
Thank you, Karl. A truly mythical man, who never stopped, and who created an absolute empire of modernity — always there, and in many ways so ageless. I'm delighted to offer in this book some brief moments of the Chanel artistry behind the scenes, carried out under your creative vision. We shared a love of photography and of a Fuji GA645Zi, as well as a few other cameras, and I am grateful that you were always interested and asked questions whenever our paths crossed. Natasha A Fraser and Philip Treacy couldn't have put it any better: you were the KING of fashion.

Amanda, Lady Harlech
Poetry, refinement, beauty and grace, knowledge, certainty, attitude and creativity. Thank you, Amanda, for casting your visionary eye over these pages and for contributing your perfect prose, precisely capturing the magic that takes place behind the scenes.

Sally Singer
My career backstage was accelerated at a fast pace when you chose me to take photographs for your fashion features pages at *Vogue*. Your bringing me on board offered me rare glimpses of an haute couture world of refinement and rock 'n' roll AAA energy backstage at every fashion house, often by myself at the turn of the century. I was granted opportunities to capture moments that I can only dream about now. Thank you, Sally, for always being such a wonderful and important figure in my career and life.

Natasha A Fraser
Thank you for your wise and witty words on what it was really like at 31 rue Cambon, including us all in a bygone era of model fittings, Parisian-style, and giving us a peek into a highly gilded world. 'Working at this level has to be fun,' said Karl Lagerfeld, and your introduction shows us it was certainly that.

Michel Gaubert
Thank you for giving us sound, revolution, pace and rhythm. The most essential part of any show is to get the blood racing — the girls', the audience's — by creating an atmosphere that we will all remember and respond to: a performance is made up of combined energy and life force. May the beat go on...

Odile Gilbert
Thank you for sharing your kind thoughts and appreciation of your years at Chanel with Karl. The inspired hairstyles you perfected every season were always a crucial part in my recording of the fantasy that is Chanel.

Sam McKnight
One of my first allies behind the scenes— a man I have known since the beginning. Thank you, Sam: your artistry and influence have been omnipresent since the 1980s, whether in fashion shows, fashion magazines or fashion campaigns.

Caroline Sieber
Thank you, Caro, a kind friend and unforgettable bride, for allowing me to feature your wedding dress fittings and *Vogue* portrait in this book. I owe much to you and Fritz, and hope to be there to photograph your girls' weddings in time.

Elisabeth von Thurn und Taxis
Thank you, Elisabeth, for your contribution to this book. So often on assignments it's a fleeting moment spent with one's editor, but we have always had fun, be it in Paris, London or Venice. You have been a generous, super-cool princess at every shoot.

Philip Treacy
Hats and headpieces: you are the master of crowns for every girl, completing the well-dressed look.

Much gratitude also to:

Anna Wintour: it has been my good fortune to have you as my editor-in-chief. Supremely modern in thinking, you gave a young man an opportunity to flourish, representing you and the magazine with a free rein. I am often asked about this time, and I have to say it couldn't have happened without you and the power of *Vogue*.

Ronnie Cooke Newhouse: my thanks to you, who have always understood the art in my imagery, enabling me to be myself and to continue working to this day with only the very best introductions and advice.

Roxanne Lowit: my fellow photographer, and an artist who dominated the behind-the-scenes reportage underbelly of the fashion and party world for seventeen years before me at *Vogue*. When you walked into the room, it was kisses from the designers and first-name terms with all the Supers. Always in awe of you; you laid the path for a new reveal. Thanks and love to you, Roxanne, for pioneering backstage and taking it to new levels for all of us that followed.

Stéphane Marais: I first glimpsed your work backstage at Galliano, and then at Dior, Chanel, Karl Lagerfeld and Chloé, to name but a few — always perfection and always thrilling.

Tom Pecheux: an iconic image-maker and friend, a superpower of beauty when working on any face.

Hamish Bowles: thank you for accompanying me as sittings editor on so many assignments. For Caro's portrait we trekked for hours up into the hills at Gutenstein, searching for a location (I've found photographs for your memoirs). You are always fun, a perfect editor and wedding guest, forever dancing the night away.

Plum Sykes: thank you for your wonderful story in the *Vogue* September issue. I love working with you.

Ivan Shaw: my friend and photography director, so glad to have shared so much of this past with you.

Desirée Rosario-Moodie: a key part of *Vogue*'s photo department and a regular voice on the phone back in the day.

Fiona DaRin and Iann Roland-Bourgade: perfection in Paris provided by the *Vogue* bureau. I miss you all and think of you often.

Teen Vogue: thank you to Eva Chen, Jane Keltner de Valle and Lucy Lee.

Harper's Bazaar USA: thank you to Cary Leitzes, my photography director in the late 1990s. Always love and support. Heady days.

Elle: Iain R Webb, Charlotte-Anne Fidler and Rosie Green, the enthusiasm you showed for my early beauty imagery in 1994–95 put me on the map. I owe much to you all, and I hope you feel it from Vanessa and me.

Sincere thanks also to:
Adelia Sabatini, Corinna Parker, Jane Cutter, Jenny Wilson, Sophy Thompson, Johanna Neurath and all at Thames & Hudson.

Hannah Montague: brilliantly art-directing your first solo act in *Unseen*; thank you for your commitment to the team and for reaching our publishing goals.

Indre Marcinkute: retouch and brilliance; your love of beauty imagery is clear, because for so long you put your own beauty and nature into the imagery — thank you.

Touch Digital, London: Graeme Bulcraig and Emma Tunstill, as well as Barbara Nowak, collaborators over many years — it's always a delight to come to Perseverance Works.

Tim and Charlotte Parkin: enormous gratitude for your total professionalism with scanning imagery for all our books.

Jonathan Ragle: light knowledge and refinement — a fantastic work colleague and friend. Long may it continue... Thank you also to Philip Volkers.

And, last but not least:

Vanessa Fairer
A blinding force of super-charged energy, words, talent, inspiration, stamina, courage and mad fun. The *Unseen* series and our incredible archive would not function without your passionate zest and zeal over the last thirty years. Your research, and your ability to define me, understand me and keep up the pace running our business life and home life, simply take my breath away. Thirty-eight years and counting...

Mum
Love and support always from you, Mum, elegance and manners. You and Dad gave me everything.

Bernard Slade
In more recent years, thank you Bernard for backing us all up.

Sam and Jimmy
Thank you for all the love. You know how much you are loved.

INDEX

THIS BOOK IS DEDICATED TO THE MEMORY OF
KARL LAGERFELD AND ANDRÉ LEON TALLEY

Endpapers: Detail from the Autumn/Winter 2003–2004 ready-to-wear Chanel collection

p. 2: Karl Lagerfeld backstage at the Autumn/Winter 2003–2004 ready-to-wear Chanel show, Paris, March 2003

Library of Congress Control Number: 2022932219

ISBN 978-1-4197-6285-7

First published in the United Kingdom in 2022
by Thames & Hudson Ltd, 181A High Holborn,
London WC1V 7QX

Karl Lagerfeld Unseen: The Chanel Years © 2022
Thames & Hudson Ltd, London

Photographs © 2022 Robert Fairer

Preface © 2022 Sally Singer
Introduction © 2022 Natasha A Fraser
'A Couture Bride' © 2022 Robert Fairer
'A Day at the Atelier' © 2022 Elisabeth von Thurn und Taxis
Quotations © the respective contributors

Original concept by Vanessa Fairer

Design and Art Direction by Hannah Montague

Printed and bound in China by C&C Offset Printing Co. Ltd
10 9 8 7 6 5 4 3 2

MIX
Paper | Supporting responsible forestry
FSC
www.fsc.org FSC® C008047

ABRAMS The Art of Books
195 Broadway, New York, NY 10007
abramsbooks.com

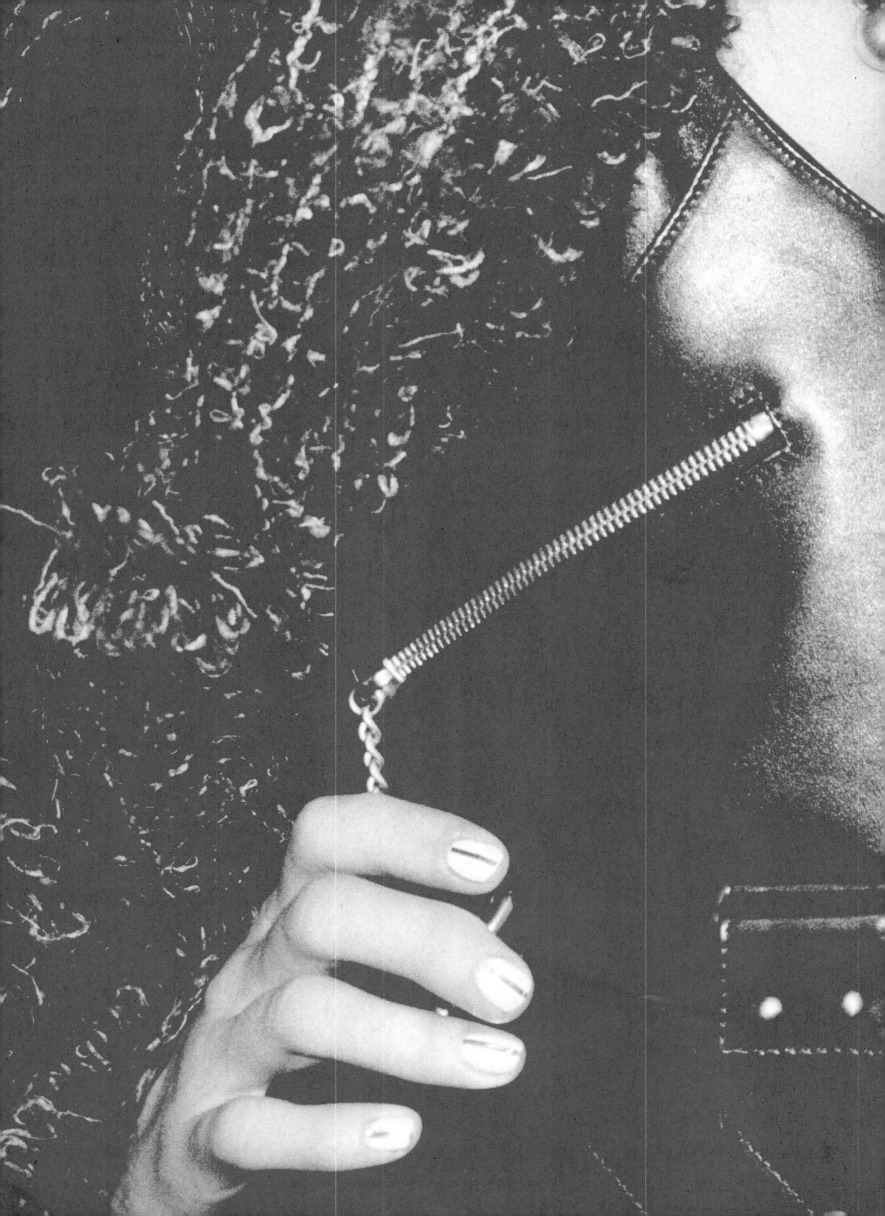